MOMENTS IN TIME

MOME
IN

PHOTOS AND STORIES FROM

ONE OF AMERICA'S

DIRCK HALSTEAD

NTS$

TIME

TOP PHOTOJOURNALISTS

ABRAMS, NEW YORK

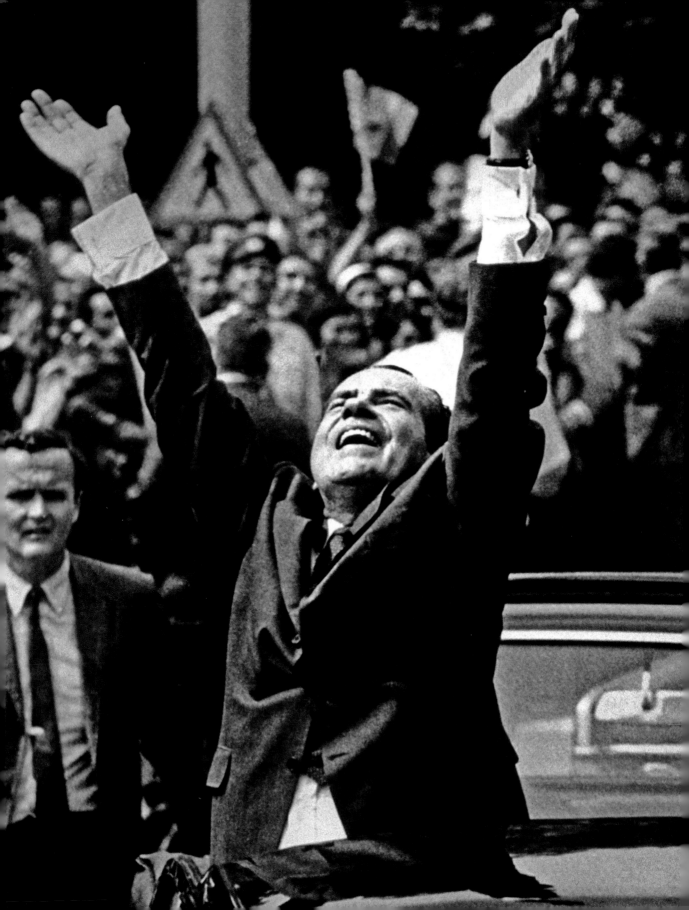

Contents

FOREWORD by Peter Howe

Photojournalism is a strange way to make a living. For one thing, the living you make is pretty marginal; it's not a career anyone ever undertook for the money. Furthermore, the working conditions under which you earn the pittance offered are appalling. They include getting shot at, being sleep- and food-deprived, spending way too much time in the coach section of an airplane, and way too little time at home. There's a reason that photojournalists don't have a union—any union organizer worth his or her salt wouldn't know where to begin righting the wrongs.

And yet, paradoxically, it's also a life of incredible privilege. The average photojournalist, if there is such an animal, gets to go to more places, meet more people, and experience more things than one could reasonably expect to force into three or four ordinary lifetimes. What other career would give its practitioners the opportunity to witness the fall of Saigon; photograph Louis Armstrong, Andy Warhol, and the cast of *Star Trek*; and document eight presidencies, including accompanying Nixon on his historic trip to China and capturing Clinton hugging an unknown White House intern named Monica Lewinsky? This job gives those who embrace it an unparalleled front seat in the long-running show called history. The reason that most photojournalists put up with the low pay and difficult circumstances is that they are amazed they are allowed to do what they do.

The word "allow" in this context is a modified use of the verb. This is not a career for the faint hearted—wallflowers need not apply. It takes an immense amount of determination and a certain level of pushiness to achieve any level of success. The barriers encountered on a daily basis include presidential advance people, military information officers, the public relations employees of major (and minor) celebrities, and security guards of all descriptions. On top of all this it is often necessary to intrude into the most intimate moments of people in abject circumstances in order to bring a story to the wider world. Few photographers like to photograph the dying, the grieving, or the victimized, but the job often demands it, and it is these photographs that on occasion actually do make a difference. For an intelligent and responsible photojournalist, the moral and ethical minefields can be almost as unnerving as the real thing.

Those who make a living telling the stories of our time with their cameras are equally adept as raconteurs. Some of the most enjoyable moments of my career have been spent in the company of photographers sitting around telling "war stories"—often, of course, stories about actual wars, but equally compelling are the tales about other battles fought, mostly with various authorities, and especially with their own editors. The reason that photographers' stories are so absorbing is that they tend to focus on the emotional aspects of any experience. Emotion is the lingua franca of photography, and the reason for its long-lasting appeal. It is not a medium that is good at analyzing why something happened, but it is unequalled in telling you what it felt like when it happened. So too are the stories that photographers tell about the work they do. If you don't believe me now, you will by the time you've finished reading this book.

Dirck Halstead has been a photojournalist for fifty years. He started out as a precocious high school student snapping a picture of Rita Hayworth leaving a courthouse in 1954, and is now engaged as an equally precocious Senior Fellow in Photojournalism at the Center for American History at the University of Texas. In between these points he has been a UPI picture bureau chief and photographer in Saigon, photographer for both *Life* and *Look* magazines, but most of his career was devoted to *Time* magazine in Washington, rising to the position of Chief White House Photographer. He was one of those members of the White House press corps that presidents knew by their first names.

Dirck's career has also spanned an era that will be regarded as pivotal in the history of photo-

journalism. It has been a period during which the profession has had to constantly reinvent itself as it responds to the new demands and opportunities, or sometimes lack thereof, of technology and market changes. It used to be that news stories were shot in black and white and transmitted over the wire by AP and UPI, whereas magazine stories were mostly shot in color and often carried back from foreign locations by unsuspecting airline passengers. Can you imagine going up to a complete stranger at an airport today and asking them to carry a package of what you swore was film that would be collected by somebody you swore was a representative of the magazine upon landing? In the early seventies this was about the only way to get color film back to the picture desk, and the flying public was more than happy to oblige. They seemed to like this connection, albeit tangential, to the glamour of international journalism, although their enthusiasm might have been muted had they known that they were called "pigeons" by the photographers they were helping. Today film is virtually irrelevant in documentary photography, and with PowerBooks and satellite phones, photographers can, and do, transmit digital files directly to their newsrooms from the middle of a firefight in Iraq.

The market for this kind of work has changed dramatically, as well. Of the three magazines that Dirck worked for, *Time* is rapidly losing readership, *Life* is a sad newspaper insert of its former self, and *Look* hasn't been around as a weekly since 1971. Television, which was prematurely credited with the death of photojournalism, is itself now under threat as a news source from the immediacy of the Internet, which represents significant possibilities as an outlet for journalistic photography. In fact, Dirck is one of the people creating these opportunities with his webzine, the *Digital Journalist*. The first law of survival is the ability to adapt to new circumstances.

What is the merit in a life spent chasing images to illustrate magazines and newspapers? For a democratic society, the value is great. There's a reason the founding fathers of this nation made the First Amendment the first amendment, and not the fourth or fifth. They understood that for a democracy to function properly the people would need both information and transparency in government. Photojournalists are among those who provide both, and in the form that we trust the most, even in these days of digital manipulation. Seeing it with your own eyes has long been the standard for believing that something is true, but we do not get to witness most of the events in the world that are important to us; we have to see them through other people's eyes—people like Dirck Halstead. He and his peers are our eyes and ears on the frontline of current affairs, and although we don't always believe what reporters write about a presidential candidate, or a flood, fire, or earthquake, for the most part we do believe what photographers shoot. For one thing, they have to be there: you can report a war from a hotel lobby, but you can't shoot one from the same location.

By any yardstick, Dirck's career has been remarkable in both its length and breadth. He has witnessed many of the key events of the last half of the twentieth century, some of whose importance was obvious as they happened, and others that have increased in significance as time went by. Not the least of the latter group is the photograph of President Clinton embracing an obviously adoring intern. Photographers have prodigious visual memory—they sometimes can't remember if they've done their expenses, but they can tell you exactly what they shot twenty years ago and on what lens. After the Lewinsky story broke, Dirck remembered that he had seen her face somewhere before and after considerable research discovered that he had already shot her. Unfortunately for President Clinton, it has become the iconic image of his presidency. But that's what history is, essentially—a constant reevaluation of events. This book is not just a collection of one photographer's pictures; these moments in time are our history brought to life. Although Dirck owns the photographs, through them we own the moments. If the most important light reading for a photojournalist is "f8 and be there," then Dirck Halstead got his exposure right every time. Not only are we better off for him being there, it is his legacy for generations to come.

PREFACE by Dirck Halstead

Photography comes in many flavors: wedding photography, underwater photography, baby photography, glamour photography, and fine-art photography, just to name a few. What distinguishes photojournalism from the pack is that the end result is intended for the printed page, television, or the World Wide Web. Its main purpose is to record true-life events as they unfold; to act as a historical record. Today, images by photojournalists can be found in art galleries and museums, but, that was not the intended destination.

Photojournalism is really all about telling a story.

At an early age I knew what I wanted to do, and pursued that path relentlessly. Over the course of more than four decades I was fortunate, indeed privileged, to have been there—everywhere—with my camera as some of the greatest events of our time took place. Hopefully along the way I managed to capture some good storytelling pictures. At least, the stacks of tear sheets from newspapers and magazines around the world seem to prove that I did.

It was impossible to watch these events unfold before me and remain unmoved. Of course I felt awed, thrilled, saddened, and even terrified. Along with the indelible images that linger in my mind, my heart is full of so many pent up, tampered down, unexpressed emotions. However, most photojournalists consider themselves professionals above all else. Just as a doctor or emergency worker has no time to indulge personal feelings under pressure, the job of a photojournalist is first and foremost to record the event. But in the end, photojournalists are human beings. They cannot cover wars, presidential assassination attempts, natural disasters, and human tragedy without carrying those scars.

There are also the wonderful lighter moments that go with the territory. I will never forget watching the Bob Hope Christmas Show on an aircraft carrier in the South China Sea; the thrill of seeing the Mets win the World Series against the unbeatable Baltimore Orioles in 1969 with an amazing five homeruns in the last three at bats; or scaling a cliff in Italy with Sly Stallone. Then there are the practical jokes photographers play on each other to combat the sheer boredom of waiting around, sometime for hours and hours, for the next "photo op."

One of the best-kept secrets in journalism is that photographers can be terrific storytellers. They recall memories in colorful, visual terms, and their sense of timing can be unerring. However, you rarely hear them regaling guests at a cocktail party or dinner. The stories are so big, and based on such important events and people, that even talking about them would be in bad taste. But late at night, in a dark bar in a place like Bangkok, Paris, Calcutta, or New York, among their own kind and usually encouraged by a few drinks, the stories start to flow and they are wonderful.

I like to think of them as camp fire stories.

You will find some of mine—highlights of my 45 years working as a photojournalist—amid the pictures in this book. I only wrote about things I personally experienced and witnessed, so it's all true. Some stories are short, while others, such as my account of the fall of Saigon in 1975, are small books in and of themselves.

Please join me for what I hope you will find to be an amazing journey.

Shooting the Democratic National Convention in Los Angeles, July 1960.

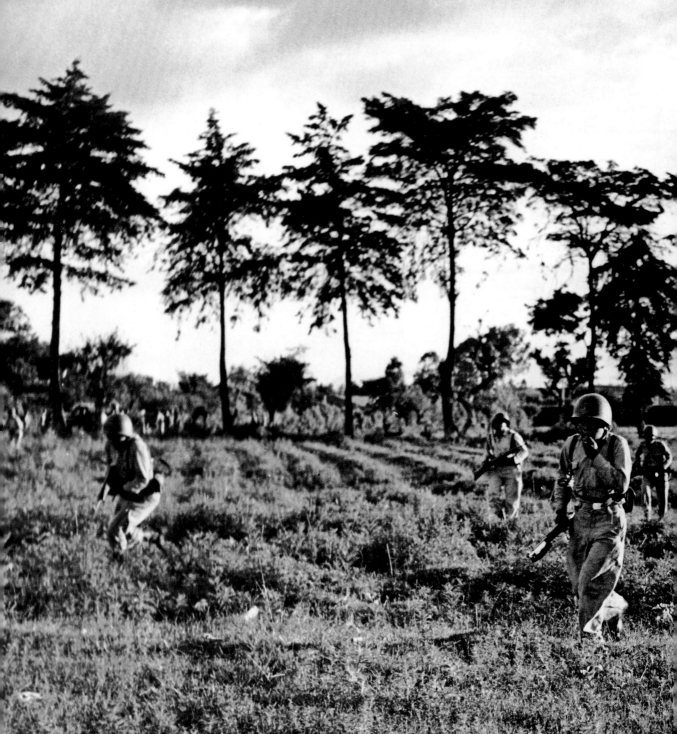

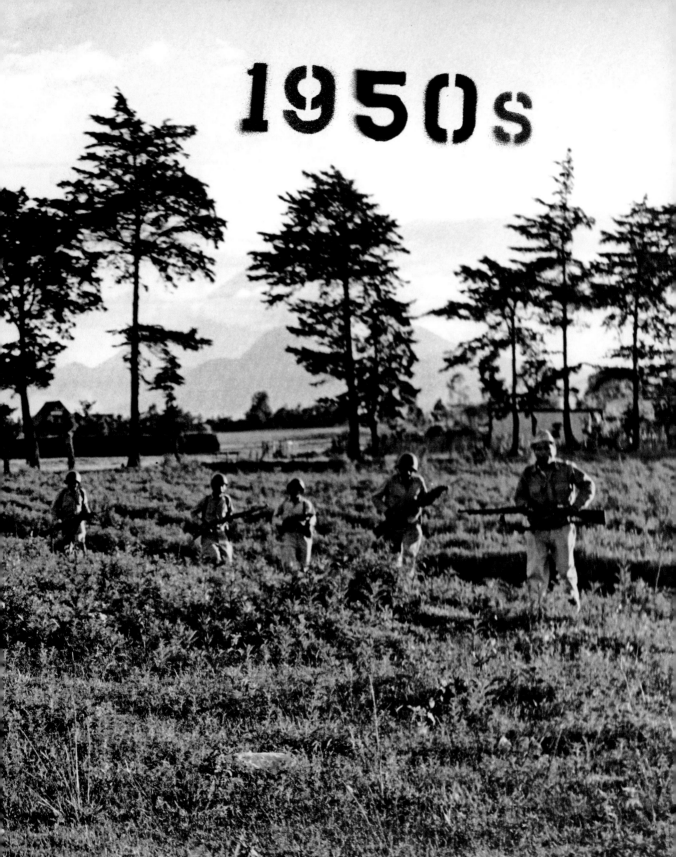

1950s

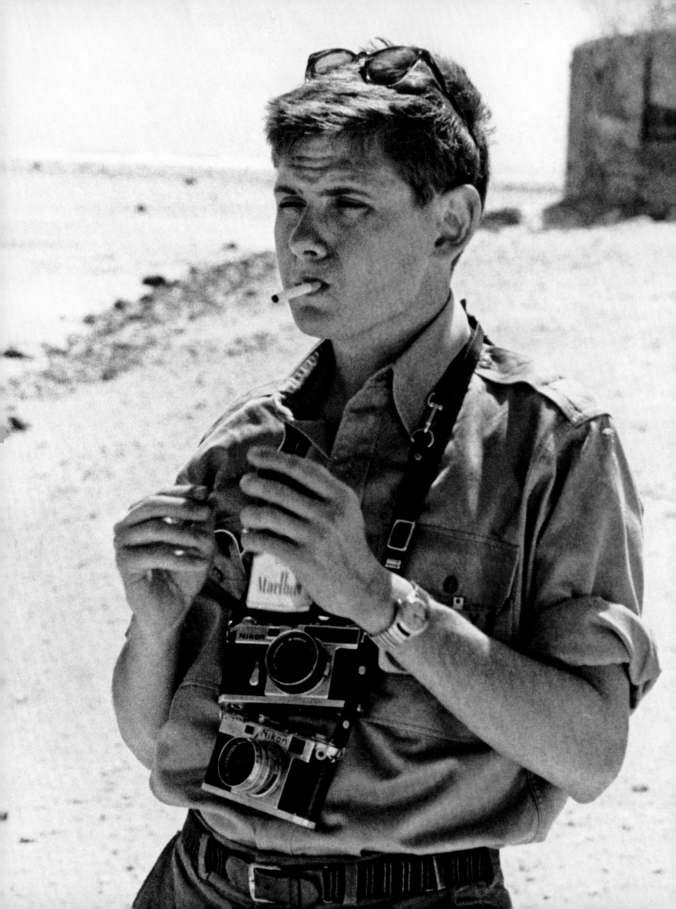

As you read this war story, you will probably say, "There's no way this could've happened." All I can tell you is, the story is true. ∎ In the last week of June 1954, I graduated from Bedford Hills High School in New York's Westchester County.

In the preceding two years, I had used photography as a way to fashion an identity. I wound up being editor of the high school yearbook, and also created a job for myself with the local newspaper chain: they needed photos, and I was cheap.

The last month of my high school experience I covered Rita Hayworth leaving a court building in White Plains after she had filed suit against her husband Aly Khan. I shot it with a 4x5 Speed Graphic, and the New York *Daily Mirror* used the picture on the front page.

A week later. I took a train to Washington on my own initiative, and covered the Army-McCarthy hearings, in which Senator Joe McCarthy held the lives of a lot of good people in jeopardy. These photographs, along with a photo of Joseph Welsh, the army counsel who said, "At long last Senator [McCarthy], have you no sense of decency?" were used on the front page of the *Patent Trader*, the newspaper I worked for.

The hearings also inspired me to write an editorial for my high school newspaper that called into question McCarthy's tactics. There was a furor surrounding the publication of my editorial; high school papers weren't supposed to cover such controversial subjects. When I graduated, there was no mention that I had ever been the editor of the paper.

So there I was, graduating, driving my '41 Chevy down the hill from the school, and wondering what I was going to do next. I happened to be listening to WNEW's "Make-Believe Ballroom" when a news bulletin broke in: photographer Robert Capa had been killed in Vietnam.

Robert Capa dead? Couldn't be. Robert Capa was my hero. To me he was the epitome of a war photographer: handsome, brave, had an affair with Ingrid Bergman. What was really fascinating about him, though, was that he was a self-made man. Robert Capa had started out in the thirties as a struggling photographer from Budapest named Andre Friedmann. While covering the Spanish Civil War, he and his lover, Gerda Taro, decided he should reinvent himself as an American war photographer, Robert Capa—a move he felt necessary to sell his photographs. His photograph of a

1950s

Pages 10–11: Troops loyal to ousted Guatemalan president Jacobo Arbenz advance on Castillo Armas's rebel forces, which are holed up in Roosevelt Hospital in Guatemala City. Opposite: On assignment for the United States Army on Kwajelin atoll in the Pacific, where I was covering the start of the U.S. space and missile program. After being drafted, I wrangled a job in the Pentagon, which allowed me to travel the world photographing stories.

Spanish Loyalist being struck in the head by a bullet became an instant classic. The newly created Capa quickly became a legend in the new field of photojournalism.

As a boy I wanted to be a cowboy. Somewhere in my teens, I decided that being a photojournalist was where it was at. It was certainly more practical since there was a shortage of range and cattle around Bedford Hills.

As I listened to the WNEW broadcast, I heard that Capa was being brought to the United States for burial in a cemetery in Amawalk, New York, within my "coverage" territory for the paper. The Capa family wanted to make a statement that he had lived his life to make people aware of the futility of war.

On the day of the ceremony, I arrived at the Quaker cemetery early. I wandered inside, looking for the site. Meanwhile, a bunch of photographers from the New York dailies had shown up at the front gate of the cemetery, waiting for the body to arrive.

A few minutes before the burial was supposed to take place, John Morris, who was then the head of Magnum Photos, came up and asked me to leave. Magnum was the agency that Capa and other photographers had created as co-op so that they could fund their projects.

At this point, a rough wooden casket, almost like a shipping box, was ushered into the cemetery. Stenciled on it were the words, "Restes Mortels, Capa Robert, Reporter Photographer, Decede le 25 1954."

I began to cry. John Morris suddenly looked stricken, and he asked me to wait. He walked away. A moment later, he came back and said, "You know, you are a photographer, he would have wanted you here." So I photographed the burial and wrote a story for the *Patent Trader* about what Robert Capa meant to me.

1950s

A week later, I drove to John Morris's Chappaqua home and delivered a set of prints to him. I was just about to leave when he asked, "What are you doing this summer?"

Well, I told him, I had no important plans. I was supposed to start Haverford College in the fall.

Right: Robert Capa's mother, Julia Friedmann, collapses over her son's coffin. Capa's brother, photographer Cornell Capa, tries to comfort her. Opposite: Robert Capa's casket was literally the box his body had been shipped in. It was flown to the United States from Hanoi after the legendary photographer was killed by a landmine.

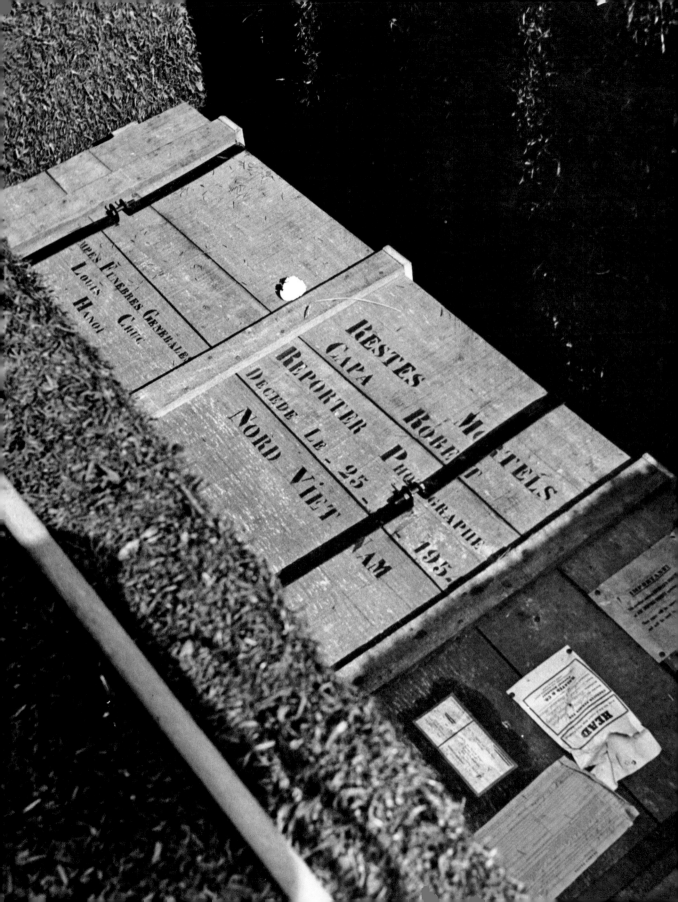

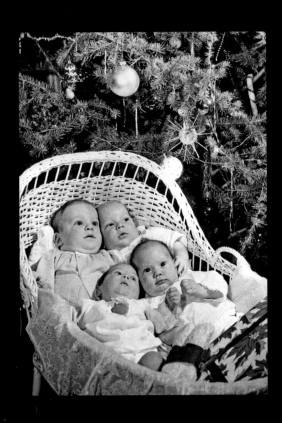

First Cover

Working for the Dallas *Times Herald*, I did all those things that a daily newspaper photographer does, from society pages to car wrecks and fires to features. It is a crucial stage in any photojournalist's development. I had a black Ford interceptor (opposite), with its two-way radios and police scanners, which allowed me to get to the scene fast. I broke the speed limit so frequently on my way to accidents, that the Dallas police had a special back-up car just to issue me speeding tickets. After my first nine months in Dallas I was feeling homesick and begged my boss, Charlie McCarty, to let me go home for Christmas. He said the only way I could go home was if I got the front page of New York's *Daily News*. UPI provided the photo staff of the *Times Herald*, and the yardstick of success was the cover of the *News*. That afternoon, I had an assignment to cover a Christmas party at an orphanage. I found these quadruplets in a bassinet (above), and set it beside the Christmas tree. I then got my extension flash, and with my 4x5 Speed Graphic made this picture. The next morning it was the front page of the *Daily News*. I got to go home for Christmas.

Morris said, "There's a story that's been suggested to us at Magnum, but we don't know what to do with it." A group at Cornell University had suggested to Magnum that they cover an expedition of a group of students to Guatemala to build a school. On my way to Morris's house I had heard a news bulletin that a war was developing in Guatemala. The CIA had sponsored a coup attempt under a leader, Carlos Castillo Armas, to overthrow the Communist government led by Jacobo Arbenz. Every war correspondent and photographer was on his or her way to Guatemala.

I thought this was my big chance.

The next day I showed up at *Life,* asking for an appointment with the director of photography, Wilson Hicks. It turned out that he was on vacation, so I got a meeting with his acting director, John Bryson, who was a great photographer in his own right. All I had was that week's newspaper with my picture of the Army-McCarthy hearings (a big deal for a small-town paper) and the Rita Hayworth pictures. But for some reason, Bryson (bless his soul) took me seriously and led me in to see *Life's* education editor, David Drieman.

They listened to my pitch about the trip to Guatemala; then they asked me if film and $1,000 would be enough to get me started.

Are you kidding? Film and $1,000 in 1954 was a goldmine to a kid who had been getting ten dollars per picture!

In retrospect, the most important thing that I asked for was a note from Drieman written on a page from a Time-Life memo pad reading: "To whom it may concern, Dirck Halstead is on assignment for *Life* magazine, and whatever you can do to help him would be greatly appreciated."

Bonding with Capa

The group going to Guatemala was made up of Presbyterian students from Cornell University. They were led by an affable and energetic man named Lee Klear. The idea was that these twenty-some undergraduates would be traveling on two canvas-topped trucks all the way from Ithaca, New York, down through Mexico, and into Guatemala City. The drive would take about ten days.

The day before my father was to drive me from our home in Mount Kisco, New York, up to Ithaca, I made a beeline for the nearest Army-Navy store. Using some of my new-found wealth, I bought military fatigues, an army cap, a knapsack, a web belt with canteens, a fanny pack, and combat boots . . . everything I could imagine a war photographer would need. With some additional help in the form of a going-away present from my parents, I also picked up a couple of brand-new Leica IIIfs, with a wide angle and a 90mm lens. My trusty 4x5 Speed Graphic would sit this one out.

The Sunday we left for Cornell dawned with leaden skies. As we were about to turn onto the interstate heading north, I asked my father to make a detour.

We drove to the cemetery where a week earlier Capa had been buried. As I walked to Capa's tombstone, the wind started to kick up, and a clap of thunder echoed through the cemetery as rain started to pour down. I stood over his grave as the rain ran down my face. For a moment, I thought I could feel the great photographer's presence. Whatever it was, I allowed it to mingle with mine. By the time I turned back to the car, I was convinced that I had taken on Robert Capa's spirit and that I was going to be covering my first war.

The Memo Comes in Handy

About the time our canvas-covered trucks pulled into Cleveland, I started to spread out my equipment and military gear on the mattresses that were strewn about in the truck bed. The other students, clad in T-shirts and shorts, were aghast.

"What do you think you're going to do with that stuff? Go to war? We're supposed to be building a schoolhouse, for Pete's sake!"

Obviously, they hadn't heard about the recent events in Guatemala. When I explained that we were heading into an active war zone, one of them said, "Oh, that! That was all over yesterday!"

Sure enough, the previous day, as the CIA-led guerrillas approached Guatemala City, the Communist leader Jacobo Arbenz had fled the capital, and Castillo Armas's men had entered the city without a shot being fired. The war was over, and all the war correspondents were heading home. But for some bizarre reason, it didn't faze me in the least. I decided I would continue to shuck my Kodachrome canisters into my belt pack, just smiling and saying, "When we get there, there will be a war!"

Five days later we arrived in Dallas. I wanted to make sure my new cameras were operating properly, or more accurately, that I knew how to operate them. I found the local newspaper, the Dallas *Times Herald,* and walked in with a couple of rolls of black-and-white to see if they could process them for me.

A compact and feisty man named Charlie McCarty met me. He was the Southwest Division newspictures manager for United Press International (UPI), and he had just taken over the management of the *Times Herald* picture department. He was looking for new photographers. As I took the film out of my new Leicas, I talked about my mission and showed him some of my tear sheets from the previous week's *Patent Trader*. Included were the Capa funeral, my coverage of the McCarthy hearings, and Rita Hayworth leaving the courthouse. He offered me a job on the spot, but I wasn't the least bit interested. After all, I had a war to cover! Thus began a relationship that would lead to my returning to Dallas a few years later to work for him. It would also lead to a lifetime of mentoring.

So far my cameras seemed to be in fine shape. I stood at the rail of the flatbed as our trucks headed south across the border into Mexico.

Arriving in Mexico City, we were supposed to be granted our visas to enter Guatemala. And here's where the expedition ran into trouble.

It turned out that the Guatemalan counsel in Mexico was a former Arbenz appointee. He didn't have the slightest interest in doing anything for the new government, let alone issuing visas for twenty school kids from the United States.

Lee Klear was beside himself. Fuming, he paced around the trucks. Suddenly, I had an idea. That little piece of paper I had been given at *Time* might do the trick.

The next morning I presented myself at the Mexico City bureau of Time, Inc., searching for the *Life* bureau chief. He was on vacation, but his assistant took one look at the interoffice memo I handed her and said, "Let me see what I can do." This lady sat down at an old clunky Teletype and knocked out a message to New York. All it said was, "*Life* photographer Dirck Halstead is being denied access by the Guatemalan Communist officials here in Mexico City for his group of Presbyterian students that are trying to enter Guatemala to build a schoolhouse. Please advise."

As the machine in New York spit out the message, it happened that Henry Luce, the founder and editor in chief of Time, Inc., saw it. Harry, as he was called, often checked incoming messages to see what his people were up to around the globe. Several words jumped out at him: *Life* photographer (his guy!), denied access (unthinkable!), Communists (God, how he hates them!), and Presbyterians (he was one of the fold!).

Shortly thereafter a seismic event took place at the State Department in Washington. Suddenly, the number-one priority of the new Guatemalan government was to get a new counsel to Mexico City and issue some visas to a group from Cornell.

As the trucks lumbered across the border, Lee Klear was still shaking his head.

1950s

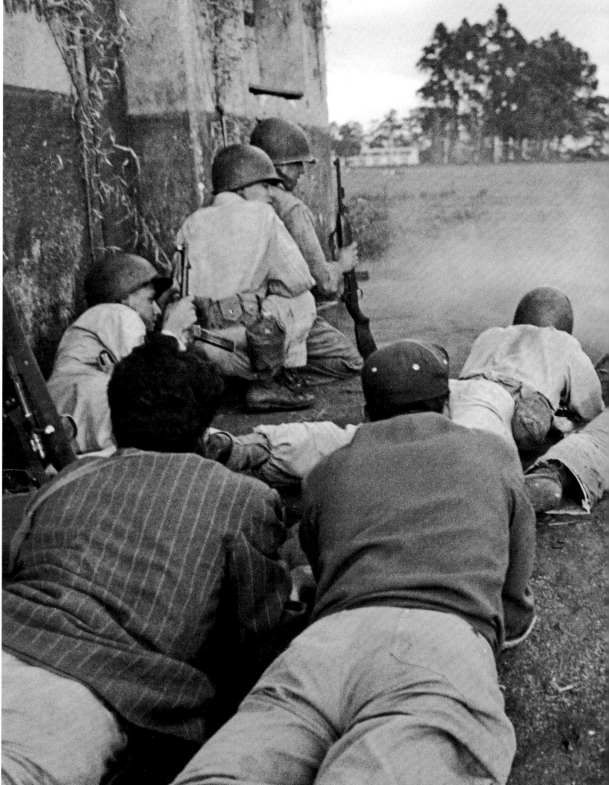

1950s

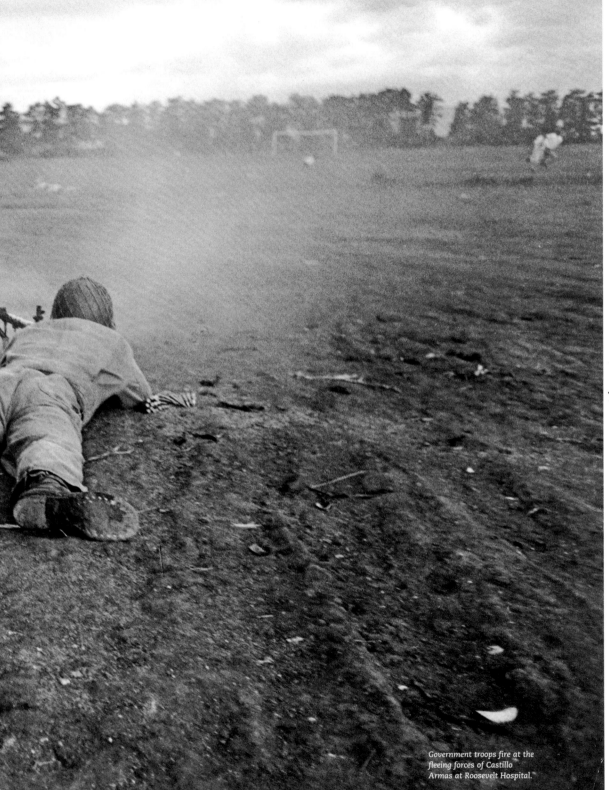

1950s

Government troops fire at the fleeing forces of Castillo Armas at Roosevelt Hospital.

HALSTEAD GETTING OLDER, TENNEY TALLER, EISENSTAEDT SMALL AND GETTING EVEN YOUNGER

BLESS 'EM ALL—THE YOUNG, SHORT AND TALL

Neither youth nor age has a monopoly on the gathering of news. Last week 17-year-old Dirck Halstead, 5 feet 10½ inches, who on his own initiative took the Guatemala City riot pictures (LIFE, Aug. 16) while on a vacation school-building project for a Presbyterian foundation, wrote breathlessly to his parents in Bedford, N.Y.: "Dear Folks—As I sit here at my typewriter pounding out this letter, I can hear gunfire in the distance and I can look across to where my cameras sit, and right in the middle of a set of lenses sits a steel helmet filled to the brim with 35-mm film. You guessed it—I'VE COVERED MY FIRST BATTLE!"

While Photographer Halstead was busy growing older in Guatemala, LIFE veteran Alfred Eisenstaedt, 5 feet 4 inches was showing increasing signs of his perpetual youth on a rugged trans-Canadian trip with Philip, Duke of Edinburgh (see cover and pp. 22–25). Wired TIME-LIFE Ottawa Correspondent Serrell Hillman, who went along too: "Eisie had certain inflexible habits. He got up every morning almost at dawn, then pounded me into consciousness. 'Come on boy, get up, get up! Poor Eisie has to wait on you hand and foot!' "Eisenstaedt wrote religiously in his diary" continued Hillman, "occasionally dipped into Longfellow's *Hiawatha*, and so fascinated his mosquito-bitten, badly fed and bored fellow newsmen with his comic talent for discovering Gargantuan woes that they were able to endure their own. . . When he left the tour at Churchill it was just as well, since he was threatening to steal the show from the duke altogether. . . ."

And just to reassure readers that teen-agers and old masters have no corner on adventure, LIFE recently followed the U.S. Weather Bureau's recommendation for a man in good physical condition to withstand sudden atmospheric pressure changes by sending 6-foot 4-inch, 218-pound Gordon Tenney to cover an artificial cloud chamber in Hitchcock, Texas (pp. 79–82). Wired Tenney after being hoisted (above) on a 60-foot platform: "This assignment was one of losses: I lost a case of flashbulbs that disintegrated in too-fast decompression, lost some film due to radium radiation and lost five pounds in sweat while hanging off the floor in 110° heat."

CONTENTS

The following list, page by page, shows the source from which each picture in this issue was gathered. Where a single page is indebted to several sources, credit is recorded picture by picture (left to right, top to bottom) and line by line (lines separated by dashes) unless otherwise specified.

COVER—ALFRED EISENSTAEDT
3—COURTESY A. B. KHOUEIR & BROTHER—DAILY GRAPHIC PICTURE SERVICE
6, 7—ARCHIE LIEBERMAN from U.S.
15-17, COURTESY THE VILLAGER, BEDFORD, N.Y.
17—JACK GAROFALO for PARIS-MATCH
18, 19—BROWN BROTHERS, WALTER DARAN from "HISTOIRE DE L'AFRIQUE DU NORD by CHARLES ANDRE JULIEN authored by PAYOT, BETTMANN ARCHIVE, BROWN BROTHERS, F.P.G., JACK GAROFALO for PARIS-MATCH—U.S. NAVY PHOTO, PHOTOREPORT, AGE BELIM, HI CRYDT, WARNER PATHE NEWS. ©
COORDINATION—THOMAS D. McAVOY

16, 17—THOMAS D. McAVOY
18, 19—ARTHUR SASSE © 1954 INTERNATIONAL NEWS PHOTOS
20, 21—LT. JOE SCHERSCHEL #T, JOHN ZIMMERMAN EXC. T. O GLOBO
22 THROUGH 25—ALFRED EISENSTAEDT
26—GEORGE SILK
29—FRANCIS MILLER EXC. T, LT. UNDERWOOD & UNDERWOOD
31—R.P.A.
36—PRESSE-BILDERDIENST (?), INT
37—C.P. DETTLOFF for VANCOUVER DAILY PROVINCE—

CHARLES WARNER for VANCOUVER SUN
38, 39—HANK WALKER
48—LT. ROBERT BOYD for MILWAUKEE JOURNAL, U.P. LISA LARSEN—A.P.
47—DENNIS STOCK from MAGNUM
48—LOOMIS DEAN
49, 50—J. R. EYERMAN
52—MAP by TONY RODARO—J. R. EYERMAN
54—J. R. EYERMAN EXC. BOT, JAMES RYAN from A.P.
54—U.P.—UNITED ARTISTS
55—LOWRY AERIAL PHOTO SERVICE
80—CONTI-PRESS

89—COURTESY NEW YORK SHIPBUILDING CORP
 CHARLES E. ROTKIN for CITIES SERVICE COMPANY
71—MICHAEL ROUGIER
72—JUN WIKI EXC. T, IRA ROSENBERG for NEW YORK HERALD TRIBUNE
78—MICHAEL ROUGIER EXC. BOT, JUN WIKI
76, 77—WILSON HICKS
78 THROUGH 82—GORDON TENNEY from B.S.
106, 107—JUN WIKI, JUN WIKI, GREY VILLET (3)—GREY VILLET
108—GREY VILLET (4), JUN WIKI
110—GREY VILLET EXC. BOT
119—LONDON DAILY MIRROR from COMBINE

A page from Life, August 24, 1954.

1950s

The 7:35 to War

At sunset, the trucks pulled into the rear of a Presbyterian mission home in Guatemala City. The streets were peaceful. Birds were singing in the clear night air.

While my friends were enjoying the buffet that had been laid out for them, I was busy checking my gear. This was too much for my comrades. They began to taunt me mercilessly: "So, where is this war? Dirck can't find his war! Yah de dah dah!"

I went on loading my cameras.

I woke up at dawn the next day, put on my fatigues, strapped on my pack, and headed out the door. I reached the corner just as a tank loaded with troops whipped around it. It paused for a second, I reached up, someone grabbed my arm, and seventeen-year-old *Life* combat photographer Dirck Halstead was off to war.

Wait a minute! The war was over . . . or so everybody thought.

It turns out that when Castillo Armas swept into Guatemala City two weeks earlier, his CIA-backed ragtag army consisted largely of peasants from the countryside. The officers of the regular army who were left in place despised Armas and his country hicks. Bad blood festered for two weeks. While Armas was away from the city for the weekend, a group of his liberation peasant-soldiers expelled some L'Ecole Militare cadets from a bordello. This was too much for the regulars to take, and it galvanized them into staging a surprise attack on the liberators' headquarters at the Roosevelt Hospital, north of the city.

My tank deposited me at the fighting. Bullets whizzed around me as I ran across the fields with the attacking troops. My adrenaline was pumping, and I felt absolutely immortal.

By noon, the war was over and my pack was bulging with exposed film. I made my way to a Western Union office where I called the Guatemala City stringer, Harvey Rosenhouse, a man whose name I had been given in New York.

I calmly said, "Harvey, this is Dirck Halstead from *Life* in New York. I have pictures of the war."

There was silence at the end of the line, and then Rosenhouse said, "You have pictures? I've been calling people all morning, nobody dares go out. . . . Where are you?"

A few minutes later, Rosenhouse showed up at the Western Union office. I thought his eyes would bulge out of his head when he saw this kid in dirty fatigues with a couple of Leicas hanging around his neck.

Without saying a word, he grabbed me and pushed me back through the office, into a restroom. "Give me your film now, and stay here. Don't leave this room till I come back."

I didn't realize that outside the citizens were going nuts. They had had enough of the fighting and were moving through the city in angry mobs, looking for anyone wearing a uniform.

A couple of hours later, Rosenhouse showed up with a change of clothes. He had shipped my film on a Pan Am flight to New York. For the next forty-eight hours we worked together as a reporter-photographer team covering Castillo Armas's consolidation of power.

A few days later, with my first double-page spread in *Life* magazine secured, I was on a plane back to New York. Building a schoolhouse never really interested me anyway.

I made enough money from selling my Guatemala pictures to buy a brand-new Ford Ranch wagon: thus began my career as a photojournalist.

A week later, *Life* ran a story about its youngest war photographer on the contents page. A photo of me was next to one of the diminutive Alfred Eisenstadt, and one of the six-foot-tall Gordon Tenney. The caption read: "Bless 'em all—the young, short, and tall."

1950s

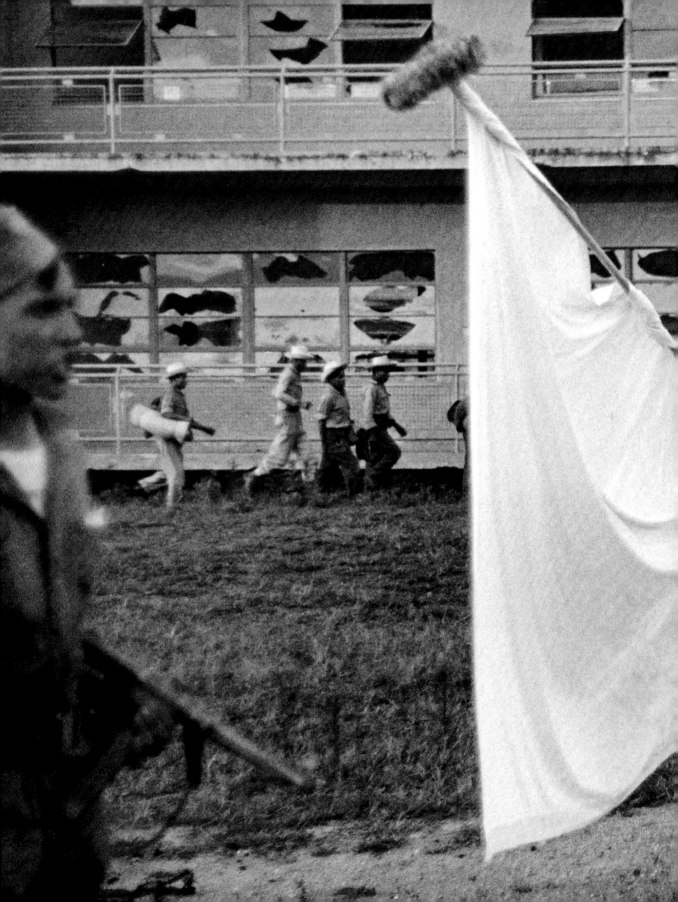

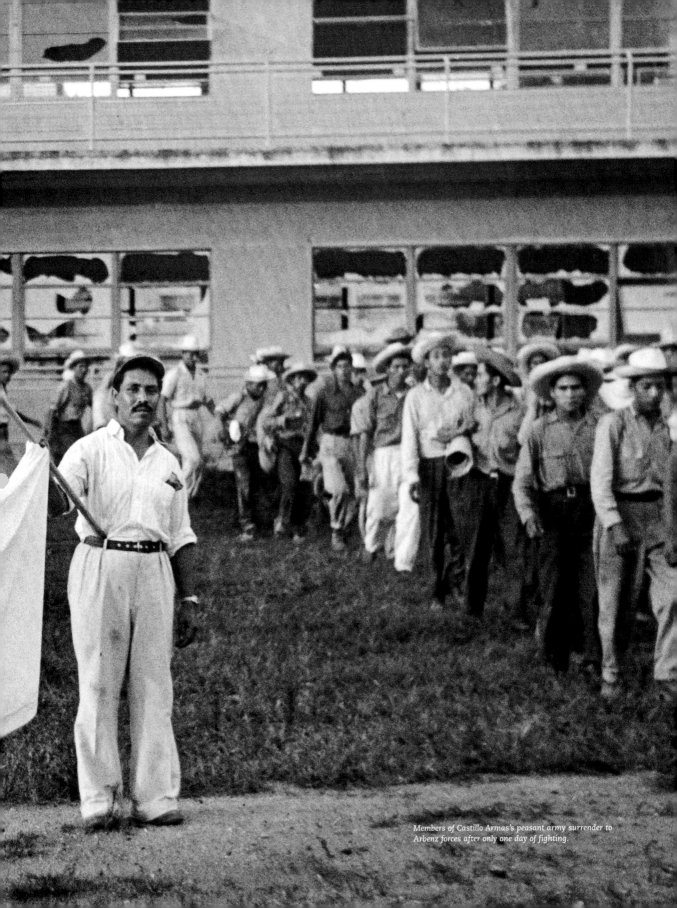

Members of Castillo Armas's peasant army surrender to Arbenz forces after only one day of fighting.

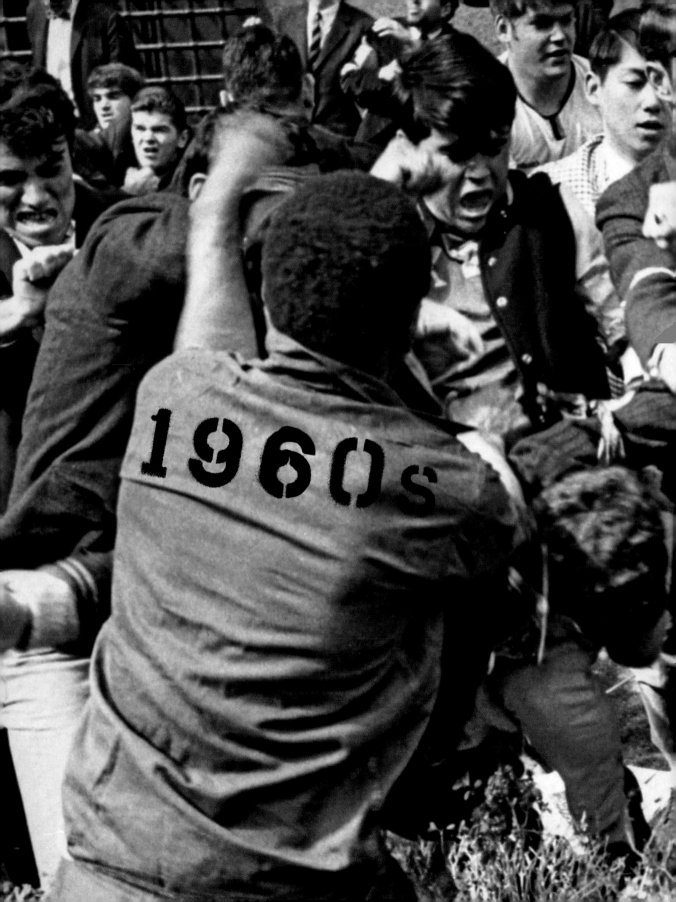

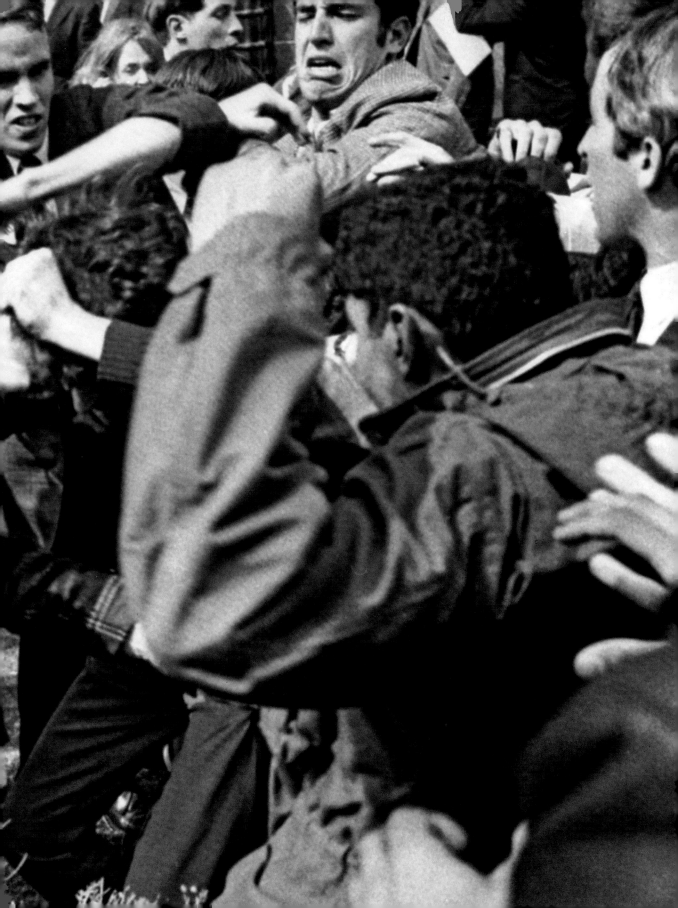

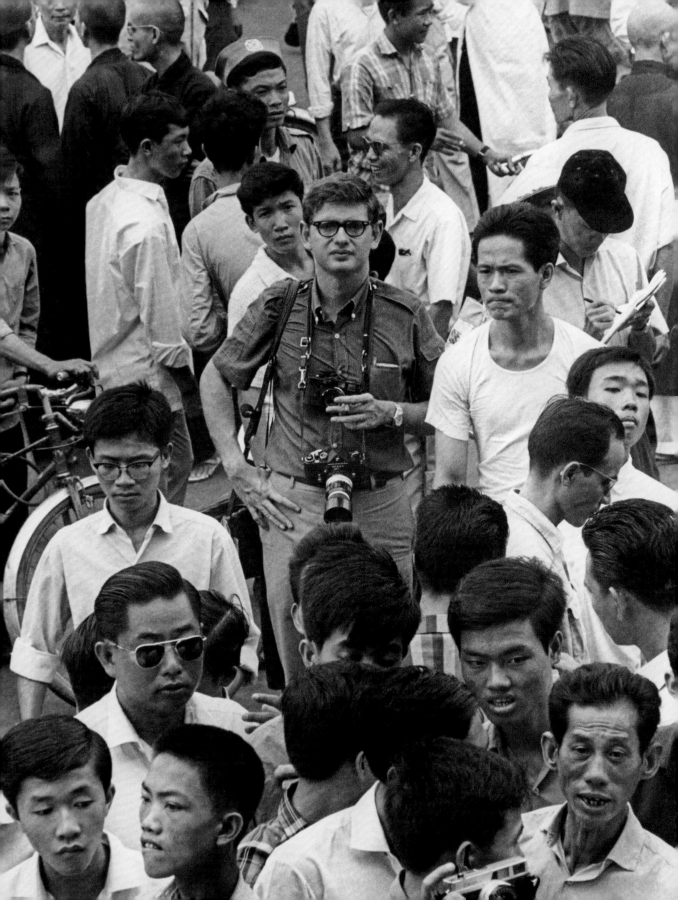

One late-January night in New York in 1965, Eddie Adams and I had dinner at the Gaslight Club. This was a rare occurrence. Eddie—who had become the star photographer of the Associated Press (AP)— and I—engaged at the time in

running the Philadelphia picture bureau for UPI but nevertheless jetting around the world on presidential travels—had something in common: we both wanted to go to Vietnam.

It was obvious to us that the situation there was getting hot. There had been the Gulf of Tonkin Resolution by President Johnson. U.S. barracks had been blown up in Pleiku in the Central Highlands. Major units of U.S. troops would soon be deployed. So we devised a plan that night over Manhattans: the next day I would tell my bosses at UPI that I had heard Eddie Adams was being sent to Vietnam immediately. Eddie would do the same thing at his end, saying that I was on the way.

It worked like a charm. In less than a month, Eddie and I were on the beach south of Da Nang watching the first landing of U.S. Marines in Vietnam.

Two years earlier I had married Betsy Zakroff, a reporter in the Philadelphia UPI bureau. The wire service, always alert to a "twofer," agreed to send Betsy with me to become a reporter in the Saigon bureau.

From the moment we stepped off the Pan Am Clipper at Tan Son Nhut Air Base, I fell in love with Vietnam. I loved the heat, the moisture, and the intoxicatingly fragrant scents in the air. Also, it was the best story in the world at the time.

1960s

Pages 26–27: Students from both sides of the Vietnam War debate get into a scuffle at Columbia University, New York, in the spring of 1968. Opposite: Here I am, a UPI photographer in Saigon, 1965. Left: My MACV Press Identity card, 1965. All press accredited to the U.S. Military Assistance Command used these cards, which allowed us to board American and South Vietnamese helicopters and aircraft for travel throughout the war zones in Vietnam. Correspondents and photographers had a simulated rank of major, giving them priority when boarding any aircraft.

In my first months there I had difficulty comprehending what was really going on. Saigon was like Dodge City. Wide-open bars on Tudo Street, lithesome Asian beauties in stiletto heels and flowing *ao dais* or skin-tight *cheongsams* beckoning from doorways. Inebriated soldiers were being handcuffed by MPs. Then, just to stir things up a little, there were the nearly weekly bombings.

The first time I heard one of these explosions I was in the Saigon bureau, which was on the ground floor of an apartment building in which I and many of the Saigon UPI staffers had our flats. I was mixing developer in the darkroom when suddenly this force moved the walls, followed by a huge thud. The air felt like it was being sucked out of the darkroom. I ran out into the street and, reacting to the sound of sirens, ran toward the building that was at that time the U.S. Embassy. A huge car bomb had wiped out several stories of the building. The smell of cordite, which anybody who has ever experienced a bombing never forgets, was in the air, along with the screams and wails of the wounded. Embassy staffers were helping each other down the stairs, while the street in front of the building was a scene of devastation.

Over the next few months I hired a talented group of photographers: Henri Huet, who may have been, in retrospect, the best photographer ever to shoot in Vietnam; Tim Page, who was totally out of control on drugs most of the time and who became the model for the photographer portrayed by Dennis Hopper in *Apocalypse Now*; Kyoichi Sawada, who used vacation time from his darkroom job at UPI in Tokyo to come to Saigon at his own expense and stayed on to become a Pulitzer Prize winner; Dana Stone, a young adventurer who made his way to Saigon on a tramp steamer to become a stringer for UPI; and most unlikely of all, a movie star, Sean Flynn, the son

1960s

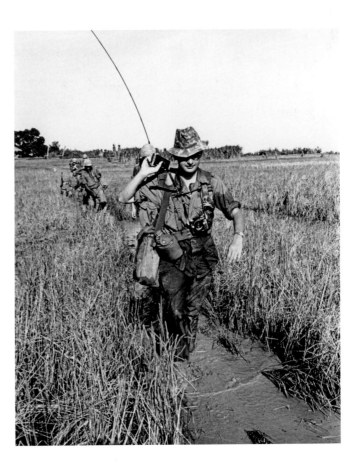

Right: I'm with the U.S. Marines on an operation south of Da Nang, March 1965. Opposite: President Lyndon Johnson pins a decoration on a U.S. soldier at Cam Ranh Bay during his visit to Vietnam in 1966.

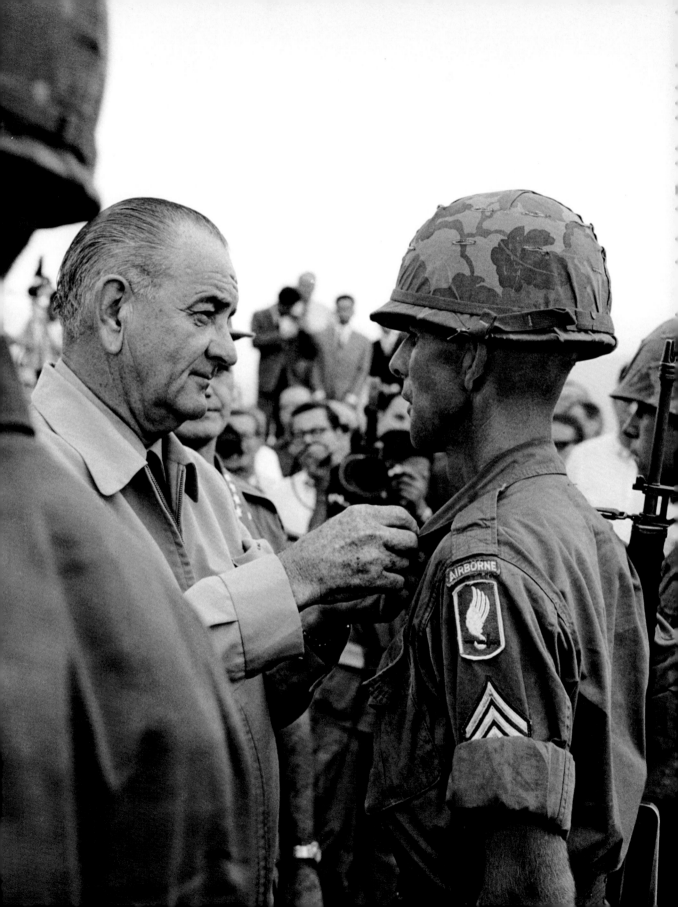

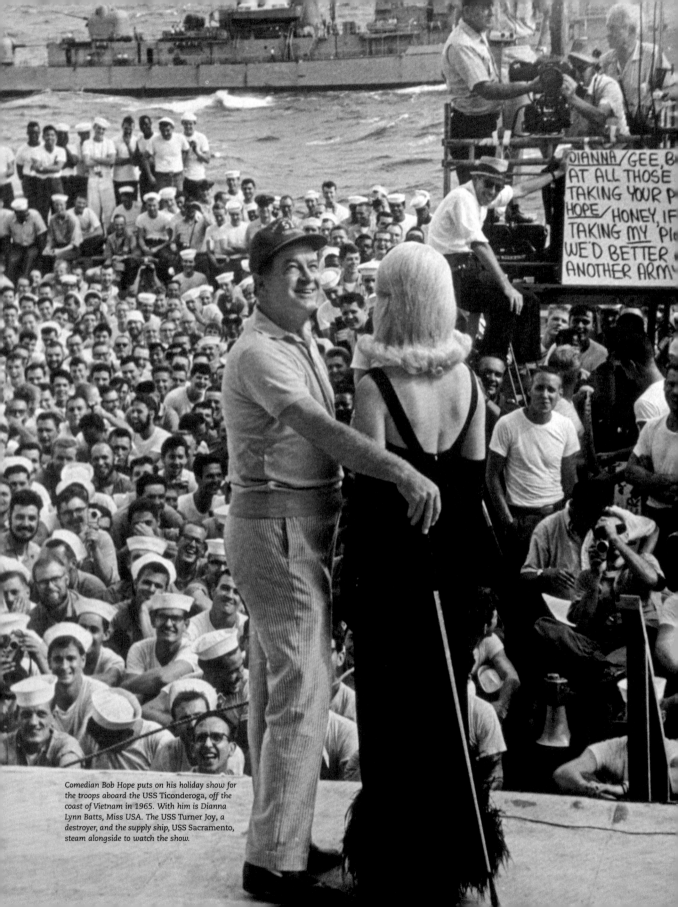

DIANNA / GEE, B
AT ALL THOSE
TAKING YOUR P
HOPE / HONEY, IF
TAKING MY 'PI
WE'D BETTER
ANOTHER ARM

Comedian Bob Hope puts on his holiday show for the troops aboard the USS Ticonderoga, off the coast of Vietnam in 1965. With him is Dianna Lynn Batts, Miss USA. The USS Turner Joy, a destroyer, and the supply ship, USS Sacramento, steam alongside to watch the show.

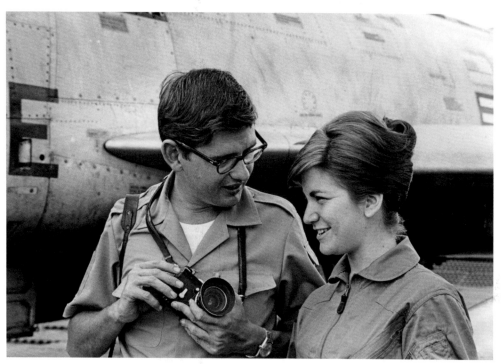

Me with my wife, Betsy, on the flight line at Tan Son Nhut Air Base, South Vietnam, 1965. Betsy became the first correspondent, man or woman, to fly on B-52 bombing raids over Hanoi.

of famed actor Errol Flynn. Having just starred in an action drama in Singapore, Sean came to Vietnam because he wanted to experience "the real thing." Both Sean and Dana would eventually be executed after being captured by the Khmer Rouge in Cambodia. Kyoichi Sawada would also die along one of those desperate roads that ran between Phnom Penh and Saigon, and Henri Huet would die with his colleagues Larry Burrows of *Life*, Kent Potter of UPI, and Keisaburo Shimamoto for *Newsweek* when their helicopter was shot down over the Ho Chi Minh Trail in Laos.

Author Michael Herr, who covered Vietnam for the *New Yorker*, once wrote: "Vietnam was what we had rather than happy childhoods." I couldn't agree more. For those two years that Betsy and I lived in a one-bedroom apartment at 19 Ngo Duc Khe in Saigon, we were in a journalist's Disneyland. We had a wonderful maid named Chi Quong, who would do the shopping and make delicious French, Chinese, and Vietnamese lunches and dinners. Although as the picture bureau chief I managed to get out into the field from time to time, Betsy was constantly on the move. She made friends in the Air Force, went off to survival school in the Philippines, and was the first U.S. correspondent, man or woman, to be allowed on B-52 strikes over North Vietnam. I would drive her out to Tan Son Nhut Air Base to check in for a flight north, wearing my Hawaiian shirt, while she would be fully outfitted in her flight suit, packing her survival knife on her hip. At such times, other journalists would turn to me and ask, "So what do you do now? Go home and wash the dishes?"

When I first arrived in Saigon, all I knew about the U.S. role in wars was what I had seen growing up watching movies like *Sands of Iwo Jima* and *Thirty Seconds over Tokyo.* I was totally unschooled in the history of Southeast Asia, even though my childhood hero, Robert Capa, had died there. U.S. soldiers were depicted as the face of freedom, fighting for human liberty around the world.

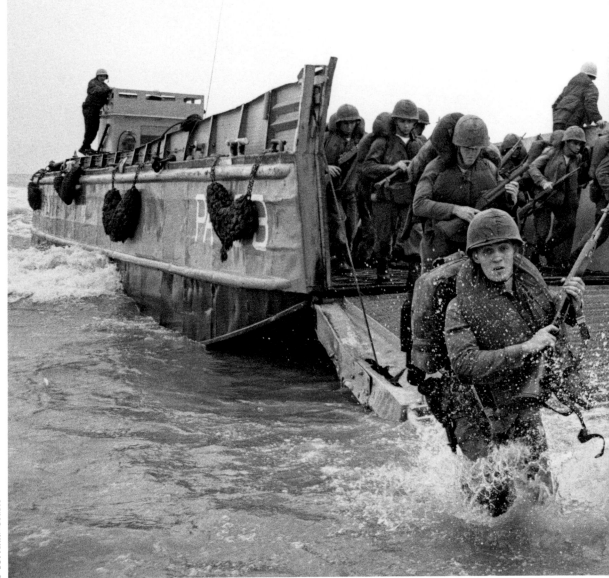

The first U.S. Marines hit the beach in South Vietnam south of Da Nang in March 1965. They are part of a force ordered to protect the Da Nang Air Base. They were relieving Vietnamese troops who had been guarding the base, freeing them for combat against the Vietcong.

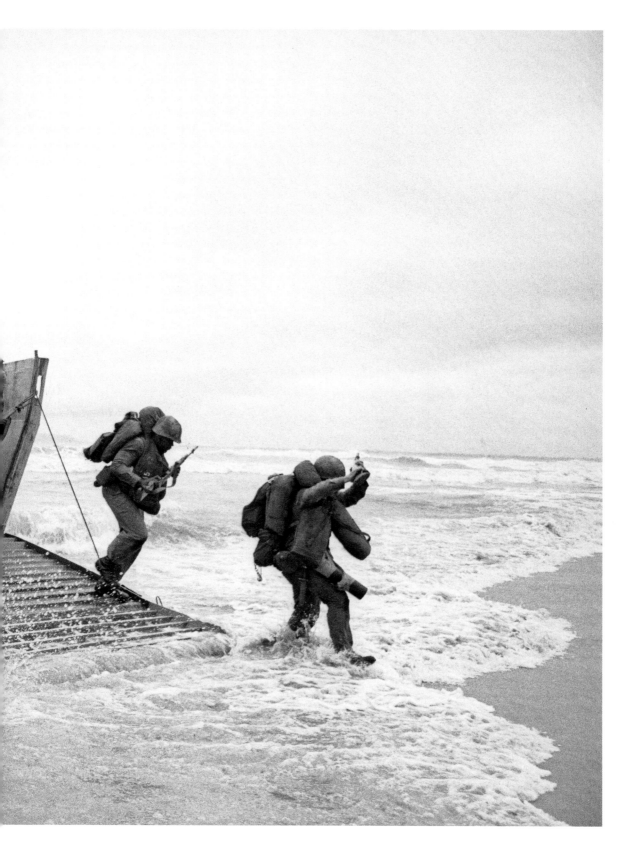

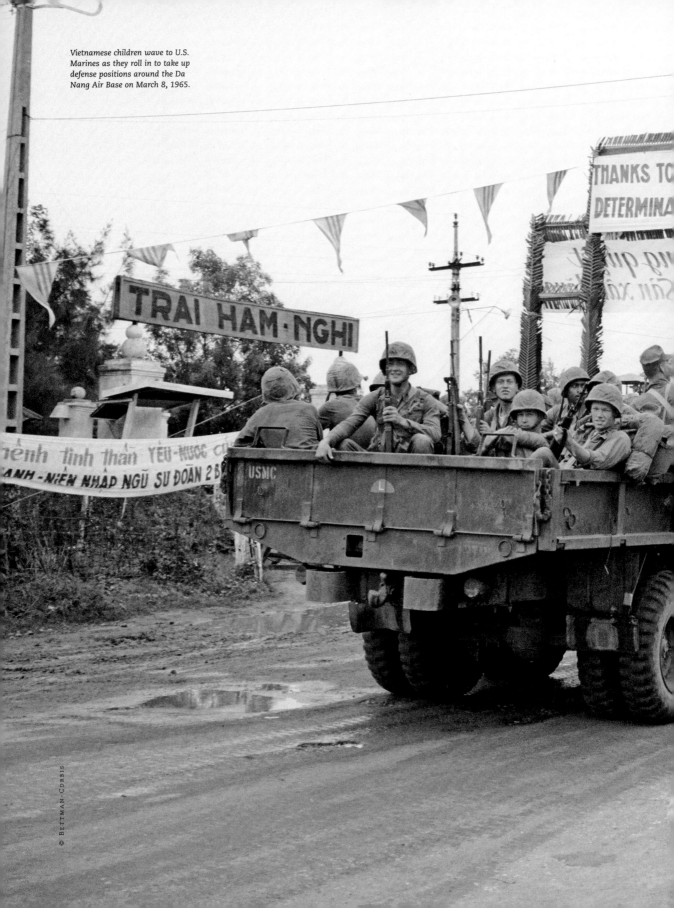

Vietnamese children wave to U.S. Marines as they roll in to take up defense positions around the Da Nang Air Base on March 8, 1965.

© BETTMAN-CORBIS

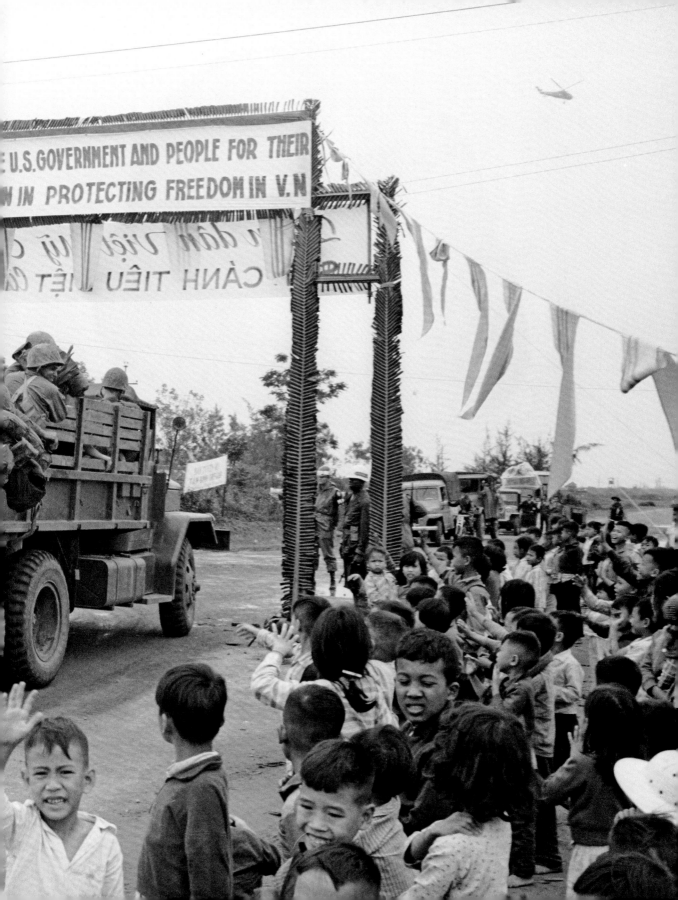

1960s

It wasn't until I went out on my first combat operation with the Big Red One, First Infantry Division, north of Saigon, that I got my initial insight into Vietnam's new kind of warfare. This was a classic search-and-destroy mission. We had stopped for a midday break, and I had broken open my C ration of franks and beans when I saw an artillery battalion firing off into the distance. Curious, I went up to the commander and asked him what he was shooting at. He gave me his field glasses; and from what I could discern among the puffs of smoke, there seemed to be a Buddhist monastery. I asked him about it but he told me that I shouldn't worry because this was a "free-fire zone." It was the first time I had heard that expression and asked him what it meant. He told me that a plane had flown overhead in the area the day before and dropped pamphlets in Vietnamese informing the people on the ground that the following day U.S. forces would be free to fire on the area. Then I saw a ragged column of about forty men, women, and children making their way from the monastery toward our position. A few minutes later they collapsed in our midst with their dead and dying. I didn't know what to think. I started to take pictures, but the commander asked me to stop—there had been a terrible mistake. So I stopped. When I got back to Saigon, I didn't know what to do with the pictures I had made. I phoned New York and explained the situation, and they didn't know what to do, either. There was nothing in the old John Wayne scripts that covered this type of situation.

It didn't take too long after that to figure out something was dreadfully wrong with our strategy and tactics in Vietnam. Some great journalists who had been there long before me, such as David Halberstam, Mal Browne, Neil Sheehan, Peter Arnett, and David Douglas Duncan, even novelists such as Graham Greene, had understood the quagmire for which the United States was about to sacrifice 55,000 lives.

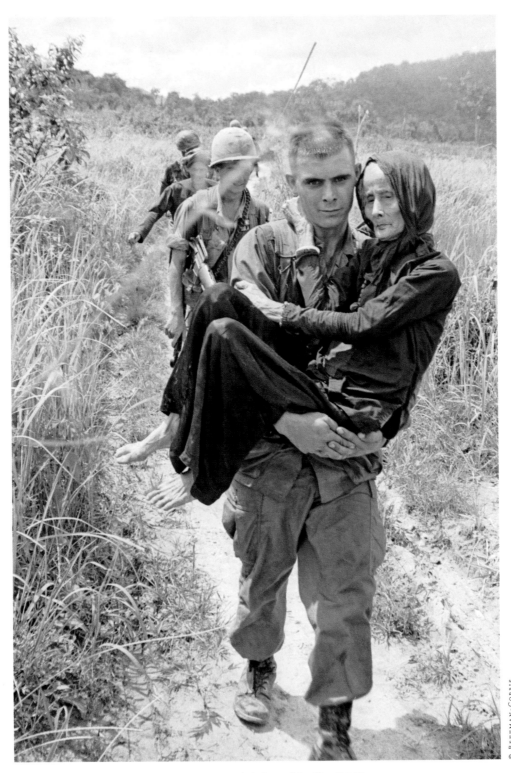

1960s

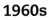

Airborne Private Carl Champ carries an aged woman to a hospital. She was injured by a U.S.-Vietnamese air strike on a Buddhist monastery forty miles southeast of Saigon. Americans and Vietnamese were carrying out joint operations against the Vietcong when the monastery was accidentally bombed. This was the first time I witnessed how mistakes by the military can cause civilian injury and death.

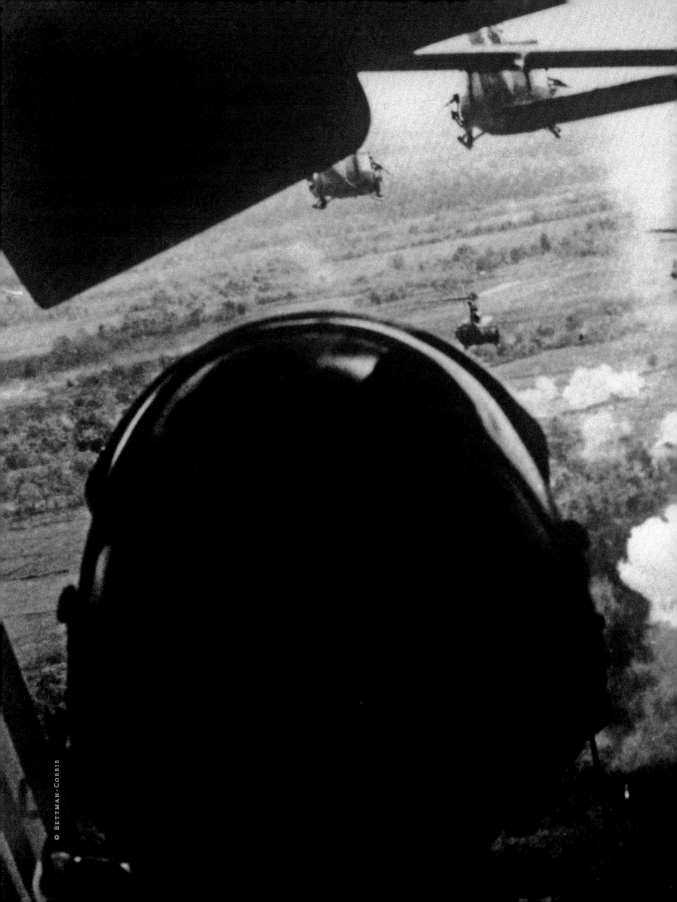

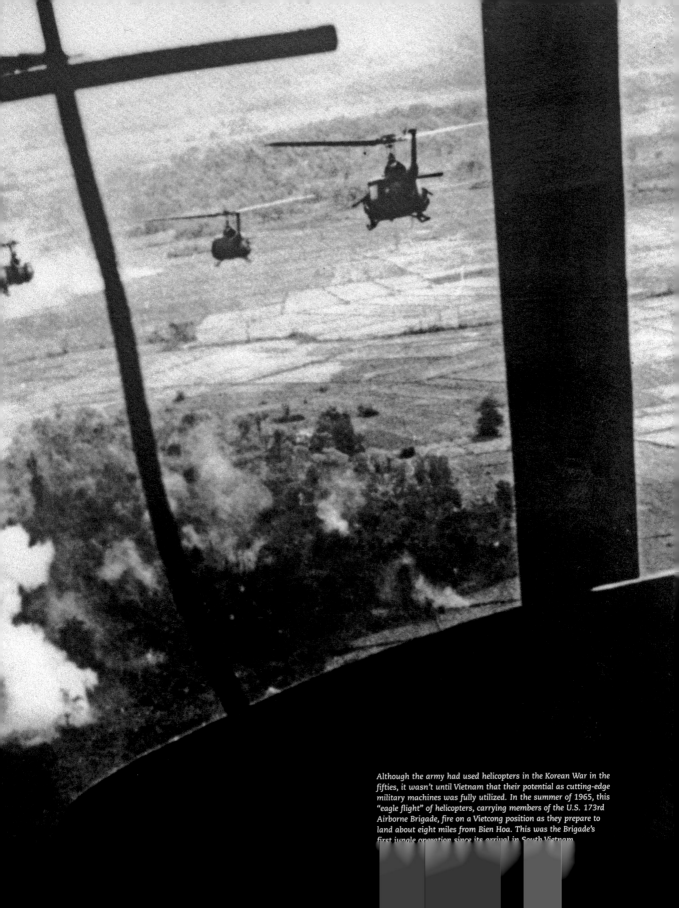

Although the army had used helicopters in the Korean War in the fifties, it wasn't until Vietnam that their potential as cutting-edge military machines was fully utilized. In the summer of 1965, this "eagle flight" of helicopters, carrying members of the U.S. 173rd Airborne Brigade, fire on a Vietcong position as they prepare to land about eight miles from Bien Hoa. This was the Brigade's first jungle operation since its arrival in South Vietnam.

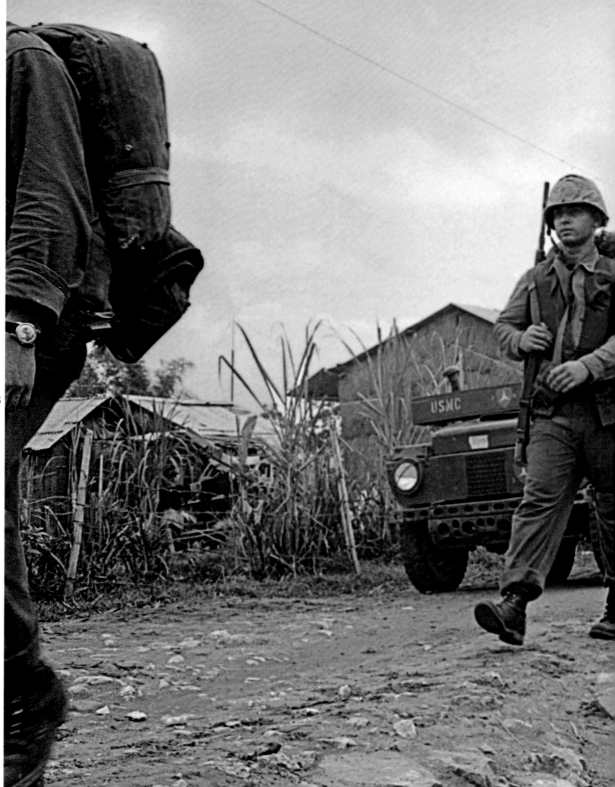

1960s

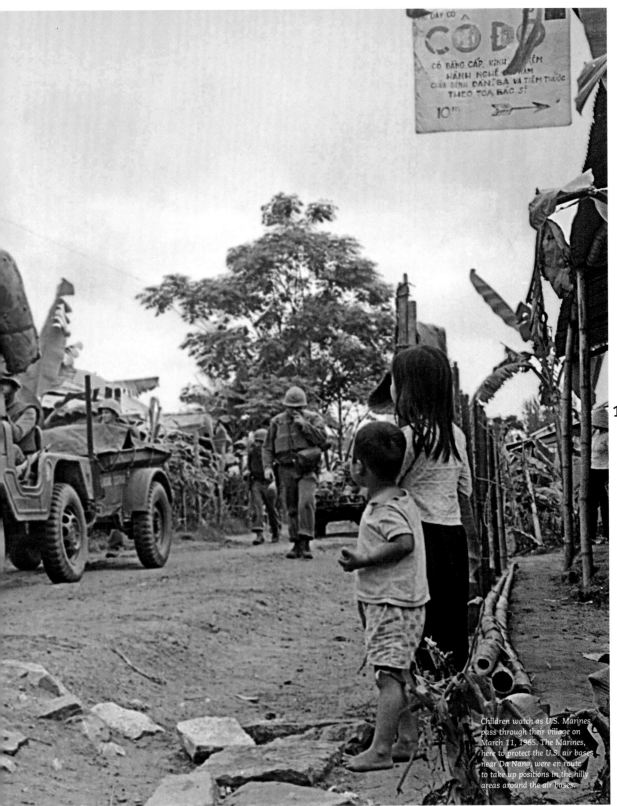

1960s

Children watch as U.S. Marines pass through their village on March 11, 1965. The Marines, here to protect the U.S. air bases near Da Nang, were en route to take up positions in the hilly areas around the air bases.

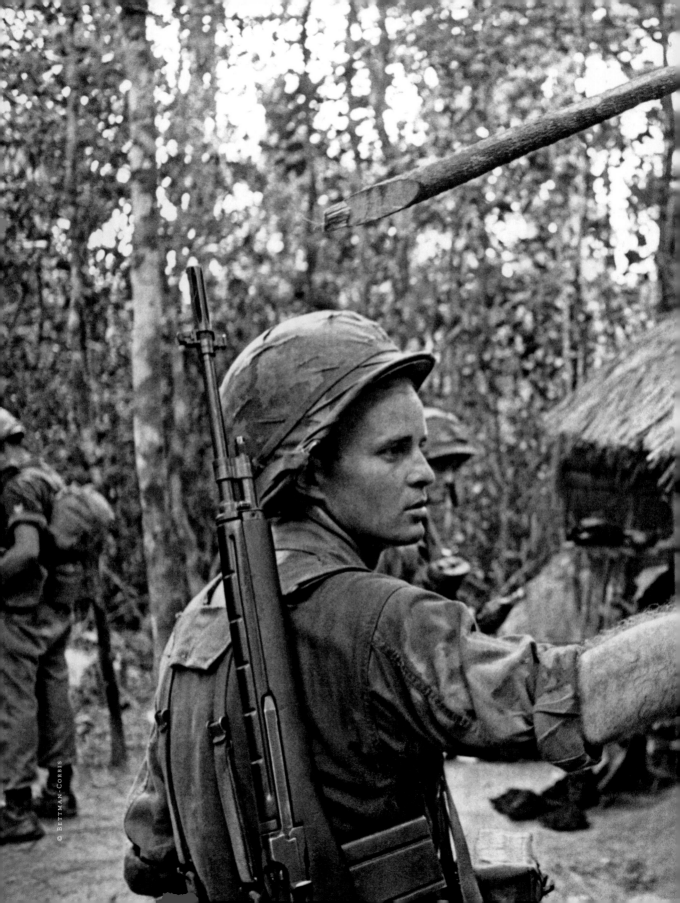

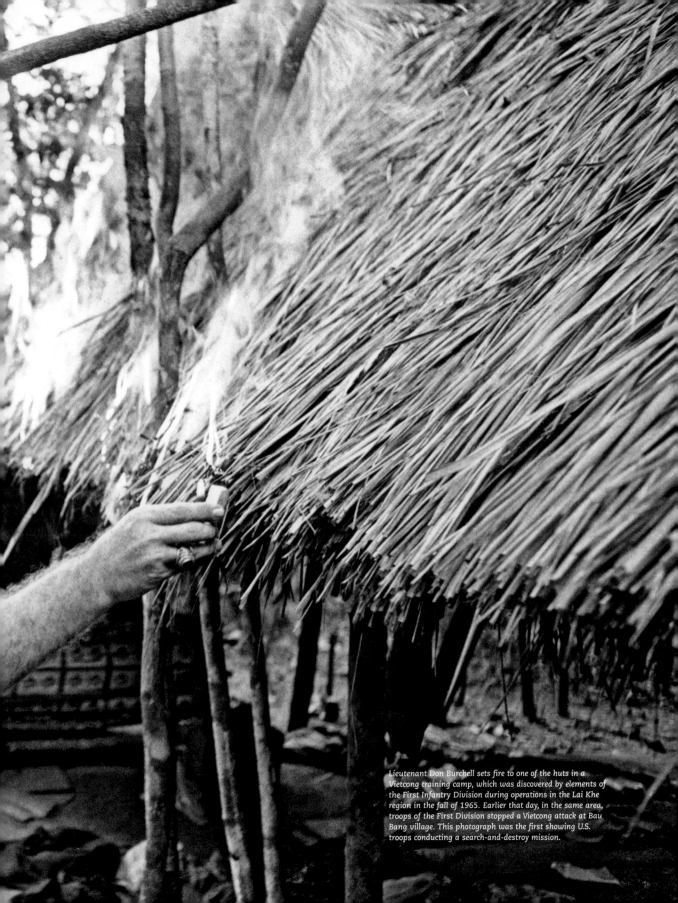

Lieutenant Don Burchell sets fire to one of the huts in a Vietcong training camp, which was discovered by elements of the First Infantry Division during operations in the Lai Khe region in the fall of 1965. Earlier that day, in the same area, troops of the First Division stopped a Vietcong attack at Bau Bang village. This photograph was the first showing U.S. troops conducting a search-and-destroy mission.

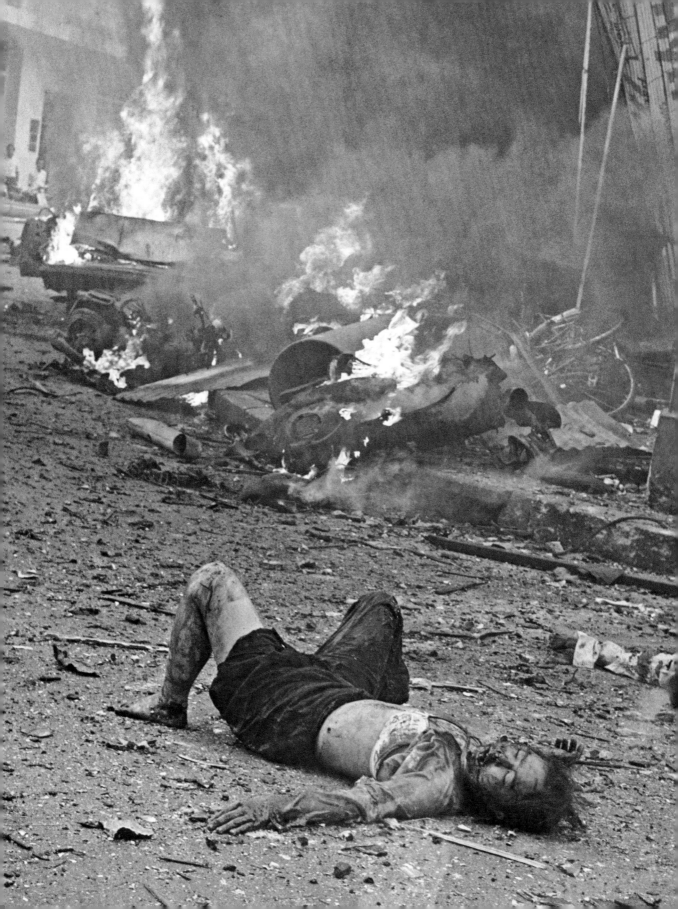

Embassy Bombing in Saigon

Although this remarkable photograph of a victim of the bombing of the U.S. embassy in Saigon in the spring of 1965 was not taken by me, I feel I can share some of the credit. At the moment this explosion occurred, I happened to be in the darkroom of the UPI bureau, located just blocks from the embassy, mixing new chemicals. Almost instantly I was on the scene of the bombing. I spent the next ten minutes photographing the dead and wounded, and just as I was taking a picture of this woman, another UPI photographer, Nguyen Than Tai, ran up to me. I told him to take over while I ran back to the bureau to start processing my film in order to make the next picture cast to Tokyo. As I dropped my film into the developing tank, I caught a whiff of fixer, a chemical I should not have been smelling. A sudden realization hit me too late. After I had run over to the embassy, our darkroom man, who was still in training, had continued to prepare the chemicals, but he had moved the hypo to the location where the developer normally was kept. I couldn't save my pictures, but fortunately, a few minutes later, Tai ran in with his film. His images appeared on front pages around the world.

1960s

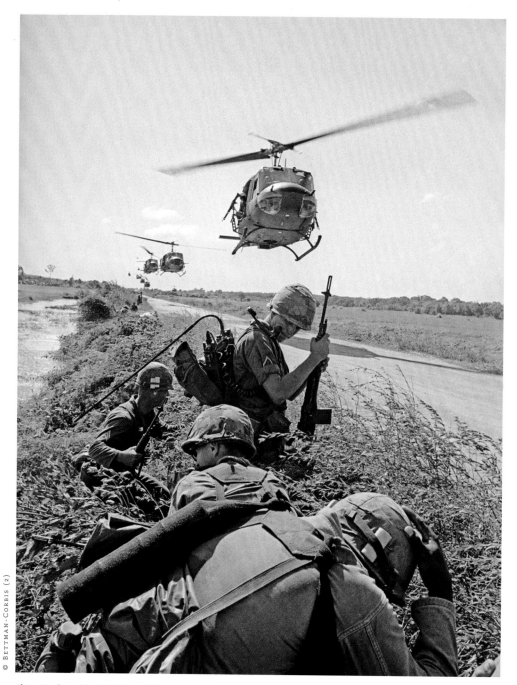

Above: Members of the First Infantry Division in Lai Khe in 1965 crouch low as a squadron of helicopters moves out to begin an attack on Vietcong positions. Opposite: In the jungle, the Vietcong used primitive methods of warfare to devastating effect. During the night, after a U.S. assault on a Vietcong stronghold area near the Michelin Plantation, they struck back at the Americans by setting a trap. Well hidden alongside a main trail where they knew GIs would travel the next morning, they set up "dolly tracks" on which they mounted a 50-caliber machine gun. As the first company moved into the killing zone, the Vietcong gun rolled up the tracks from behind the unit, cutting down nearly every man. This was one of the first encounters that prophesied the ugly fighting ahead.

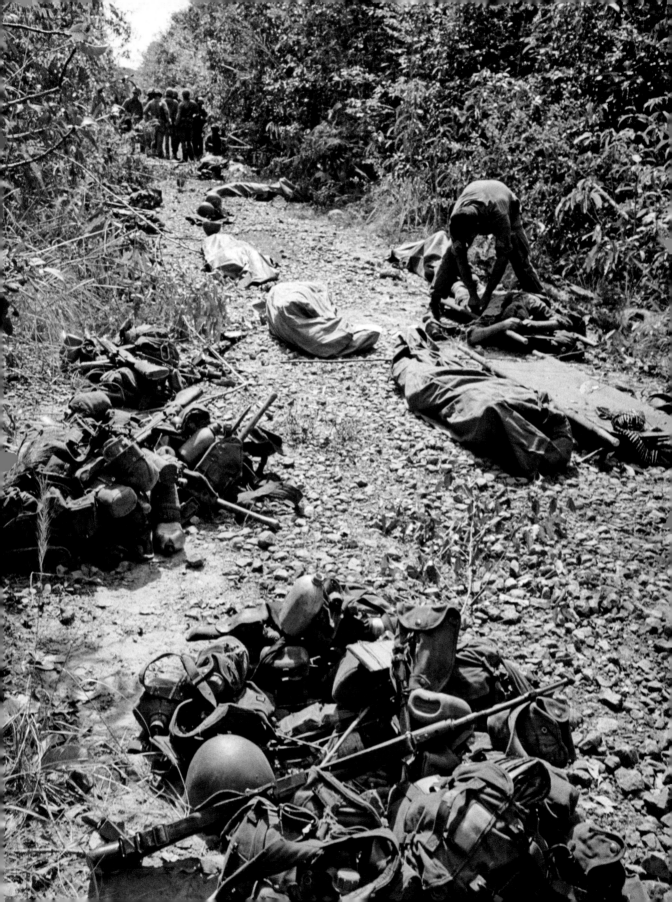

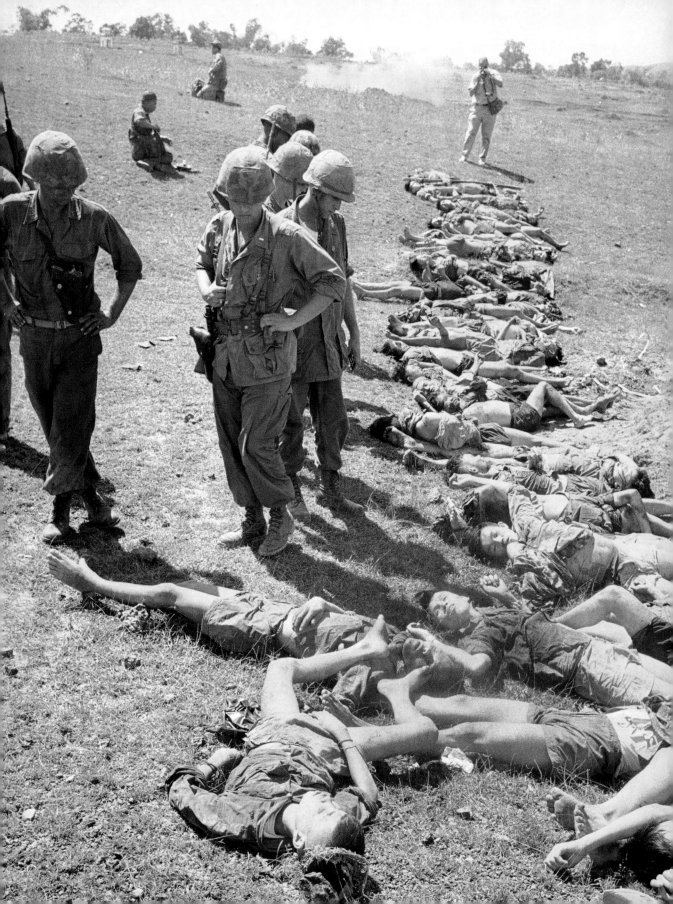

Opposite: U.S. Marines inspect bodies of Vietcong killed during an attack on marine defensive positions on the outskirts of the Da Nang Air Base on October 30, 1965. During the battle, a company of marines, outnumbered four to one, repelled the attacking Vietcong and killed at least forty-one guerrillas. Above: The first marines to land on the beaches of Vietnam came ashore expecting to fight. Instead they were met by a score of ao dai–clad women from the Da Nang Chamber of Commerce, who waded into the water to throw leis around the marines' necks.

1960s

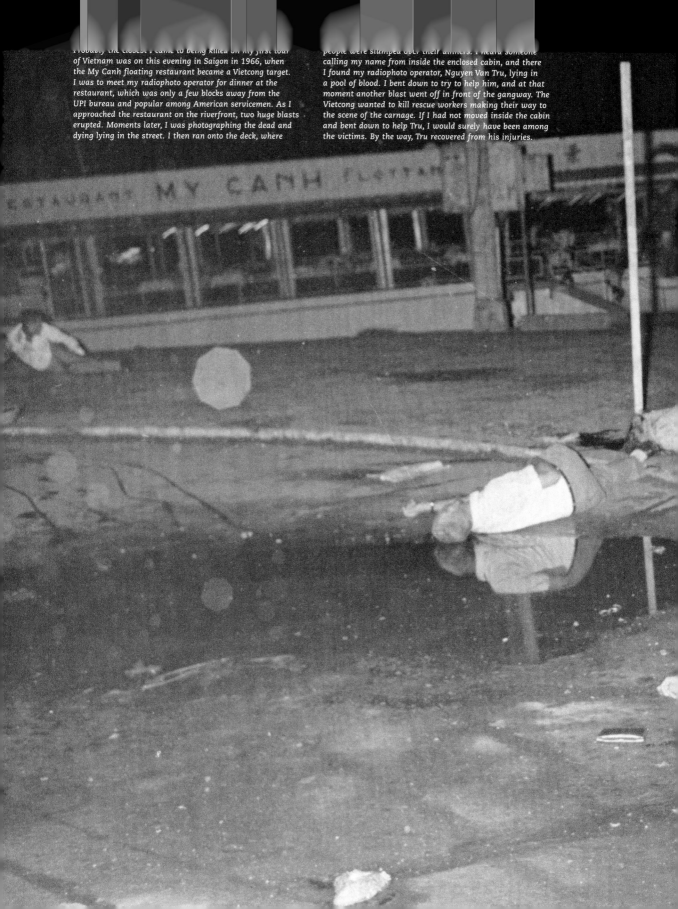

Probably the closest I came to being killed on my first tour of Vietnam was on this evening in Saigon in 1966, when the My Canh floating restaurant became a Vietcong target. I was to meet my radiophoto operator for dinner at the restaurant, which was only a few blocks away from the UPI bureau and popular among American servicemen. As I approached the restaurant on the riverfront, two huge blasts erupted. Moments later, I was photographing the dead and dying lying in the street. I then ran onto the deck, where people were slumped over their dinners. I heard someone calling my name from inside the enclosed cabin, and there I found my radiophoto operator, Nguyen Van Tru, lying in a pool of blood. I bent down to try to help him, and at that moment another blast went off in front of the gangway. The Vietcong wanted to kill rescue workers making their way to the scene of the carnage. If I had not moved inside the cabin and bent down to help Tru, I would surely have been among the victims. By the way, Tru recovered from his injuries.

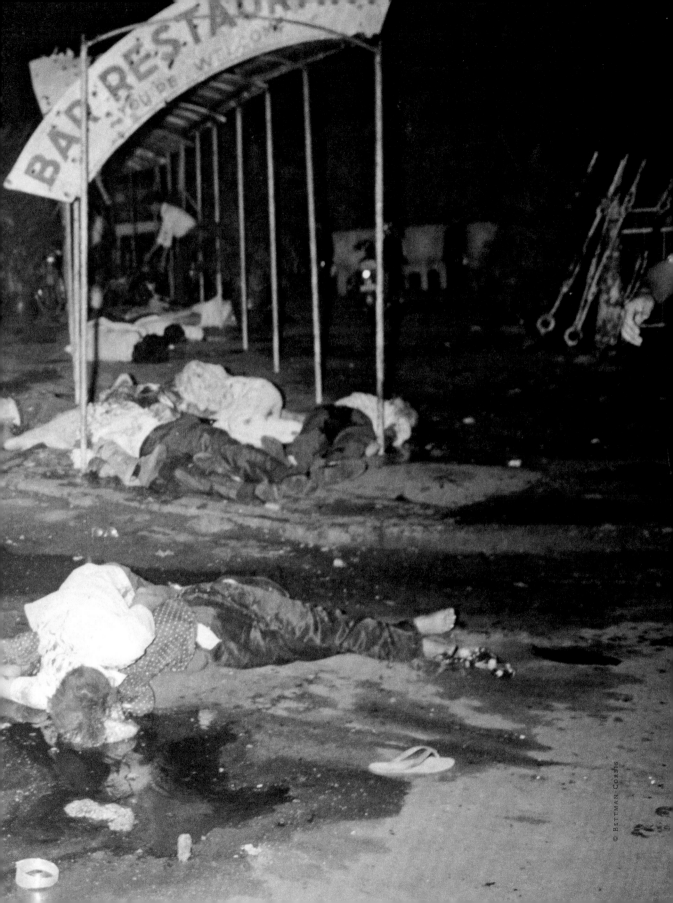

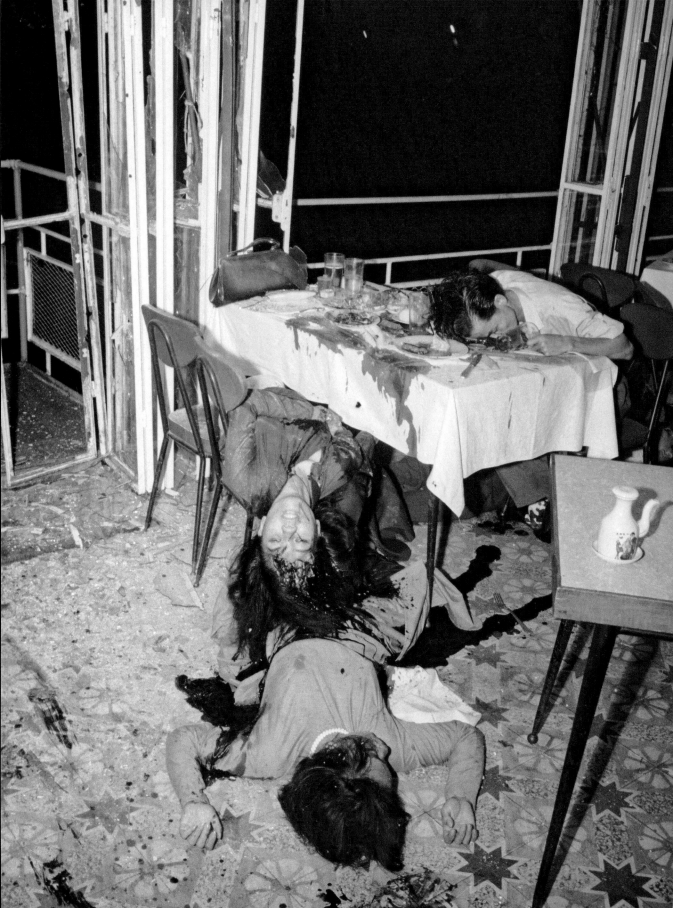

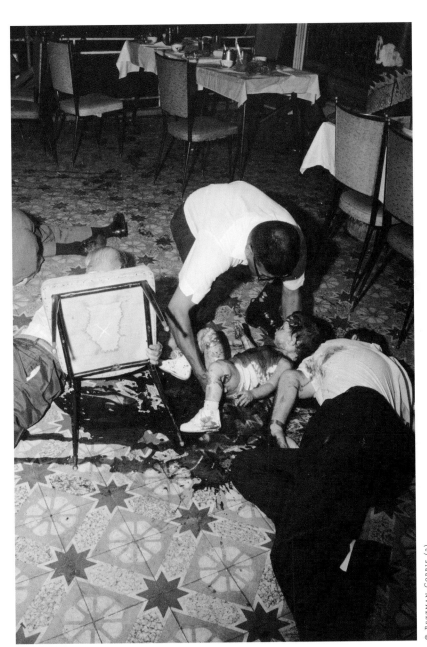

1960s

Victims of the My Canh restaurant bombing. The explosive device was a Claymore bomb, which doesn't rely so much on the force of its blast as it does on metal pellets, which it spews outward like bullets. Thus, many of the place settings, with glasses still full of water and wine, remained untouched.

Above: The very first time I photographed Richard Nixon was the night he received his party's nomination for the candidacy in New Hampshire in 1968. Opposite: President Nixon with troops north of Saigon, 1966. The question he would ask each soldier was what town he was from, and then he would immediately make some comment about the baseball team.

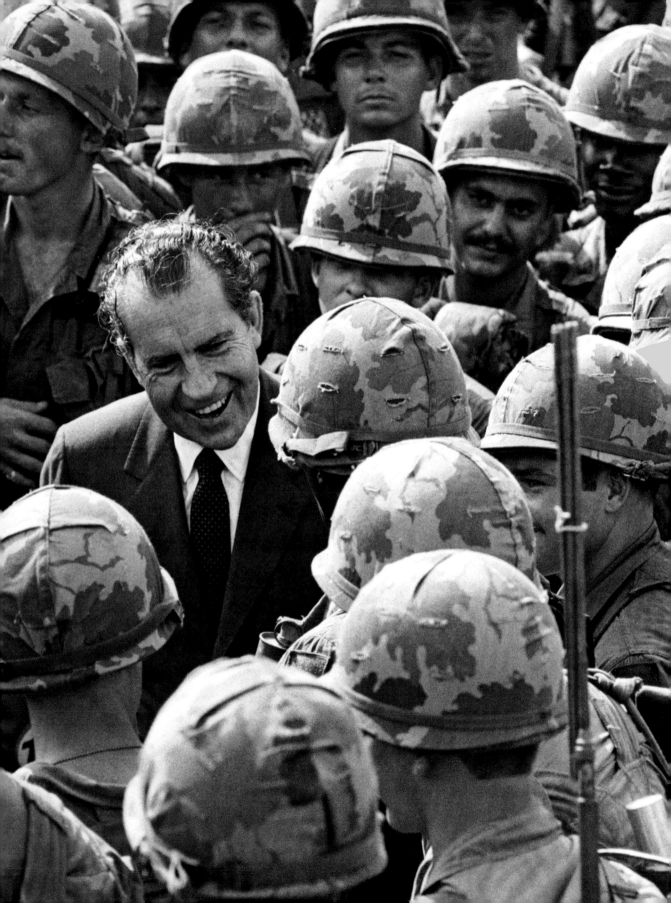

Richard Nixon gives his victory sign to enthusiastic supporters at his last campaign rally in San Diego, California, on the eve of the 1968 election. Advance people and campaign workers made the posters for the crowd.

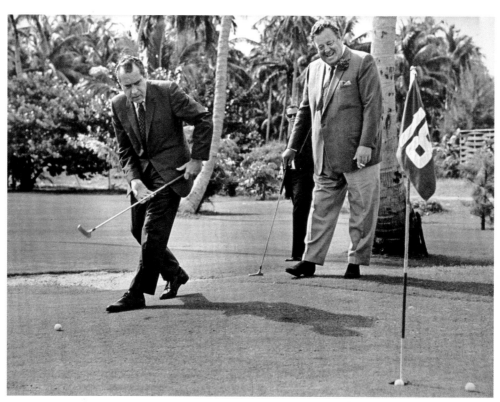

Above: Immediately following the 1968 Republican Convention in Miami, I was assigned to the campaign of Richard Nixon. One of the first images I made of him as a nominee was while he was playing golf in Key Biscayne, Florida, with Jackie Gleason. Nixon was wearing his trademark golfing outfit: suit, tie, and wing-tip shoes. Opposite: Later that evening he serenaded the traveling press at the piano.

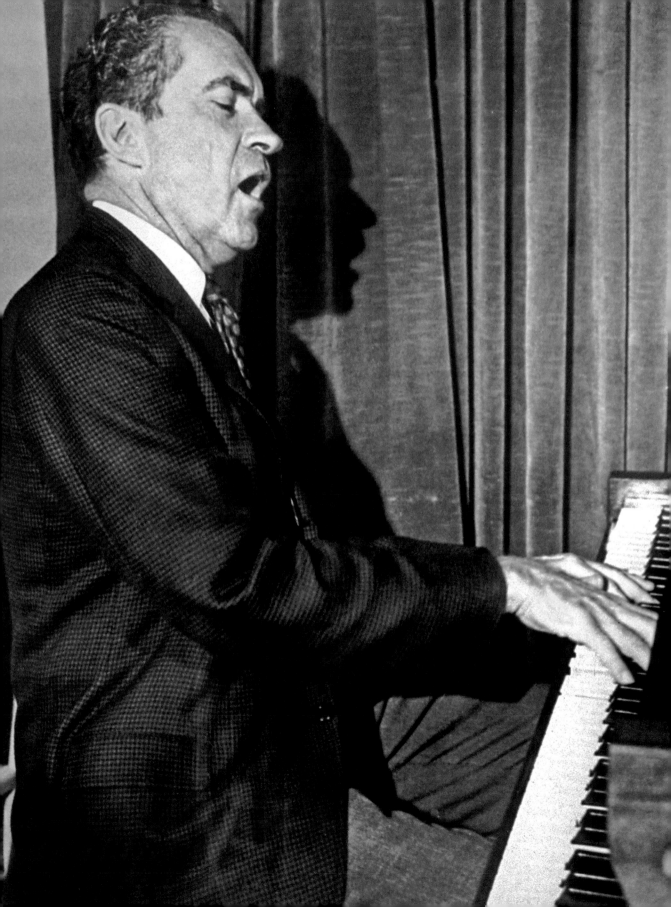

HORNET +

1960s

PERSONNEL ONLY

US GOVERNMENT

STATION

SEAL OF THE PRESIDENT OF THE UNITED STATES

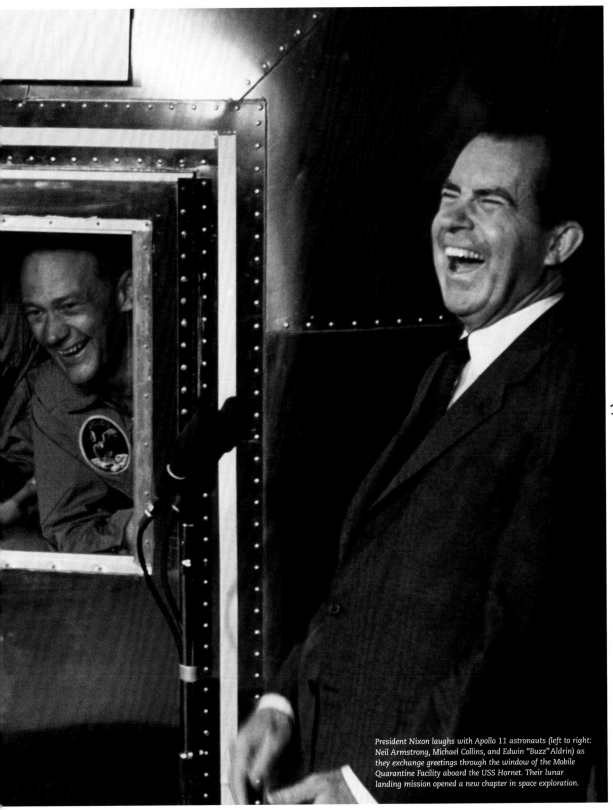

President Nixon laughs with Apollo 11 astronauts (left to right: Neil Armstrong, Michael Collins, and Edwin "Buzz" Aldrin) as they exchange greetings through the window of the Mobile Quarantine Facility aboard the USS Hornet. Their lunar landing mission opened a new chapter in space exploration.

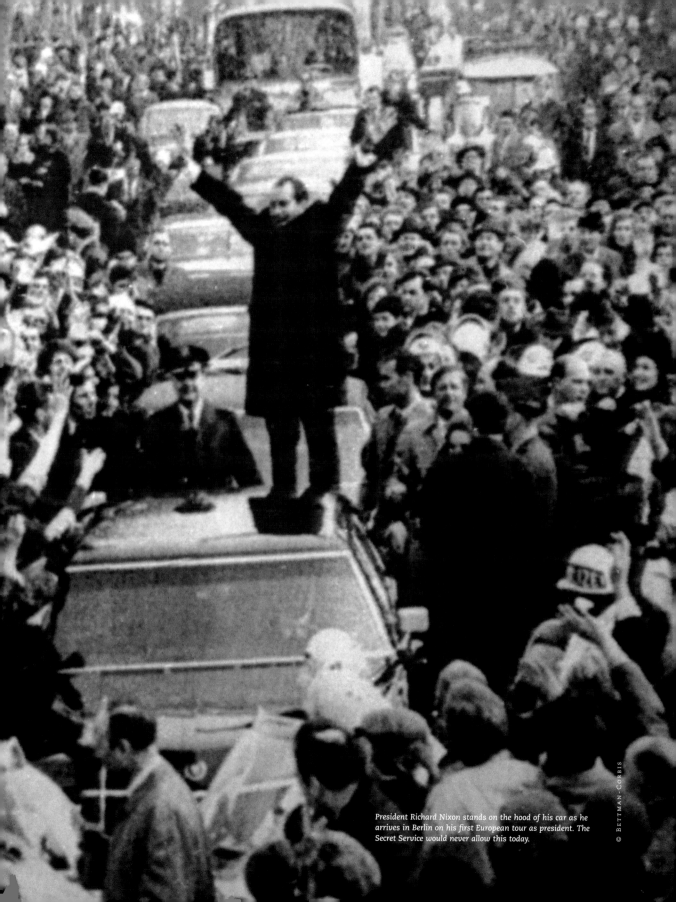

President Richard Nixon stands on the hood of his car as he arrives in Berlin on his first European tour as president. The Secret Service would never allow this today.

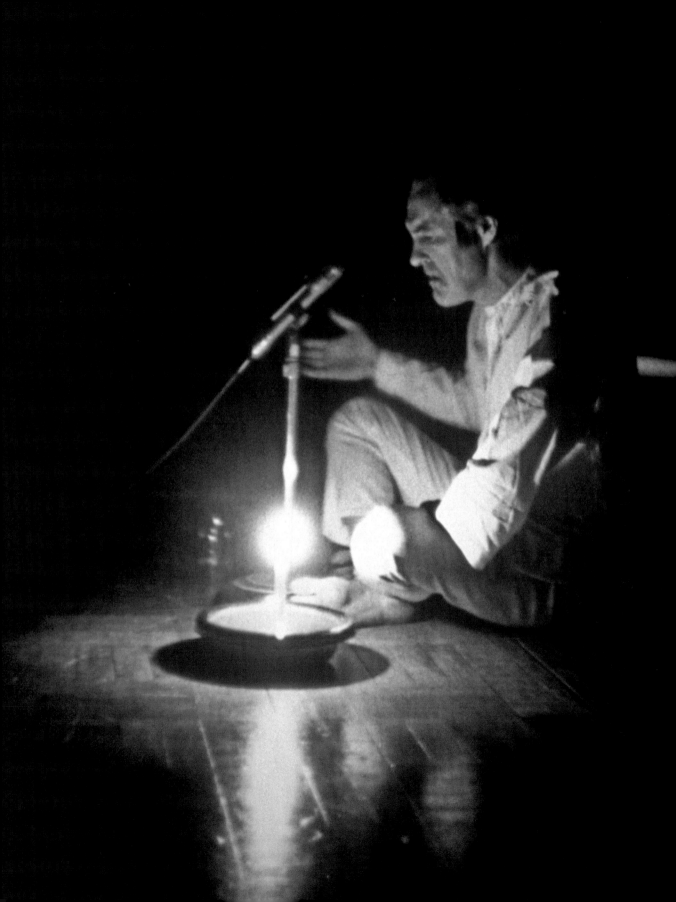

After I had spent two years covering Vietnam, the America I returned to in late 1966 was a very different America than the one I had left. Jefferson Airplane, the Beatles, the Mamas and the Papas, the Supremes, the Rolling Stones,

and Bob Dylan had replaced the Four Freshman, Stan Kenton, and Frank Sinatra while I was in Vietnam. I had heard the music blasted through the jungles courtesy of Armed Forces Radio, and it had taken over the States. Everything was shaking, rocking, and rolling, and drugs I had never heard of were being passed around not only in underground haunts, but also in the back hallways of major corporations (the news business was no different).

Betsy and I moved into a thirty-first-floor apartment on East Eighty-fifth Street in New York City. UPI had no idea what to do with me. I was suffering from severe post-Vietnam letdown, and was in a very bad mood. It seemed that all news organizations wanted to talk about was how to cut back on expenses and overtime. UPI decided the best thing to do was to get me out of the office and

1960s

Opposite: Psychedelic drugs became the rage, and the guru of LSD was Dr. Timothy Leary, here in 1969 bringing his message to students at the University of Michigan. Left: After covering the front lines of the Vietnam War for two years, I suddenly found myself immersed in a very different kind of revolution taking place in my own country. But this one involved more pleasure than pain—drugs, rock 'n' roll, and free love.

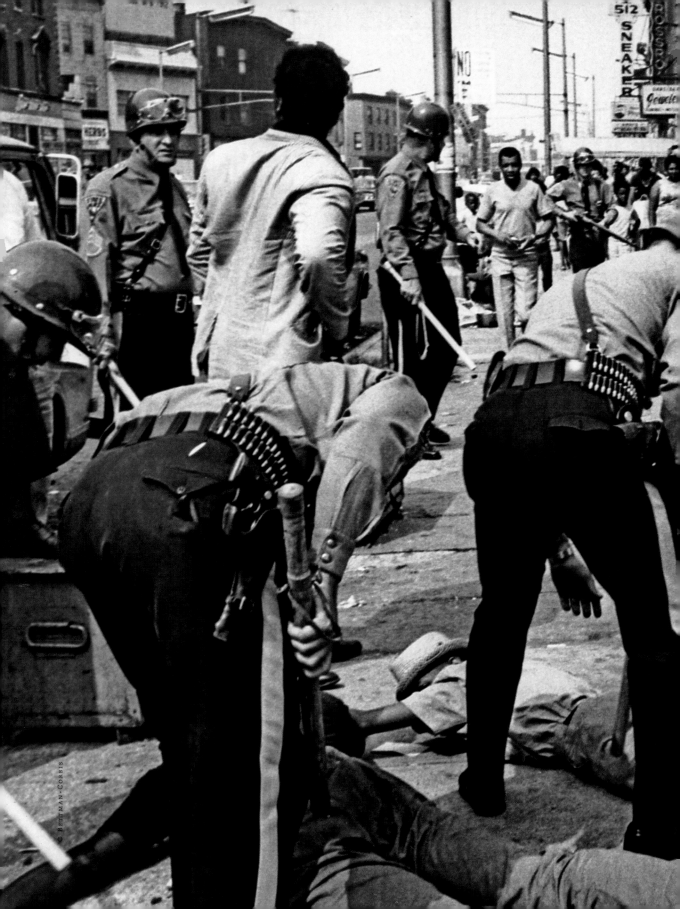

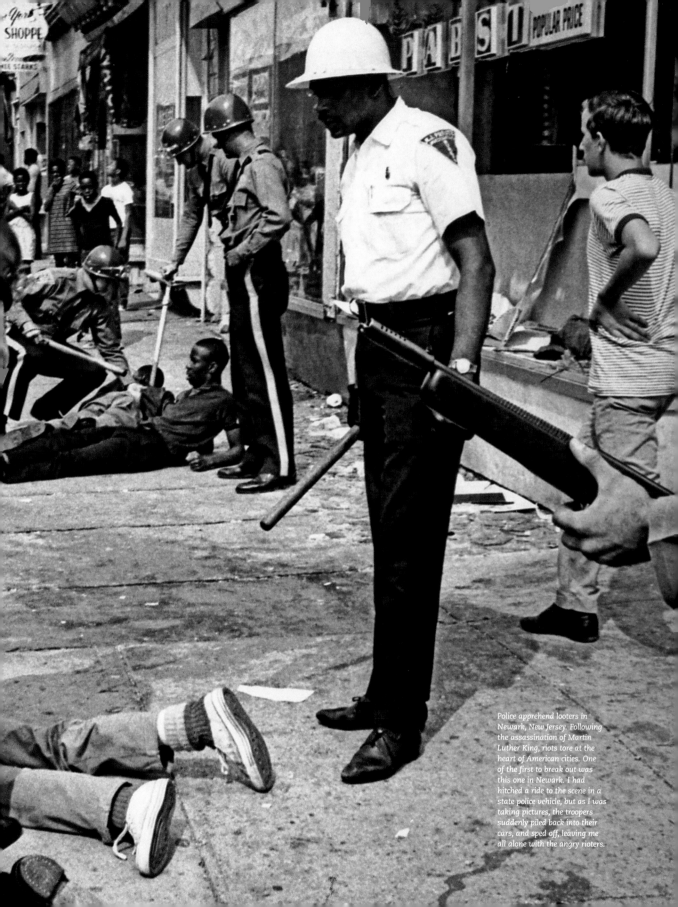

Police apprehend looters in Newark, New Jersey. Following the assassination of Martin Luther King, riots tore at the heart of American cities. One of the first to break out was this one in Newark. I had hitched a ride to the scene in a state police vehicle, but as I was taking pictures, the troopers suddenly piled back into their cars, and sped off, leaving me all alone with the angry rioters.

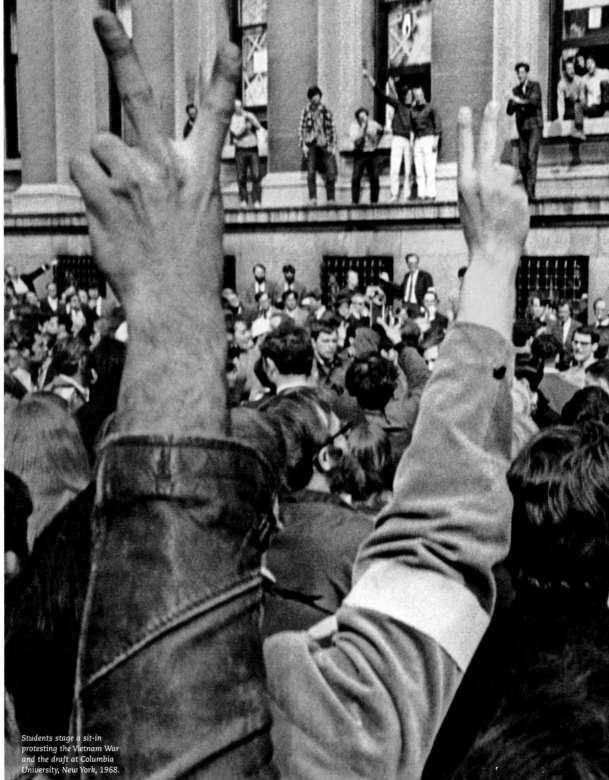

1960s

Students stage a sit-in protesting the Vietnam War and the draft at Columbia University, New York, 1968.

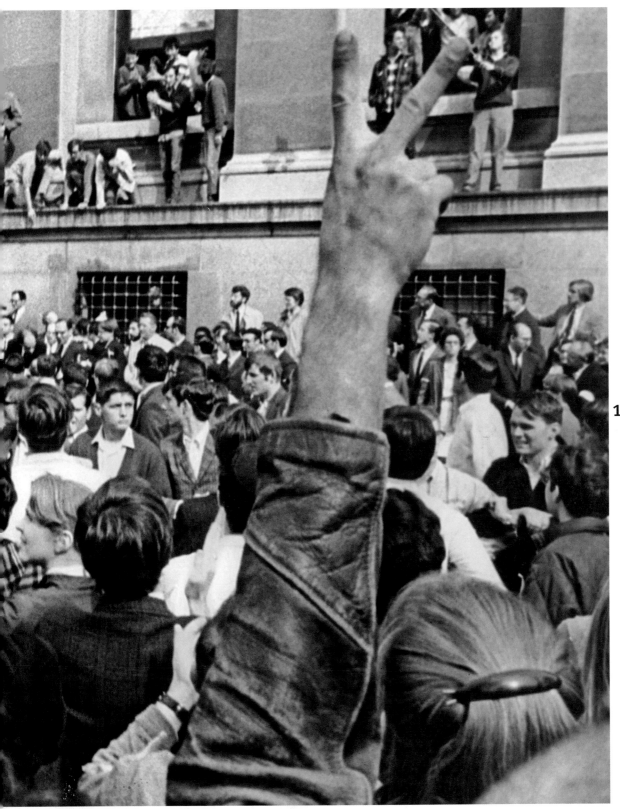

1960s

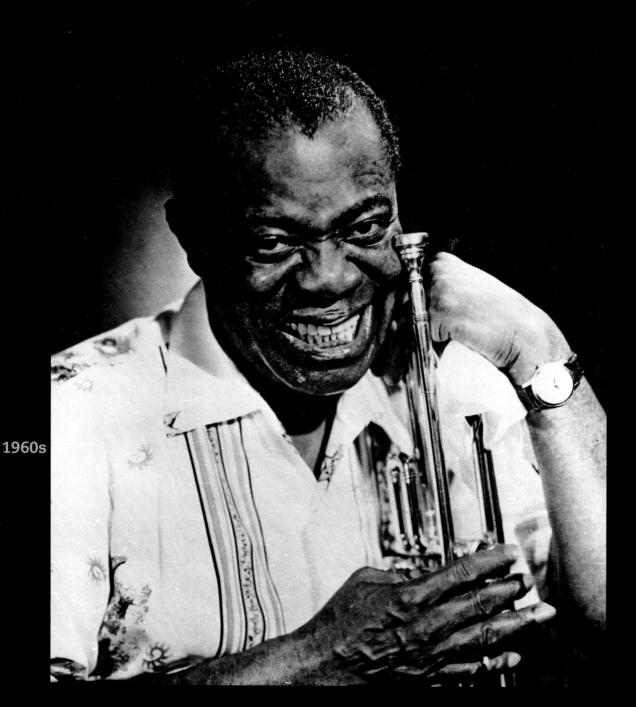

Louis Armstrong

When I look at this portrait of Louis Armstrong in his home in Queens, New York, six months before he died in 1971, I am reminded of his great humility. He lived with his wife, Lucille, in the same house for decades. He posed for me exactly as I found him—no hair or makeup artists, no stylists, no hovering publicists or agents. Just Satchmo and his horn. Think Joe DiMaggio, Edward R. Murrow, Humphrey Bogart, Katherine Hepburn—no matter how famous they became, they were still one of us. There was a naturalness and grace about them, which today's celebrity culture has all but wiped out.

into shooting projects, not realizing that was a good way to increase their expenses! Fortunately, I had allies in the Forty-second Street office, such as my old mentor, Charlie McCarty, and managing editor Ted Majeski. McCarty used to chuckle about how, when I handed in my expense account, he would hold his hand over his eyes and sign it.

UPI was involved in a cooperative arrangement with Cowles Communications in the spring of 1968, and I was assigned to *Look* magazine, along with UPI reporter Elaine Moseby. Our job was to check out the exploding universe of the hippie generation. I had three months to see what I could find.

When I came back from Vietnam, in some ways I was the same person I had been when I left. I had some combat under my belt, the experience of running a line bureau on a big story, but I still had my short haircut, horn-rimmed glasses, and my idea of a big night out was dancing to a swing band. I had even in 1968 gone to the Waldorf-Astoria to listen to the music of Guy Lombardo.

The first thing I learned as I entered the underground of this new world, which had its head-quarters at Andy Warhol's Factory on New York City's East Side, was that these people stayed up all night. Instead of working 9 to 5, I would start shooting at 5 p.m. and go to 9 a.m. Surprisingly, Warhol and his assistant, Paul Morrissey, welcomed me into their midst. It wasn't long before I figured out that there were a lot of wild and crazy people around them. But how to keep up with them? One of Andy's denizens, noticing that I was lagging around 2 a.m., handed me a little bottle of green-and-white pills and said, "Take some of these. You'll feel a lot better." Whoa! Did I ever! They were called Dexamil—and, boy, did they work.

Andy Warhol, other than being one of the giants of modern art and practically the inventor of Pop art, was the great enabler. If you told him that your secret desire was to be a transvestite dog rapist, he would just look at you in a nonjudgmental way and say, "Oh." His Factory became home to scores of artists, filmmakers, and hangers-on. He was courted by the rich and famous, all of whom, it seemed, had some long-repressed urge that Andy would draw out. His dispassionate comportment extended even to his own life. He thrived on gossip, and if a writer wanted to do a story about him, Andy would always say, "Make it up." He was far more interested in what people could invent than in a simple restatement of facts.

Over the next few months, I met every major figure in this underground culture: Marshall McLuhan, who had come up with the brilliant concept, "The medium is the message"; Timothy Leary, whose mantra was "turn on, tune out"; "superstars" such as Nico, Ultra Violet, Baby Jane Holzer, and poet Allen Ginsberg. I traveled around the country with them, haunted their dives, and participated in a lifestyle I had never imagined myself living. After three months of throwing myself into it, I became a cool and groovy guy. I can vaguely remember frolicking in a fountain with a spaced-out blonde in front of the Seagram Building on Park Avenue during a February snowstorm.

Not surprisingly, one morning I showed up at my apartment to find that Betsy was gone. It was a shame: She was a good woman—better than I deserved. She had had trouble finding work in journalism after our return from Vietnam, and eventually wound up practicing law, very successfully, in Ohio.

Some are fond of saying, "Everything is connected." It goes along with the theory of six degrees of separation. I have never been a gun lover, maybe because I have witnessed assassination attempts. So when I was UPI's photo chief in Vietnam and young photographers would come to me and ask whether they should carry weapons or not, I always said, "What you decide to do is ultimately up to you. But you can't shoot pictures and people at the same time. If ever the time comes when your being armed would make a difference, there will be plenty of weapons around for you to pick up."

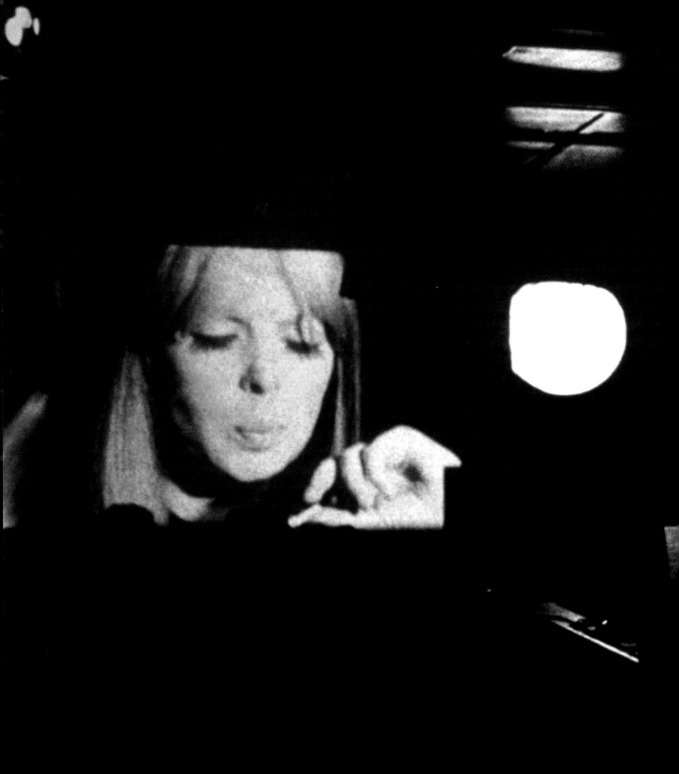

Singer Nico pops a pill during a performance in New York's East Village in the late 1960s.

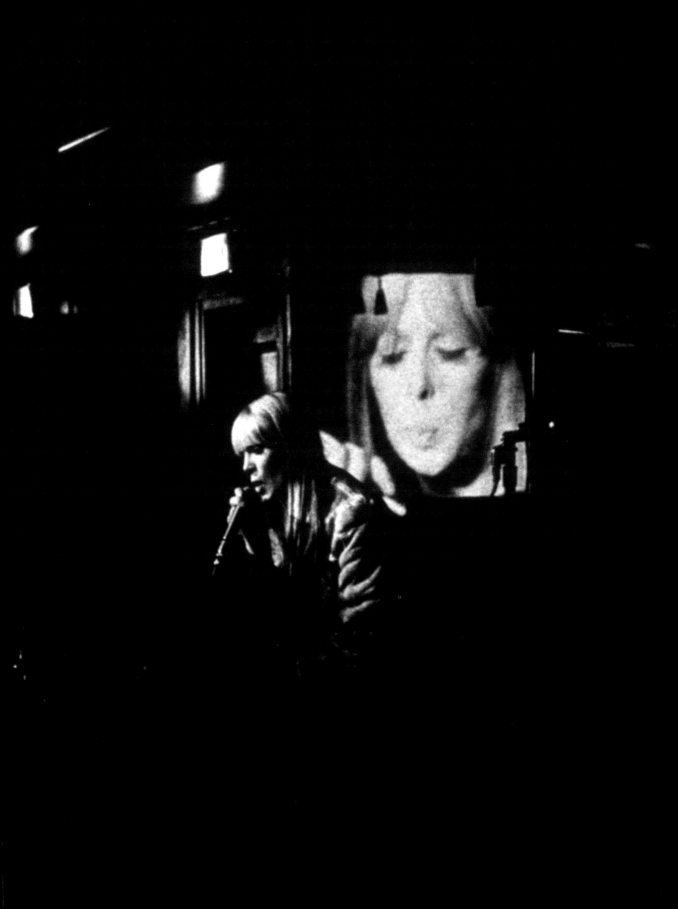

One day I got a call in my Saigon bureau. It was from an Air Force public-information officer I had befriended. He was leaving for the States and asked me to meet him planeside at Tan Son Nhut Air Base. He pulled me aside and said, "I want you to do something for me. I have a weapon, and I don't want to carry it home." He handed me a Walther PPK, a small-caliber automatic handgun—the same gun used by 007. I had no use for it, but I took it from him.

While I was in the process of moving, the gun wound up among my personal effects; it was delivered to my apartment in New York. Not knowing what else to do with it, I put it in a bedside table drawer. It was loaded with hollow-point .22-caliber cartridges.

In 1968 I entertained the whole retinue of Andy Warhol's Factory at a late-night party. A few days later, I noticed the gun was gone.

Several months later, Valerie Solanis stalked into the factory and shot and wounded Warhol. News reports stated that he was shot with a hollow-point .22-caliber bullet. Was it from my gun? I don't know, but then I really don't want to know.

The late sixties were definitely a testament to the Dylan lyric "The times they are a-changing." From my ringside seat, I saw it all. Sex, drugs, and rock 'n' roll changed everything, and the baby-boomer generation came of age. We lost Bobby Kennedy and Martin Luther King Jr.; got Richard Nixon; our cities were rocked by riots; and the war in Vietnam just dragged on and on.

1960s

WHAT'S HAPPENING...Turned-on and Tuned-in...Teeny-boppers, Hippies, Long-hairs, Short-hairs...Sunset Strip to Washington Square...Conversations parents never hear—Sex, Drugs, God, Morality, Success—PRESSURE, PRESSURE, PRESSURE...The OUT and the IN...Beatles...Monkees... Mod and Mini...Psychedelic Lights...and much, much more...

Youth Quake

$1.00

A COWLES SPECIAL IN COOPERATION WITH UNITED PRESS INTERNATIONAL AND LOOK

Right: The cover of a special issue of Look *magazine, 1969. Opposite: Andy Warhol in his Factory. It was in this workspace on East 47th Street in Manhattan that he was shot by one of his followers, Valerie Solanas. Pages 78–79: Andy Warhol became the fountainhead of a new culture. His world was peopled with his "superstars," such as, from left to right: John Dellesandro, Andy Warhol, Ivy Nicholson, Ultra Violet, and Nico.*

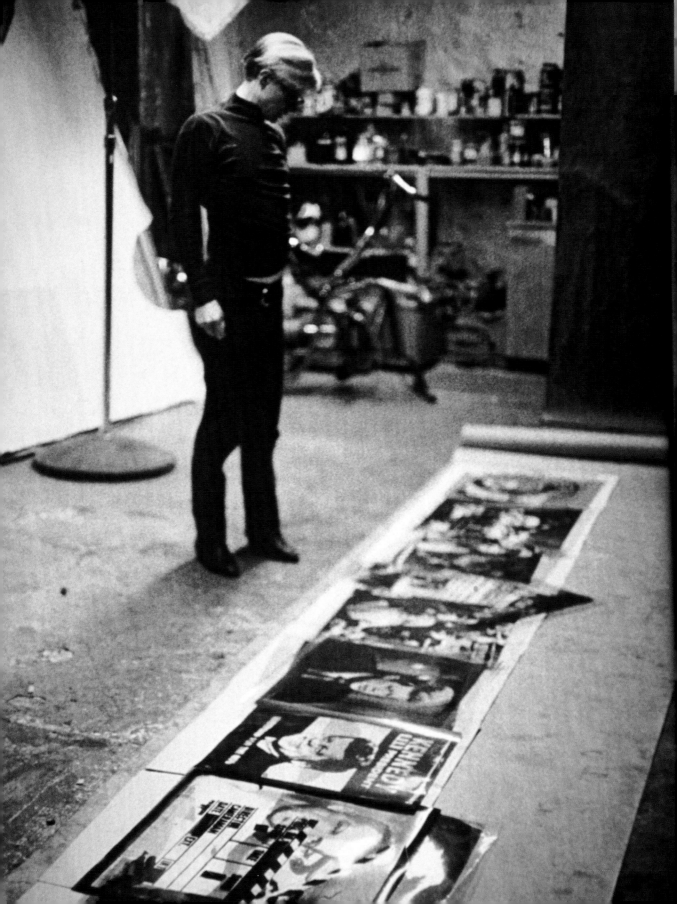

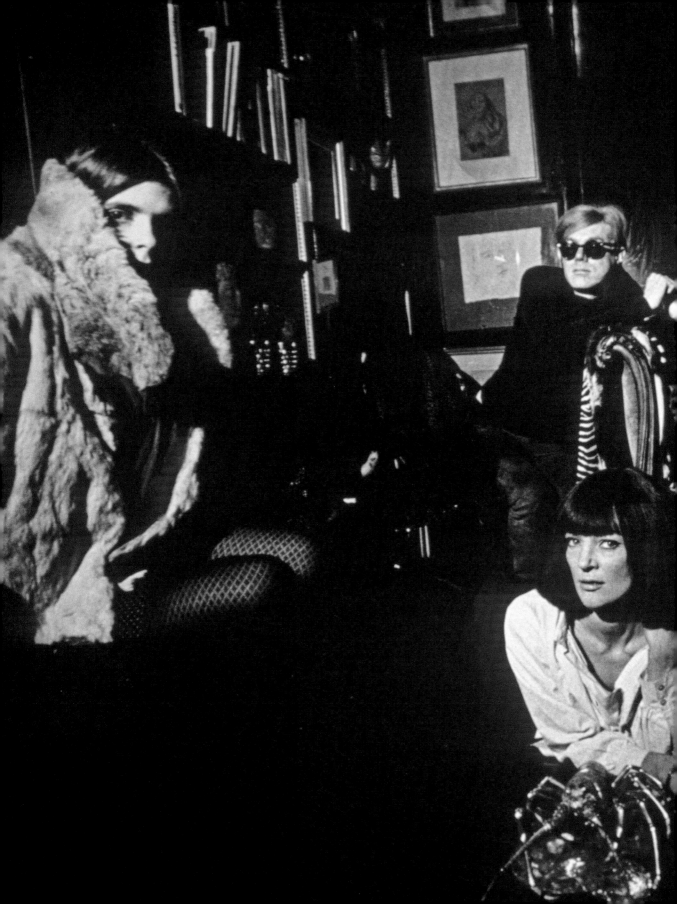

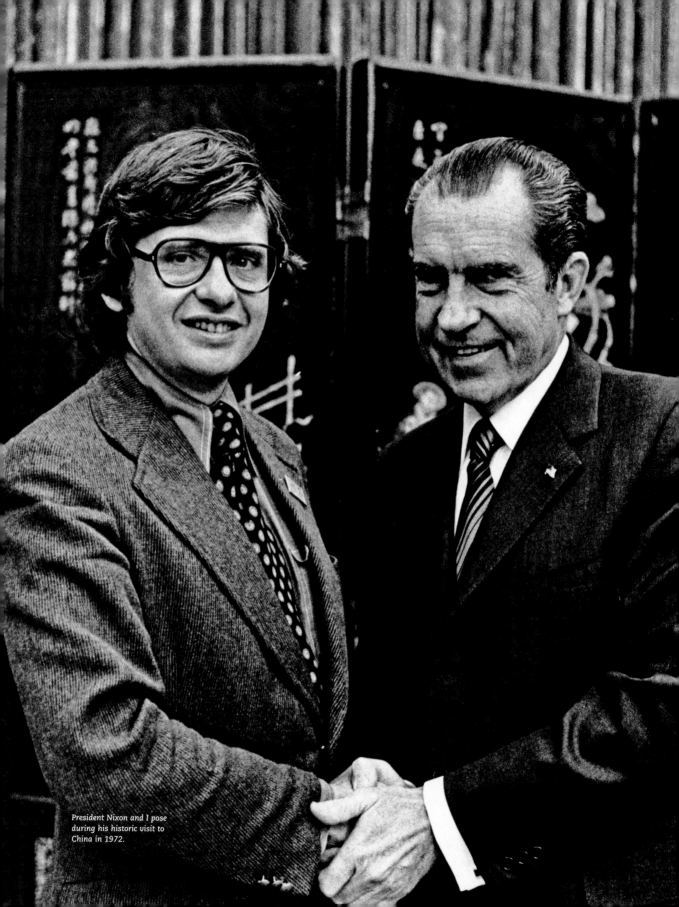

President Nixon and I pose
during his historic visit to
China in 1972.

One of the first things I learned as a young UPI photographer was that coverage of the White House was, in the eyes of the editors, the biggest continuing story in the world.

On one of my first visits to Washington, veteran photographer Maurice Johnson told me, "Regardless of who is the president, in one way or another his actions influence everything else in the world. That's why you can never miss the shot."

Later, when I was shooting for *Time*, I discovered that the White House was also the most expensive story in the world to cover. Up until recently, *Time* covered the White House seven days a week; that translates into photographers' day rates, which today run to about $700. Add to that the exorbitant cost of travel as the president whisks around the country and the world, and it's easy to imagine some very worried bean counters.

It is a truism among the White House press corps that if you want to know what kind of president the new Oval Office occupant will be, you should ask the photographers. The reason is that reporters rely on information often obtained through White House sources, which are constantly spinning the current administration. They are inundated by a torrent of releases, memos, and backroom conversations with officials.

Photographers, on the other hand, rely more on instinct and on what their eyes tell them than on the words of the president or his administration. It is not uncommon for most photographers covering the White House to have a gut feeling about what they see in the incumbent. That is why, in the early days of the Nixon administration, we could tell that trouble lay ahead and why, before he even got to the White House, we knew that Bill Clinton's obsessive appetites were going to be his downfall.

Each president is different. Some we like, others we don't. Some even like us. But I don't know of any photojournalists covering the White House who ever revealed a political agenda in their photographs.

Let me share with you some brief impressions, from a photographer's point of view, of these men—the most powerful men in the world.

John F. Kennedy: Camelot was indeed a place on the Potomac. The energy in that White House was palpable. In those days there was very little antagonism between the president and the press. Reporters, such as *Life*'s Hugh Sidey, would be invited on a regular basis to go skinny-dipping in the White House pool with the president. However, among photographers, Kennedy had the nickname of Jack the Back. He was such a master at presenting himself to the camera that he always knew exactly where they were and would often keep his back turned to them

President Nixon prepares to swear in a new federal judge in the Oval Office as press-pool photographers record the event.

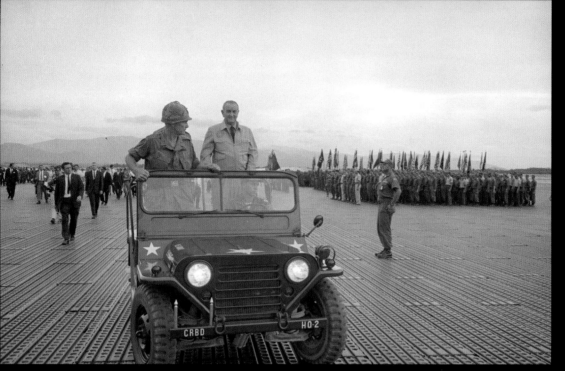

President Johnson reviews American troops at Cam Ranh Bay, Vietnam, in the spring of 1966. Opposite: With the storm of Watergate breaking over his presidency in 1973, Richard Nixon fights to regain support.

until he was fully composed.

Lyndon Johnson: Larger than life. He had no inhibitions around the camera. In fact, he would insist that his personal photographer, Yoichi Okamato, take pictures of him on the toilet. He would not hesitate to pull up a shirt to show off scars from surgery or to pick up a pitiful pooch by its ears while the shutters clicked.

Richard Nixon: Without a doubt the greatest subject we ever had in front of the lens. Every mood was clearly displayed on his face. As he slipped more deeply into the woes of Watergate, his visage became more and more creased. His eyes would dart around the room, and tell-tale sweat would pool above his upper lip. Nixon's presidency became a national tragedy of Shakespearean proportions.

Gerald Ford: One of the sweetest people ever to occupy the Oval Office. He actually loved photographers. His second appointment on the day he became president, right after he nominated Henry Kissinger to be secretary of state, was to hire *Time* photographer David Hume Kennerly as his official photographer. If he heard that a photographer covering the White House was having a birthday party, he would hop into a motorcade and pay a call. On the night he lost the election and broke into tears, some of us got misty-eyed as well.

Jimmy Carter: A total disaster visually. From the moment he arrived, talking about America's "malaise," he projected ineptitude and uncertainty as a leader. He would slink, rather than stride, with a floppy raincoat on his shoulders. One photographer called him the "Potomac Flasher." In later years, he would prove to be an eminent statesman, but during his four years in office, he was only remembered for three images: 1) the historic handshake with President

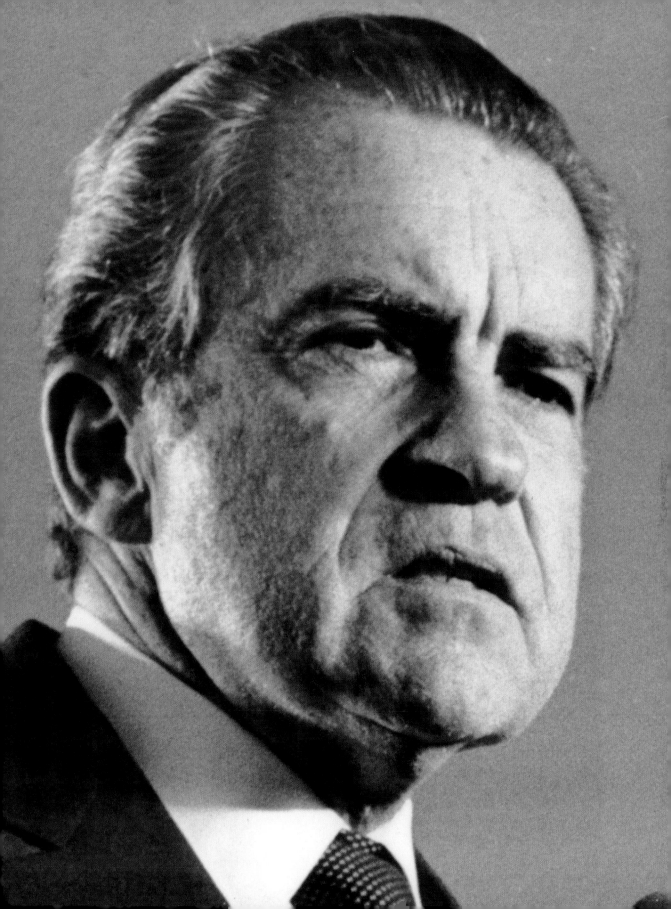

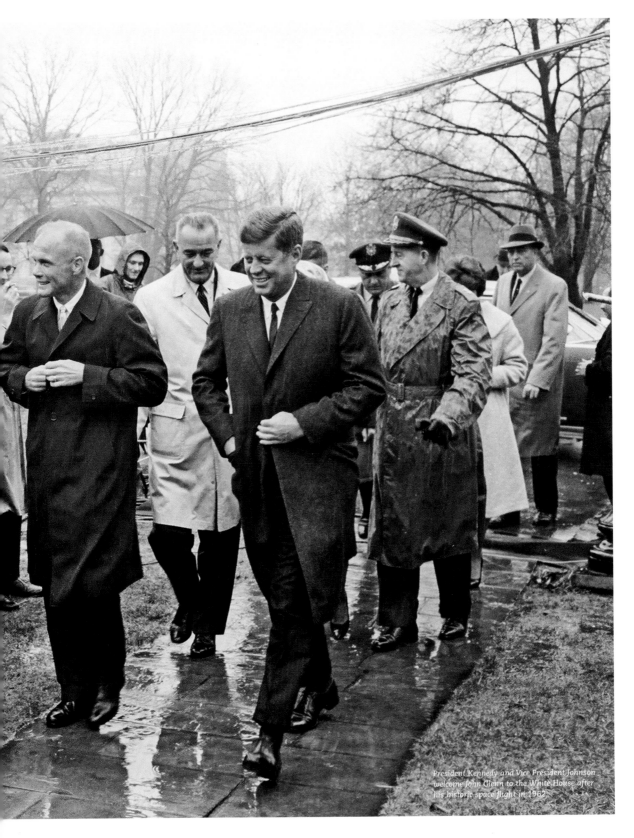

President Kennedy and Vice President Johnson welcome John Glenn to the White House after his historic space flight in 1962.

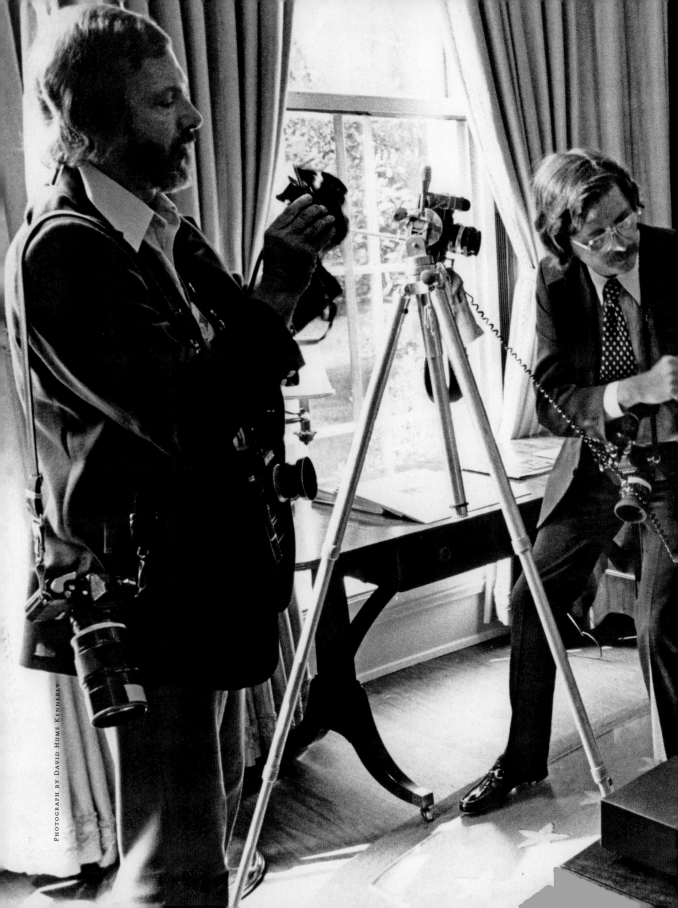

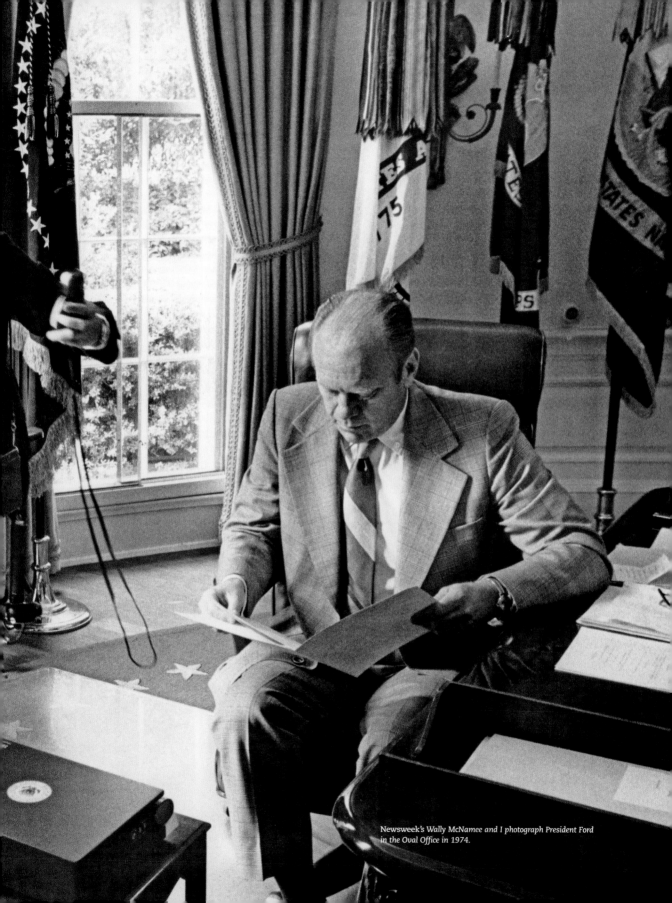

Newsweek's Wally McNamee and I photograph President Ford in the Oval Office in 1974.

Anwar Sadat of Egypt and Prime Minister Menachem Begin of Israel, 2) a gasping Carter dropping out of a marathon near Camp David, exhausted (that picture was on the front page of newspapers around the world the next day, which, unfortunately, also bannered the disastrous news of Carter's ill-fated operation to rescue American Embassy hostages in Iran); 3) Carter batting away at a rabid rabbit circling his rowboat in Georgia. It became known as the "Attack of the Killer Rabbit."

Ronald Reagan: What you saw was what you got. He was a professional, an actor. He knew how to play a part—the greatest role in the history of show business: the presidency. He also had a heartfelt conviction about America—at least, the America he knew growing up in the 1920s. Everything was possible. After Carter, he was a breath of fresh air. In his mind, it seemed the White House was his trailer, and the Oval Office his soundstage. He would walk to work every morning to hit his marks and deliver his lines. Photographers were secondary to the TV camera operators—they were behind the scenes on the set taking stills of his film. But, boy, was he *good*. He managed to sucker the Soviet Union into dismantling itself.

Below: President Carter hurdles a ditch during a visit to a farm on his tour of Mexico with First Lady Roselyn Carter.
Opposite: President Reagan with students at a Catholic school in Ohio during his 1984 campaign.

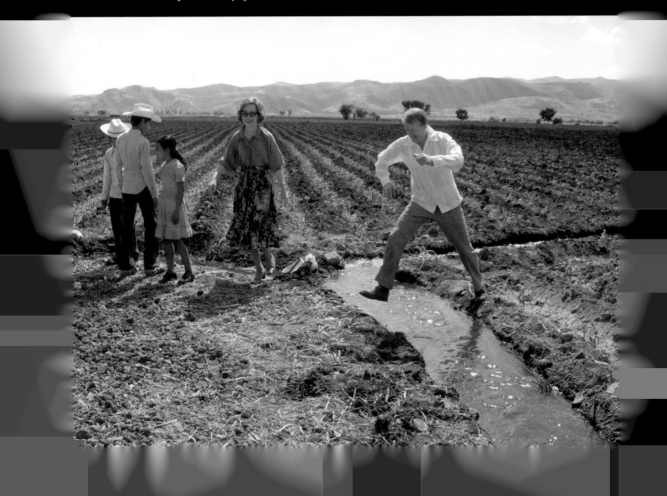

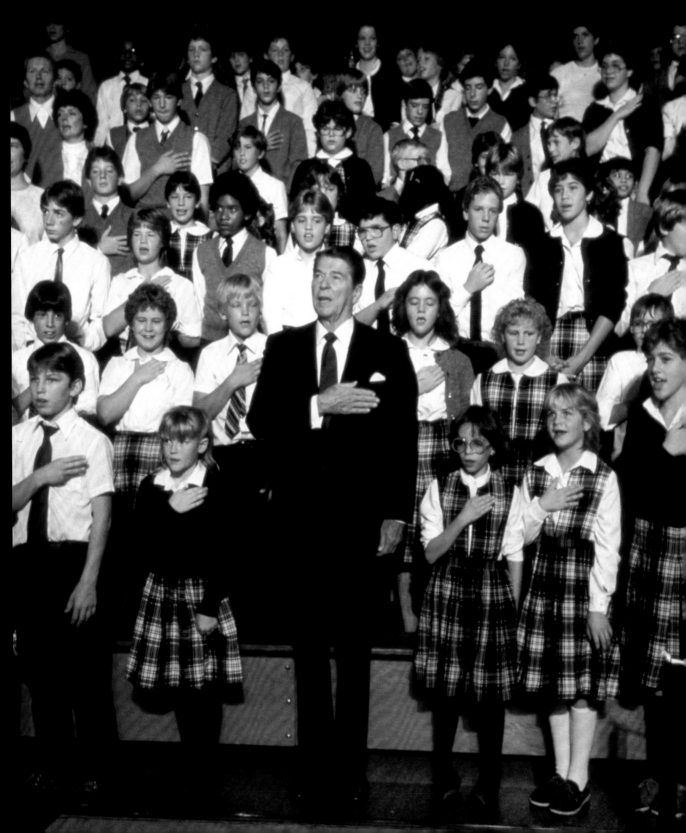

UNNECESSARY PERSONNEL
STAY BEHIND LINES

Officials brief the president and Mrs. Carter as they tour the control room of the nuclear reactor at Three Mile Island. On the way to the plant, I listened to these same officials heatedly debate over whether it was safe for the president to go into the plant. The safety of others like myself didn't seem to concern them. For the next twenty years I would receive inquiries from the Atomic Energy Commission asking about my health.

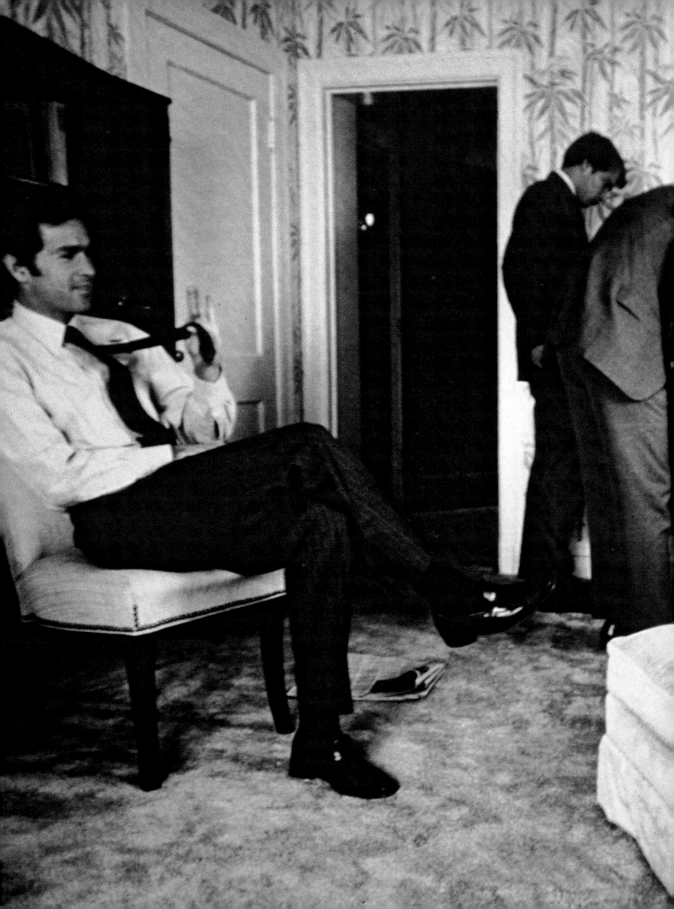

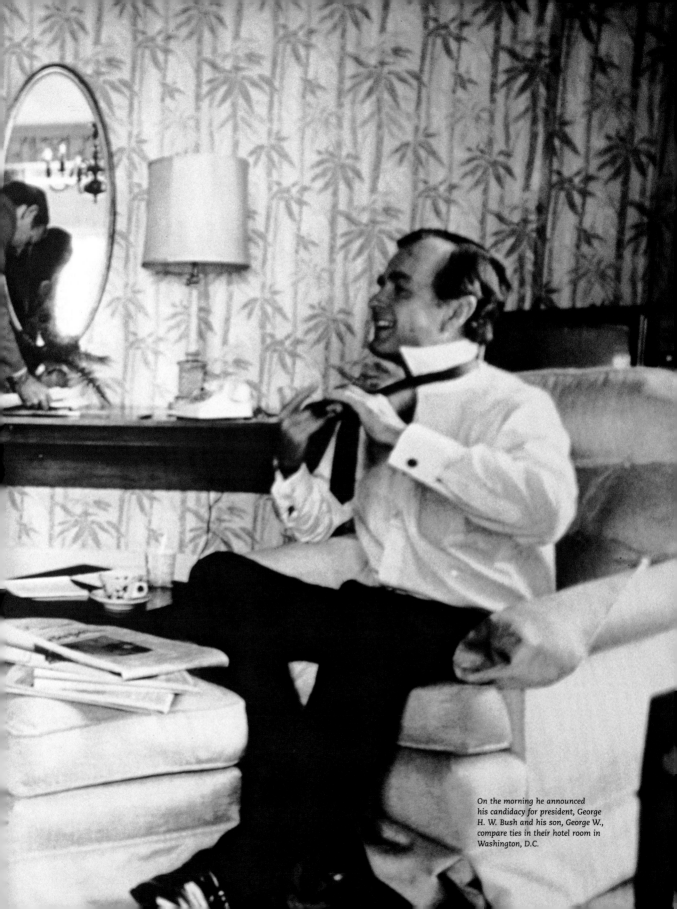

On the morning he announced his candidacy for president, George H. W. Bush and his son, George W., compare ties in their hotel room in Washington, D.C.

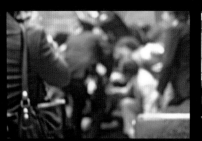

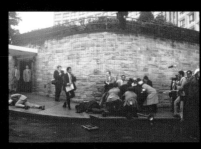
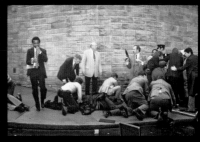
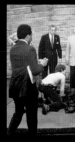
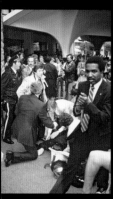
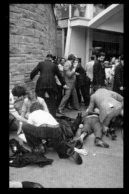
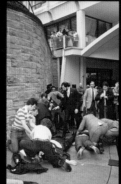
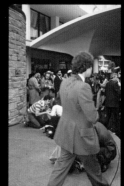
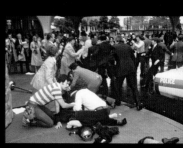

Assassination Attempt

The Washington Hilton, March 30, 1981: As I emerged from the hotel following President Reagan's speech, I heard gun shots. In the time it took me to get to the side of the limo, Reagan had already been shoved into the car, which immediately sped away. I had three cameras with me—two of them were loaded with tungsten film to cover the speech indoors, but one was loaded with daylight-color film, just in case something happened. The next moments are something of a blur, but I forced myself to remain calm, and I managed to squeeze off each frame. Here is the entire roll as it was shot in the two to three minutes following the shooting of President Reagan by John Hinckley Jr. Reagan was hit in the chest, but three others took hits as well: Secret Service agent Tim McCarthy; Press Secretary Jim Brady, who took a near fatal shot to the head, which left him paralyzed for life; and a Washington police officer. On the following pages, Secret Service and local police have surrounded Hinckley (far right).

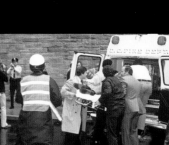

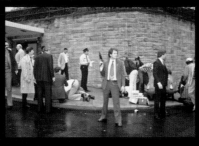

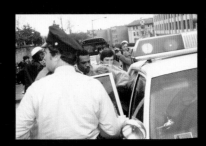

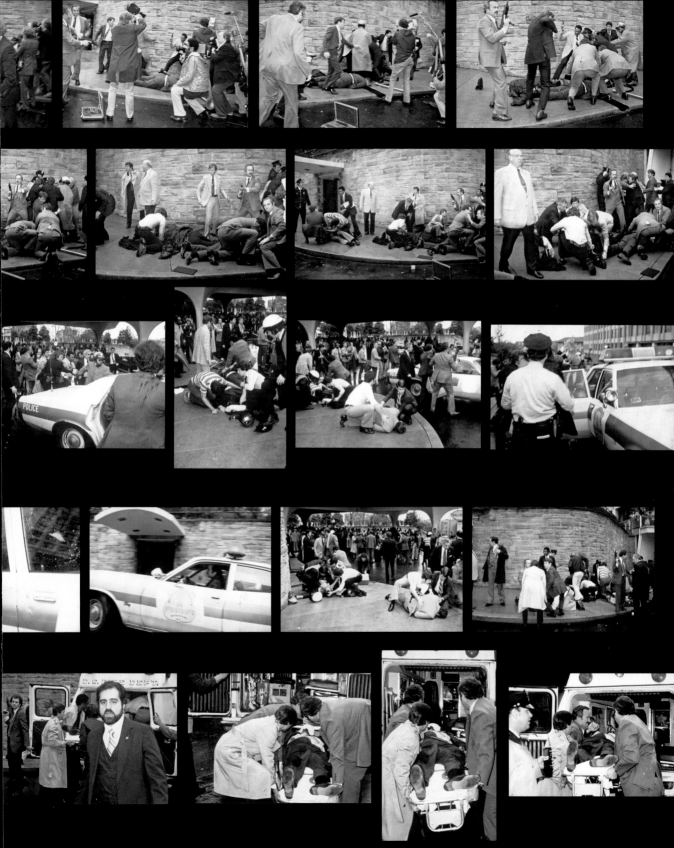

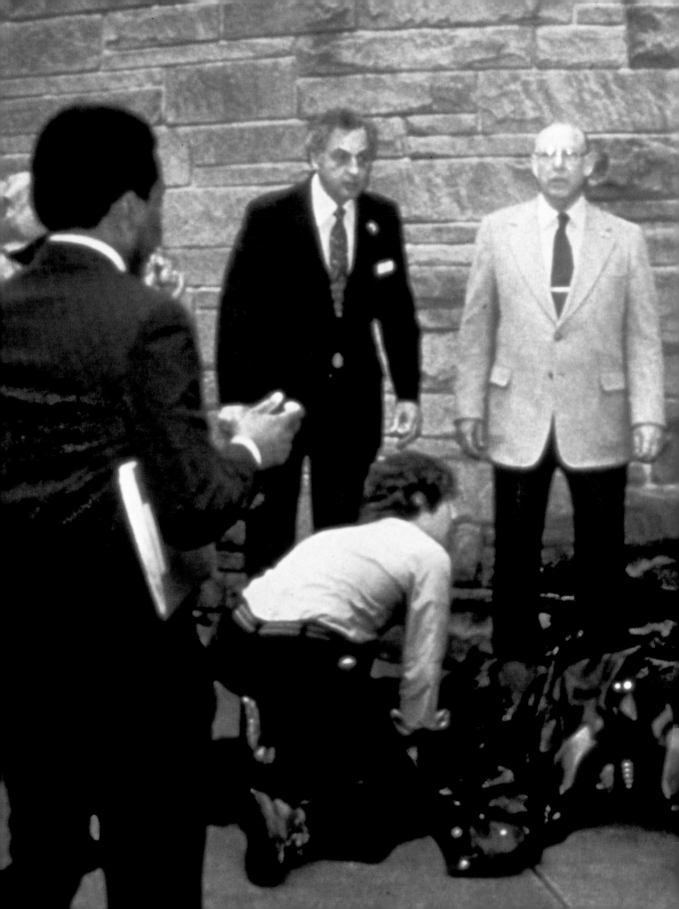

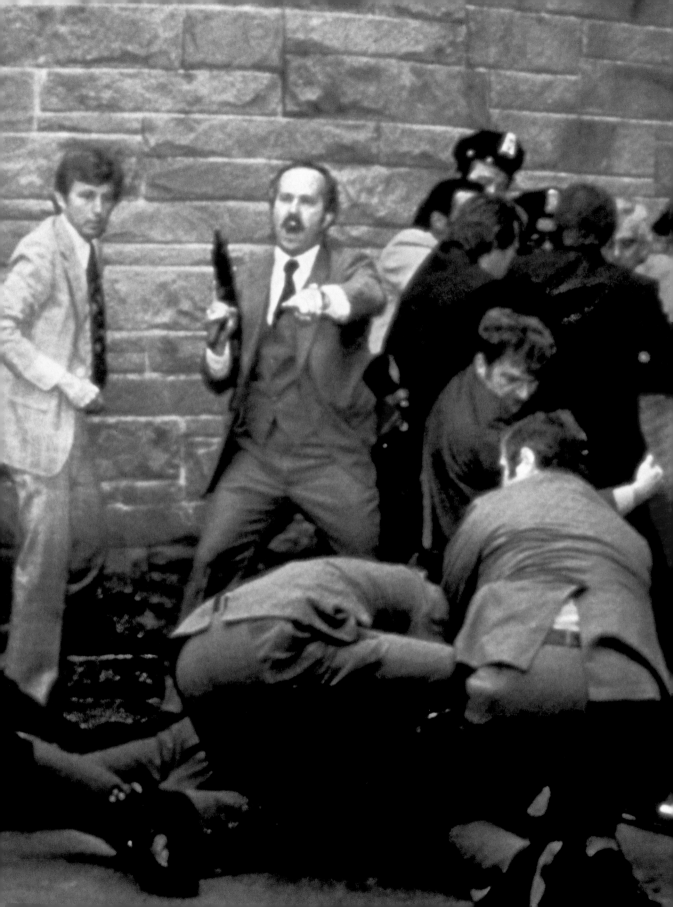

photo-op at the White House in 1976.

It boils down to arriving at the mansion at 8 a.m. and sitting in the West Wing pressroom waiting for photo ops. These happen two or three times a day.

The pool members (the wires, magazines, and networks) are notified on a speaker system assemble by the pressroom door, and then they are escorted to the doors of the Oval Office o the South Portico. When the signal is given, they are ushered into the room, take a position a quickly as possible, and the TV lights go on. Roughly forty seconds later, the lights go off whe an aide yells, "Lights!" and that is the end of the photo op. Day-to-day coverage can be extreme boring, so most members of the pool doze in their theater-style seats, but when the call come everybody knows this could be the big one.

On the road, it gets more complex. On every trip, there is a pool section on Air Force On consisting of sixteen first-class-type seats (minus foot rests). These are allocated to the wi reporters and photographers (AP, Agence France Presse, Reuters), a magazine reporter, a new paper reporter, a network correspondent, a network crew (of two), a radio reporter, and a ma

What is it like traveling on Air Force One? The press shows up at Andrews Air Force Base, ten miles southeast of Washington, one hour before the president lifts off from the White House in Marine One, the presidential helicopter. After going through security, press members are escorted to the presidential aircraft to wait. The compartment they occupy is in the far rear of the plane; they are totally sealed off from the rest of the plane. A Secret Service compartment, a staff compartment, a visitor's compartment, and the Presidential Suite sit ahead of the press compartment. Unless the president decides to pay a visit to the rear, there is no access to him at all. Because the press compartment is in the very rear of a 747 that is often trying to make up time, the ride can be very bumpy. The noise is so loud that any chance of hearing the movies on the in-flight system is minimal.

There are pursers to look after the press' needs. However, food service is determined by the per diem allotted to the lowest-ranking military person on the plane. Therefore, most meals are in the Hamburger Helper category. Liquor and wine are available.

Another hitch is that meal service is based on whether the president wants to eat. If the president doesn't want to eat, no one eats. On a trip to Eastern Europe one Memorial Day, I showed up at Andrews at 6 p.m. for a ten-hour flight. When I asked what we were having for dinner I was told "nothing." Bush had attended the Indianapolis 500 that day and had eaten on the way back to Andrews. The European trip was considered an add-on, so no food was provided.

Pools are based on the number of people who can be boarded onto either Air Force One or a Chinook helicopter, which is often used upon arrival at the destination. The sixteen-person Air Force One "tight" pool is extended after arrival to other magazines and local publications to form an "expanded" pool that travels with the president.

Additional press members on the trip travel on a chartered aircraft that takes off and lands one hour prior to Air Force One. For years, Pan Am had the monopoly on White House travel, and every flight for the press charter was Pan Am's. For more than twenty years the same pilots and flight attendants made every trip, and because it was a press relations dream, the finest food and wines were brought aboard.

The cost of these charters was split among the organizations (magazines, newspapers, etc.) covering the trip. The average airfare was first class plus 50 percent, directly billed to the media offices. However, the press traveling on Air Force One, in much more spartan conditions, were all paying their prorated share of the press charter. In other words, if a nice meal cost seventy dollars on the press plane, so did that Hamburger Helper on Air Force One.

Most days on the road start at dawn and don't end until after midnight. On a long trip involving international travel the practice of snoozing in the White House pressroom is extended to every bus and pool vehicle.

So why do so many organizations spend so much money, and so many photographers work so hard to cover the White House? Well, it isn't in the hope of getting a different, defining image of the president. It's because of people like John Hinckley, Squeaky Fromm, Sara Jane Moore, and Lee Harvey Oswald. The sad fact is, there are deranged people out there who from time to time insist on trying to kill the leader of the Free World. Ever since the Kennedy assassination, Congress has mandated that there must always be a press pool traveling with the president, within response distance. I've gone through two assassination attempts during my coverage of the White House, and it's on those days that you really earn your money. So even if you are dozing in the motorcade en route to an event, your camera is still around your neck, ready for action in an instant.

Covering the White House on a daily basis is frustrating and boring almost beyond endurance, with the occasional moments of pure shock and terror thrown in. It's all worth it, though, when you carry the knowledge that you are covering history.

1970s

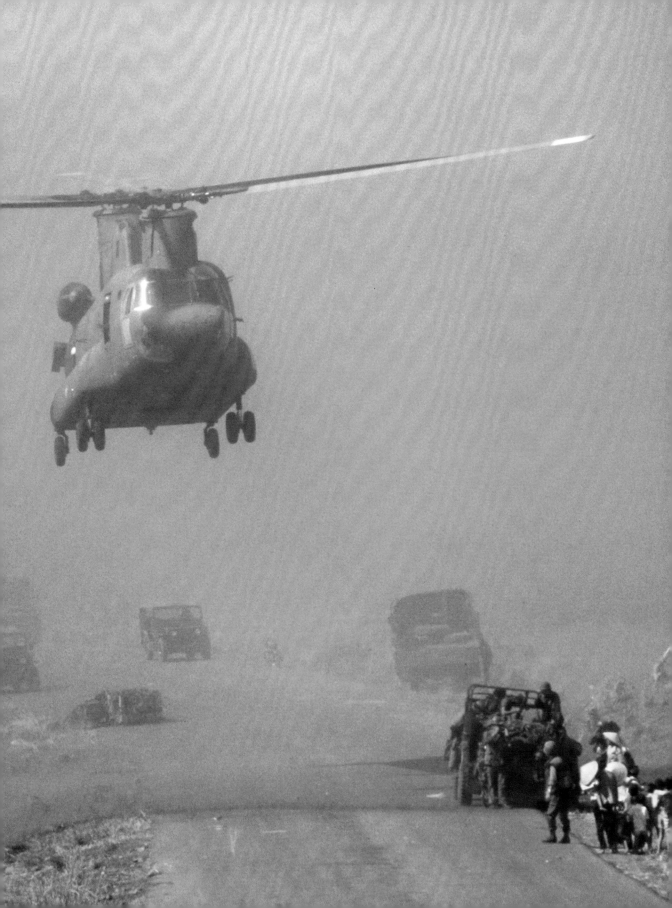

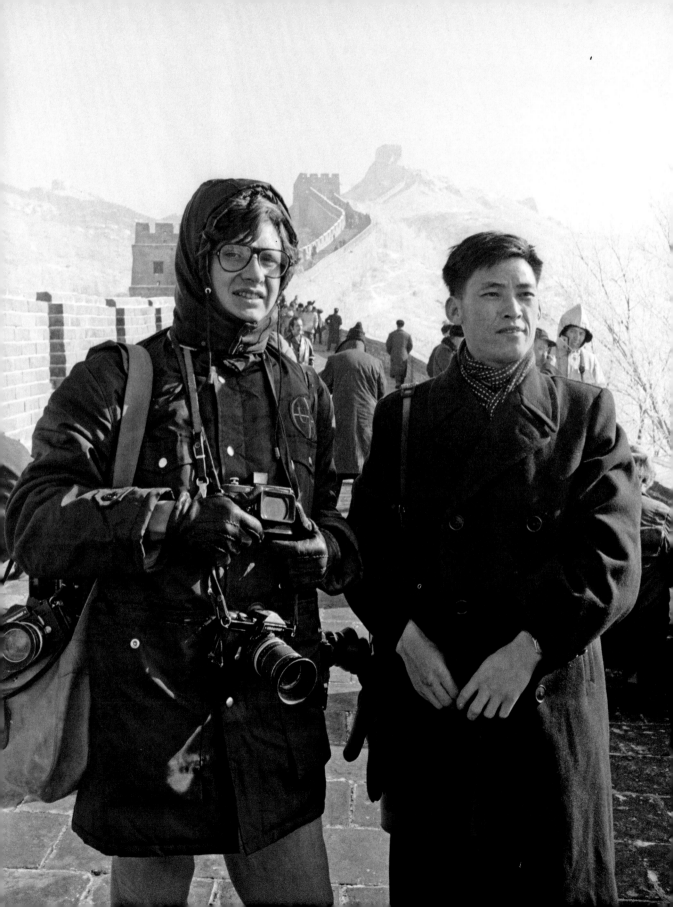

If I had to point to one story that was the most important of all I covered in my fifty years as a photojournalist, there would be no doubt as to the winner: President Richard Nixon's trip to China in 1972. ▪ I had covered the Nixon presidential campaign in 1968 for UPI and during the next four

1970s

years. Although I was then based in New York, I was frequently asked to cover Nixon's major international trips.

In July of 1971, while Nixon was summering in San Clemente, a bombshell exploded. It was revealed that National Security Advisor Henry Kissinger, who had mysteriously disappeared after the president's arrival in California, had secretly flown on to Beijing (or Peking, as it was known then) and had gotten the Chinese to agree to invite President Nixon on a state visit the following year.

To understand the significance of the announcement, you have to consider the times in which we were living. The United States was bogged down in a war in Vietnam, and the Cold War between the West and the Soviet Union was at its height. China and Russia were the principal suppliers of arms to the North Vietnamese. The world was polarized between East and West. China had been sealed off from the West since Mao Tse-tung's Cultural Revolution. With the exception of a few

Pages 104–105: VNAF CH-46 helicopters pick up refugees and army troops and their families retreating from the siege of Xuan Loc, a month before the collapse of South Vietnam. Opposite: On the Great Wall of China with my "minder"—each photographer and journalist was assigned one by the Chinese government— waiting for the arrival of President Nixon in 1972. Above: Press passes used during the China trip.

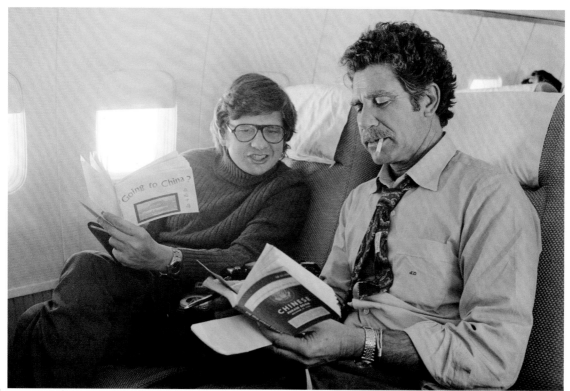

Life photographer John Dominis and I study our guidebooks aboard the Pan Am clipper NiHao 2, en route to China.

left-leaning Western journalists, no Western press had been allowed to enter what was then called "the Middle Kingdom."

As you might imagine, once the announcement was made, every journalist in the world started to jockey for position to be included in the presidential delegation. The main question asked at Press Secretary Ron Ziegler's briefing was: *"Can I go?"*

When Kissinger had conducted his negotiations with the Chinese, the makeup of the press corps that would cover the visit had not been a priority. As the meetings concluded, Kissinger was told that of course Chairman Mao would welcome the press with the president's party. They had in mind one print reporter, preferably from the *New York Times*. Kissinger's people tried to explain to the Chinese that photographs and television were of supreme importance in the West, but it became clear that this was not the moment to push the issue. You can imagine the bedlam that broke out in the press briefing room when Ziegler announced that the Chinese had decided to allow only one print reporter on the trip.

By fall, the U.S. advance teams had made some headway with the Chinese, who relented and agreed that eighty reporters could accompany the president.

Over the next several months, every news organization was transformed into what amounted to a battleground of Shakespearean proportions, as reporters schemed to be one of the chosen few. Gloves came off; these people would have happily driven over their own mothers to be on that plane.

Eventually, the Chinese decided to allow a total of six still photographers to accompany the president. But since they had no real experience with television news, they did not think it was necessary to include the networks. This led to pressure from the very top of those organizations, but the Chinese would not budge. Finally, an ingenious White House advance person on the ground in

China came up with the perfect pitch: "Television is not really considered press. What these people do is provide technical support." This made sense to the Chinese, so at last television was allowed. There was a caveat, however. The Chinese desperately needed modern communications. Therefore, it was agreed that every piece of equipment the television people brought into the country would be left behind, in operating condition, including ground stations.

This led to bloodshed at the networks as correspondents and crews fought to be included.

Of course, the big guys (and girls) won. Walter Cronkite could go, as could John Chancellor, and the correspondents such as Barbara Walters.

During this time I made innumerable trips down to Washington, where I wined and dined my friends at the White House. Eventually the six photographers chosen were John Dominis, representing *Life*; Wally McNamee, *Newsweek*; Bob Daugherty and Horst Faas, AP; and Frank Cancellere and me, UPI.

In addition, two "technicians" were allowed to go to China in advance and set up transmission facilities: Bill Lyon, who was then the general manager of UPI, and Bill Achatz from AP.

It's Going to Be Very Cold

The selected press then received a number of briefings in Washington. We were warned that a Beijing winter could be very cold. We all received various inoculations, and were told to go out and buy warm coats and several sets of long underwear and thermal socks. We were warned that anyone who got sick would immediately be sent to the hospital and might not make it home. We all followed the recommendations, and had layers of long johns that we wore every day under our suits. They only actually came in handy once, when we went to the Great Wall. Other than that, we sweltered in overheated halls, and the Chinese giggled at our body odor.

In pool meetings, we were also told that we should expect no sleep during the six days in China. Everyone would have to do double and triple duty. In addition to shooting, each of us had other responsibilities. For example, every night after a long day covering events, I would go into the darkroom we

Left: The pass I wore at all times during the China trip.
Pages 110–111: President Nixon and the Chinese premier, Chou En-lai, review the honor guard following Nixon's arrival at Peking Airport on February 21, 1972.

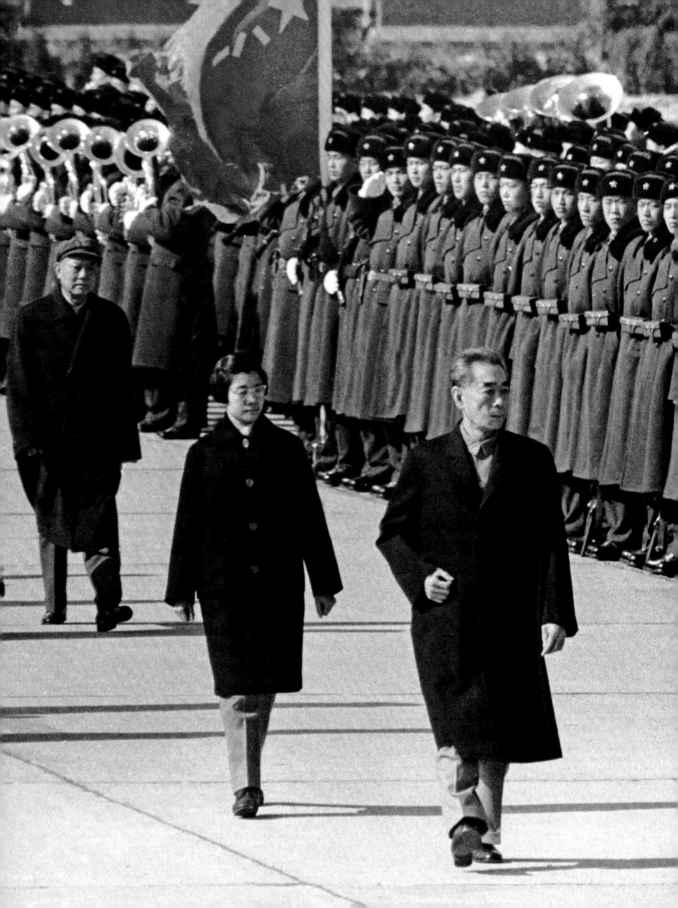

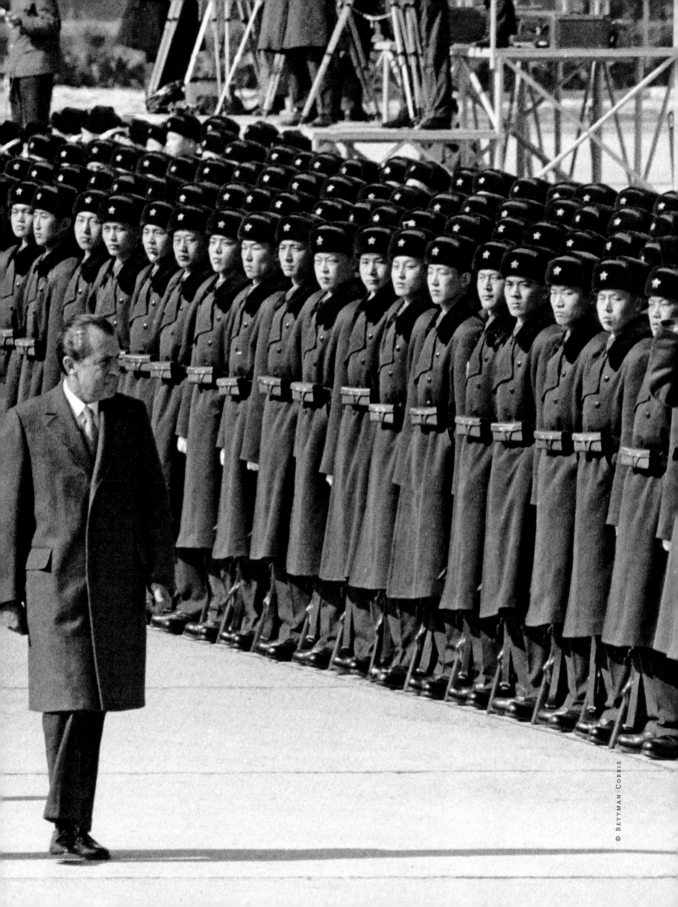

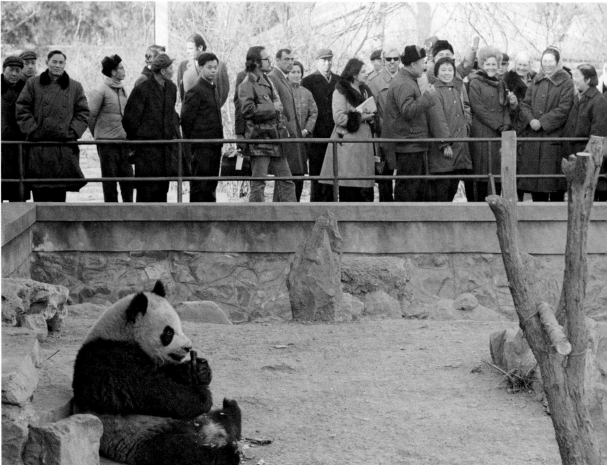

1970s

The Nixon party view giant pandas at the Beijing zoo.

had set up in the Minzu Hotel and process not only our black-and-white but also color film—not just for UPI but for the magazine pool as well. I then had to make dupe slides of the selects that would be put on a courier aircraft at dawn to be sent to the pool headquarters in Tokyo.

Two separate press planes, both Boeing 707s, were chartered for the trip. One, dubbed NiHao 1, was a TWA jetliner, and the other, NiHao 2, was a Pan Am clipper. Both were outfitted with first-class configurations throughout the plane. Correspondents and TV network stars would travel on the TWA plane. Photographers and "technicians" would be assigned to the Pan Am aircraft, which was dubbed the "Zoo Plane."

On the red-and-white TWA jetliner were the greatest names in American journalism: Walter Cronkite, CBS's anchor; John Chancellor, NBC's anchor; Theodore White for Time-Life, who had written the definitive book on Mao's long march; novelist James Michener; Eric Severeid of CBS; William F. Buckley of the *National Review*; and the fabled Hugh Sidey, keeper of all things about the American presidency, for Time-Life.

Somehow, ABC's Barbara Walters wound up on Pan Am, and she sulked throughout the flight to China, especially when she would look up through the window and see the NiHao 1 flying proudly overhead.

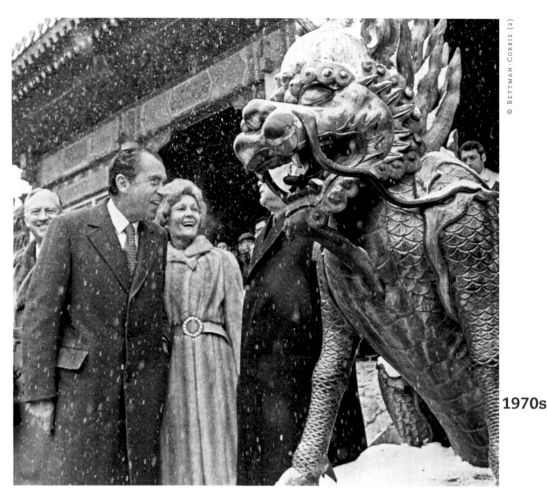

1970s

The president and Mrs. Nixon stand before a huge Chinese dragon as they tour the Forbidden City in Beijing.

Opening the Middle Kingdom

As the planes crossed landfall over the People's Republic, the normally blasé travelers jostled to take pictures through the windows. You have to remember, no Western journalist had seen this country passing below for more than thirty years.

The charter planes arrived to clear formalities in Shanghai, the port of entry to China. From there, we would go on to Beijing on Chinese aircraft. Our planes would follow behind, empty but for the pilots.

As I peered out through the windows while we rolled across the tarmac, my mouth dropped open in surprise. It looked like an SAC base! As far as the eye could see there were huge U.S. Air Force C-141 Starlifters lined up. These planes had carried all the ground stations, military communications, and even huge network control trucks.

White House advance man Tim Elbourne told me of working alone in China throughout January, and then a week before we were to arrive, he went out to the airport to see the arrival of the first jumbo Air Force planes. As he was standing with astonished Chinese onlookers who had never seen a plane of such size, the back of the plane opened up, and a huge truck lumbered out with the proud insignia of NBC's peacock all over it. As the Chinese who were watching gasped, Elbourne's heart swelled with pride, and he began to weep.

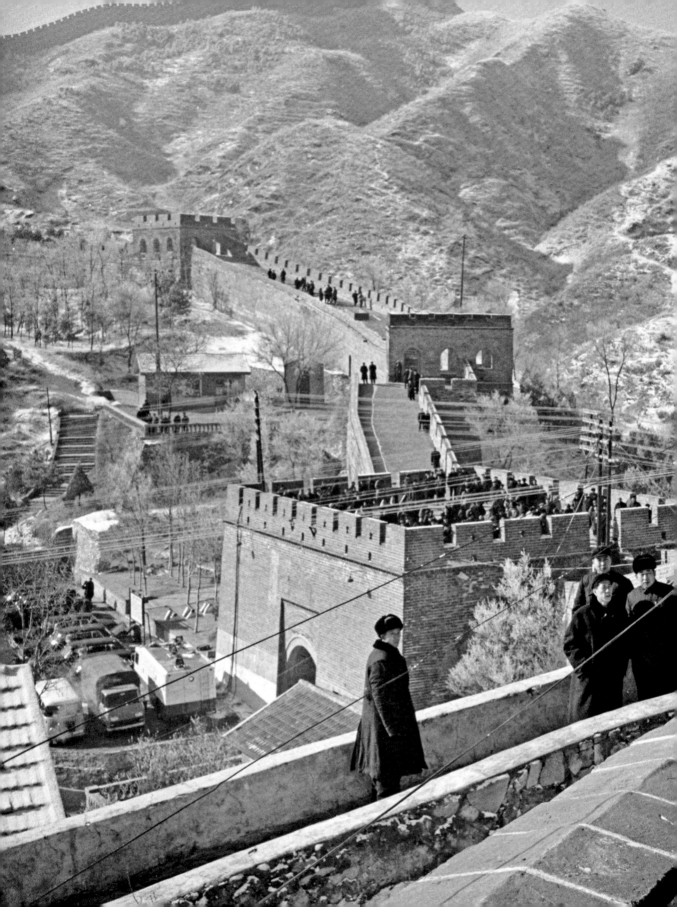

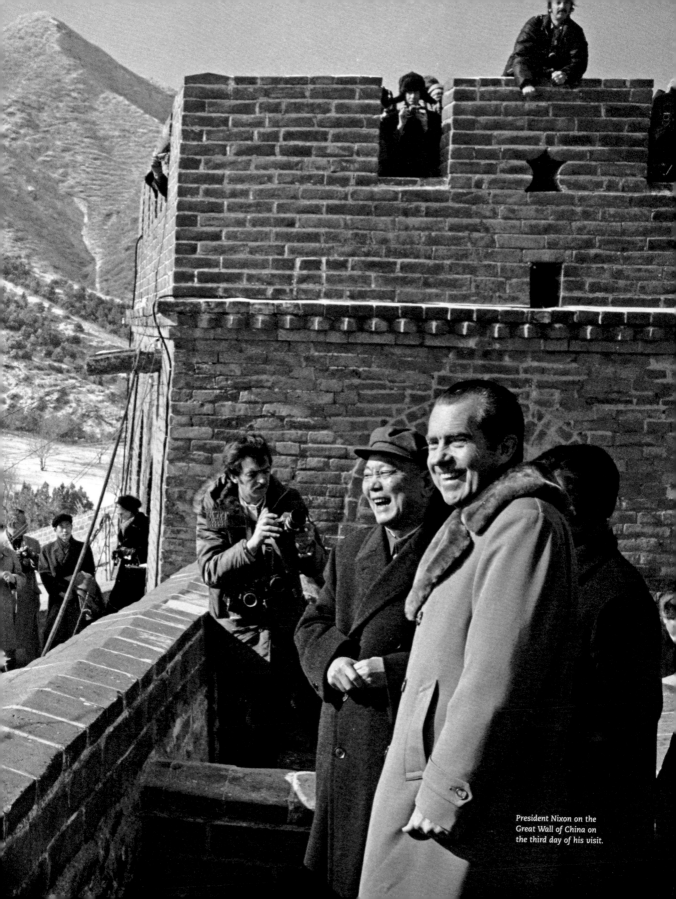

President Nixon on the
Great Wall of China on
the third day of his visit.

We arrived at Beijing's airport eighteen hours ahead of the president. As we drove into the city on buses, we were all taking pictures out the windows. The streets were covered with snow, which workers with brooms were trying to move to the side. The most astonishing thing was that there were no cars. Some people rode buses, but everyone else was on bicycles. It was very cold, but what you noticed was the acrid smell of coal that was used to heat the buildings.

Arriving at the hotel, we were introduced to our "opposite numbers." The Chinese had made sure that every reporter, TV technician, and photographer had a minder who would stay with them twenty-four hours a day. In addition to keeping track of the foreign press, these minders were instructed to learn the skills of their American guests.

My minder was a government photographer who would constantly ask me what exposure I was using and what my film speed was.

There is a legendary story about one of the minders in action. He had been assigned to the pool TV producer, whose elbow he stayed at every second. Early in the coverage of the presidential visit, the minder turned to his American colleague and said, "I understand almost everything you are

1970s

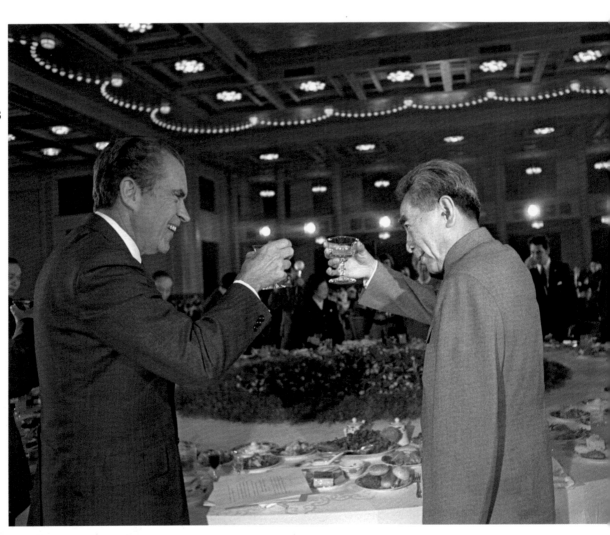

saying—the feed, the uplink, the stand-up—but there is one thing you keep saying that I don't understand. Please explain: What is 'the fucking audio'?"

Nixon in China

On the morning of February 21, we were all bused out to the Beijing airport for the arrival ceremony. As we stood on camera stands in the frigid cold, we watched as Chinese soldiers raised the Stars and Stripes alongside the Chinese flag.

The President and Mrs. Nixon were greeted by Premier Chou En-lai, and did a formal review of the honor guard, then took honors as the American and Chinese national anthems were played. I photographed the ceremony from a camera stand, while my colleague Frank Cancellere, who had arrived on Air Force One, took close-in pictures.

I was able to get his film, and got back on the bus to the hotel. UPI's Bill Lyon was frantically awaiting the film. By now it was past deadline for most East Coast papers, which were holding for the first photographs. He didn't even ask for my film, since Cancellere was the pool photographer on the ground, but immediately processed his roll. You note I say roll, not rolls. Frank came from the old school of Speed Graphic news photography,

Opposite: President Nixon and Premier Chou En-lai toast each other with potent mao-tais at the official reception dinner at the Great Hall of the People in Beijing. Below: President Nixon and Madame Chiang Ch'ing, wife of Chairman Mao Tse-tung, enjoy a chat at the Chinese Cultural Shop.

1970s

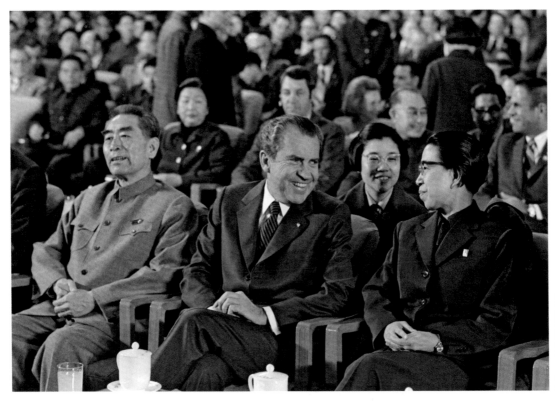

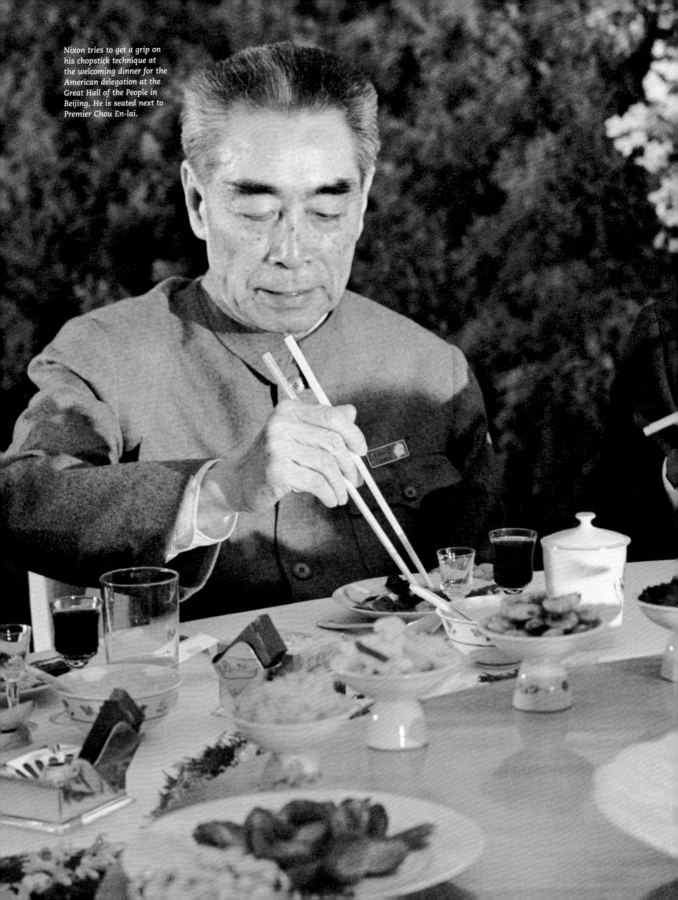

Nixon tries to get a grip on his chopstick technique at the welcoming dinner for the American delegation at the Great Hall of the People in Beijing. He is seated next to Premier Chou En-lai.

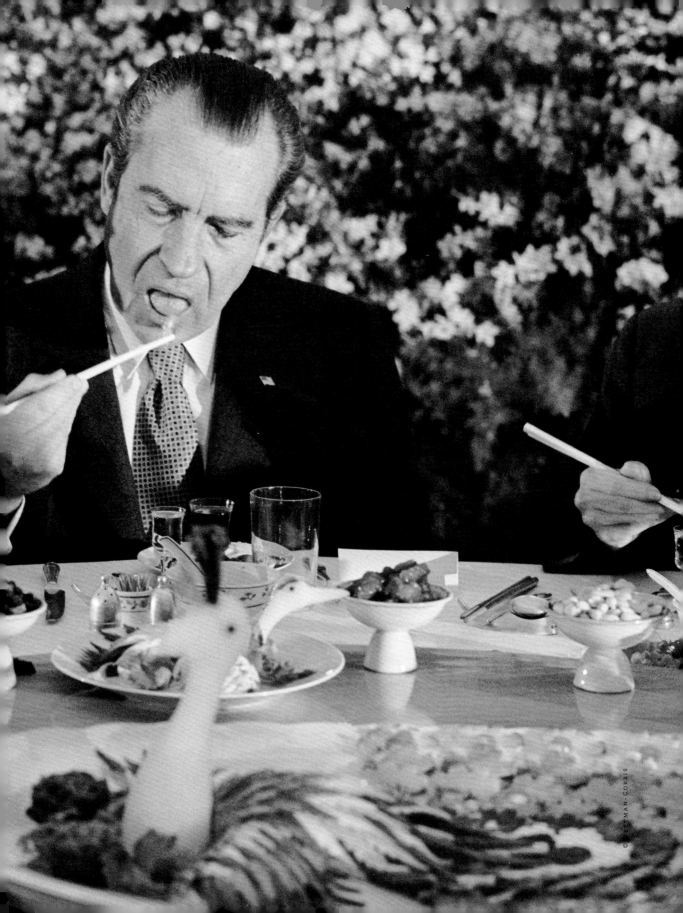

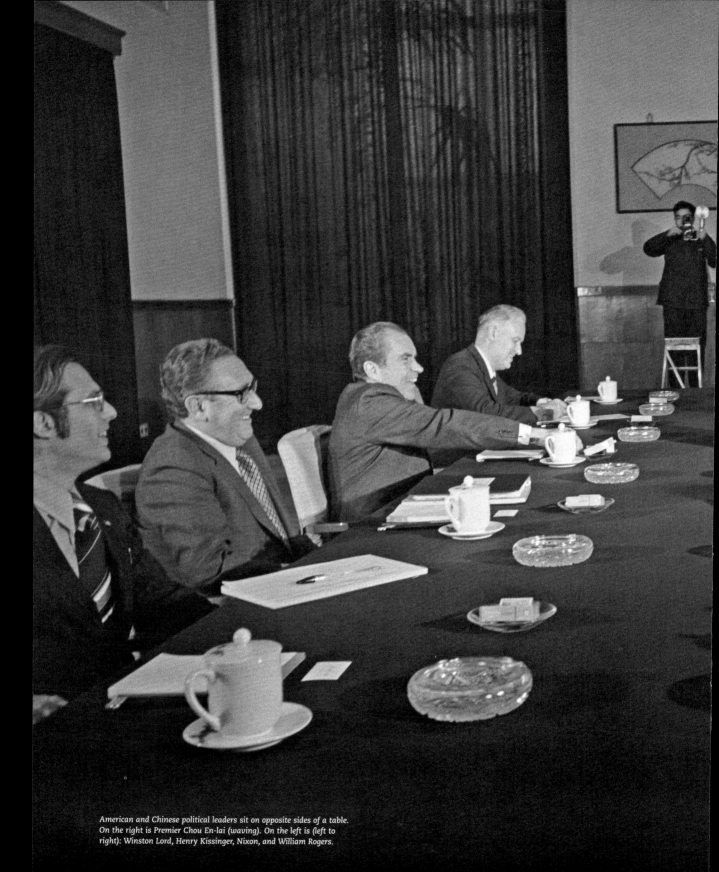

American and Chinese political leaders sit on opposite sides of a table.
On the right is Premier Chou En-lai (waving). On the left is (left to
right): Winston Lord, Henry Kissinger, Nixon, and William Rogers.

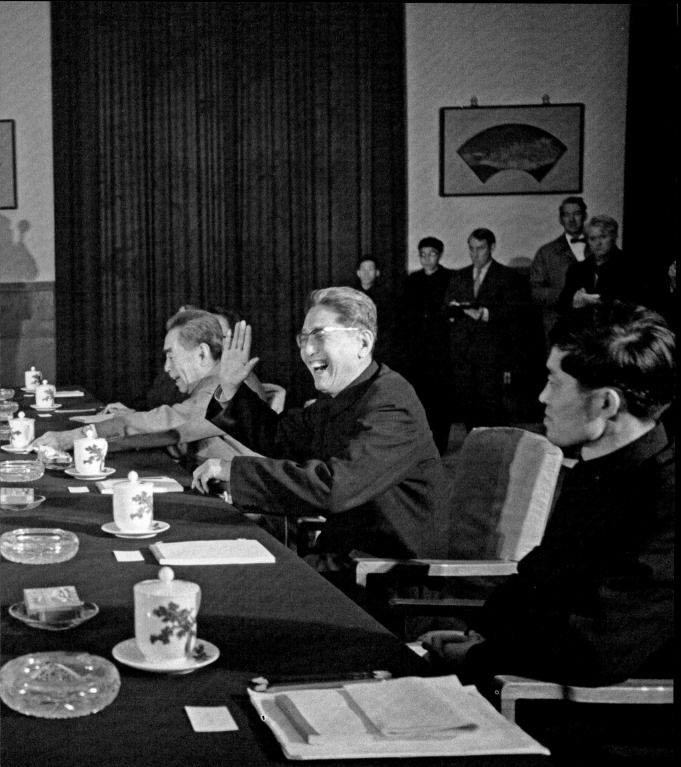

in which any story could be shot on one holder (two shots). When Lyon emerged from the darkroom, his face was red.

"Where are the other pictures?" he bellowed.

Cancellere, like most White House photographers, eschewed 36-exposure rolls in favor of 20-exposure rolls. True to his reputation, Cancy, as he was called, had shot only eight frames that morning. We used every one.

I have discovered in most of the old Communist countries an expression that is commonly repeated when you ask whether you can cover something. It goes like this: "No problem! Impossible." The agenda the Chinese had laid out for coverage was naive. They actually thought they could control the movements of a modern American White House press corps. They soon learned otherwise. The sheer technological modernity of the American coverage left them speechless. Suddenly young network pool producers were telling senior Chinese bureaucrats how many minutes they had to get their message across on the *Today Show*.

And of course, they had never met anyone like Barbara Walters. The barbarians had indeed crashed the gates!

The President and Mrs. Nixon were staying in an official Chinese guesthouse not far from the Hall of the People. The president's movements were to be covered by the small White House traveling pool, which included Cancellere and Daugherty. They rarely got into position to do any of the major events. The rest of the press members were bused ahead of time to the events, to pre-position. Today, on a similar state visit, the pre-positioned pool would number in the hundreds, but in China that day, I doubt there were more than twenty photographers in the room.

Everyone on the trip, regardless of whether they were White House staff or press, was considered part of the "official U.S. delegation." That led to something I never saw before or since: everyone on the trip was treated equally; there really was no "press." At the major banquets we all sat at large tables, and we each had our Chinese counterparts to the left or right. When toasts were given, it was appropriate that the press participate and walk around the table, toasting each member at the table. The drink, by the way, was Chinese mao-tai, a highly combustible rice wine that was essentially sake—times ten. We watched as President Nixon struggled with his chopsticks on his Peking duck.

The Chinese were chain smokers, and packs of cigarettes were in front of every place setting. On the evening of the American reciprocal banquet at the Great Hall of the People, the White House had arranged for California wines and champagnes to be served. They also provided packs of American cigarettes with the Air Force One seal on them. A few minutes after the guests sat down at their tables, a murmur began to arise from the room. The Chinese were whispering to each other and pointing to the cigarette packs. This was their first introduction to the warning "that smoking these cigarettes can be harmful to your health."

Generally, when covering a White House trip, there is very little suspense about what is going to happen. The advance teams for both sides have worked out every detail, and it is only necessary for the principals to take their positions for the photo ops. Twice in my career, I have seen entirely unscripted summits: more recently, the meeting between Mikhail Gorbachev and Ronald Reagan in Reykjavik, Iceland, where everything suddenly went off track; and, back in '72, the meetings between Nixon and the Chinese. Although Kissinger and his opposite numbers had prepared the playing field as best they could, you were still left with Chairman Mao, archenemy of the West, and Richard Nixon, a conservative from Yorba Linda, California. How these two men would find common ground was a question that tantalized the most brilliant minds in statecraft. In this case, a possible realignment of world politics was at stake.

This was how I spent my nights in China—processing color film in the bathroom of my hotel room in Beijing.

While President Nixon and Premier Chou were engaging in their talks, we would cover the first lady as she took tours. Generally some of the best pictures on a presidential visit come from these walk-abouts. Pat Nixon was resplendent in her fur coat and all her Republican majesty as she walked through the streets and shops of Beijing. The women gawked. At one shop, which featured antiquities, a television cameraman made the mistake of putting down his frezi pack on the glass countertop, which gave way, shattering centuries-old china. The cameraman gulped, "I'll pay for it!" and Mrs. Nixon, with an icy stare, replied, "Yes, you will!"

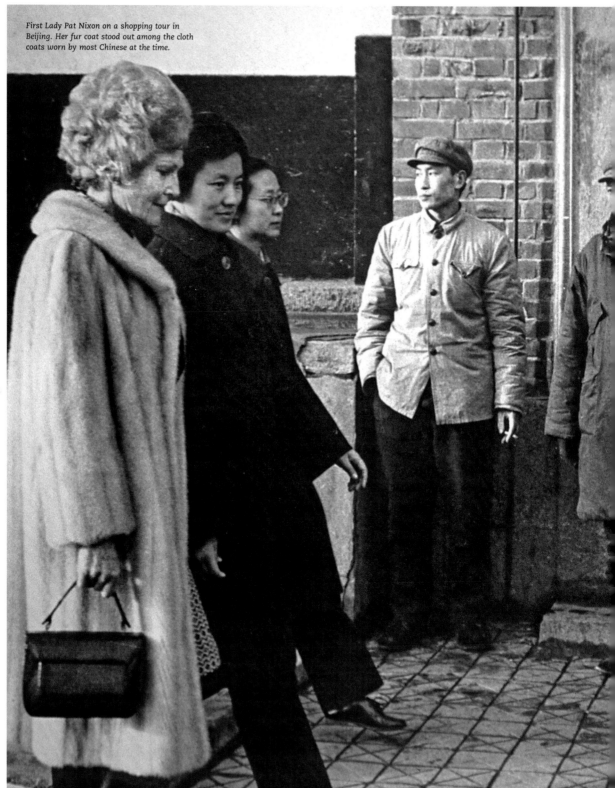

First Lady Pat Nixon on a shopping tour in Beijing. Her fur coat stood out among the cloth coats worn by most Chinese at the time.

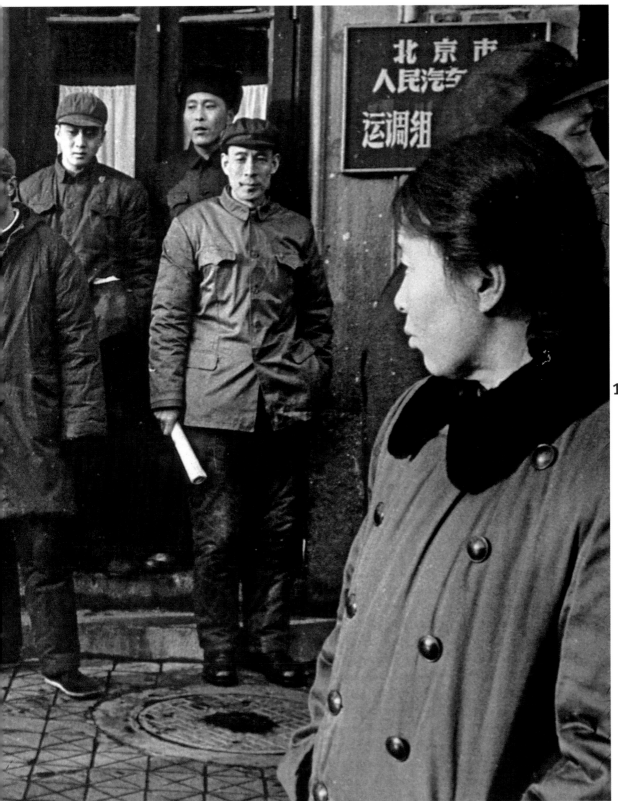

1970s

Then there was the Great Wall of China. We were bused to the Wall, half an hour from Beijing, and waited in the cold for the presidential party to show up. The president and first lady, accompanied by Secretary of State William P. Rogers, walked toward our cameras. A reporter cried out, "Mr. President, what do you think of this wall?" After thinking for a few moments, Nixon responded, "I think that you would have to conclude that this is a great wall, and it had to be built by a great people."

For six days, the schedule was packed. We would be bused from one event to the other, then back to the hotel to drop off our film, then we'd get back on another bus. Every night there was a dinner, which would go on until nearly midnight, and mao-tai flowed like water. Then it was back to the darkroom for another five hours of work, processing and making dupes. After the second day, I adopted a routine. I would go back to the hotel, drop my coat off in my room and take a shot of Jack Daniels. Then into the darkroom to start the color processing. About 3 a.m., I would go back to my room, take another shot of Jack Daniels and a clementine orange, then back to the darkroom to start making dupes, finishing about 5 a.m., in time for the courier packet pickup, then get an hour's sleep, and be in the lobby at 7 a.m. to start the next day. After four days of this, as I came out of the darkroom at 3 a.m., my erstwhile opposite number, who had to keep track of me, stumbled over to me and wailed, "Please, Mr. Dirck, you must get some sleep! You will die if you don't!"

So, it was in a state of complete exhaustion that the press corps approached the end of the visit. We were about to fly to southern China for a brief visit, which Premier Chou En-lai was hosting. Before arriving in China, most of us had filled out forms requesting that we be allowed to stay after the president left. As the time to leave approached, we became panic-stricken that the Chinese would take us up on our requests. We were totally exhausted, and all we wanted to do was to get back on our friendly U.S. planes and go home. Word spread that Chinese officials were walking through the hotel offering visits. We all locked our doors.

As we got ready to leave the hotel, we decided to play a parting joke. We all had these smelly sets of long johns. So we piled them up in the room of one highly paid TV correspondent, on her bed. At the final departure ceremony, as this correspondent was in line to say farewell to Premier Chou En-lai, an assistant came bustling up, saying, "Excuse me, Missus, but you left these in your room." Thinking it was a parting gift, she opened the package, and the odor of scores of fruity long johns filled the air.

Back on the Zoo Plane, which had been waiting for us in Guam to exit China, Pan Am went to great lengths to provide a festive return to the United States. They decorated the plane with balloons and signs and brought aboard the finest food and wines. The 707 had barely cleared Chinese airspace when the flight attendants looked back into the cabin with dismay: it looked as though someone had released sleeping gas. The entire press corps was dead to the world and would not regain consciousness until the plane had settled to earth at the Anchorage air force base.

It was a week that literally changed the world.

The following year, peace talks started in Paris to end the American involvement in the Vietnam War. China, and then the Soviet Union, started to dramatically reduce their arms shipments to North Vietnam. China began to pursue free trade and consumerism. Within a few short years, those streets that had seen only bicycles were filled with new cars. Nearly two decades later the Berlin Wall fell, and the Soviet Union, now a broken military power, was no more.

But two years after his monumental trip to China, Richard Nixon left the White House in disgrace. But by that time he had negotiated the crucial SALT treaty that ended the nuclear arms race. And all these events came about as the result of one cold week in the Middle Kingdom.

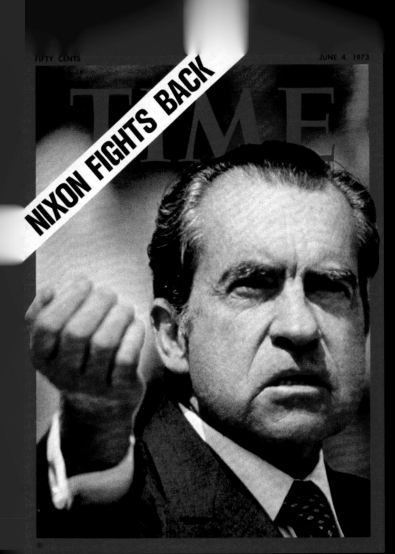

TIME

NIXON FIGHTS BACK

TIME

LANDSLIDE

Prospects for the Second Term

TIME

Nixon's Gamble

Nobody is a friend of ours

I am being the devil's advocate

You could get a million dollars

We have to keep the cap on the bottle

You can say, I can't recall

I say [expletive removed] don't hold anything back

IMPEACHMENT

Crisis at Home and Abroad

TIME

Nixon Covers

Magazine photographers covering the White House have a different job than that of the other photographers working for the wires and newspapers. If the president, for example, is meeting with the president of Lithuania, the wires take a standard "2 shot," which shows both leaders, because they have to serve members and subscribers around the world. As a magazine photographer, I would use the same photo-op time to zoom in on the president's face, to try to capture an expression or extract some sort of context. During the beginning of the Watergate saga, I was told that the president would answer his critics at a ship launching in Newport News, Virginia. I knew from experience that Nixon was uncomfortable looking at people in the audience; instead, he tended to look at a flag or some other neutral point of reference above the crowd. I brought with me to Newport News a ladder and an 800mm lens, positioned myself under a flag, and shot a roll of film as he looked directly into my lens, shaking his fist. I took out a caption envelope and wrote COVER – NIXON FIGHTS BACK on it. A few days later, the managing editor of *Time* called John Durniak, the picture editor, and told him to alert the Washington photographers that they would do a cover on Nixon fighting back. Durniak knew he had exactly what they wanted.

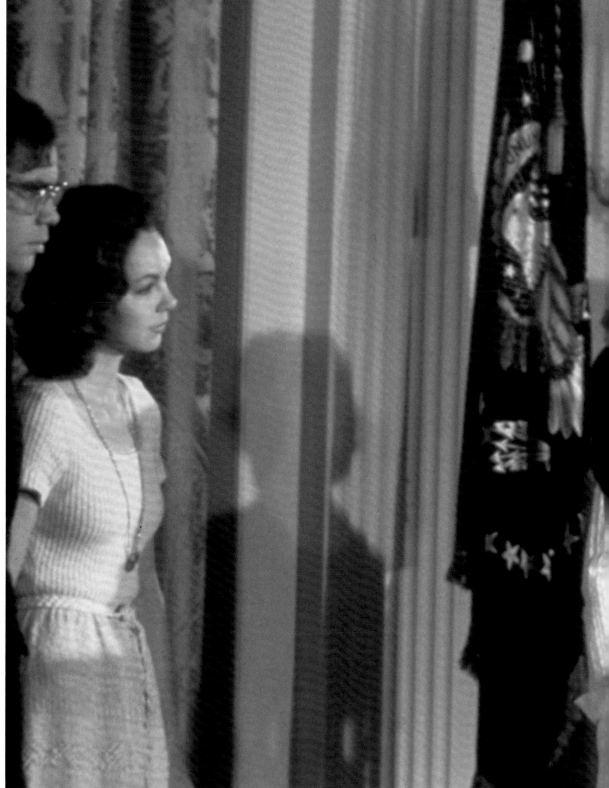

1970s

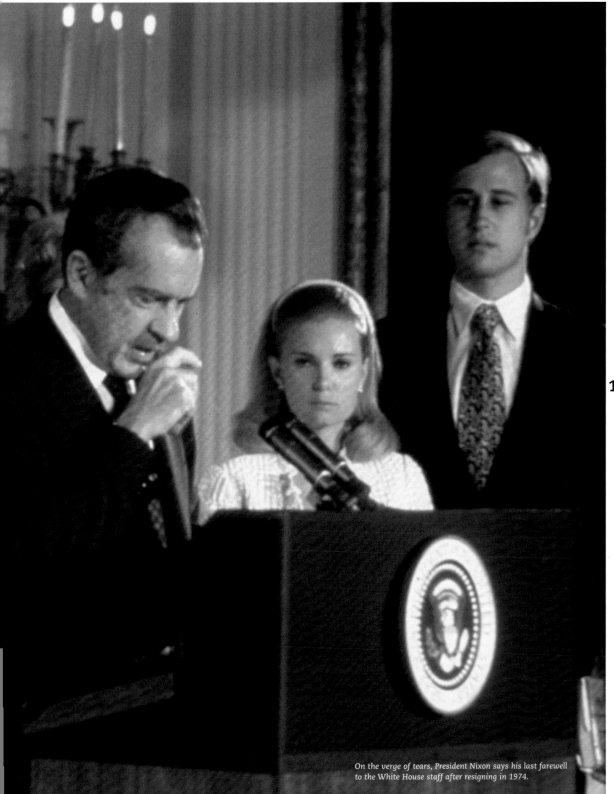

1970s

On the verge of tears, President Nixon says his last farewell to the White House staff after resigning in 1974.

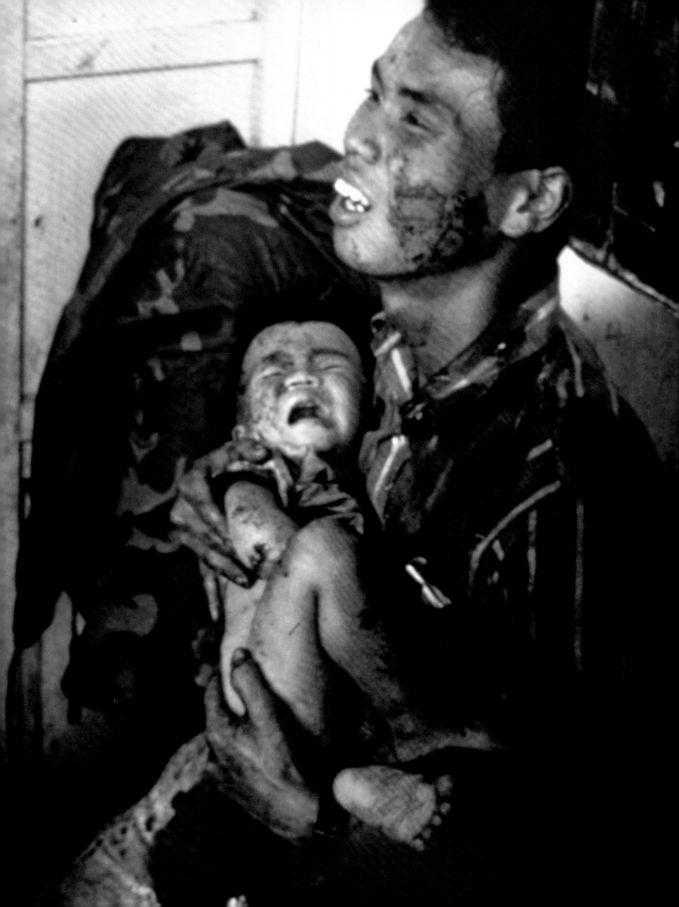

White Christmas: The Fall of Saigon
A Diary: April 20–30, 1975

I signed a contract with *Time* magazine in the spring of 1972. When John Durniak, then the picture editor, asked me what I wanted to do, I told him I'd do anything, with two exceptions: I didn't want to cover the White House anymore, nor did I wish

to cover any more wars. In the previous two decades, as a staff photographer for UPI and a photographer for the Army, I had covered too many presidents and far too many wars and riots.

My wishes were ignored. Two weeks after signing the contract, I found myself looking for the bottom of a water-filled hole along Vietnam's Highway 13, as North Vietnamese Army (NVA) rockets and artillery tried their best to abort my new career as a magazine photographer. Upon my return to New York, I was asked if I would mind going down to Washington for "a week or so," to cover the Nixon administration. I'm still here.

In March 1975, I was given a photographer's dream assignment. I was to photograph "The New Beauties"—famous people's daughters who had just reached the age of eighteen. The U.S. cover was to be of Margaux Hemingway, who at the time was the hot model, and the European cover was to be Princess Caroline of Monaco. The story would take me throughout the United States and Europe.

1970s

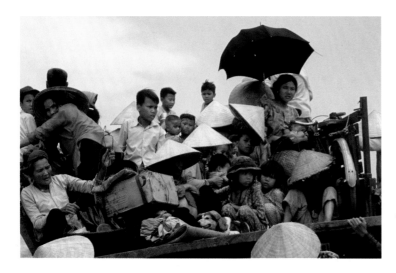

Opposite: A father holds his wounded baby after being caught in the crossfire between American and North Vietnamese forces in Quang Tri province in 1972. Left: Vietnamese refugees from Quang Tri during the 1972 offensive offer an eerie preview of what would happen to the entire country three years later.

By the end of the first week of April, despite the fact that I was ensconced in a suite at the Hôtel de Paris in Monaco that would turn Donald Trump green with envy, I was becoming increasingly restless. Vietnam, the country with which I had held a love-hate relationship for the past twenty years, was on the verge of collapsing. Photographing lithe, rich glamour queens was fast losing its appeal. I was, after all, a photojournalist.

Part I: Welcome Back to the Paris of the Orient

HONG KONG AIRPORT

I'm half in the bag from too much alcohol consumed in the flight from New York, and punchy from the time zone change. Queuing up to the Air Vietnam counter to get my boarding pass for the flight to Saigon, I see a sign being posted: ALL FLIGHTS TO SAIGON CANCELED.

It turns out that Saigon is under air attack. It doesn't make any sense—the North Vietnamese have never flown a flight over Saigon during the war. Milling about the counter are the oddest bunch of travelers I have ever seen. Spaced-out hippies with weird lights in their eyes; soldiers of fortune with golf bags full of cargo that never would pass inspection; wealthy Hong Kong bankers carrying empty valises; and of course, photographers and reporters with whom I have ridden down many dusty roads over the years. They all seem to have the sense that a major act in their lives is coming to an end.

Later we learn that there had been a brief coup attempt, one of many that had occurred in the past few years. By early evening, our Air Vietnam Caravelle is descending through the tropical sunset, skimming over rice paddies, exposing the bends of the shimmering Mekong River to my eye as we drop into the Paris of the Orient.

1970s

SAIGON AND SOUTH VIETNAM

I always forget how hot Saigon is. It's only 7 a.m. and already my shirt is sticking to my back as I climb the stairs to the Time-Life bureau in the Continental Palace Hotel. The smells of freshly cooked *pho*, the beef soup that serves as breakfast, lunch, and dinner for many of Saigon's residents, fills my nostrils. It reminds me of just how much I love this place. I feel as though the past three years since my last visit have just evaporated—no presidents, no new beauties, just Saigon . . . just like always.

I grab a key from its hiding place and walk to a small shed behind the U.S. Embassy. Opening the door, I see the bureau Mini Moke, with its BAO CHI/PRESS sign taped to the windshield. Poking around in a corner, I come across my old combat bag. I spread the contents on the floor. Two sets of fatigues: jungle, tropical, with DIRCK HALSTEAD, TIME-LIFE sewn onto the blouse pockets; a pair of standard-issue, jungle-tropical boots, with metal soles designed to withstand sharpened pongee stakes but useless against a land mine; a Musette camera bag, still holding some long-since-expired color film; a zipped baggie containing malaria pills, water-purifying tablets, a couple of old Kool-Aid packets, a bottle of Tabasco sauce, and a small half bottle of Mekong whiskey; a couple of towels, covered with red dust; a web ammo belt with harness and two canteens; and on the bottom, my old helmet, still bearing BAO/CHI, UPI PHOTOS, HALSTEAD. I forget where I first got the helmet. It was picked up on some long-forgotten battlefield. I think to myself, *God, it feels good to be home!*

0900 HOURS SAIGON

I'm sitting at a table at Gibrals on the corner of Tudo Street having a "cafe-soda," when I spy Leon Daniel, veteran UPI correspondent and an old friend. He yells at me that if I want to see some "bang-

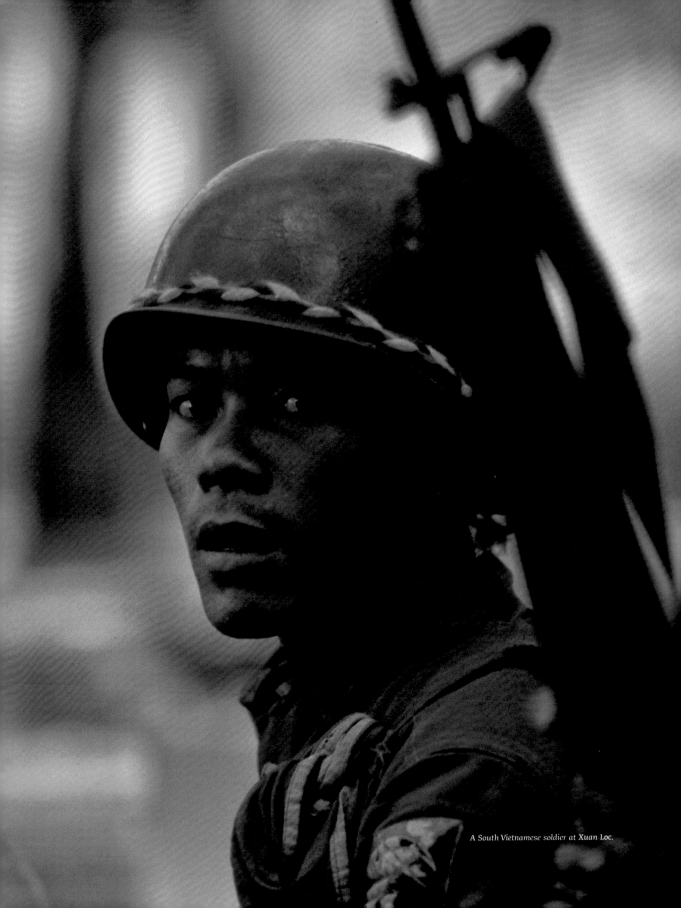

A South Vietnamese soldier at Xuan Loc.

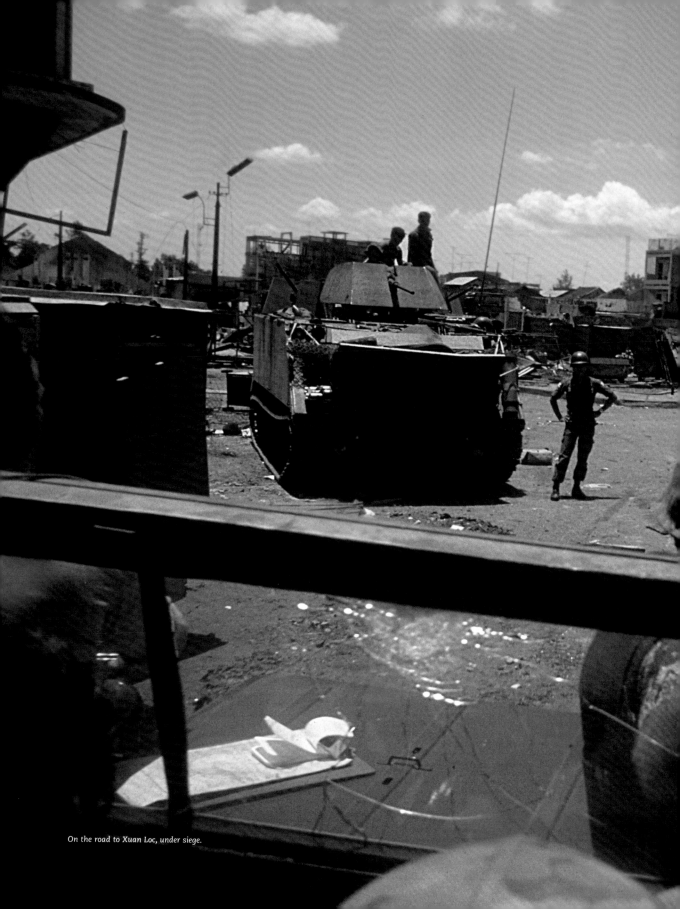

On the road to Xuan Loc, under siege.

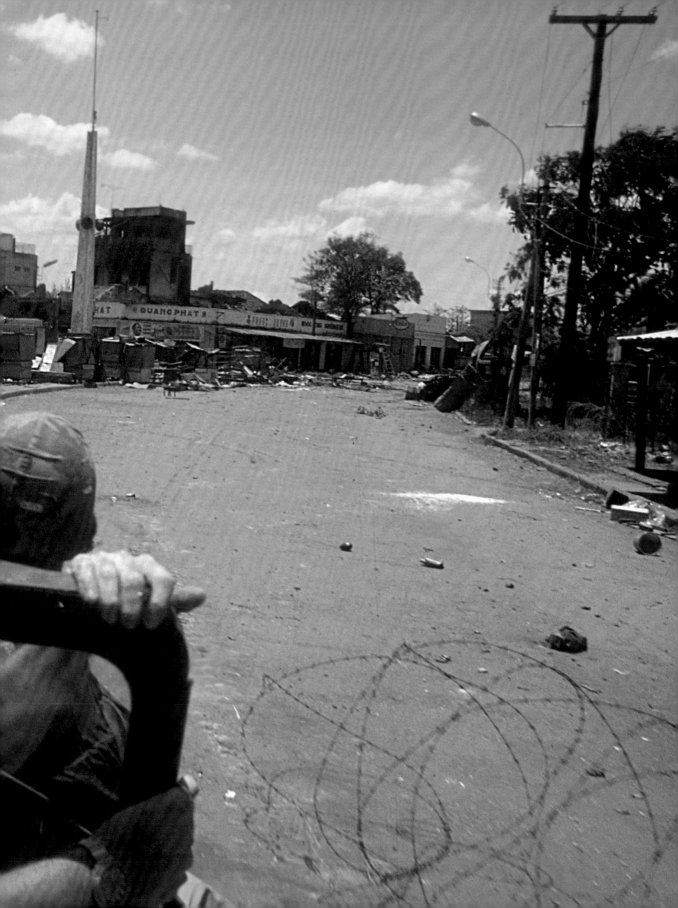

The devastated town of Xuan Loc.

bang" I better get my camera. I pile into his car, and we speed toward Bien Hoa, a few miles up the highway from Saigon. He explains that the Army of the Republic of Vietnam (ARVN) has long since ceased allowing press to come along on any operations. Their military briefings have become less than worthless, but because of constant pressure from the American press, the Vietnamese Air Force (VNAF) has decided to run one helicopter lift to what appears to be the last stronghold of the South Vietnamese forces.

During the preceding month, nearly all important South Vietnamese strong points have collapsed: first Ban Me Thout and Pleiku in the Central Highlands; then Hue, where nearly all the South Vietnamese Marines were trapped and destroyed on the beaches while awaiting naval evacuation; then Da Nang, which had been the key American air base during the war; then Nha Trang. And now, as North Vietnamese forces rush south down the highways, the only things holding them back are the inability of their tankers to keep pace with fuel demand, and one ragged ARVN battalion, the 18th Division, that is doing its best to hold the door to Saigon shut. It's one battalion against the combined weight of an overwhelming NVA military machine barreling down the road to Saigon . . . and that is exactly where we are going.

1100 HOURS NORTH OF SAIGON: XUAN LOC OUTPOST

Our aging Chinook helicopter kicks up a wall of red dust as it settles on a highway. Everywhere we look there are refugees, many of them having walked hundreds of miles to get to this point, where they hope to find safety. ARVN wounded call from stretchers for a drink of water. Two jeeps careen toward us and the drivers yell for us to get aboard, as incoming rocket rounds scream overhead.

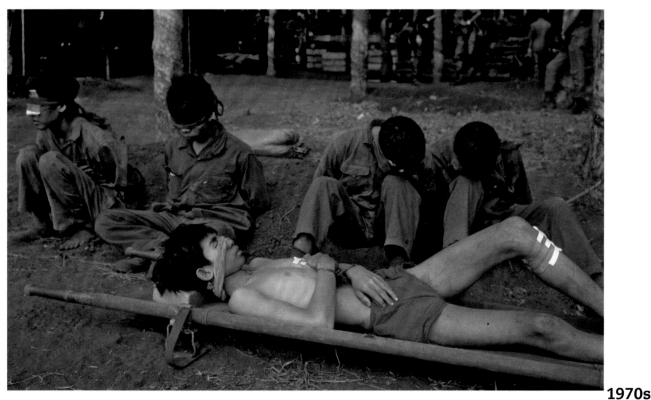

*North Vietnamese prisoners at the 18th Division headquarters
south of Xuan Loc.*

In his command tent, General Le Minh Dao whips his swagger stick against his neatly pressed fatigues. "We will hold this location," Dao barks into a field telephone in Vietnamese. Upon seeing us—a gaggle of reporters, photographers, and a TV crew—he gives us a big thumbs-up. "I don't care how many divisions the Communists send against me! I will smash them!" he yells as if for our edification.

He ushers us outside his tent where roughly a dozen North Vietnamese prisoners, stripped to their underwear, are bound like hogs waiting for the slaughter. Leon Daniel tells him that based on what we know of North Vietnamese movements, his situation appears to be hopeless. Dao becomes furious. Leon insists his men are in total control of the town. But neither Leon nor AP's Peter Arnett will back down. Leon insists that if things are so good, we should be allowed to look for ourselves. More incoming slices through the trees around us. A bunch of us start to feel as though it's time to go. But now, the general has taken Leon's bait. He brings up the jeeps, packs us in, and we take off down the jungle path toward Xuan Loc.

1200 HOURS THE TOWN OF XUAN LOC

Our little group of press cautiously moves up the deserted street. The general has taken the lead, swinging his swagger stick. He is calling out in Vietnamese but there is no answer. There are bodies lying in the road. Smoke is still rising from their charred remains. The town is a mess. But other than Dao's voice there is not a sound to be heard.

Slowly, heads begin to rise from foxholes on the sides of the streets. Wide-eyed ARVN rangers look at us in disbelief. Others simply have the proverbial thousand-yard stare. We get the picture. This place

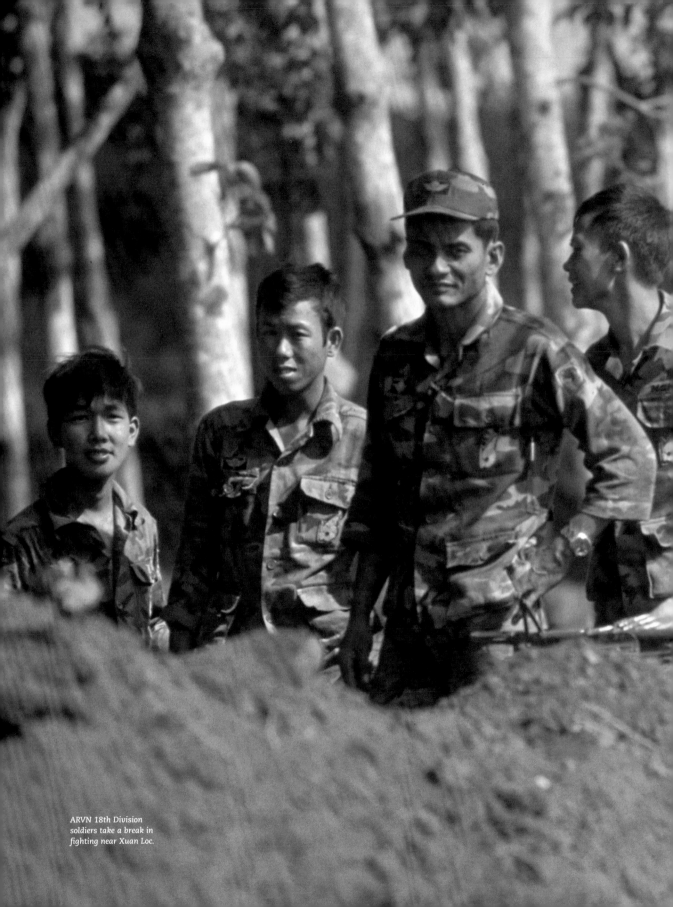

ARVN 18th Division soldiers take a break in fighting near Xuan Loc.

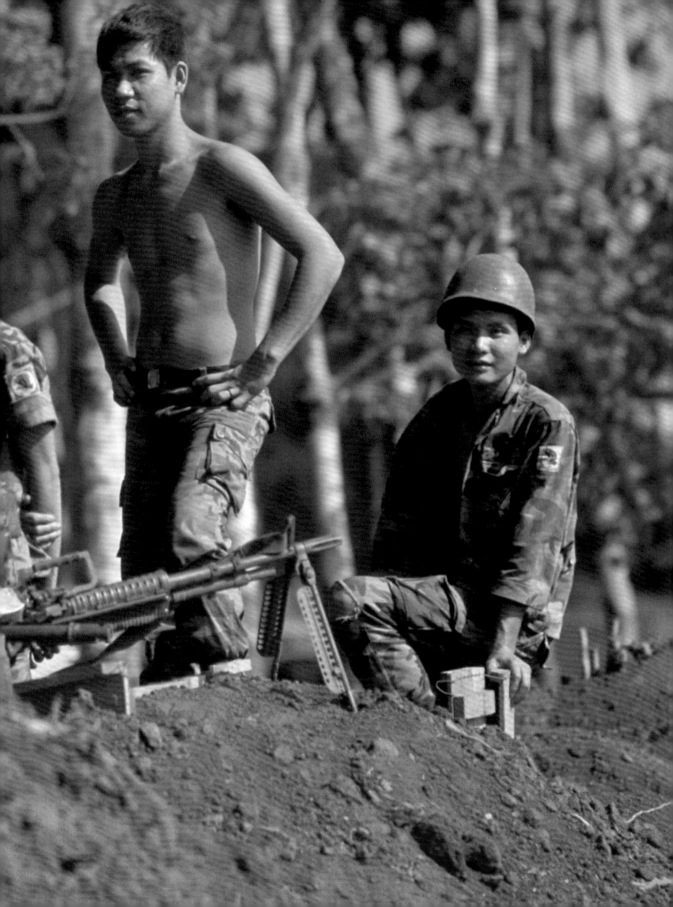

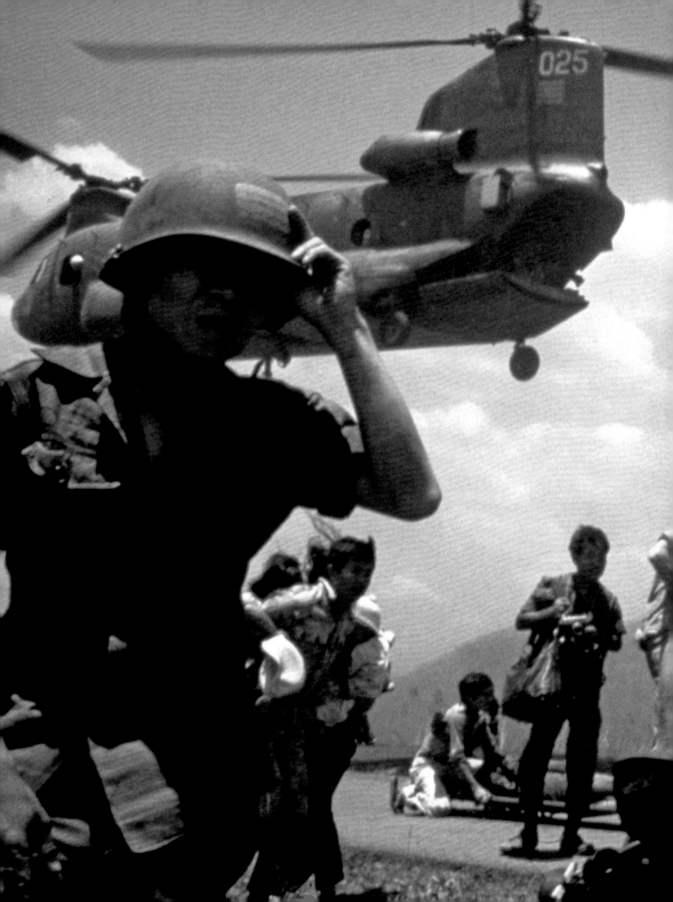

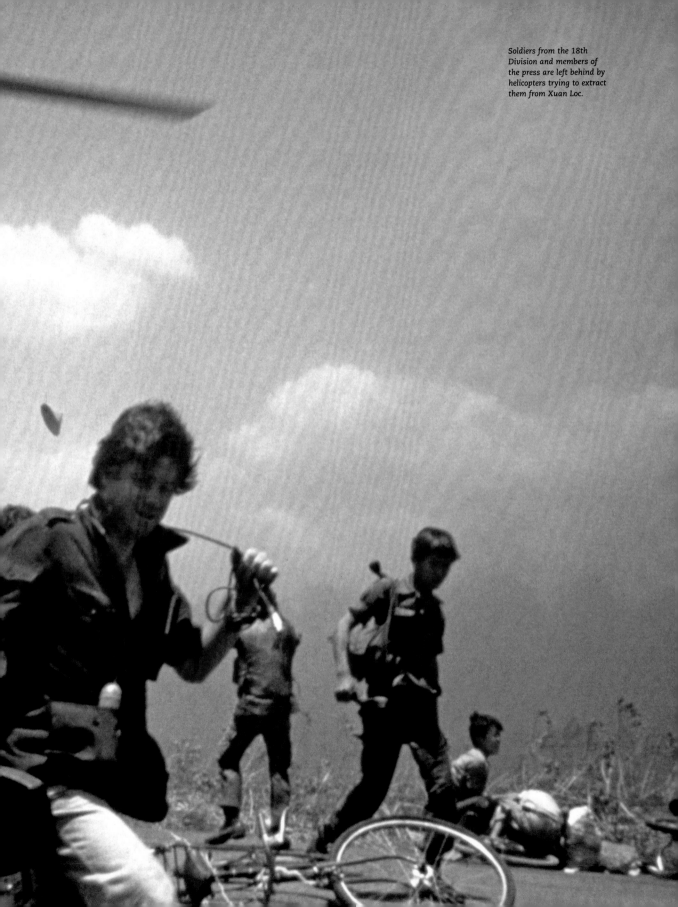

Soldiers from the 18th Division and members of the press are left behind by helicopters trying to extract them from Xuan Loc.

is in bad trouble. Gunfire erupts up the street. An alarmed aide runs to the general and points toward the tree line. Black-clad figures seem to be flitting between the trees—or is it my imagination?

Dao suddenly decides its time to go. Our jeeps spin around and head toward the helicopter landing zone, as the aide barks instructions into a radio. Two Chinooks touch down, filling the air with red dirt. As we begin our sprint toward the helicopters, the ARVN men who had followed us from town overtake us in a mad dash for the Chinooks. Two ARVN soldiers who had been carrying a wounded soldier drop him. The soldier in the rear runs over the wounded man. Leon Daniel goes berserk. He runs after the soldier who ran over the wounded man and coldcocks him. Other troops are flinging themselves on the rising helicopters. Some fall as the choppers rise into the air. In less than a minute it is over. The helicopters are slipping into the distance. The wounded moan. Other soldiers fire toward the helicopters. We look around. The entire small contingent of press are still on the road. It begins to appear that for us, the war may be nearly over.

1500 HOURS OVER XUAN LOC

The Chinook that we thought we would never see again rises into the air, carrying us out of Xuan Loc. Dao evidently felt responsible for our safety. He called in his personal command helicopter to get us out, and has it landed in an area where it won't get mobbed. As General Le Minh Dao says good-bye, tears begin to well in his eyes: "I do not want you to die with me . . . if they give you a chance to return here, you must refuse. Please tell the Americans you have seen how the 18th Division can fight and die. Now please go!"

As our helicopter clears the treetops, we look north, and as far as the eye can see, dust is rising from the movement of armor headed south. None of us ever sees the general again.

PART II: "You Take Me to USA?"

04|21|75 **0800 HOURS SAIGON**

The street in front of the U.S. Embassy is jammed with an unruly mob. Hundreds of Vietnamese are shouting and waving documents in front of the massive gate.

Along with other photographers, I weave my way through the crowd, snapping photographs as I go. Suddenly, a jeep and two truckloads of Quan Canh, the Vietnamese police, screech to a stop on the edge of the crowd. They take up a skirmish line to one side of the embassy wall. They carry wicker shields in one hand and long poles in the other. An officer shouts, and they charge the crowd.

Stumbling, falling over each other, the crowd falls back before the onslaught to a position across the street.

We duck through the gate into the embassy grounds just as a white Air America helicopter sits down on the roof.

Ambassador Graham Martin, impeccably dressed in a suit and tie, stands under a tamarind tree. He doesn't seem to be the slightest bit concerned that Communist forces are now poised less than forty miles from the capital. For the members of the Saigon press corps, there are urgent and personal questions. Most of the news organizations have staffs of Vietnamese who have worked for them for years. Now the question is how to get them out of the country.

At a hastily convened press conference, Martin refuses to even discuss the problem. One reporter asks how many Vietnamese embassy staff have left Saigon. The ambassador replies, that to his knowledge only 444 American and Vietnamese personnel have left the country in the last twenty-four hours. For Martin, the question of evacuation is an idea he simply doesn't wish to entertain. He feels that if too many people are seen leaving, a panic will ensue that could under-

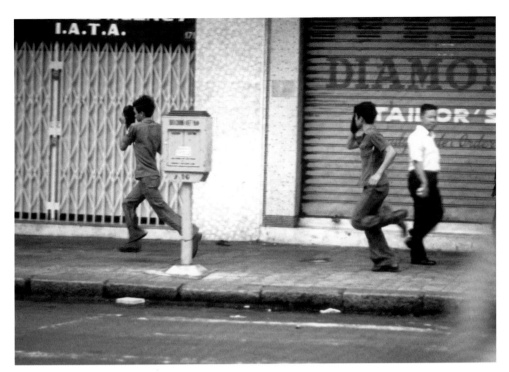

Vietnamese Army deserters flee military police on Tudo Street in downtown Saigon.

mine the government of President Nguyen Van Thieu. After Martin leaves the press conference, bureau chiefs buttonhole the press attaché and begin crafting their own evacuation plan.

1200 HOURS HIGHWAY 1

We drive the yellow Mini Moke up Highway 1, thirty-five miles north of Saigon. We come to a stop at the last government command post. For me, it is déjà-vu. Three years ago, it was almost exactly in this spot that David Kennerly and I had been pinned down in a fierce fire fight. It was the first time I had ever seen North Vietnamese troops that weren't either dead or prisoners. We had been surrounded for hours. Now, in 1975, the front line has hardly moved a thousand yards. ARVN soldiers sit near their foxholes cooking meals, as occasional artillery shells pass over their heads. The deserted highway, pockmarked with shell holes, stretches out to the horizon where we can see black clouds of smoke and hear muted thumps.

Nik Wheeler, a photographer on assignment for *Newsweek*, wants to go farther up the road into no-man's-land. I think it is a lousy idea. I've been to Xuan Loc once . . . been there, done that. It's no longer a story about what happens on Highway 1. The big story is coming, and it's clear that it will be the fall of Saigon.

04|22|75 **SAIGON**

The mood in Saigon has changed. Tudo, the bustling main street that has always been filled with a cacophonous din, is strangely quiet. There are no street urchins yelling, "You give me money." The art shops filled with classic Vietnamese paintings and strange Chagalesque canvases depicting the horrors of war have no visitors. The bars with high-heeled hostesses asking patrons, "You want

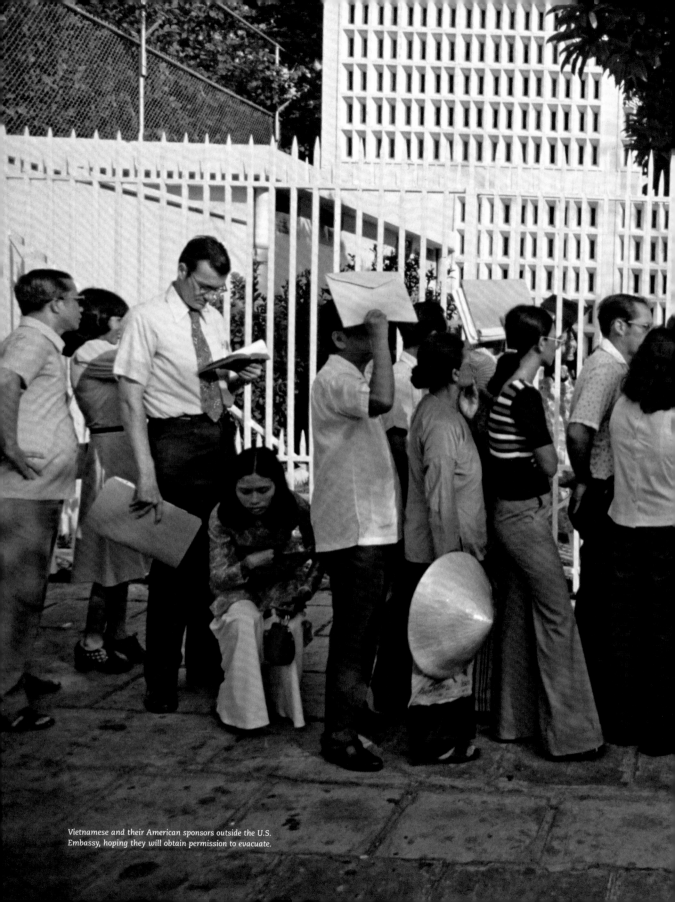

Vietnamese and their American sponsors outside the U.S.
Embassy, hoping they will obtain permission to evacuate.

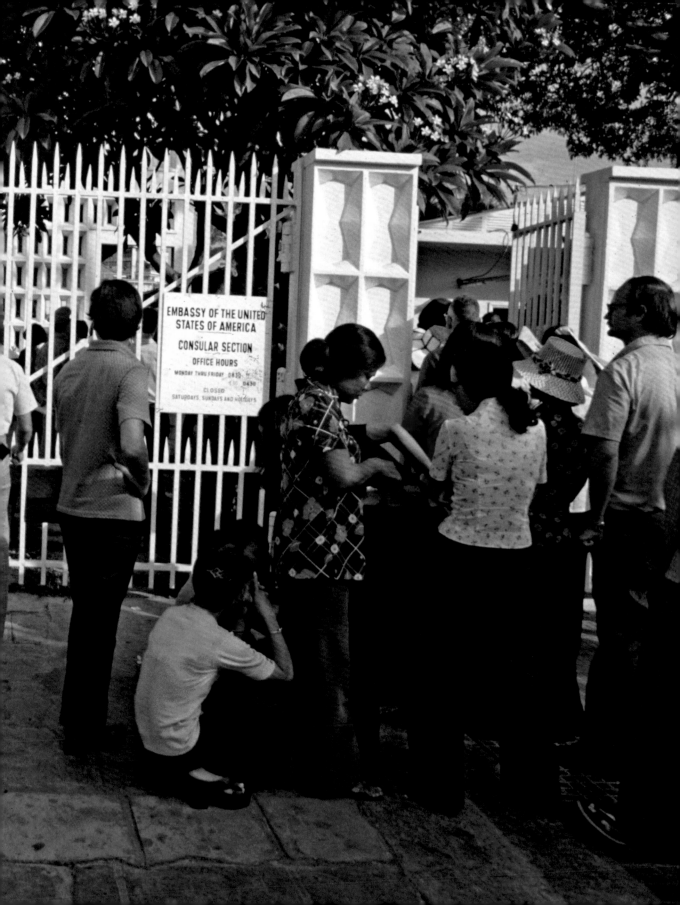

Saigon tea?" are empty. The Indian bookshops that sell Vietnamese pastries at five cents to the dollar have no customers. I've never seen anything like this.

Instead, anxious faces peer out from shuttered doors. Military police chase ARVN deserters down the alleys. A group of children attach themselves to me shouting, "You take me to USA?"

2000 HOURS

A curfew has been declared. A group of us gather around a TV set in the bar of the Caravelle Hotel. President Nguyen Van Thieu is making his most important speech to the nation. A farewell. Dressed in an open-collared uniform shirt, he delivers a bitter valediction. He blasts President Ford, Secretary of State Kissinger, and the U.S. Congress for letting Vietnam down. Tears flowing down his cheeks, Thieu ends his speech by adding, "I depart today. I ask my countrymen, the armed forces, and religious groups to forgive my past mistakes I made while in power. The country and I will be grateful to you. I am undeserving. I am resigning, but I am not deserting."

We all look at each other in disbelief. This guy was almost single-handedly responsible for the mess that Saigon is now in. His decision to pull his troops back from the North to reinforce Saigon was the catalyst that led to the undoing of Vietnam.

2300 HOURS

The streets of Saigon are deserted except for an occasional Quanh Canh jeep and a few Vietnamese police quietly pedaling bicycles on their rounds. All of the bars are silent. The curfew is in force. Lights out, several black buses slip quietly down the street, stopping in front of the Palace Hotel.

1970s

Opposite: Apprehensive bar girls watch for Americans who can help them flee Saigon. Below: South Vietnamese President Nguyen Van Thieu waves a final farewell on television before leaving the country.

An American in civilian clothes leads a group of Westerners and Vietnamese out of the hotel and into the street in front of the buses. A child starts to cry, but the sound is immediately muffled by the mother. The group steals onto the waiting buses, as similar groups are doing that moment throughout the city. As noiselessly as they came, the buses slide into the night.

In the morning, Vietnamese on their way to work will notice shops have closed. Friends calling on families will find the doors locked. A few empty bags and boxes will be piled on the sidewalk.

The evacuation has begun.

PART III: God Only Knows What Will Happen

04|23|75 **1100 HOURS**

TAN SON NHUT AIR BASE: DEFENSE ATTACHÉ'S COMPOUND

A child is being washed from a large water-filled tomato can. We are in a bowling alley in the former American compound at Tan Son Nhut. Vietnamese are sprawled everywhere, sleeping on the lanes. Garbage and human waste fill the gutters. The smell makes people want to gag. I wind my way through the bowling alley. I watch as an American construction worker, wearing a cowboy hat, fills out papers for his young Vietnamese companion, who is hanging onto his arm,

1970s

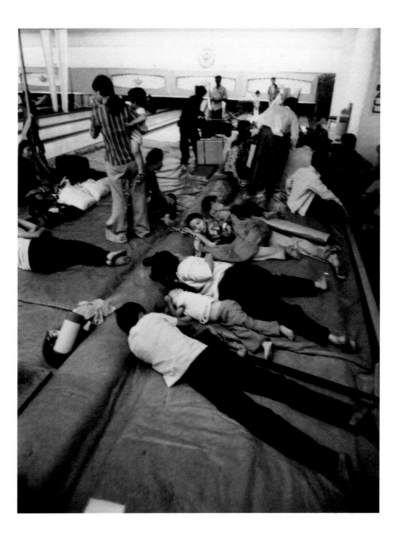

Right: Vietnamese waiting to be airlifted out of Saigon sleep in the bowling alley of the Defense Attaché's Office. Opposite: A Marine directs Vietnamese to the bowling alley to await evacuation.

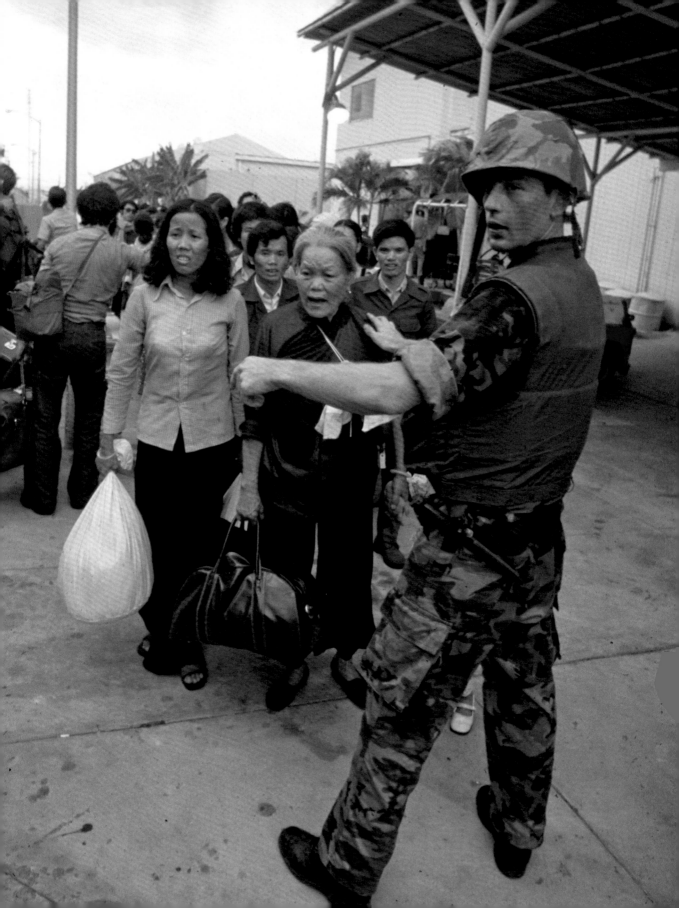

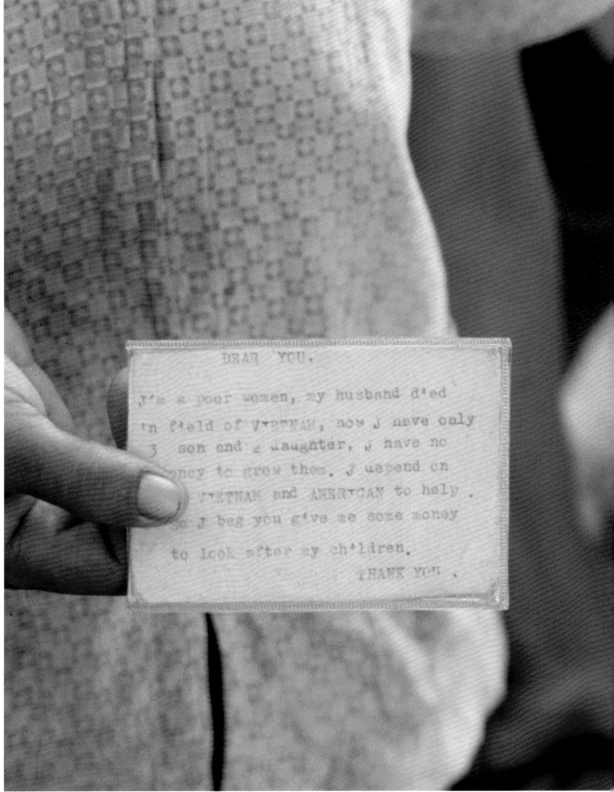

1970s

A desperate woman begs
for help for children on
the streets of Saigon.

a worried look on her face. She is obviously a bar girl, her miniskirt hiked high over her glossy patent leather boots. An embassy official is explaining that it is only necessary that the man sign an affidavit for her support in the United States in order for her to leave the country. He knows full well that this girl is not the only one leaving in this manner. Several enterprising Americans have signed for entire bars full of girls. God only knows what will happen to them when they get to the United States. I think to myself: *we're not only adding to the ranks of prostitutes in America, the government may be subsidizing a whole flock of instant pimps.*

Thousands of Vietnamese and Americans mill about outside the bowling alley. Everybody is waiting to be airlifted out of Saigon. The lucky ones sit in the shade of an occasional roof or tree, their belongings piled around them. Many are well dressed. Some are wealthy, their suitcases heavy from the gold bars they obtained from Chinese merchants in return for their money and valuables.

At the end of the compound, air force personnel gather groups of one hundred, and as soon as the group is complete, they are loaded onto a bus to be taken to the flight line. Overhead there is the constant roar of jet engines as giant Star Lifters approach on their landing patterns, or take off for Guam, Manila, and San Francisco.

1400 HOURS HIGHWAY 1: THIRTY-FIVE MILES NORTH OF SAIGON

I am taking pictures of ARVN troops carrying chickens on their shoulders, followed by angry villagers in conical hats yelling at them. The nearly constant thud of incoming artillery rounds jolts the ear and mind as they hit the highway a half mile away from our position.

Suddenly, a column of ARVN armored personnel carriers tears by, moving away from the fighting. They hit one of the chicken-stealing troops on the road, but don't slow down. I look at Nik Wheeler as he yells, "Jesus Christ! This is a rout! The 18th Division has been routed!"

04|24|75 ### 0830 HOURS SAIGON

The main street of Saigon looks very much as it has for the past ten years of American presence in Vietnam. Already some of the bars are open, and pretty girls in miniskirts beckon invitingly from the doors. At street stalls, Vietnamese squat at the curb, enjoying their morning *pho*.

The only evident change, to the more practiced eye, is that suddenly there appear to be many more Vietnamese soldiers in the streets. They have deserted their commands. Strolling aimlessly or moving in packs, demanding—not begging for—handouts. A brawl erupts as a group of soldiers demands to be fed for free at a street stall. A Quanh Canh jeep screeches to a stop and disgorges MPs. Shots are fired in the air, and civilians and soldiers alike run for cover, trampling over a double amputee—a veteran—who has been begging for food from his small wheeled cart on the corner.

Farther down the street, a Ford pickup truck quietly pulls up to the curb in front of a tall building by the waterfront. A U.S. Marine dressed in fatigues steps from the vehicle, followed by a handful of Vietnamese women carrying paint buckets and brushes. Quickly they duck into the building, take an elevator to the roof, and set to work. An hour later they are through, back in the truck, and on their way to the next stop.

Atop the building they just left sits a huge, yellow, freshly-painted number two. This will identify the landing zone to the helicopters that everyone prays will come.

1230 HOURS SAIGON: THE CERCLE SPORTIF

The passage of time has been gentle to the Cercle Sportif. Built by the French during the colonial days, the lush country club behind the presidential palace has shut its eyes to war since its construction.

1970s

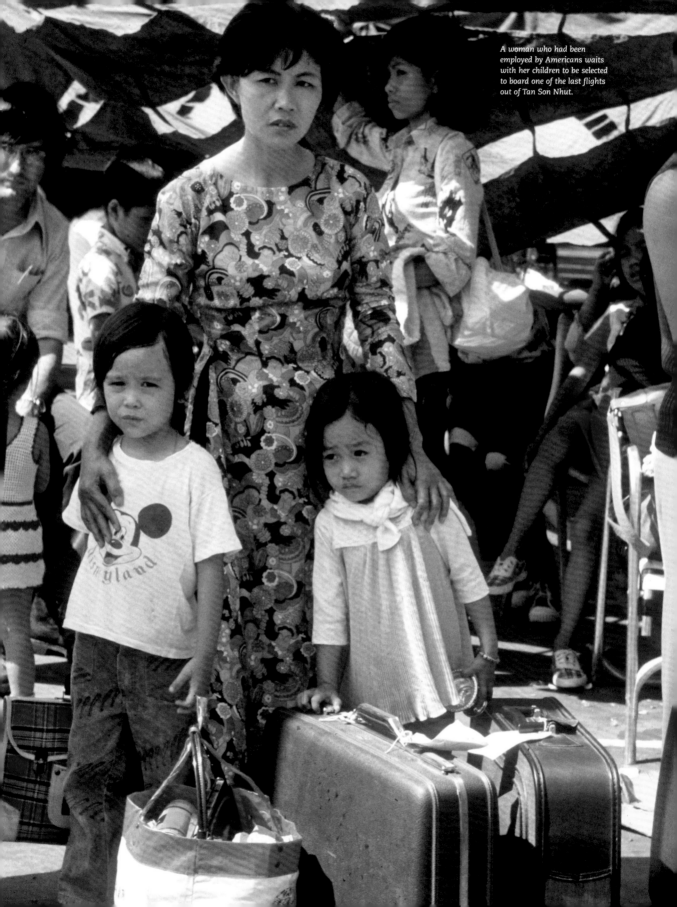

A woman who had been employed by Americans waits with her children to be selected to board one of the last flights out of Tan Son Nhut.

Americans and Vietnamese fill the tennis courts, sitting in the heat of the noontime sun, while around the pool waiters serve tall, cool, citrons pressés as Americans, Frenchmen, and beautiful Eurasian women bask in the sun.

Michel Laurent, a French freelance photographer dressed in blue jeans and field jacket, is eager to get out of Saigon. He thinks we are wasting our time sitting by the pool. Nik Wheeler and I remind him of what we saw on the highway the day before. Now that the 18th Division has crumbled, there is simply no place to go outside of Saigon.

We plead with him—even if he is able to get past the roadblocks, what happens if an evacuation signal is given? He would be stuck in the boondocks while the real story is going on in Saigon. Michel doesn't buy it. He stalks away, his cigar clenched between his teeth. We order another citron pressé.

1730 HOURS SAIGON: THE NBC BUREAU

The NBC bureau overlooking Nguyen Hue Street is a beehive of activity. Besides the correspondents, camera crews, and production personnel, there are at least a dozen Vietnamese standing patiently in a line against the wall.

In his office, Henry Griggs, an NBC field producer from New York filling in for the moment as bureau chief, draws a sigh as one more of the Vietnamese is ushered into his office. Tearfully, a Vietnamese woman, well dressed but her hair in disarray, pleads for his help in assisting her family out of Saigon. She tells him that her cousin, who was killed while in the army during the Cambodian incursion, had once worked for NBC as a courier, taking film to the airport. He had always talked highly of the American company, and surely now NBC would get her family out of the country.

Griggs knows that this scene is being repeated in every American news agency in Saigon. He starts to explain that it will be all he can do just to get the immediate NBC staff and their families out. The night before, he had been up all night with a special group of bureau chiefs devising exodus schemes for his charges. Nothing seemed to work. The same group had even chartered a jet for evacuating their Vietnamese staff a few nights before, but the plane had been refused permission to land. The week before, Griggs had gone to Hong Kong to place a call to White House photographer David Kennerly to ask him to intercede with the president to see if something could be done. Kennerly, who had taken his own fact-finding tour of the collapse of South Vietnam, promised to do everything he could to help, but so far—goddammit—nothing!

Griggs looks out the window, across the street to the Rex Cinema, where crowds of Vietnamese are buying tickets to watch a new Brigitte Bardot film, *Boulevard de Rhum*. He looks up to the now-deserted roof of the Rex, and remembers when it had been the posh restaurant of the U.S. Officers' Club. He had had good times there, made good friends back in 1966. God, it had all seemed so simple then.

PART IV: "Please, Can You Get Me Out?"

04|25|75 ### 0800 HOURS SAIGON: THE BRITISH EMBASSY

Clouds of black smoke pour into the sky above embassy chimneys. The English are burning their records. The gate of the embassy swings open, and Ambassador John Christopher Wydows Bushell, in a pressed safari suit, drives out in his silver Jaguar, past a crowd of yelling embassy employees on the way to Tan Son Nhut Airport, and evacuation.

On the opposite side of the street, I turn to Nik Wheeler, who says, "Well, at least it's better than

the bloody Canadians. They told their employees to come back today to be taken out, and when they got there, they found everyone had buggered out during the night."

1400 HOURS
SAIGON: A CATHOLIC NEIGHBORHOOD NEAR TAN SON NHUT

A procession—almost a parade—is marching down the dusty, hot side street toward us. There are signs everywhere that bear such slogans as WE WILL FIGHT TO THE END . . . LONG LIVE THE REPUBLIC OF VIETNAM. Occasionally there is a different banner in blue and gold that reads, FOR PEACE AND NEGOTIATION, NOT BLOODSHED. All of the banners are written in Vietnamese across the top, but also in English across the bottom, for the benefit of the American TV crews shooting on the sidelines.

The procession reaches a stage in front of the church. With great cheering, their hero is hoisted onto it. This general of the Vietnamese Air Force, former prime minister of Vietnam, and vice president is none other than Nguyen Cao Ky. Ky sports a jaunty scarf around his neck above his flight suit and a pearl-handled revolver on his hip as he addresses the crowd.

Ky calls for the people to resist the Communist advance. They are mice, Ky yells, and will never enter Saigon. He vows to continue the fight. "Let the cowards who are leaving with the Americans go," he shouts, "and let those who love South Vietnam stay and fight!"

A Vietnamese reporter turns to us and mutters, "He is *fou*" (mad). We leave the rally, and with Ky's voice on the loudspeaker following us, reach the main street. As we await a taxi, sirens cut through the din of traffic. A Quanh Canh jeep, .50-caliber machine gun mounted on the back, cuts through traffic, followed by a long black Mercedes and a follow-up Ford, filled with Vietnamese Secret Service. "Who was that?" I ask, as the cavalcade disappears down the street. The Vietnamese reporter smiles and replies, "That was Mr. Thieu. He goes bye-bye now."

1700 HOURS SAIGON: THE TIME-LIFE BUREAU

Roy Rowan, the acting bureau chief for *Time*, is holding a staff meeting. I look around the room. There is Mark Godfrey, a Magnum photographer, who has joined us.

New instructions have been issued for us from both New York and the U.S. Embassy. *Time* has placed a lid on additional staffers coming into Saigon. They want us to reduce our numbers as quickly as possible. The orders from New York are clear: get the Vietnamese staff out, then pull down the rest of the staff. Only a skeleton staff will remain till the end. The embassy has told the bureau chiefs that in the event of an evacuation of Saigon, the Armed Forces Radio Network will issue a special weather report stating, "The temperature is 105° and rising!" At this signal, all Western news personnel should report to their evacuation staging areas, which are being set up around town. We are told that the evacuation will be in full swing when Armed Forces Radio begins broadcasting Bing Crosby's "White Christmas."

2000 HOURS SAIGON: THE CONTINENTAL PALACE HOTEL — THE BAR

A nervous group of the Saigon press corps has gathered around a table to listen in awe to the latest-arriving superstar. Hunter S. Thompson has just flown from San Francisco to cover the fall of Saigon for *Rolling Stone*. "The Good Doctor" is in his usually zonked-out state, rambling about stories he has covered around the world. I notice a silence has fallen at one end of the table, followed by a murmuring that spreads throughout the room. One by one, reporters and photographers drift away. I catch up to Nik Wheeler as he descends the steps of the hotel. His jaw is clenched. Turning to me he says, "Michel Laurent has just been killed."

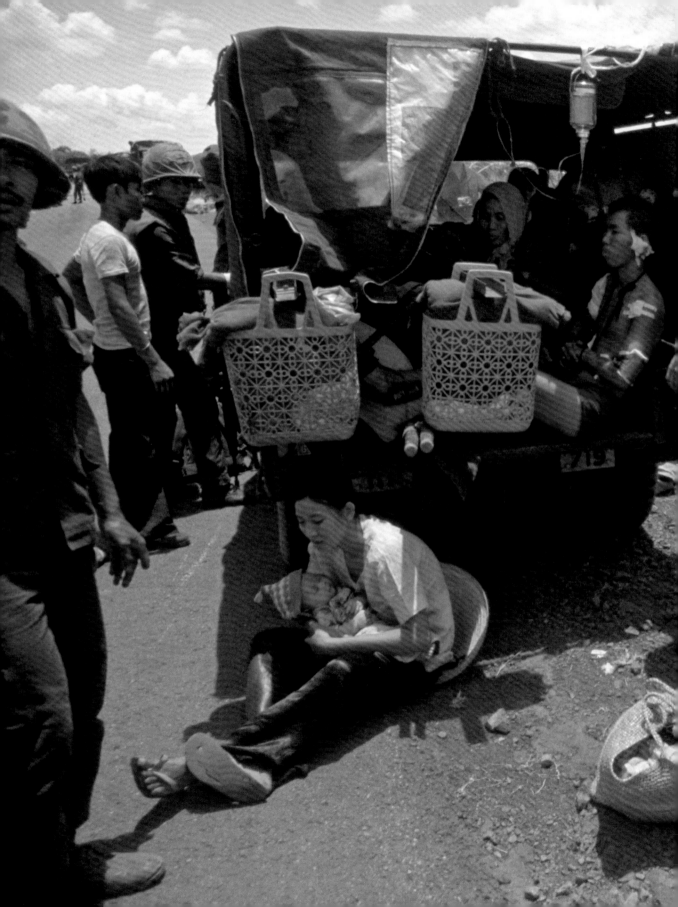

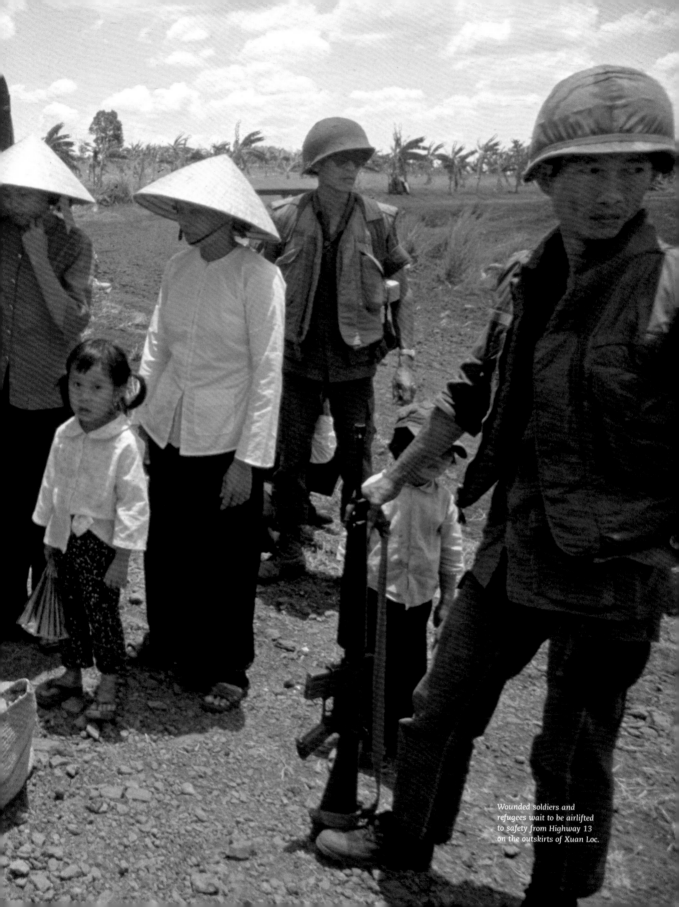

Wounded soldiers and refugees wait to be airlifted to safety from Highway 13 on the outskirts of Xuan Loc.

Roy Rowan is at the Teletype machine. He is communicating directly with the *Time* offices in New York, through the Vietnamese PTT. He is in the middle of a message when the *Time* Hong Kong bureau breaks in: "This is Eddie Adams. I am in Hong Kong and booked on a flight to Saigon tomorrow morning." Rowan replies that according to New York's instructions, no more Americans can come in. Adams answers that John Durniak, the picture editor, has given instructions that Dirck Halstead should come out so Eddie can come in. Rowan looks at me, sighs, then returns his reply, "Sorry, your message is garbled," and breaks off contact.

We are leaving the bureau when once again the Teletype comes back to life. It is the PTT operator in the Saigon office transmitting: "Please, can you get me out?"

04|26|75 **0900 HOURS SAIGON: THE CONTINENTAL PALACE HOTEL**

A small knot of American newsmen sit around a table on the open patio of the Continental Palace. The old hotel has seen its share of occupying armies. First the French, then the Americans. While newer hotels have been built around it, some of which were later destroyed in terrorist bombings, the Palace has managed to come through it all—largely by paying enormous "taxes" to the Communists. There is even a feeling that some of the press members who work in the hotel may in reality be Communist agents.

As a result, the hotel has become a favorite of journalists who like to pretend, for at least a short time, that they can taste the pleasures of a colonial world now long gone and given over to chrome and glass.

1970s

Street urchins, keeping a wary eye out for the waiters, duck into the patio to shine shoes, sell magazines, sell their sisters—or for that matter, their brothers or themselves.

In one corner, a table of elegantly gowned women is being served morning tea. The more experienced journalists know that, in fact, these "women" are transvestites, and the seasoned take great delight in watching the younger would-be suitors make fools of themselves as they make propositions.

This morning, however, none of the newsmen is paying any attention to the circus going on around them. They can only speak of the fate of Michel Laurent. He had been with a cameraman when they found themselves under artillery attack on Highway 1. The cameraman managed to make it out, but the last he saw of Michel he was running away from him, right into enemy fire.

Maybe Michel has only been wounded. He is a veteran who has spent five years covering this war, plus another two in Africa with the French, to say nothing of Bangladesh, where he won a Pulitzer Prize. But somehow you know—as you always know when a friend has gone—that he will not return.

2300 HOURS SAIGON: THE MAJESTIC HOTEL — ROOFTOP BAR

A group of us, together possessing more than thirty years of experience covering the Vietnam War, are finishing brandies and Cuban cigars. The group includes Roy Rowan, who had witnessed the fall of China to the Communists in Shanghai. Within the New York offices of *Time*, Roy has earned the nickname Man Who Shut Down Countries for reporting one failed regime after another. The others are Catherine Leroy, a feisty but diminutive Frenchwoman who scored her first big scoop for *Life* by going behind NVA lines during the siege of Hue; Dave Greenway of the *Los Angeles Times*; Mark Godfrey; Nik Wheeler; and I. For a long, pleasant hour we are surrounded by the damp night air, rich with the fragrances of the Orient, and it seems, if only for a brief moment, as though there is no war. The food has been delicious, the wine superb, and as the warmth of the brandy spreads through our bodies, it seems as though our Saigon could go on forever.

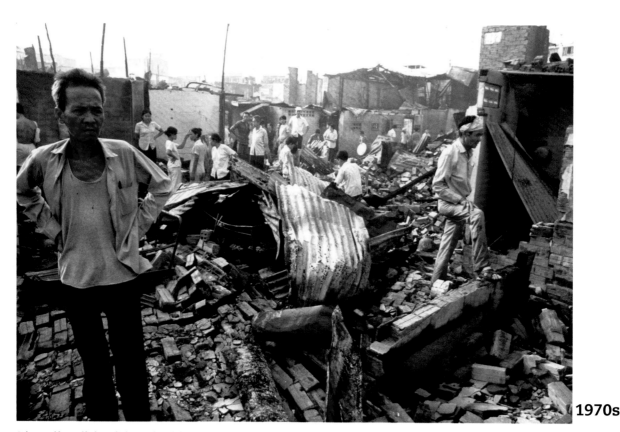

*Saigon residents sift through the wreckage left
by an attack by the North Vietnamese.*

As waiters begin to close the bar, our conversation turns to the immediate future. What do we do? None of us thinks that any real danger will come from the North Vietnamese. They have no real argument with the press. The disorganized, leaderless South Vietnamese army and police force, however, do worry us. They could go berserk in the interim between the departure of the Americans and the time it takes the Communists to establish order. We have had this discussion scores of times, but unfortunately, the answers seem no clearer now than before.

Nik Wheeler and I rise from the table and look out from the fourth-floor terrace of the old hotel on the Saigon River waterfront. We find ourselves looking down at the My Canh floating restaurant, now shrouded in darkness. I was nearly killed one night when a blast from a Claymore mine went off behind me as I photographed the scene. I was saved by a wounded friend who saw me and called to me. As I knelt beside him, mine fragments ripped through the air over my head.

So many friends are dead now: Henri Huet, who had been my first staff photographer for UPI in Saigon; Dana Stone and Sean Flynn, adventurers whose pursuit of excitement took them into the hands of a Cambodian execution squad; Larry Burrows, the gentle artist of *Life*; Kyoichi Sawada, who won his Pulitzer Prize while working in my UPI bureau; and now Michel.

As we walk down the stairs, we pass a large room that has been set up by the new government for peace negotiations. A huge circular table occupies the middle of the room. In its center lies an I Ching symbol, flanked by two doves. It is the new seal of the conciliation government. We laugh upon seeing the night watchman asleep on top of the table.

I walk out into the silent night.

Refugees are blocked from crossing the bridge to Saigon, as air strikes pound North Vietnamese forces in the background.

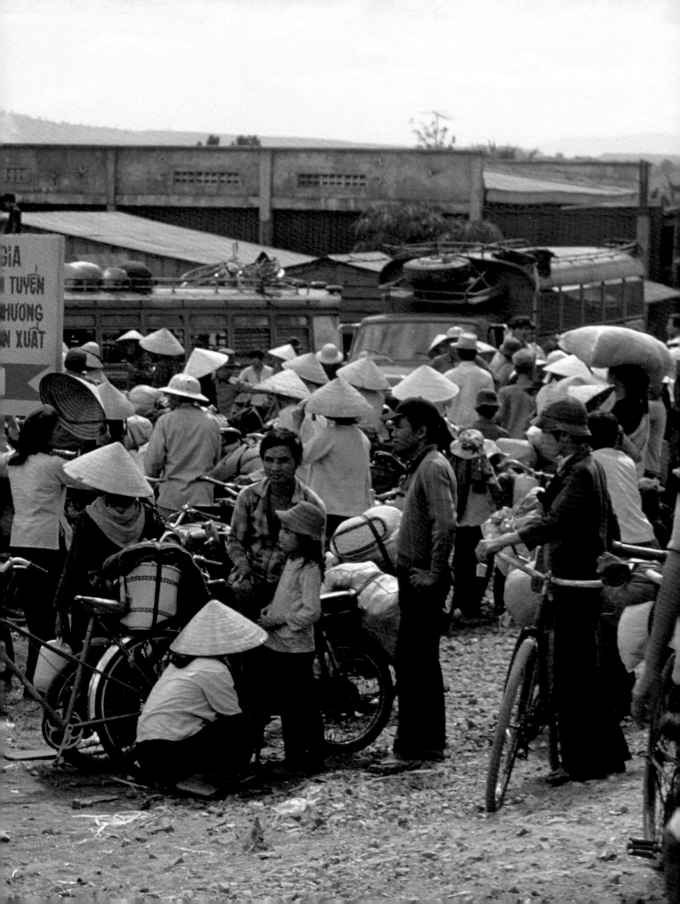

Part V: Anyone Who Makes an Honest Living Can Stay

0100 HOURS SAIGON: THE CONTINENTAL PALACE HOTEL

I'm feeling the brandy. I pull a 33 beer from the minibar. I still have half of the Romeo and Juliet cigar from the Majestic. I sit down on the bed and begin writing caption envelopes that will be sent to New York tomorrow with my film. I walk over to the fridge, pull out a small bottle of cognac and add a little soda. I turn off the air conditioner and open the window. Curfew enforced, the city streets are nearly absent of sound. I realize that I have never experienced Saigon so quiet. It must have been quite similar to this back in the twenties, before all the cyclos, Lambrettas, and little yellow-and-blue taxis swarmed the streets.

I look out at broad city streets. They are deserted. When the French drew up the plans for Saigon, they envisioned it this way—broad, tree-lined boulevards. At one time, it really was the Paris of the Orient. I pick up my cameras and start to clean them. The red dust has found its way into every part of the camera. I try to clean the viewfinders with my T-shirt. I really should try to make the trip up Highway 13 one more time. Maybe in the morning.

David Kennerly picks me up at the curb in a Caravelle Hotel car. We have decided to do a "safe" trip to the front. Leon Daniel occupies the back seat. Twenty-five miles north of Saigon on Highway 13, we enter the beginning of no-man's land. We slip our flack jackets over our shoulders, and duck down inside the car. The driver floors it, and we bolt through "rocket alley," just as, sure enough, a couple of NVA rockets whiz by overhead.

We join up with an ARVN company moving north. We take pictures of the troops and their armor moving up the highway, then stop to eat some of our picnic lunch from the Caravelle. As we nibble on the sandwiches, dark rain clouds move in. As the first drops of rain start to fall, a round from an AK-47 cracks through the air by my head. I can feel the air move. Suddenly, the tree line erupts in fire. Our hotel car spins around and tears back down the highway, leaving us behind. Large artillery shells, 105-mm rounds, start to fall around us. I see an armored personnel carrier with its back hatch open. I make a run for it through the driving rain. I slam the door closed behind me.

In a corner, a figure is collapsed, smoke rising from the body. I look down—it seems to be a photographer. His Nikon F is lying on the floor, the body smashed. I try to reach for it. It is so hot, I have to drop it. Outside the dimly-lit APC, I can hear shells finding their range. My eardrums pop. A phosphorous grenade goes off inside the APC. The din is incredible. The phosphorous rises into the air and floats down like flakes of snow—except where they fall, they burn. I see my skin catch fire, but strangely I can't feel any pain. The artillery shells and rockets are targeted on me. They are getting closer and closer . . .

0400 HOURS THE CONTINENTAL PALACE HOTEL

I wake up with a start, my T-shirt drenched in sweat. The air conditioner has stopped working. Suddenly, there is a jolt as a rocket falls just outside my window. Debris fills the air. I hear sirens. I run from my room and down the stairs to the street. Explosions are lighting the sky. There is fire coming from the roof of the Majestic Hotel, just a block away. I fight my way through panicked people who had been sleeping on the grates in front of the hotel. Nik Wheeler calls down to me from the second floor. I run to him. Behind him is the presidential suite. The suite has a gaping hole in its roof, and smoke is rising from the room. Amidst the debris, we can barely make out a body. Lying atop a blood-soaked I Ching symbol on the Vietnam peace-talks table is the body of the night watchman.

1970s

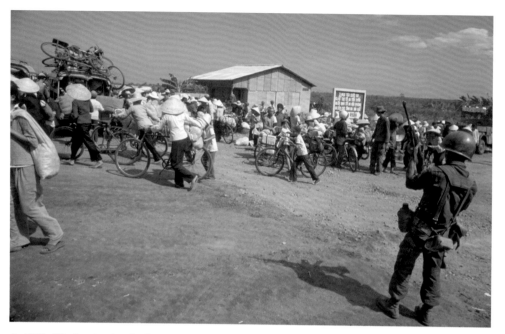

An ARVN soldier fires shots into the air to disperse refugees at the gateway to Saigon.

0730 HOURS SAIGON: CENTRAL MARKET

A lone cross, twenty feet high, dominates a scene of horror. The church surrounding it has been reduced to rubble. An area two blocks long and a block wide has been devastated in an early-morning rocket attack and ensuing fire. Medical personnel pull a corpse from the still-smoking rubble. Women walk through the debris, crying softly into handkerchiefs. Occasionally, someone will find a child's body in the wreckage and start to wail. As I take pictures, I catch sight of a pretty TV reporter I have never seen before, wearing a print blouse, skirt, and boots. She looks out of place as she shoots her stand-up in the midst of the debris. ABC's Hillary Brown has just arrived in Vietnam. She has been covering the bombings in Northern Ireland. She is no stranger to this kind of scene. As she wraps her stand-up, she is saying, "This is the first time Communist rockets have landed on Saigon since 1968. For the residents of this city, it has been hard to imagine that enemy forces are now just outside the limits. They realize now that this may be just the beginning of the final act in this war."

1200 HOURS THE NORTH VIETNAMESE COMPOUND AT TAN SON NHUT

Despite the fact that Saigon is now under attack, with NVA armies poised on its outskirts, the Communist cease-fire observers from Hanoi are holding their regular Sunday press conference. Due to the Paris Peace Talks, the airport has become the venue for this briefing.

Tucked away in a back corner of the sprawling former American air base, a compound is sheltered by tall palms. North Vietnamese soldiers—pith helmets on their heads, AK-47s on their shoulders—patrol the perimeter or stand impassively. A group of American correspondents and TV crews file into a long Quonset hut for the morning briefing.

At the far end of the room, a large Vietcong flag—half red, half blue, with a big yellow star in the center—is hanging on the wall. At a green felt-covered table under the flag, the chief spokesman, Colonel Ba, is answering questions. At the sides of the room—which is growing steadily hotter

from the TV lights—North Vietnamese soldiers serve a steady stream of Cokes, orange drinks, and Vietnamese beer to the thirsty newspeople.

Hillary Brown asks Colonel Ba: "What are the chances now for a negotiated settlement with the Saigon government? Will the new president, Huong, be acceptable to the Communists as part of a conciliation government, now that President Thieu has left?"

Ba shakes his head gravely and answers: "*Messieurs Huong et Thieu sont Bonnet bleu and Bonnet blanc.*" ("Messrs. Huong and Thieu are Tweedledee and Tweedledum.")

We are all trying to figure out our chances in the days ahead, so the question asked repeatedly by the press is, What will happen if we stay when the North Vietnamese take the city? Will we be safe?

Smiling, Ba answers, "Anyone who earns an honest living will be welcome."

1500 HOURS SAIGON: NATIONAL ASSEMBLY BUILDING

A South Vietnamese honor guard in crisp white uniforms, their helmets of shiny chrome reflecting the scorching sun, are standing at attention in front of the flag-bedecked National Assembly building by the Saigon waterfront. TV crews scurry to cover the arrival of delegates. Nguyen Cao Ky appears with his beautiful wife, Mai, a former Air Vietnam stewardess. Big Minh, who had his brief time in power as president, also arrives. Finally, with drum rolls and a blare of trumpets, a long black Mercedes pulls up, surrounded by M16-toting security forces. President Huong, who has been in office for the past twenty-four hours, stops in front of the flags to take his honors. The Vietnamese national anthem plays. Slowly, he turns, and one by one, climbs the steps of the Assembly to resign, his brief presidency over.

1970s

04|28|75

Part VI: "I Think Everybody Is Going Crazy!"

1000 HOURS SAIGON: THE NEWPORT BRIDGE

Helicopter gunships streak overhead, rockets spewing from their mounts. ARVN troops are crouched on either side of the roadway by the bridge, firing their guns blindly toward the bank on the opposite side of the river.

Giant columns of smoke rise from the Newport warehouses and refinery tanks at the harbor entrance to Saigon. Here on this four-lane highway bridge less than two miles from the center of Saigon, the Republic of Vietnam is fighting its very last stand.

I lie prone on one side of the bridge as Hillary Brown, tape recorder clutched in her hand, rolls across the highway toward me. Together we peek over the edge of the bridge. Below us, just ahead, we can see figures running amidst the burning warehouses. As we watch, the low-flying gunships pour rocket and machine gun fire into them. The North Vietnamese have reached the very gates of the city.

Several flatbed trucks, their air horns shrieking, roar past us from the direction of Newport, piled high with crated ammunition. They are no sooner past than a huge explosion flattens us against the guardrail, and we see a fireball just ahead of us as one of the trucks in the convoy evaporates before our eyes. Screaming in fear, ARVN soldiers throw down their M16s and dash past us, running down the ramp of the bridge back toward the city.

1130 HOURS SAIGON: THE MAIN PX

Vietnamese are smashing through the windows of the giant American Post Exchange (PX) and Commissary. As burglar alarms bray, they wheel off shopping carts filled with sugar, medicine, and frozen pork chops that immediately begin to thaw and drip in the blazing sun.

Police in the parking lots watch with amusement, occasionally plucking choice items from the passing carts as a kind of toll.

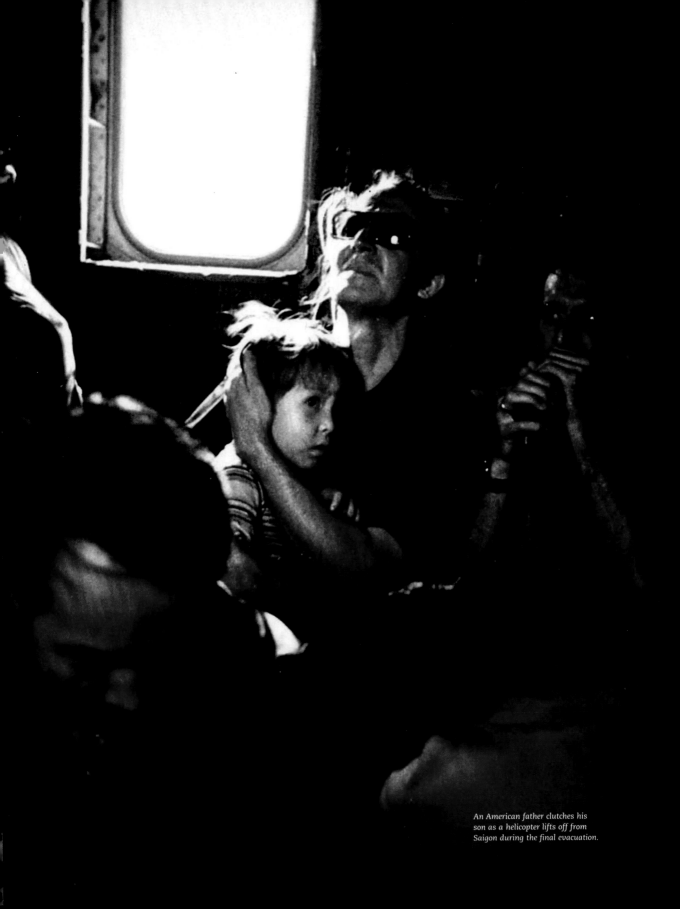

An American father clutches his son as a helicopter lifts off from Saigon during the final evacuation.

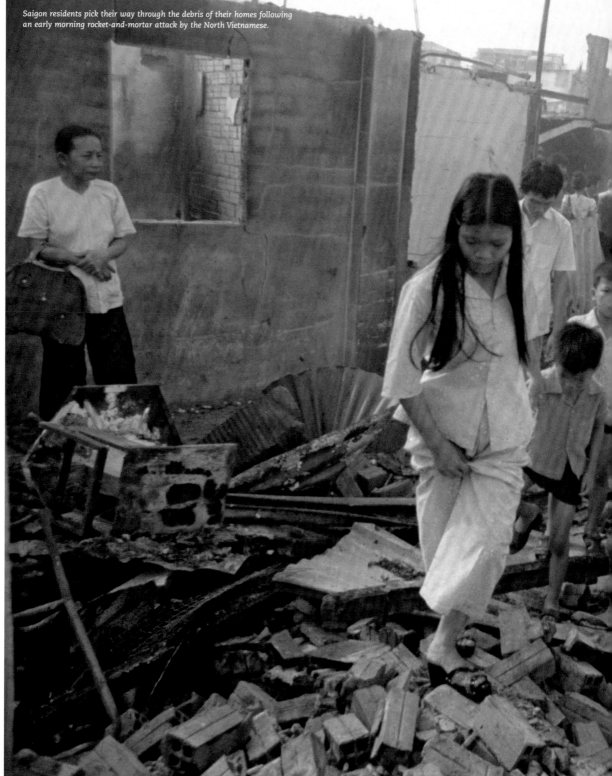

Saigon residents pick their way through the debris of their homes following an early morning rocket-and-mortar attack by the North Vietnamese.

1970s

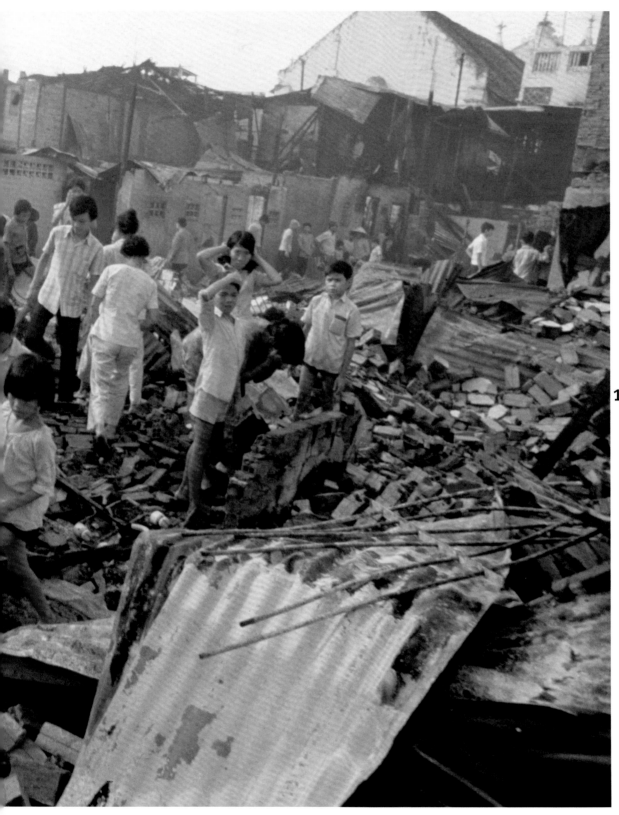

1970s

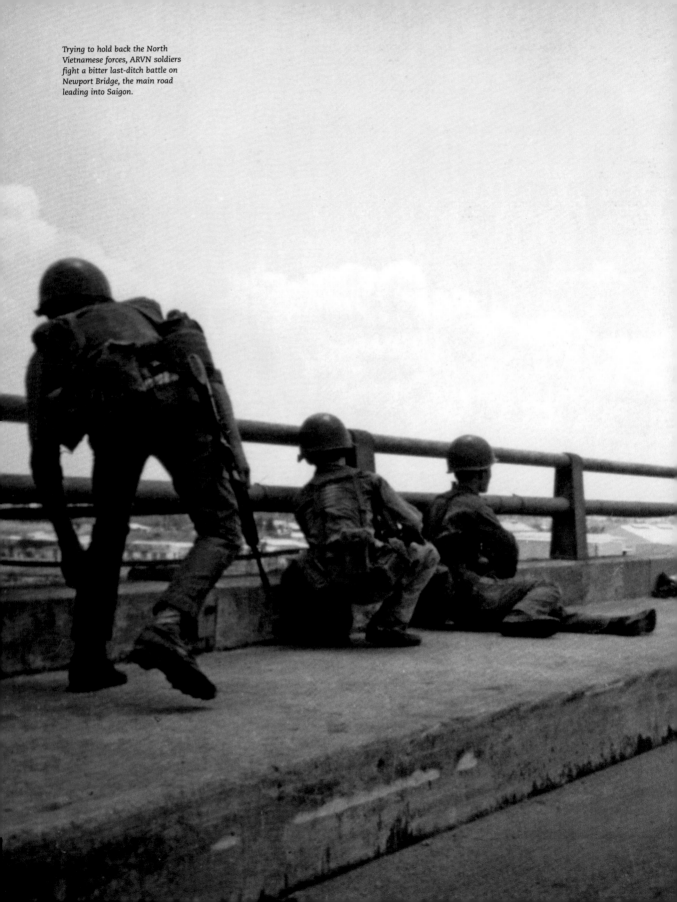

Trying to hold back the North
Vietnamese forces, ARVN soldiers
fight a bitter last-ditch battle on
Newport Bridge, the main road
leading into Saigon.

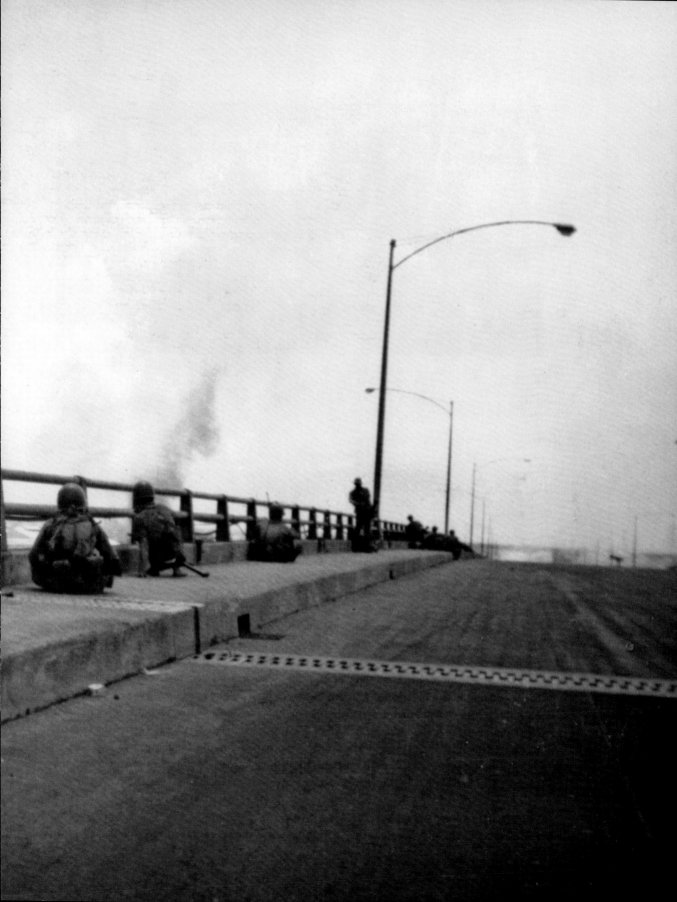

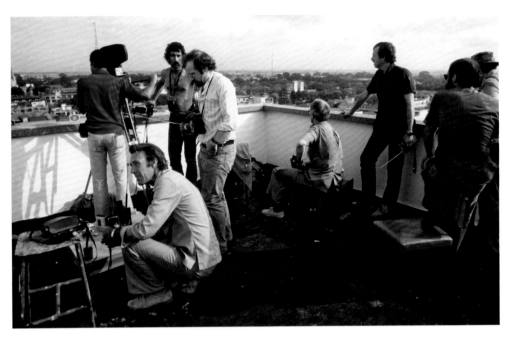

Members of the press photograph the Saigon skyline from the roof of the Palace Hotel on the morning of April 30th. They had just watched a VNAF C-130 Gunship shot from the sky by the North Vietnamese. At lower left is NBC correspondent Don Harris, who would be killed in Jonestown a few years later.

1970s

1530 HOURS SAIGON: THE PRESIDENTIAL PALACE

The huge gold-brocaded main room of the presidential palace is filled with government officials, National Assembly delegates, American Embassy officials, and the press. The room is sweltering under the hot TV lights. Occasionally, a wisp of humid air ruffles the curtains at the open windows as storm clouds brew in a darkening sky.

Seventy-one-year-old Tran Van Huong, the last president of the Republic of Vietnam, hobbles to the podium. Tearfully, he delivers his final address. As he finishes, a soldier in starched white uniform strikes the familiar yellow flag with red stripes, as another soldier removes the national symbol from the podium. An electric silence grips the room. All of the participants seem frozen in a historical tableau.

Suddenly, as if on cue, a resounding thunderclap booms. The curtains are blown inward from the windows, as a driving rain, accompanied by bolts of lightning, beats against the palace. It is as if the heavens are serving as an angry witness to this moment.

Amid the lightning bolts and thunderclaps, fifty-nine-year-old General Duong Van Minh walks to the podium. It is to this man that South Vietnam's final destiny has fallen. Twelve years earlier Big Minh helped usher in American involvement by toppling South Vietnam's autocratic president Ngo Dinh Diem. That commitment is now coming to a crushing close. He approaches the stage of history for the final time, to preside over the transfer of power to the Communists.

The new symbol of the new government, the I Ching flanked by two doves, is attached to the podium as colossal claps of thunder roll across the countryside and reverberate in the room.

1800 HOURS SAIGON: LAN SONG SQUARE

I am dashing across Nguyen Hue Street, trying to keep my cameras as dry as possible in the torrential

rain. A tremendous traffic jam has forced me to jump out of the Mini Moke and attempt to make it to the bureau on foot. Cyclos, Hondas, taxis, and cars are stalled in the traffic, horns blaring.

Waiting for a break in the traffic, I look up the street to the huge statue, three stories tall, of two Vietnamese soldiers that dominates the park in front of the Vietnamese Senate building. As I look past the statue, I see three specks on the horizon moving toward me at what seems to be the speed of sound. The A-37 fighters, bearing VNAF markings, swoop over my head. I am relieved momentarily at the show of force, but at that instant, one of the jets peels off and heads toward the presidential palace, rockets spewing from its wings. A fireball billows up from the grounds of the palace. The sounds of the explosions mix with thunder as the other planes follow the first and open fire.

I throw myself under a car, along with other press members coming from the palace, and begin crawling to find some semblance of cover and safety. The planes break formation again and make a strafing run right over our heads, machine guns blasting. They pull up and head north toward the airport. I plug the earphone of my small police radio into my ear and listen to the Mission Warden frequency. The radio is alive. The planes are now making a bombing run on Tan Son Nhut.

As I run across the street to the Continental Palace Hotel, I see Mark Godfrey trying to help Hillary Brown to safety. They are both soaked to the skin. Shooting has suddenly erupted everywhere. It is as though all the soldiers and policemen in the city are firing their guns blindly. CBS cameraman Mike Marriott is watching a "white mouse" pump rounds from his automatic into the side of a yellow Renault taxi cab. News correspondent Ed Bradley watches in horror as the policeman then swings around, points his gun directly at Mike's head, and pulls the trigger. The hammer strikes on an empty chamber.

The voices in my earphone are screaming at each other in a mix of Vietnamese and English. One American voice breaks in saying, "Control . . . control . . . I don't know what is going on, but I think everybody is going crazy!"

2300 HOURS

SAIGON: THE CONTINENTAL PALACE HOTEL — ROOFTOP RESTAURANT

Harry Griggs and Don Harris of NBC and I are finishing one of the best meals we have ever eaten, with Cuban cigars and brandy, in the rooftop restaurant of the hotel. We might as well relax since there is no place to go. A full curfew has been in effect since early evening. Anyone caught walking the streets will be shot on sight! We are the only Americans in the restaurant, and the entire staff is doing their best to make us happy.

Lurking in the shadows are more than a dozen bar girls who have made their way to the roof, just to be near us. It is made quite clear that if we can offer passage on a plane out, anything—repeat, *anything*—is not only possible, but guaranteed. None of the Vietnamese want to leave us. As the manager brings yet another bottle of brandy from the wine cellar, the sky to our north is lit by explosions. A second later, we hear the sounds of salvos coming from the direction of Tan Son Nhut Air Base.

The Embassy Mission Warden's radio on our table comes to life, "This is control . . . We have reports of incoming at the DAO!"

"Control . . . control, Mission, we have damage and casualties reported at the gymnasium!"

"Control . . . control . . . We have a gunship down near the gate!"

"Control . . . control . . . This is Security One. We have marines hit by the front gate! We need help *now!*"

From our vantage point, we see one explosion after another light up the sky. It appears the entire flight line is being targeted. I duck down to my room and try to reach the bureau on the phone . . . no answer. Going back to the roof, I see Harry Griggs on his two-way radio talking to NBC. There is still no word from the embassy.

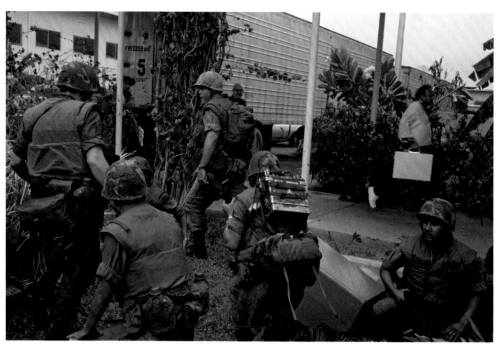

*U.S. Marines under fire at the DAO complex at
Tan Son Nhut call in evacuation helicopters.*

1970s

The Mission radio blares again: "Control, Security One. We have three marines dead at this post. Please advise situation! Get us help!"

Now there is another voice on the radio—one we have never heard before. A deep and steady voice says with great authority, "Mission control, Mission control, Silver Hill. Repeat, this is Silver Hill. Please advise, you are hearing us 5x5. We are taking direct control of all operations. All traffic will now pass through Silver Hill."

None of us has ever heard of Silver Hill. Then I remember—from my many trips to Andrews Air Force Base—a sign pointing to Silver Hill. Washington is now running things.

Part VII: It's 105° and Rising

04|29|75 **1000 HOURS SAIGON**

The streets of Saigon lie deserted. The curfew begun at sunset last evening remains in force. The capital has become a ghost city.

From the roof of the New Palace Hotel, we are looking out over the city toward Tan Son Nhut. The NBC crew has set up their tripods; handkerchiefs cover their heads against the broiling morning sun. A Vietnamese waiter from the hotel's restaurant brings up plates of sandwiches and glasses of beer.

As we look north, we watch a C-119 Puff make lazy circles over the air base. Every few seconds we hear its Gatling guns pour fire into the ground. Suddenly, we see the plane explode in a brilliant flash, then parts of it slowly fall to earth, twisting and smoking. "Jesus," Neil Davis exclaims, "that was a SAM!" (a surface-to-air missile).

I feel a tap on my shoulder. I turn to see one of the people I have been most haunted by these past few days. Nguyen Van Thom stands behind me. I had asked everyone I knew from the old days if they knew where he was. Thom had been my darkroom man in the two years

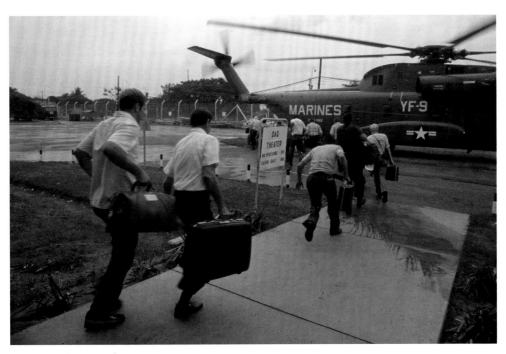

American civilians and press race for a
Sea Stallion helicopter at the DAO.

that I ran the Saigon photo bureau for UPI in the 1960s. He had avoided being shipped off to the army primarily by living in the darkroom. He had printed pictures that had gone on to win World Press Photo Awards and Pulitzer Prizes, getting the most out of the negatives of brave photographers. Nobody has heard from him in months . . . now here he is standing in front of me.

Thom looks at me and says, "Mr. Dirck, I am so happy to see you! Can you get my family out?" It is the same request so many of us have heard. I have no idea how I am going to do it, but I tell Thom to round up his wife and children and get back to me here on the roof as soon as he can. As he turns to go, I ask him if he can pick up a few batteries for my monitor radio on the way back. He scurries down the stairs.

He is no sooner gone than Harry Griggs, holding his radio, yells, "We just got the word! This is it! Evacuate! Everybody out!"

I race down to my room and call the bureau. Rowan says the embassy has just ordered all American personnel to report to evacuation stations immediately. Our station is right behind the bureau at the Continental Palace Hotel. New York wants to make sure that we leave immediately. It has already been decided that Mark Godfrey, who wants to stay, will be the only staffer remaining. Everyone else has been told to report to the staging area without delay. I flip on the radio by my bed, and there is a weather report playing over and over: "The temperature is 105° and rising!"

I run back up to the roof. The NBC crew is already gone. I look over the side, and can see Americans suddenly emerging from hotels and offices, moving up Nguyen Hue. I start to gather my cameras, and remember Thom. Shit! Where is he? I wait ten minutes. The streets are deserted again. A jeep filled with marines in combat gear tears down the boulevard.

I wait another ten minutes. I can hear distant helicopters overhead. Shit! I look up and down the street one more time. No Thom. As I reach for my camera bag, I see a small bag next to it.

I open it. My batteries! Oh God! Where is he? Just wait for a few more minutes. I feel panic rising in me. A shadow passes over me, and I look up to see a CH-54 Sea Stallion pass overhead. I've got to go . . . *now!*

1100 HOURS SAIGON: GIA LONG STREET

A group of Americans cautiously walks through the deserted street alongside the Continental Palace Hotel. They are carrying bags, typewriters, cameras, and recording equipment.

Vietnamese peer at us from behind locked doors and windows. I know there is no mistaking the look in those eyes. They know we are bugging out.

The eerie silence continues as we assemble in front of a building at 35 Gia Long. On the wall is a faded sign: UNIVERSITY OF MARYLAND, SAIGON EDUCATION CENTER. We are joined by other Americans and Westerners. In short order there are several hundred of us standing on the corner, waiting.

Two big black buses come down the street and glide to a stop in front of us. A U.S. Marine in flak jacket and helmet steps from the bus and exclaims, "Let's go, people!" One by one, we mount the buses. A few Americans help a Vietnamese friend onto the bus. The temperature inside the bus is sweltering. It has no air conditioning. We lurch a block down the street and find ourselves behind the U.S. Embassy. A crowd of Vietnamese, numbering in the hundreds, is trying to climb over the walls as marines inside the compound beat back the advances. Seeing our buses, a crowd starts to form a line in front of us. The marine officer inside the bus yells to the driver, "Move it!"

The driver is panicked. He is immobilized. Fists start to beat on the wire mesh covering the window. Blood from Vietnamese hands starts to run down the grenade shields. The marine pulls out his .45-automatic, points it at the driver and yells, "Move this bus! Now!" The vehicle lurches ahead, and suddenly we feel a wheel roll over a body. The crowd is screaming. The marine pushes the muzzle of his gun against the driver's neck and repeats, "*Move it!*" We feel sick as the bus clears the crowd.

1230 HOURS TAN SON NHUT AIR BASE

The gate of the air base is deserted as our buses race past the huge memorial in front dedicated to OUR NOBLE ALLIES . . . THEIR SACRIFICE WILL NEVER BE FORGOTTEN.

The lead bus crashes through the wire that had been the last barricade and swings through the gate of the defense attaché's compound. Alongside the gate is an embassy sedan, upside down. Huge columns of smoke rise from the Air America complex across the street. A helicopter lies abandoned in a ditch, one skid missing, its rotors still turning. The buses screech to a halt inside the gate in front of the thick-walled Defense Attaché Office (DAO).

Hillary Brown and I are just off the bus when a huge explosion throws us forward onto the ground. A 130-mm shell has just hit the Air America terminal fifty yards away. The marine in the flack jacket crouches over Hillary to make sure she is okay, then stands up and yells, "Let's go people . . . Don't panic!"

Crouching and running, we dash into the DAO. Incoming rockets fall right behind us. One Vietnamese woman falls, and the AP's Mal Browne picks her up and pulls her inside.

Inside the long hall, the explosions can hardly be heard. Hundreds of Vietnamese and Americans are sitting against the walls, bags in front of them. Marines in full combat gear are passing out tags. "These are for you, not for your baggage," they explain.

Sitting in the hall, a few reporters unlimber their typewriters and start to write. A nun kneels over her suitcase and prays. The building occasionally shakes as a shell lands outside. A marine officer walks the hallway and attempts to calm us. "Don't worry," he says. "The helos are on the way."

1970s

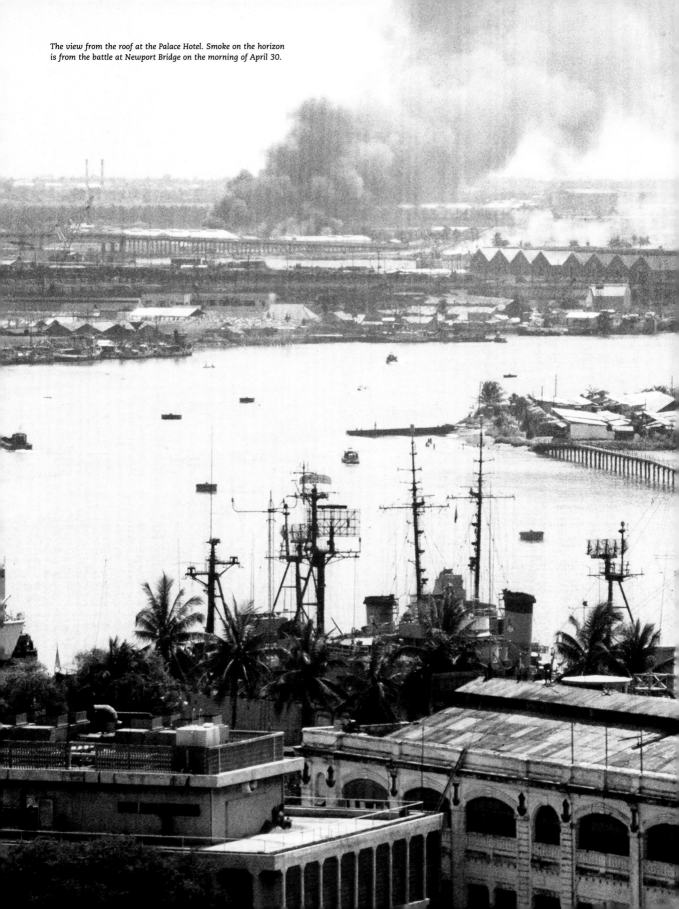

The view from the roof at the Palace Hotel. Smoke on the horizon is from the battle at Newport Bridge on the morning of April 30.

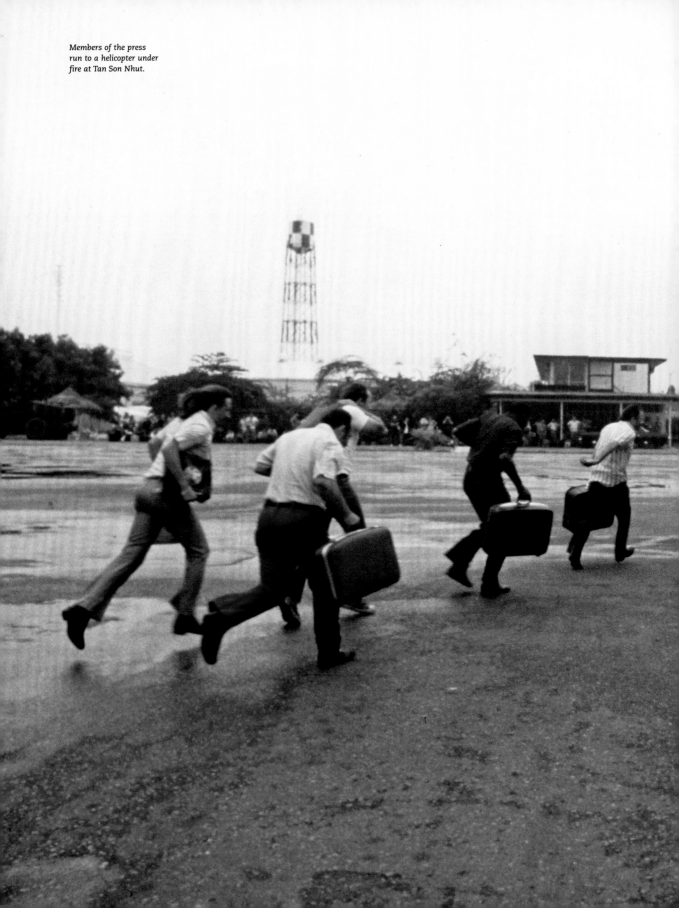

Members of the press
run to a helicopter under
fire at Tan Son Nhut.

Marine Colonel Alfred Gray, helmeted but wearing only a T-shirt under his flack jacket, is lying in a ditch of water outside the DAO building, next to the movie theater. The colonel is shouting into a field pack radio held by a terrified-looking younger marine. The two repeatedly duck their heads into the water-filled ditch as shells land around them.

The colonel has contacted the approaching helicopters coming in from carriers off the coast in the South China Sea. Suddenly, his words are drowned out by the roar of diving jets. Navy F-4s dip and wheel overhead, spewing rockets and bombs. Fireballs erupt just outside the compound. The colonel looks up and sees me taking his picture. "The show's about to start!" he exclaims. With a big smile he points at the abandoned theater. Marines dash into the center of the compound as clouds of yellow smoke billow up into the gray sky.

Skimming low over the horizon, the lead Sea Stallion helicopter fills the sky, followed by another. The two helos settle to earth inside the compound, their rotors continuously turning at full pitch. The rear loading ramp comes down and a squad of marines carrying M16s, M50s, and mortars dash out. In seconds they form a perimeter around the compound and dig in.

Simultaneously another marine, holding the hand of the nun, leads a group of a hundred Americans and Vietnamese on the run from the DAO building. They crouch as they race down the corridor connecting the DAO with the movie theater—through the theater lobby, past the young marines, into the courtyard, and onto the waiting helos.

Less than ninety seconds after the lead Sea Stallion has settled down, it takes off at full pitch, carrying its precious cargo, as another helo lands in its place and the process starts again.

1970s

Part VIII: Good-Bye to All That

04|29|75

1500 HOURS TAN SON NHUT AIR BASE

One of the last departing Sea Stallions, Swift 22, hovers over the landing zone at the DAO compound. Most of the Americans and Vietnamese have gone. Colonel Gray turns to me and yells, "Let's get out of here." The marines who dug in around the compound grab their weapons, and we dash to the ramp of the helicopter. Scott Butterfield of the *New York Times* and Mal Browne help a Vietnamese woman and a child onto the helo as it begins a rapid climb away from the air base. We are conscious of the fact that once the evacuation started, incoming North Vietnamese fire virtually ceased. Unfortunately, I also vividly recall the C-119 I saw shot down this morning. What is happening with those SAM batteries?

The noise in the helicopter is incredible. These are combat birds, with little acoustic padding. The whine of the engines, running at full pitch, assaults my eardrums. I look across at an American holding a child. The child is crying, but I can't hear a thing. I look out the window and see a Navy F-4 flying escort, skimming over the outskirts of Saigon. Our helo pulls into a sharp ninety-degree turn and heads across the city toward the coast. I look down and watch as the city that has been so much a part of my life slips over the horizon. The bends of the Mekong lie before me. I realize that I'm feeling as though a vital part of my life is coming to a close. After I first experienced this place in my early thirties, it became the thing that meant the most to me. I could leave it for months or years, but each time I came back, it was a grounding experience. How can it be that in a place of war, I find the happiest times I have ever known? How could I possibly explain to someone who hasn't experienced it how much more alive I feel returning to Saigon at the end of a day, and living and enduring in a place where I'm not even sure I will survive? Now I am losing it . . . and I know a big part of my life is coming to an end.

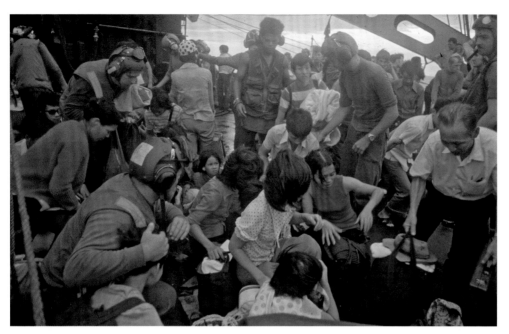

Evacuated families of Vietnamese military huddle on the flight deck of the USS **Midway**.

1800 HOURS THE SOUTH CHINA SEA: ABOARD THE USS MIDWAY

Hillary Brown is standing on the windswept flight deck, being pelted with rain. Her hair streams out behind her. The camera crew alongside her, she faces the camera to tape her stand-up, relating the flight from Saigon to the carrier: "After thirty years of fighting occupying armies, the long war for the Vietnamese people is finally coming to an end."

As she signs off, there is a flurry of activity. The ship's public-address system booms out: "*Flight deck crew, prepare to recover helos!*" The horizon is filled with tiny specks fluttering toward the carrier. As they draw closer, Hillary realizes they are not the lumbering Sea Stallions that shuttled back and forth between the fleet and Saigon, but rather much smaller and swifter Hueys. On their sides is emblazoned the insignia of the South Vietnamese Air Force. The first helicopter sits down on the flight deck as the landing crew boss races toward it, cursing. "Goddammit," he screams into the wind and noise, "get that fucker off! We've got our own birds on the way!" As he screams at the crewmen, the doors slide back and nearly twenty ARVN soldiers tumble out onto the flight deck. Marines scurry to disarm them. The flight deck boss is screaming at the pilot through the window. The pilot gives a thumbs-up, as the ship's PA system booms urgently: "*Clear flight deck! Clear flight deck! Swift's downwind! Prepare to recover helos!*"

The ship's claxon blares as the VNAF chopper rises into the air and flutters out beyond the bow of the ship. As an astonished Hillary Brown watches, gaping, the chopper slides to the left, the pilot jumps clear, and the Huey ditches in the ocean. The *Midway's* claxon blares: "*Man overboard! Man overboard! Rescue aft! Flight deck is clear! Prepare to recover Swift 19!*"

Everyone on deck is on the run. Frogmen appear from a hatch in the island. A boat is being lowered as the carrier turns into the wind. A flight of Sea Stallions bears down on the landing zone, as the Vietnamese pilot is pulled from the water. The ramp of Swift 19 is lowered at almost the moment of touchdown, and more Americans and Vietnamese spew from the helo. Overhead, American and VNAF choppers amass.

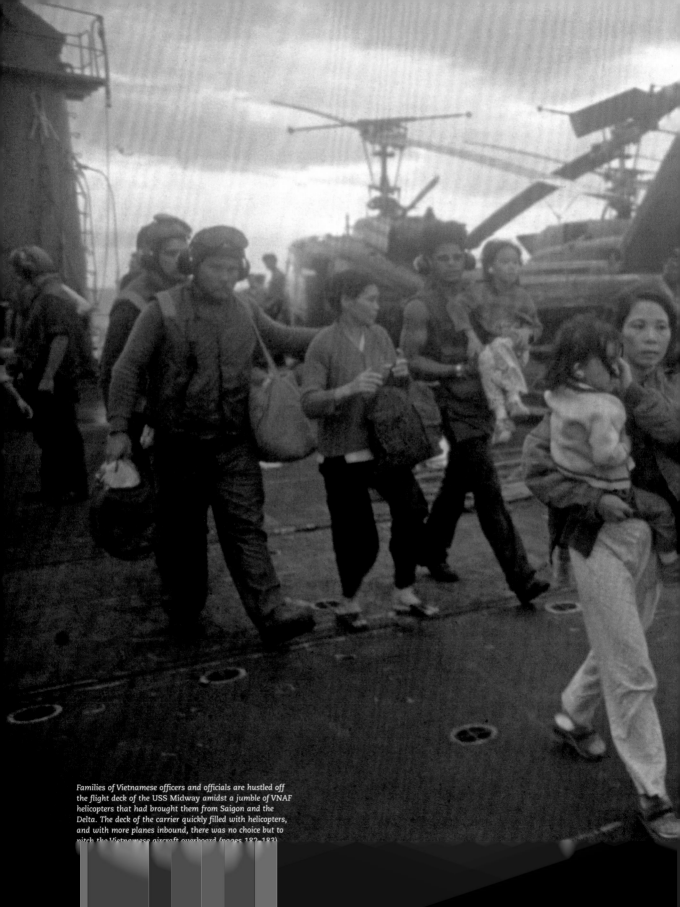

Families of Vietnamese officers and officials are hustled off
the flight deck of the USS Midway amidst a jumble of VNAF
helicopters that had brought them from Saigon and the
Delta. The deck of the carrier quickly filled with helicopters,
and with more planes inbound, there was no choice but to
pitch the Vietnamese aircraft overboard (pages 182–183).

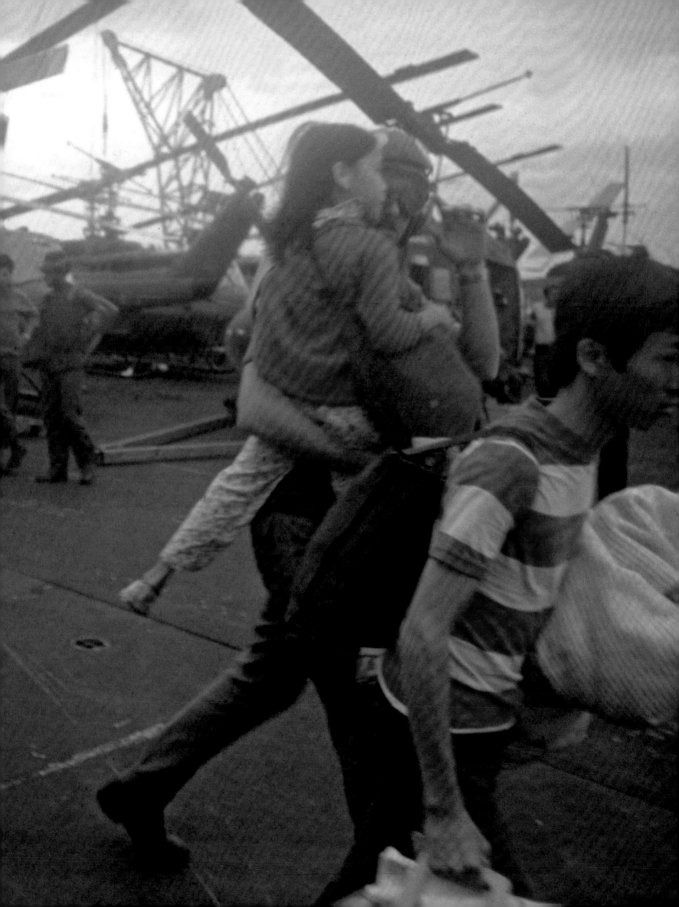

1970s

1970s

The last Sea Stallion of the squadron flutters off, back toward the coast. Once more, the flight deck prepares to recover the circling Vietnamese helicopters buzzing overhead like angry mosquitoes.

As Hillary's camera crew rolls, another VNAF helicopter settles onto the deck. As its rotors come to a stop, the pilot's door slides back and General Nguyen Cao Ky, debonair in his baseball cap with scrambled braid on the visor, steps out. He is no sooner on deck than crewmen, responding to the landing crew boss's directive, rush forward and push the Huey overboard. Other Hueys land, and as quickly as the crew and passengers are off, the choppers are pushed over the side. The same thing is happening aboard the USS *Coral Sea* and other ships in the task force. The claxon blares again, as the air boss, overhead on the bridge, yells, "*Unidentified aircraft downwind!*" Hillary watches in astonishment as a small airplane buzzes over the carrier.

The Cessna banks, turns, and makes another pass less than a hundred feet overhead. The deck boss yells, "That crazy fucker can't land here!"

As the plane passes overhead one more time, flaps down, at nearly stalling speed, the loudspeaker announces: "That aircraft is being piloted by a civilian. It has been advised to ditch. Prepare to recover survivors."

Once again, the small plane passes overhead, circling. An object falls from it, tumbles to the deck. The deck boss picks up a woman's pocketbook. Inside is a note that reads, "I HAVE MY FAMILY, WITH OUR FOUR CHILDREN ABOARD. I CANNOT DITCH, PLEASE HELP ME!"

Moments later the loudspeaker announces: "*Aircraft will attempt to land! Aircraft will attempt to land! Clear flight deck! Clear flight deck! Crash crew standby!*"

Sirens scream as a small red tractor with a foam gun wheels into position. Crash crew personnel don their asbestos helmets. On deck, crewmen frantically push to the sides the few remaining aircraft.

Hillary and her crew are unceremoniously hustled from the deck. Moments later they reappear on a walkway beneath the bridge. Next to Hillary is a navy commander. She turns to him and asks, "What are that plane's chances?"

"Not very good," the commander replies. "A civilian pilot with no carrier experience . . . no deck hook—it's like trying to land a plane on a moving postage stamp. I wish the poor bastard luck."

The PA system barks to life again: "*Aircraft downwind! Prepare for recovery!*"

A hushed silence falls over the ship. Hundreds of crewmen line every walkway on the superstructure of the carrier.

The tiny Cessna approaches from the stern; it bobs and weaves in the turbulence. It is too low. Frantically the landing officer waves it off, as the plane screams by overhead, makes a lazy turn, and tries again. On its next approach its position is better. The PA system announces, "*Aircraft in the groove! Recover aircraft!*"

The plane settles to the flight deck, a perfect three-point landing. Shapes can be seen through the windows. It comes to a stop fifty feet short of the A-deck bow. Its propeller stops.

Suddenly, the whole ship explodes in cheers and applause.

Part IX: We Just Walked Away

1130 HOURS SOUTH CHINA SEA: ABOARD THE USS BLUE RIDGE

04|30|75

Most of the press evacuated from Saigon on April 29 have managed to make their way to the flagship of the task force, steaming fifty miles east of Vietnam.

They had been deposited willy-nilly on various ships of the fleet and all carried film or tape that needed to be seen by the world. For me, time was running out. It was now Thursday,

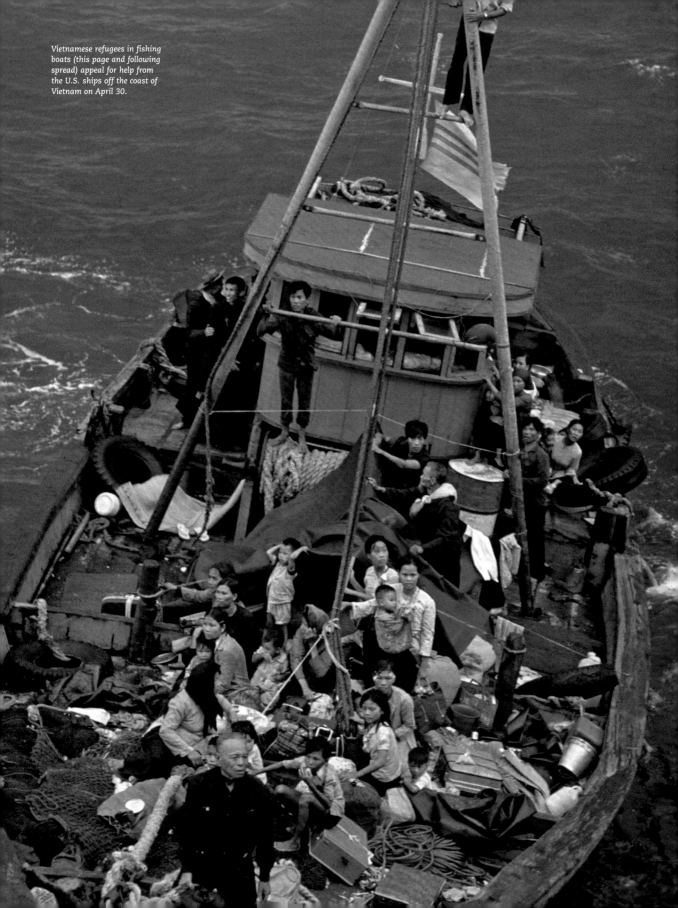

Vietnamese refugees in fishing boats (this page and following spread) appeal for help from the U.S. ships off the coast of Vietnam on April 30.

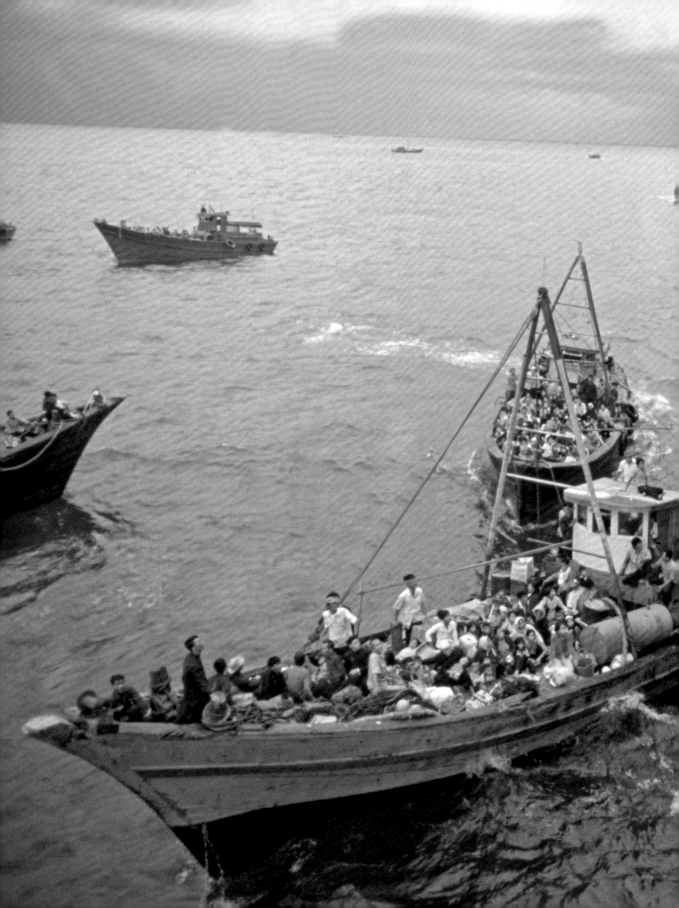

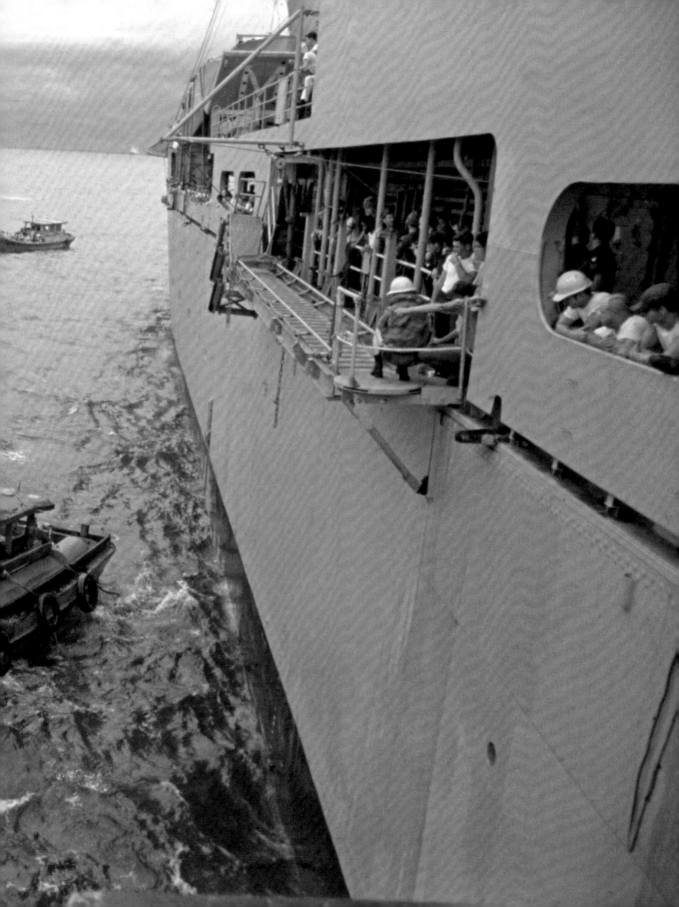

A sick and weary U.S. Ambassador Graham Martin tearfully talks to press aboard the flagship USS Blue Ridge following the evacuation.

which meant Wednesday night in New York. *Time* closes on Friday, so somehow I had to get my film from the fleet to Subic Bay. Subic was the nearest point from which a *Time* courier could get it onto a Pan Am flight to make it back to New York in time for publication.

We gather in a makeshift pressroom on the *Blue Ridge*. As each correspondent or TV crew arrives, we are able to piece together the puzzle of what happened in the last twenty-four hours. Saigon is now gone—history! The North Vietnamese have raised their colors over the presidential palace, and all of a sudden, there is a new city: Ho Chi Minh City.

As we compare notes, I notice a lonely figure standing by the door. I recognize Graham Martin, and everybody rushes toward him, pushing mikes in his face. The ambassador looks sick—which he is. He has been suffering from the flu and exhaustion. He finally had to be physically carried out of his office to the waiting helicopter on the roof of the embassy, as the marine security detail tossed gas grenades down the stairs to stem the rush of Vietnamese attempting to get out on the last helicopter. Everybody screams questions at the ambassador, but he just turns and walks silently down a passageway into the bowels of the ship.

A navy spokesman tries to regain order in the pressroom. All of the press are trying to write a finis to their stories, but one more question remains. Following the retrieval of Ambassador Martin,

all lifts had been suspended. Several hours later, someone realized that the entire marine security detail, ten people, had been left behind on the roof of the embassy. Under direct orders from the White House, one last exhausted Sea Stallion crew took off to rescue the marines, evacuating them just as North Vietnamese tanks rolled past the embassy.

Now, the overriding concern for the press is how to get our stories—our film, tape, and notes—off this ship! We form a committee and go to the admiral commanding the operation; he agrees that one person will be allowed aboard a helicopter headed for the carrier *Coral Sea*. This ship has a fixed-wing aircraft capable of making it to the Philippines. We draw straws, and I win. I round up all the film and tape from the wires, magazines, and networks, and a few minutes later I am whisked off the *Blue Ridge*.

1600 HOURS ABOVE THE SOUTH CHINA SEA

I am on a carrier-on-deck (COD), a propeller-driven aircraft launched from the *Coral Sea*. We are winging our way east with high-priority cargo. Among the passengers are the planners of the evacuation, all on the way to be debriefed at Subic Bay Naval Base.

I turn to one, a marine officer whose fatigues are still damp with sweat, and ask him what he thinks about the evacuation. He hesitates a minute and replies, "You know, we were the firemen. And the fire was out. This was America's wedding day. It is the first time we ever walked away and left an ally behind . . . I keep asking myself: is there something more I could have done? If I had more helicopters, more airplanes? Whatever it could have been, I feel as though I let these people down . . . I just walked away."

I wander up to the cockpit and sit in the jump seat behind the pilot and copilot. I ask whether they have heard anything from Saigon. They point to the headset on my seat and I slip it on. They reach overhead and dial in the FM signal from the Saigon Armed Forces Network. As the plane flies into the darkening sky, I can hear what sounds like Mantovani standards on the radio. Then a recorded voice says, "This is Armed Forces Radio, Saigon." There is a pause, then through my earphones, I hear Bing Crosby start to sing "White Christmas."

Epilogue

It may have been over thirty years ago, but the events of those last days in Saigon still haunt me. I don't know anyone who went through that experience who hasn't been permanently affected by it.

After hopscotching from one ship in the fleet to another, I managed to make my way to Subic Bay, securing from the *USS Coral Sea* a seat on a plane to carry my film and that of my colleagues. The film arrived in New York by deadline, but Saigon was already old news. *Time* ended up running an "art" portrait of Ho Chi Minh on the cover, and used wire service photos for most of its inside coverage. The majority of photographs accompanying this diary were never published at the time, although they did end up winning me the Robert Capa Gold Medal that year.

Several of us made a stopover in Hong Kong a few days after the fall. There we ran into Hunter S. Thompson, who had left Saigon long before the evacuation. Frustrated with the inability to tell our stories in print, we poured our hearts out to him, in the hopes that he, at least, could shape them into a story. He never wrote a word.

Time flew my wife, Ginny, to meet me in Hawaii. For the next week, we occupied an idyllic and peaceful thatched-roof bungalow on Kona. Instead of relaxing, though, I went into a deep depression. I would walk across the lava at the water's edge, unable to talk about what I had seen. A year later, our marriage was over.

1970s

In the fall of 1976, I took my caption envelopes and notes and reconstructed my experiences as a screenplay. NBC bought it for a Movie of the Week, but just as we were going into preproduction Brandon Tartikoff became head of the network and the project was scrapped. This diary is gleaned largely from my original notes.

In 1995 I revisited Vietnam to work on my documentary *Goodnight Saigon* (which can be viewed in streaming video on the *Digital Journalist* website). Nguyen Van Thom now owns a one-hour photo lab, a block from where I last saw him in 1975. Graham Martin, who had left the embassy in the early morning hours of April 30, carrying his dog and the American flag, returned to the United States and roamed the halls of the State Department for several years, until he retired from the foreign service. Colonel Alfred Grey, who ran the marine evacuation, went on to become commandant of the marine corps. Hillary Brown still reports from the world's trouble spots for ABC News. Roy Rowan, who shut down *Time*'s Saigon bureau, is just back from Vietnam with a major story for *Fortune* magazine. Neil Davis, the NBC correspondent who was on the rooftop with me that last day, was killed September 9, 1985, in Bangkok covering a coup. Michel Laurent was the last photojournalist to die in Vietnam.

The North Vietnamese took Saigon, bulldozed the cemeteries where South Vietnamese troops were buried, and renamed it Ho Chi Minh City.

Today, the old general who was the first official named by the North Vietnamese to run the city wanders the streets barefoot, protesting the results of the revolution he fought so hard for—a bizarre combination of corruption and commercialization. Skyscrapers go up on an almost monthly basis, and American tourists clog the streets, ducking into trendy California-style restaurants.

The F-15 fighter that led the bombing raid on the palace that day in April 1975 now sits in a square in the center of Saigon. Its pilot, Nguyn Thanh Trong, who deserted with his plane to join the North Vietnamese, is now a senior captain for Air Vietnam, and his daughter is a flight attendant. The one wish he has is to fly the airline's first commercial flight to the United States.

1970s

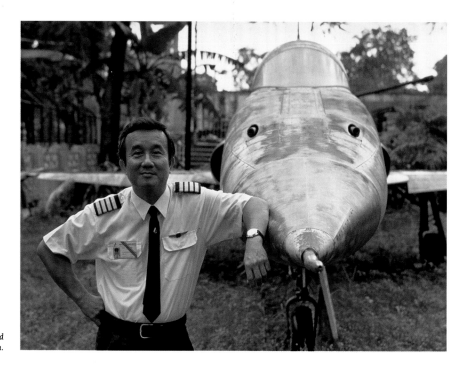

Right: Nguyn Thanh Trong stands next to his F-15 fighter, which he used in the bombing raid on Saigon. Opposite: This photo was my last Time *cover from the Vietnam War. ARVN 18th Division soldiers struggle to board one of the last helicopters to leave the siege of Xuan Loc. This was the end of the road for South Vietnam.*

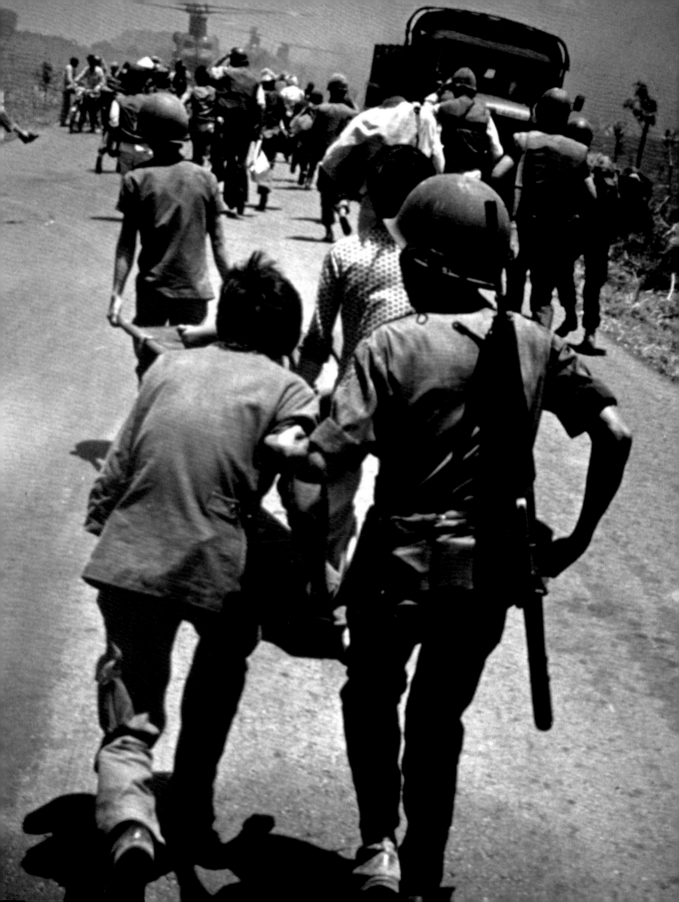

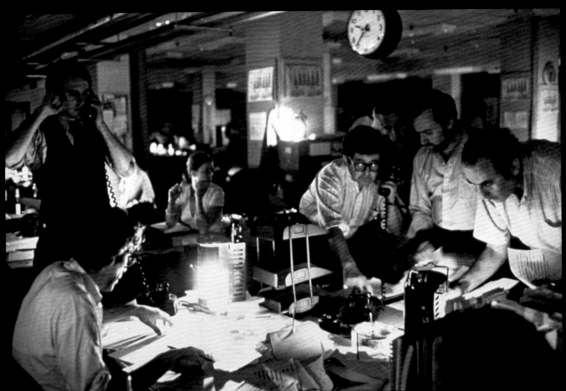

Blackout at the *New York Times*

In the newspaper business, the *New York Times* is called "the Grey Old Lady." There is very little seat-of-the-pants reporting or editing done in its staid West 43rd Street office. However, on July 13, 1977, a blackout in the Northeast left some nine million New Yorkers without power. Elevators left passengers stranded in high rises, subways ground to a halt, and rioting broke out in Queens. That evening, the top editors of the *Times*—including managing editor Abe Rosenthal, Seymour Topping, and Sydney Schanberg—worked by candlelight and lantern on the city desk in sweltering temperatures to put out the newspaper.

Wounded Knee

When I joined the contract staff at *Time* in March 1972, I was told by the picture editor John Durniak, that I and my new colleagues—Eddie Adams, David Hume Kennerly and Bill Pierce— were going to be given total freedom to cover stories on a worldwide basis. We were not to wait to get an assignment; we were to call from the scene and simply announce we were there. For one of the stories that I jumped on, I managed to drive through a zero-visibility snowstorm. It was 1973, and members of the American Indian Movement (AIM) had seized the historic monument at Wounded Knee on the Sioux reservation in South Dakota in the name of the Lakota Nation. It was in response to racial tensions and government corruption that had been building for decades. As I drove to the site, I noticed abandoned cars all along the roadside belonging to FBI agents who had been killed by the Indians. For the next two days I worked inside the Lakota camp, and shortly after taking this photo of a defiant AIM member holding aloft his AK-47, two F-4 jets swept over the camp at treetop level, breaking the sound barrier. That was the end of the standoff.

AIM leader Dennis Banks displays war paint as conflict with federal agents looms.

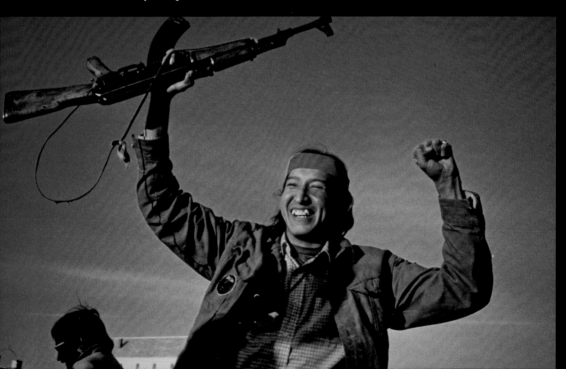

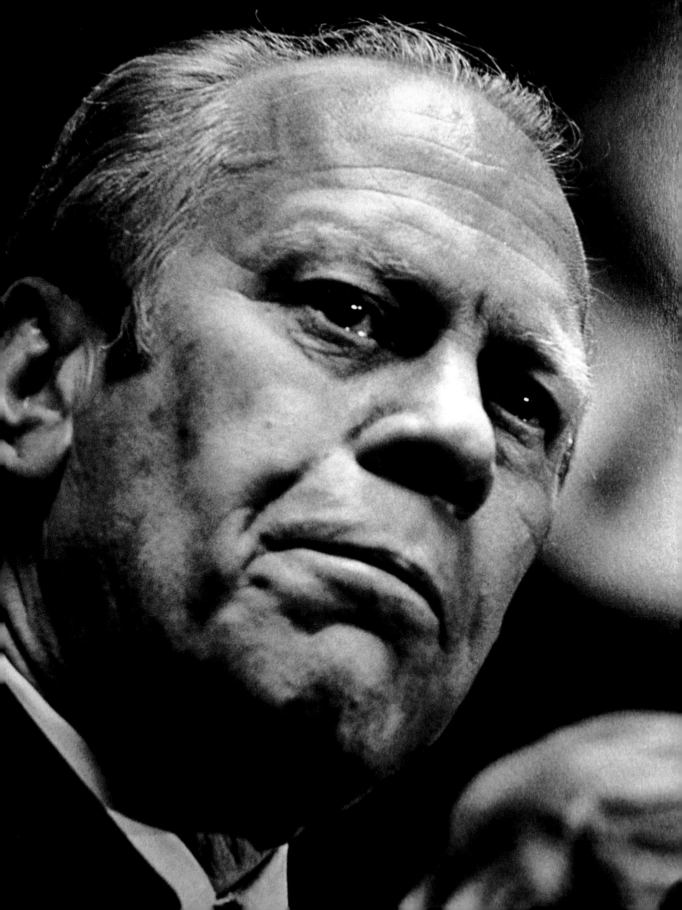

Ford at the Debates

What we are seeing here is the end of a presidential campaign. Gerald Ford was facing huge obstacles in his 1976 bid for office. His staff had calculated the fallout from his pardon of Nixon and felt that if he made no further mistakes, he could win the election. However, in his final debate against Jimmy Carter in San Francisco, he was asked a question about Soviet dominance of Eastern Bloc countries. He answered that he did not feel that these countries were under Soviet rule. The intake of breath in the audience was audible. Immediately following the debate, Ford's staff went into damage-control mode and tried to get him to clarify his position to the public. It took another four days for Ford to set the record straight, but by that time it was too late. These photographs were made with a Canon 800mm F5.6 lens from the top balcony of the theater.

1970s

Opposite: Totally exhausted after criss-crossing the country in the last week of his campaign, President Ford tears up as he leaves Dearborn, Michigan, on election eve to return to Washington, D.C. It would be his last two months in the White House.

Carter on the Cover

This is one of those pictures that should have been a cinch. The problem was that at the 1976 Democratic Convention in New York, with the rostrum so high above the floor and the shooting stands on each side, there was no position to shoot from that would give me the vertical shot I needed for a cover. I spent the first day of the convention searching for a vantage point, and finally found one—a spot in the stands, over 400 feet from the rostrum, that offered just the right angle that would encompass the candidates and their families. Zeiss had just manufactured a 1,000mm f5.6 lens, which was the longest, sharpest (and heaviest) lens of its type. I lugged mine up into the rafters and squeezed off this shot.

TIME

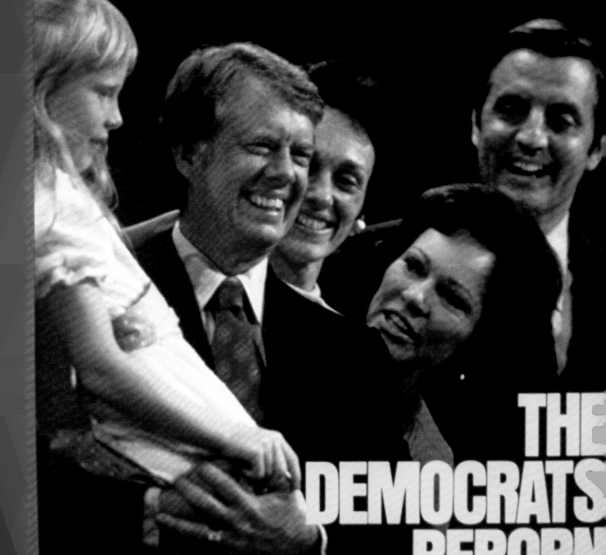

THE DEMOCRATS REBORN

Apocalypse Finally

We were in the jungle. There were too many of us. We had access to too much money, and little by little, we went insane. —Francis Ford Coppola, from an interview about the making of *Apocalypse Now*.

Here I was, riding on an ancient commercial air transport DC3, almost a year to the day since I had flown over the Philippines aboard a U.S. Navy aircraft on my way out of Vietnam, following the collapse of Saigon in April of 1975. It bumped and bucked its way

through torrential tropical rain onto a dirt strip carved out of the jungles of Luzon. The runway lights were kerosene lanterns. I was arriving at the most unlikely movie location imaginable. I had been invited to spend a week documenting the making of *Apocalypse Now*.

Photographing on movie sets was nothing new to me. I had regular work as a "special" photographer for the movie industry. Going in, though, I had no idea how very different this project would be from anything I had known. I was entering a strange world where the lines between art and reality were blurred, and the professionalism of a big-budget movie unit, which I was used to, would be threatened by delusion and madness.

In the late 1960s, America was becoming ever more bogged down in the quagmire that was Vietnam. Writer John Millius, at the request of director Francis Ford Coppola, wrote a screenplay based on Joseph Conrad's 1902 novella *Heart of Darkness*. Coppola wanted to reset the story in Vietnam and draw the characters from that war. At one point, he even considered shooting the film in Vietnam, using 16mm cameras. He assembled a talented cast and crew who were more than willing to risk their lives to make the film. However, it was more than Warner Brothers could tolerate, and the project was put on the back burner. In the years that followed, Coppola went on to produce *The Godfather* and *The Godfather II*, and in the process became one of the richest and most powerful filmmakers in the world.

In early 1976, Coppola decided to try again. United Artists put up $18 million as a budget. Production was scheduled to start in February 1976 on the island of Luzon in the Philippines.

In order to convince UA to put up the money, Coppola had signed a contract with Marlon Brando to play the role of Colonel Kurtz, a former Green Beret commander who has gone mad. Brando was to get a million dollars a week during three weeks of work. It was a classic play-or-pay deal, which meant that Brando would be paid regardless of whether he actually worked or not. This deal pushed preproduction ahead much faster than normal. Also, in order to get the cooperation of

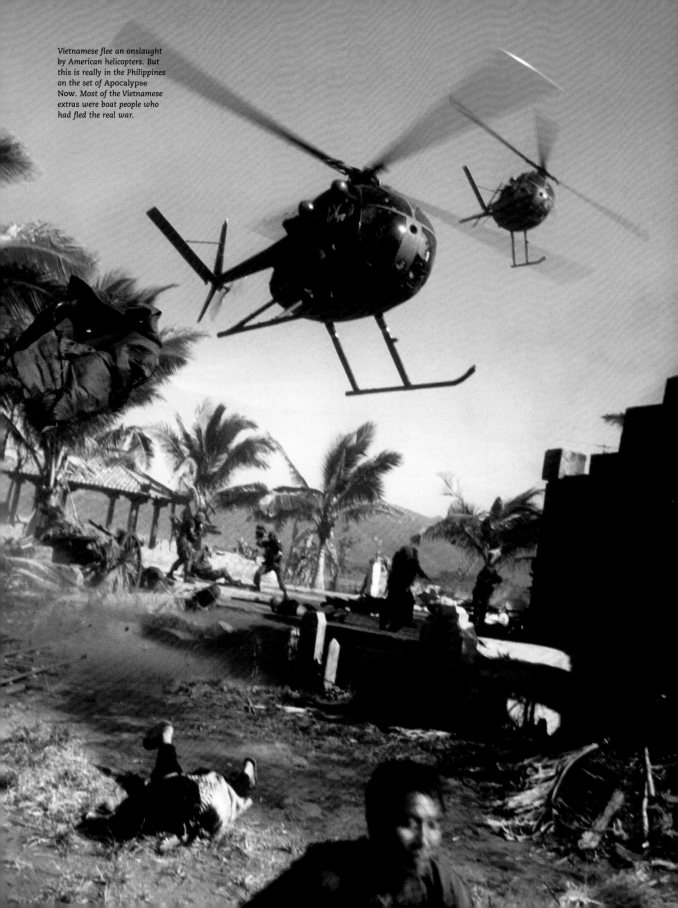

Vietnamese flee an onslaught by American helicopters. But this is really in the Philippines on the set of Apocalypse Now. Most of the Vietnamese extras were boat people who had fled the real war.

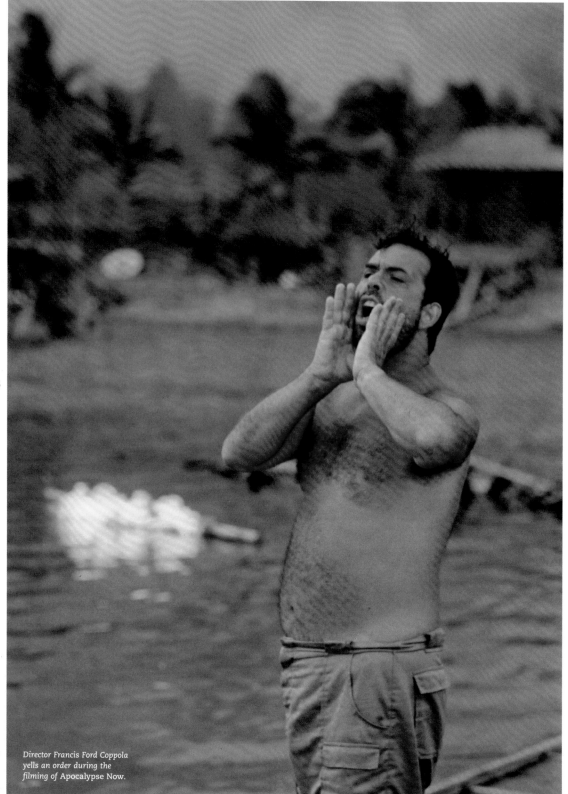

1970s

Director Francis Ford Coppola yells an order during the filming of Apocalypse Now.

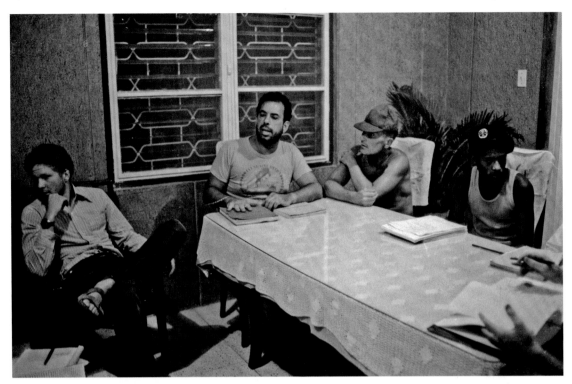

*Coppola goes over the script with actors (left to right) Sam
Bottoms, Robert Duvall, and Laurence Fishburne during rehearsals.*

the Philippine military, which controlled the helicopters, tanks, and planes, a financial agreement
had to be put in place, and a firm start date had to be set. The shooting schedule for principal pho-
tography was to run about sixteen weeks. But it was two years and 238 shooting days later before
Apocalypse Now was finally in the can.

My first full day on the set I awoke before dawn to the sounds of roosters and pigs. My bed-
room was on the second floor of the house belonging to the mayor of Luzon. Coppola had taken it
over to use as his production office, and to house occasional guests. There was no air conditioning.
Even at that early hour the temperature was in the nineties, and the humidity was 100 percent.
There was not even a hint of a breeze.

Groggy, I stumbled out of the house as dawn streaked the sky. All of a sudden there was a roar
overhead I hadn't heard for a year. It was the unmistakable drone of UH-1B military helicopters
coming in to land. I blinked as I looked up and saw the familiar olive-drab colors and insignia of
the U.S. Army 1st Cavalry Division on the sides.

Helmeted door-gunners were clearing their M60 machine guns as the choppers sat down in
the town square. A jeep came roaring around a corner, another gunner standing behind its machine
gun. Orders were being barked as troops came spilling out of their barracks and formed into lines to
prepare for inspection. Vietnamese civilians were boiling the broth for their morning *pho* in front of
their hootches. There wasn't a movie camera in sight. Somehow, overnight, I had been transported
through time and space back to Vietnam in the 1960s.

Coppola had sent his scouts to every bar across the Philippines and signed up any expatriate
who looked like he could be a U.S. soldier. There were Germans, Norwegians, Brits, and Americans
who signed on for months of living in cold-water barracks so they could play soldier.

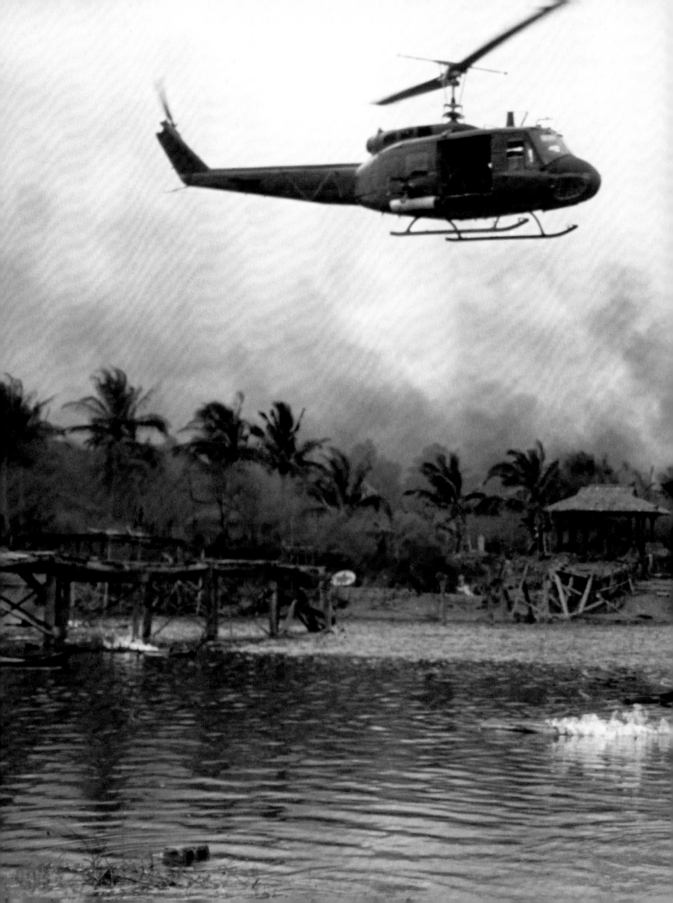

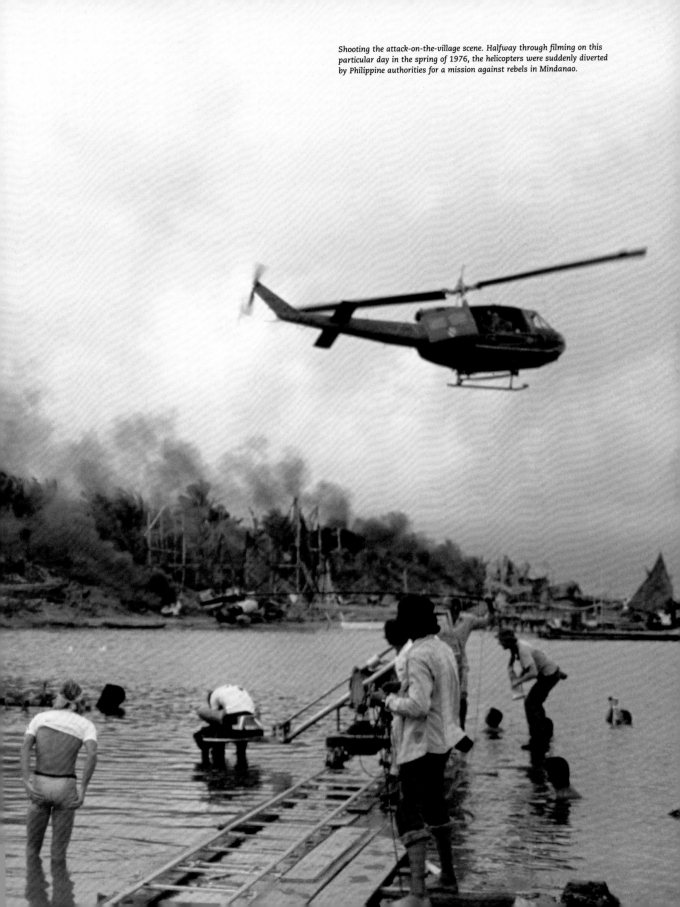

Shooting the attack-on-the-village scene. Halfway through filming on this particular day in the spring of 1976, the helicopters were suddenly diverted by Philippine authorities for a mission against rebels in Mindanao.

To whip them into shape, his military advisors, including Lieutenant Colonel Peter Kama (U.S. Army, Retired), were brought in. They achieved a remarkable transformation in these would-be grunts during a two-week drill. At breakfast in the mess hall, I sat across from a young man who had worked as an editor for City magazine in San Francisco. During the Vietnam War he had fled to Canada to avoid the draft. Yet here he was, dressed in tropical fatigues, dog tags dangling from his neck. There was a strange gleam in his eyes as he told me that his platoon was the best in the unit. They had perfected jumping from hovering helicopters, digging in, and setting up a defensive perimeter in minutes. They called their group the Donald Ducks. He proudly exclaimed, "If we had been in Vietnam we would have won that war!"

Coppola had also done more than his part in relieving the Philippine authorities by caring for hundreds of Vietnamese refugees who had come to their shores: he moved them to Luzon. They set up their own villages right on the set. Meanwhile, up the river, 600 Filipino workers were busy constructing Kurtz's temple out of 300-pound dried adobe blocks, under the direction of production designer Dean Tavoliarius. To play the headhunters Kurtz had recruited in his jungle stronghold, Coppola transported a tribe of Ifugao Indians from the south. It was rumored that until recently the tribe had still practiced head-hunting for real.

My visit coincided with the start of the biggest "set piece" of action in the film. This was the famed Air Cavalry attack on the Vietcong village. Production on the film had been underway for just over a month, and already Francis was bedeviled by circumstances that were spinning out of his control. Harvey Keitel was his first choice for the lead role of Captain Willard, who makes the long journey up the river to find Kurtz and to "terminate with extreme prejudice." Keitel was fired after a week of shooting, which meant the first week of film was now useless. Coppola flew to Los Angeles and signed Martin Sheen to replace Keitel.

Vietnamese extras and I on the set. Coppola rounded up boat people who had fled Saigon and had them shipped to the set in Mindanao. Suddenly they were back at war, but this time the pay was better.

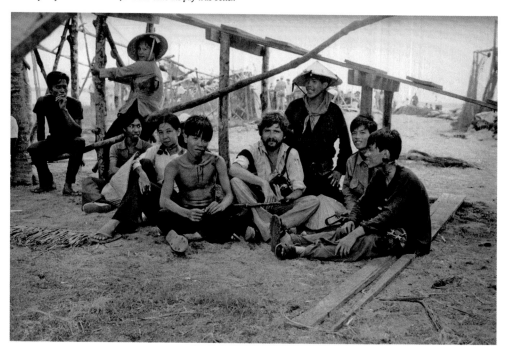

Meanwhile, the Philippine Air Force was becoming increasingly difficult as far as keeping their promises. After Coppola had paid enormous sums to rent—and in many cases, reequip—their helicopters, they would suddenly disappear in the middle of filming to fly off to engage real-life rebel forces in the hills.

My first day on the set, the attack on the village was being shot. Coppola acknowledged this was the most complicated sequence of filming in his career. Explosive charges had been wired throughout the village. As Coppola called "Action!" Vietnamese extras ran toward machine-gun emplacements and opened fire on the incoming helicopters. Buildings exploded, bullets ripped up the ground. As the helicopters—spewing rockets, machine guns blazing—roared overhead, the assistant director yelled, "Cut!" Director of photography Vittorio Storaro complained that the helicopters were too high. They were not in the shot.

Over the next four hours, the set was prepared again. New charges were put in place. With the light beginning to fade, Coppola yelled "Action!" and once more the guns began to fire and Vietnamese ran across the long bridge that had been rigged to explode. Then, suddenly, the lead Huey veered off to the south, followed by the rest of the squadron. As the choppers disappeared into the distance, the Philippine Air Force liaison officer told Coppola that they had been called off the filming to attack a rebel force.

> This film is a 20-million-dollar disaster. Why won't anybody believe me?
> I'm thinking of shooting myself!
> —Francis Ford Coppola, April 1976

1970s

Coppola was discovering that he was unwittingly replicating the American experience in Vietnam: with all this equipment and all these people, he was still losing every day—and he was the commanding general. He had to beg United Artists to add another $3 million to the budget, which the studio agreed to do—but only on the condition that if the film made less than $40 million, Coppola would be personally responsible for repaying the extra.

Marlon Brando insisted he play his role according to the original schedule, or he would simply cash the million dollars a week he had been promised. But Coppola was a long way from that point; by this time, the original script had been made irrelevant. Daily call sheets for cast and crew would simply say "scene unknown." Now he was directing by the seat of his pants. He was starting to commit the worst crime a director can be accused of—shooting impulsively, letting things just "happen." In the process, he was throwing away narrative structure. He had moved too far up the river in his own mind to turn back.

> My greatest fear is to make a really shitty, embarrassingly pompous film on
> an important subject, and I'm doing it. I confront it. I acknowledge, I will tell you right straight from the
> most sincere depths of my heart, the film will not be any good.
> —Francis Ford Coppola, from an interview with his wife, Eleanor

Drugs, alcohol, and delirium became the norm on the set. Actors and crew were dropping acid or taking speed. At times, this resulted in astonishing performances. While preparing to shoot what would become the opening scene of the movie, with Martin Sheen playing Willard, Coppola had been told by an advisor that a real Green Beret would be a vain, narcissistic man who would likely spend hours looking at himself in a mirror. After Coppola made this suggestion to Sheen, who was already feeling the effects of the long shoot in the jungle, Sheen decided to go for his own style of method

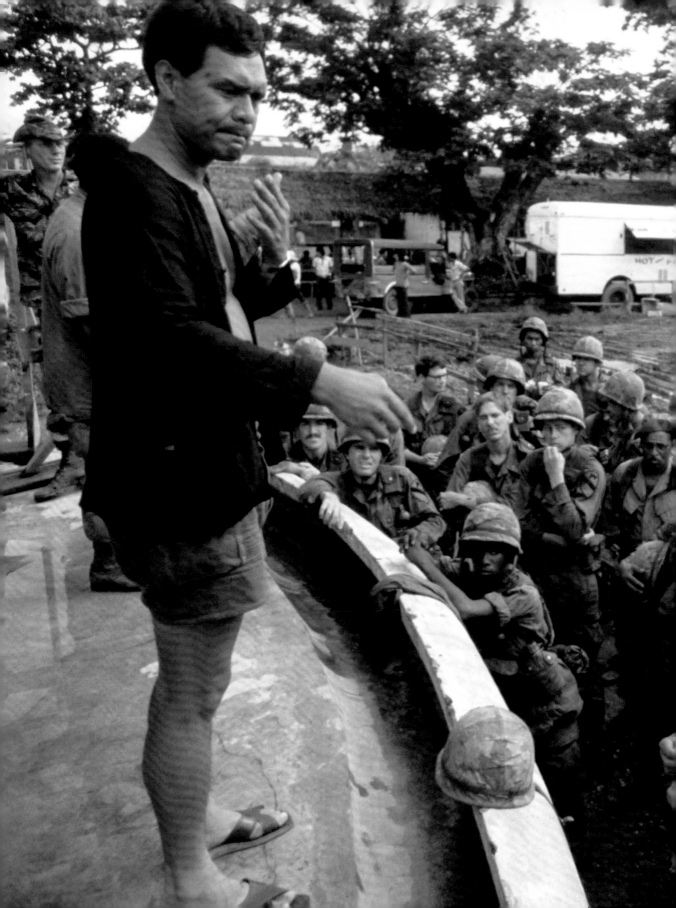

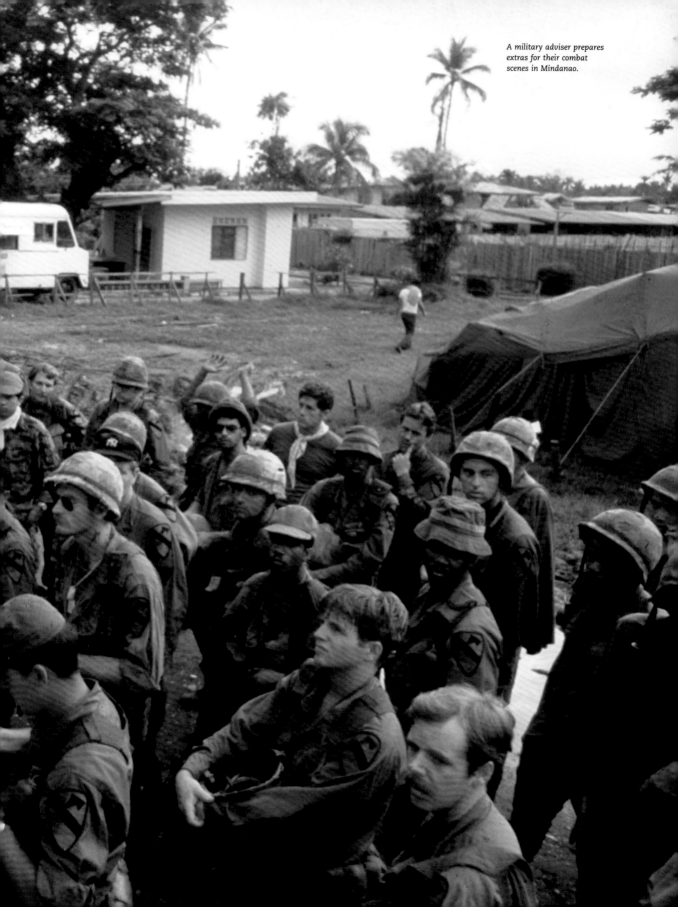

A military adviser prepares extras for their combat scenes in Mindanao.

acting. After consuming prodigious amounts of liquor, he started the shot doing karate moves, naked, in front of a mirror. As the alcohol took over, he lunged forward and shattered the mirror with his hand. It split open his thumb. Coppola immediately called, "Cut!" and shouted for a doctor. Sheen, however, insisted the filming continue. Over the next half hour, the bleeding actor slouched against a bed cursing at the camera and the director. Crew members feared Sheen might become violent. The resulting performance is one of the most gripping in acting history.

Then came the storm. In May, a giant typhoon smashed the Philippines. It wrecked many of the sets. The film was forced to shut down for two months. By now, Coppola had hocked many of his assets, including his home in northern California. By July, filming restarted, but where the story was going was anybody's guess. Coppola did a major scene, which took place on a French planta-tion that the crew of the river patrol boat encounters on their trip up the river. The plantation and its owners represented the colonial history of Vietnam. Meticulous attention was paid to every detail. The white wine would be served at fifty degrees, and the red at room temperature after breathing for an hour and a half. It was one of the most evocative scenes of the movie, but Coppola hated it. Because of pressure regarding his budget, he couldn't afford the French cast he wanted, and after a week of shooting he decided to kill the entire scene.

In the motion picture industry, wags began to talk about "Apocalypse Later." There were rumors that Coppola had suffered a breakdown. Bizarre stories circulated. Had real body parts been taken from cemeteries to be used in the Kurtz temple scenes? And then, in July of 1977, Martin Sheen had a major heart attack on the set. He was out of action for six weeks. During that time the director and crew would spend days on the boat, wandering the river, trying to conceive of shots. Each day they would go farther up the river. Coppola would lay down clouds of smoke, which made each trip seem further and further from reality.

Then there was the tiger scene. Coppola came up with the idea that the crew of the PBR would get off the boat to find some mangoes. Frederick Forrest and Martin Sheen suddenly came face-to-face with a charging tiger. The trainer, Marty Cox, who had been severely mauled by one of his charges, told the crew that he had not given the tiger anything to eat for a week, and he was "plenty hungry." A small pig was dragged toward the camera to make the tiger charge, but once the animal burst through the jungle, the cast and crew panicked. Frederick Forrest later said, "I was never so scared in my life. It was so fast, man Guys were running everywhere . . . climbing trees. To me, that was the essence of the whole film in Vietnam. The look in that tiger's eyes . . . the madness There was no reality any more If he wanted you, you were his." As they say in the movie, "Never get off the goddamned boat!"

Then, into all this chaos came Brando. It was the event Coppola feared the most. Finally, he would be forced to confront the ultimate narrative of his story. How was all of this going to end? When he had been hired two years earlier, Brando was already overweight, living a life of indul-gence on his Pacific Island paradise. He had promised to get into shape for the film, but when he finally arrived on the set he was heavier than ever, and extremely sensitive about his girth.

One way out of the Brando predicament for Coppola was to use the fact of Brando's weight as a physical example of how living outside civilization, in the jungle, had caused this Green Beret to let himself go. But Brando wouldn't hear of it. Somehow, they would have to shoot him in semidarkness.

Next problem, what was he going to say? There was no script. For long days, with the Brando million-dollar-a-week meter running, the star and director would huddle on the set trying to come up with anything that they could shoot. Finally, Coppola decided to let Brando improvise. He fig-ured that if he just kept shooting, sooner or later something would make sense.

A look inside one of the barracks used to house the extras who were playing American soldiers.

This movie was not made in the tradition of Max Ophuls or David Lean. It was made in the tradition of Irwin Allen. I made the most vulgar, entertaining, actionful, sense-a-ramic, give them a thrill every five minutes, sex, violence, humor, because I want people to come see it. But the questions I kept running into and facing every five seconds was the stupid script! Going up the river to kill a guy, but that was the story! The questions that story kept putting to me, I couldn't answer, yet I knew I had constructed the film in such a way that not to answer would be to fail.

—Francis Ford Coppola, from an interview with his wife, Eleanor

Finally, Francis was forced to call it quits in Luzon. But the film still did not make sense. More scenes were scripted and shot in northern California. Michael Herr, an author who had written one of the best books about the Vietnam War, was hired to construct a narrative that would link the scenes. It was largely Herr's words that Martin Sheen speaks as the PBR goes up that river.

On August 19, 1979, the movie opened. I was in the audience at the Ziegfeld Theater in New York City. Until that point, no one had ever made a movie about Vietnam that I thought was right. Details might have been correct, the history solid, but they had all missed something crucial. Perhaps it was the rock 'n' roll we all associated with that time and place. But sitting in the dark, looking up at that screen, I knew Coppola had got it right. Maybe the reason was that the war had made no sense, and in his own search to sort it all out, he came to the only real truth of that struggle: that everyone was mad.

The movie won three Golden Globe Awards, two Academy Awards, and the Cannes Film Festival's Palme d'Or. It made $150 million at the box office and is now considered one of the great war movies of all time.

Coppola would eventually add back in scenes that had been cut from the original—the plantation scene, the Playboy Bunnies entertaining the troops—to a new version of the film, nearly an hour longer than the original. The present version is arguably the most accurate film depiction of the collective madness of the Vietnam War.

1970s

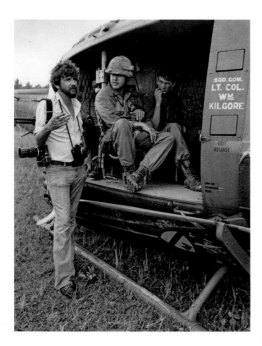

Opposite: Robert Duvall in his apartment in Baler after a long day of shooting. Left: On the set of Apocalypse Now in the Philippines, 1976. For years this picture hung on the wall of the light room at Time in New York, which led to the myth that I went into battle in Vietnam wearing Gucci loafers.

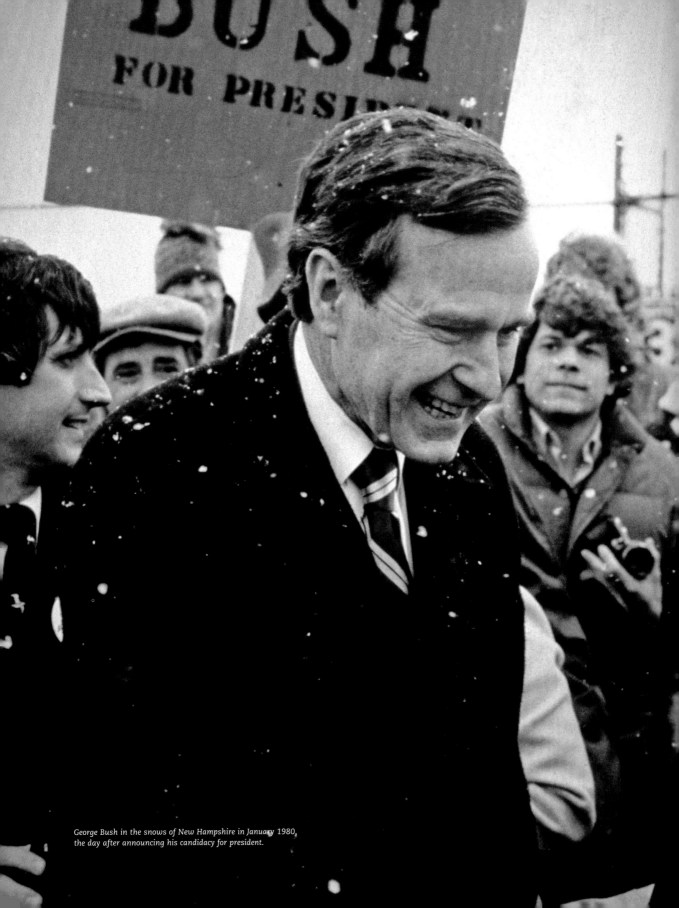

George Bush in the snows of New Hampshire in January 1980,
the day after announcing his candidacy for president.

In the spring of 1979, *Time* asked me to choose a candidate for president. I chose a long shot: George H. W. Bush. The magazine has always prided itself on having a photographer "inside" a campaign. The goal

is to be able to get exclusive moments. So they sent me down to Houston, where he was living at the time. He had already been ambassador to China and director of the CIA, and he was dipping his toe into the campaign waters, undecided as to whether to run for president in 1980.

Houston in June is only a few degrees cooler than Houston in August, making it one of the most miserable spots on earth. I showed up at Mr. Bush's house as his wife, Barbara—who I soon found out was called "Bar"—was making lunch. I had barely introduced myself when Mr. Bush shouted exuberantly, "Are you a runner?"

1970s

In those days I was. Not exactly an Olympic would-be, I was more of a one-lap-around-the-reservoir-in-Central-Park kind of guy. I had my running shoes and shorts in my rental car, so within minutes the Bushes, their dog, Millie, and I were in a car headed toward the park. Lunch would have to wait.

For the next hour I ran with the Bushes. I would spurt ahead, then spin around and shoot a picture. I watched as George literally leapt over a couple having a picnic lunch, with Bar and Millie bringing up the rear.

As we returned to the car, dripping with sweat, Millie decided to cool off in the creek that ran alongside the jogging trail.

The car, which had been sitting in the sun, was approximately the temperature of an oven on "broil." As I started to roll down the window, Mr. Bush yelled, "No, don't do that! You'll spoil it." At the same moment, he reached forward and cut off the air-conditioning, as Bar and a wet and steaming Millie hopped into the backseat.

"This is the best part!" Bush exclaimed. "We get a sauna."

Indeed, between our sweat and Millie's wet coat, the heat and smell quickly went off the charts. It was suffocating inside that car.

Halfway back to the house we stopped for a red light at a busy intersection. As we pulled up next to a minivan, two children in the back began to point at us and giggle in delight. Sure enough, steam was boiling up inside our car, and our windows had fogged over. We had our sauna.

That was my introduction to George H. W. Bush. For the next year, I would travel with him, from the announcement of his candidacy at the National Press Club in Washington, crisscrossing the nation, even off to Puerto Rico and on into the snows of Iowa, to his disastrous encounter with Ronald W. Reagan in Manchester, New Hampshire.

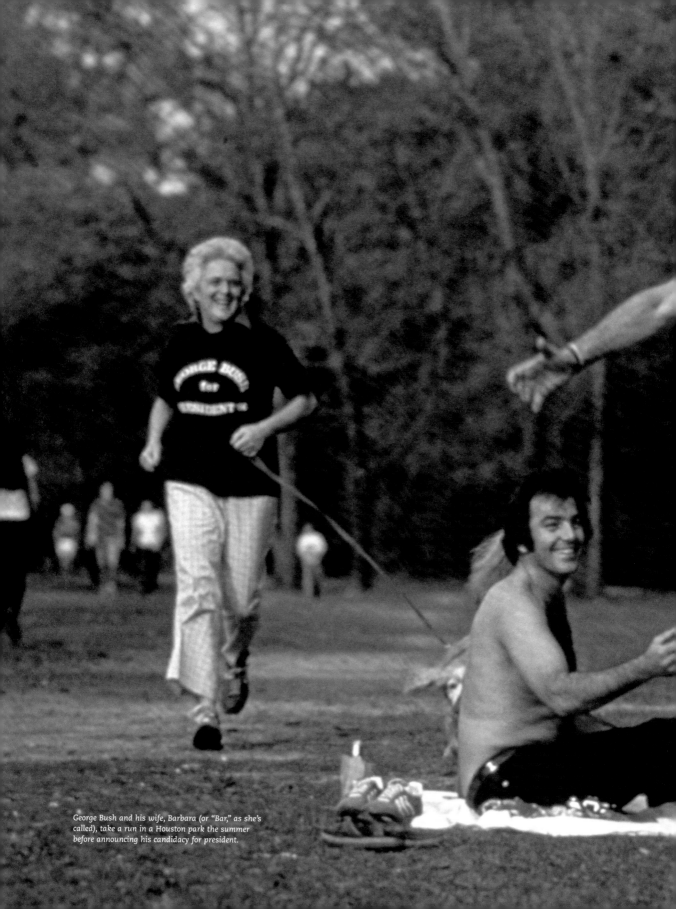

George Bush and his wife, Barbara (or "Bar," as she's called), take a run in a Houston park the summer before announcing his candidacy for president.

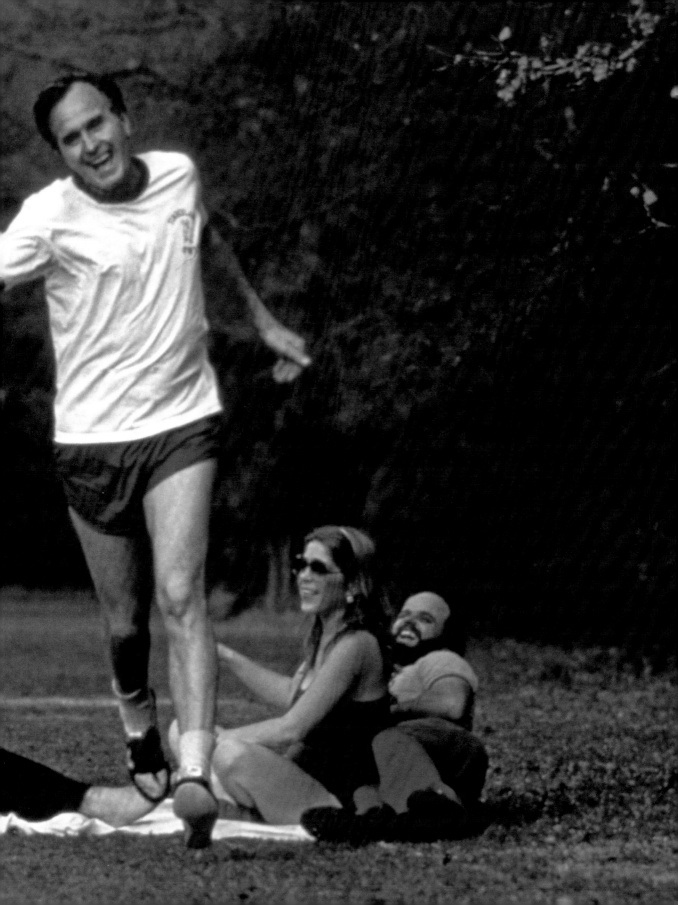

1970s

The early days of the fledgling presidential campaign of George H. W. Bush, in New Hampshire, 1980.

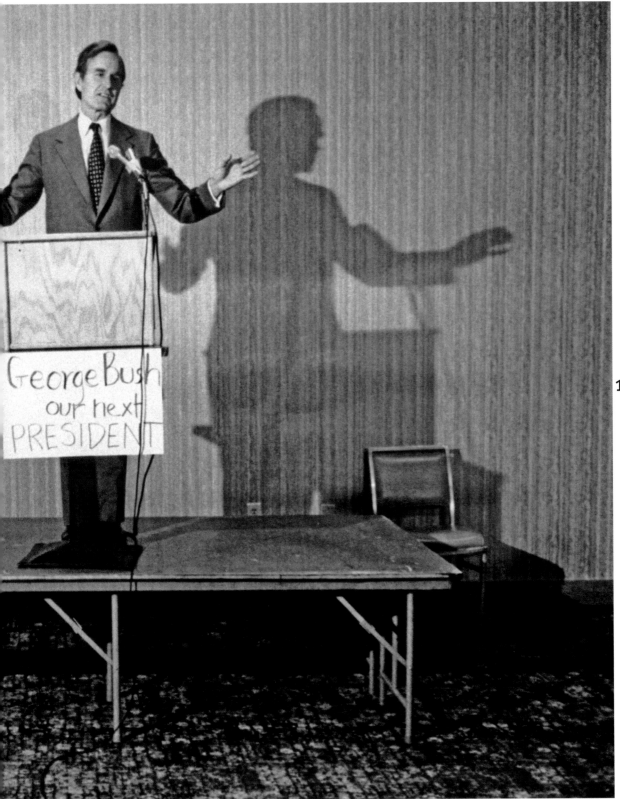

1970s

In his hotel room in New Hampshire, candidate Bush stretches
out his legs (and the holes in his socks) as he confers with aides.

Enjoying a light moment on the campaign plane, Bush uses the intercom to make an announcement to the traveling press.

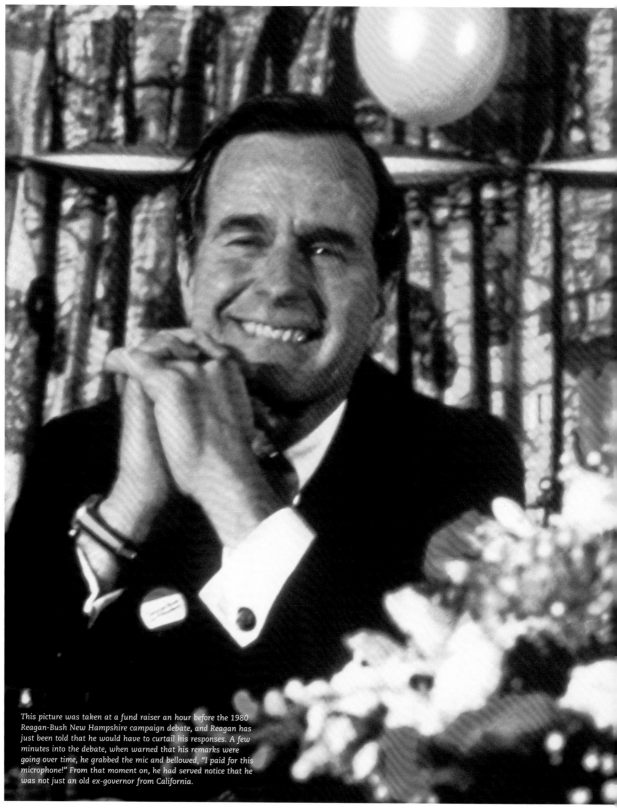

1970s

This picture was taken at a fund raiser an hour before the 1980 Reagan-Bush New Hampshire campaign debate, and Reagan has just been told that he would have to curtail his responses. A few minutes into the debate, when warned that his remarks were going over time, he grabbed the mic and bellowed, "I paid for this microphone!" From that moment on, he had served notice that he was not just an old ex-governor from California.

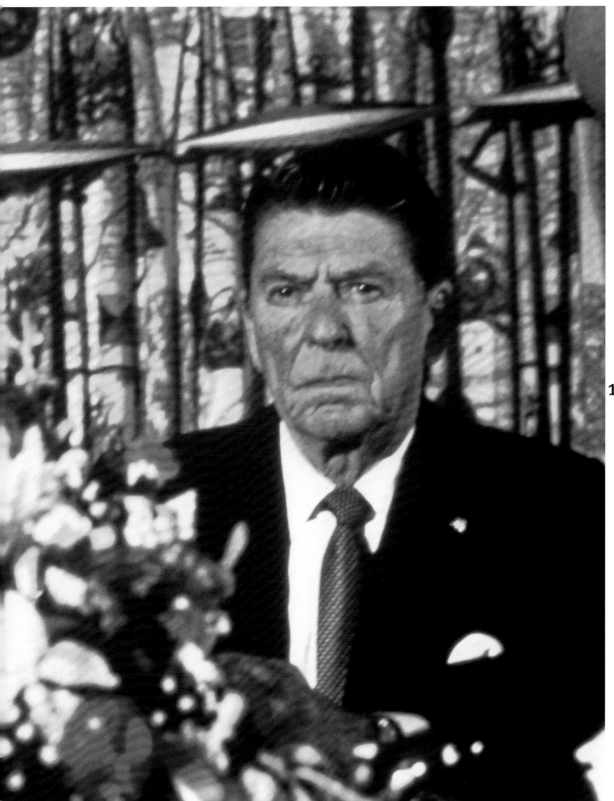

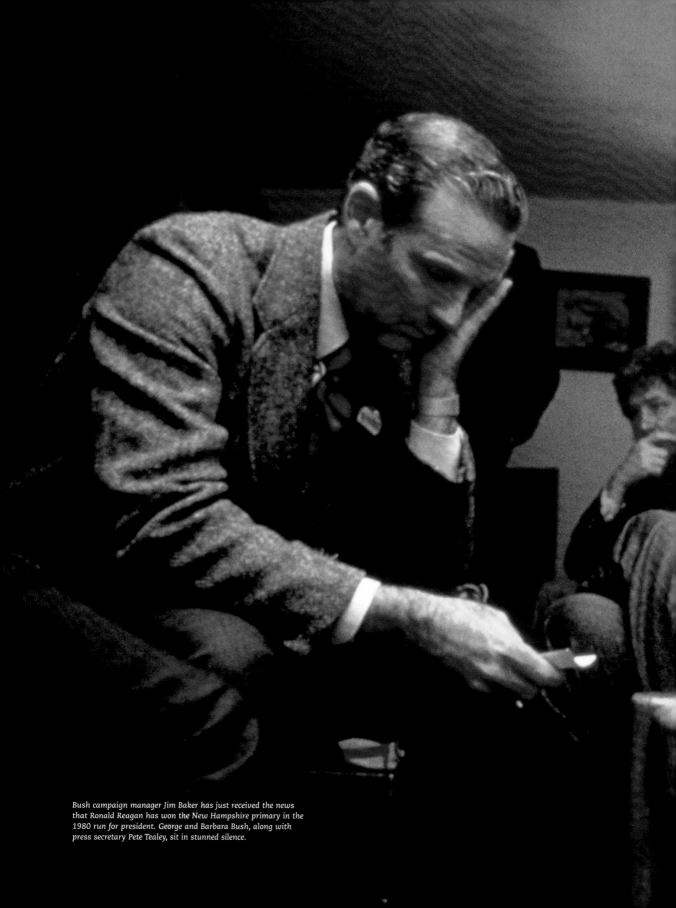

Bush campaign manager Jim Baker has just received the news that Ronald Reagan has won the New Hampshire primary in the 1980 run for president. George and Barbara Bush, along with press secretary Pete Tealey, sit in stunned silence.

1980s

When I think back on the eight years I spent covering the Reagan presidency as *Time*'s senior White House photographer, the first thing that comes to mind is China. ▪ For the members of Congress, the press, and the staff who populate a presidency, Christmas has always been a big deal. Starting the first week in December, right up to

Christmas Eve, the White House is transformed into a beautiful and joyous celebration of the season. Each room on the State Floor is bedecked with trimmings. In the center Blue Room, there is a huge Christmas tree decorated with thousands of lights, ornaments, and presents. Throughout the season, the Marine Band, dressed in red uniform jackets, plays Christmas music in the hallway every night, while roving bands of singers raise their voices in carols and a dance band plays in the East Room.

In the State Dining Room, the table is covered with bowls of fresh shrimp, platters of roast beef, ham, and smoked salmon with creamy dill sauce, which hungry visitors heap onto the White House china and pick at with delicate silver knives and forks.

However, from 1977 until 1981, before the Reagans, tackiness descended on this grand house. During this "Age of Malaise," as the Carters liked to call it, the silver, glass, and china were stowed away. Paper plates and napkins were the rule of the season, along with plastic utensils. Instead of the open bars in every room, cheap wines were served in plastic cups. Scrooge had indeed taken over the holiday. I suppose the Carters saved tons of money, which hopefully went to better causes, but there is, after all, something very special about going to the White House. It's not supposed to be like Christmas in Plains, Georgia.

So when the Reagans threw open the doors to the residence for their first Christmas party, it was as though Santa himself, and all his elves, had rediscovered the china. Once again, the White House was filled with cheer, laughter, and the Christmas spirit.

Pages 226–227: President Reagan at a rally in San Diego in 1984. Opposite: Working behind the scenes at the Reagan inaugural, 1980.

That was very much like the Reagans; to have an understanding of what was proper and expected. The White House is the people's house, and going there should be one of the most special events in the world. It was also how Ronald Reagan viewed his job. There were standards to be upheld, traditions to be observed; appearances were important, and every year, between Christmas and New Year's Day, the Reagans would fly west to their beloved California to spend the New Year's holiday in Palm Springs. However, it was very important to the president that his personal travel should not disrupt the lives of the families of the staff, Secret Service, and even the press. So he would always wait until the day after Christmas to wing west.

As a photographer, I have to say that Ronald Reagan was a delight to cover. For one thing, from his years of practice as an actor, he knew stagecraft, and that translated into great pictures. He was also the most "comfortable-in-his-own-skin" person I have ever photographed. He might have been using his training as an actor, but there was never the feeling that we were watching "an act."

Once, after covering the first term, I felt I wanted to dig deeper photographically, to find out who this man was before and after the photo ops. So I made a deal with one of the senior staff that I would be allowed to observe the president as though I were a member of the staff. No cameras—just watch and learn what it was we were missing, and then perhaps, once I knew what I was looking for, I might be permitted to photograph those moments. I should have anticipated the result. After a typical Reagan day, from 9 a.m. until 3 p.m., during which I was allowed to see everything, I handed back the staff pin I had been loaned and said, "You know what? There is no behind-the-scenes." What we saw in the photo ops was, in fact, the presidency. What you saw was what you got.

1980s

Below: President Reagan gets a Republican salute at a rally in Las Vegas, 1984. Opposite: President Reagan and the First Lady pose for a portrait at the White House. It was difficult to shoot these two—they were forever making jokes and cracking each other up.

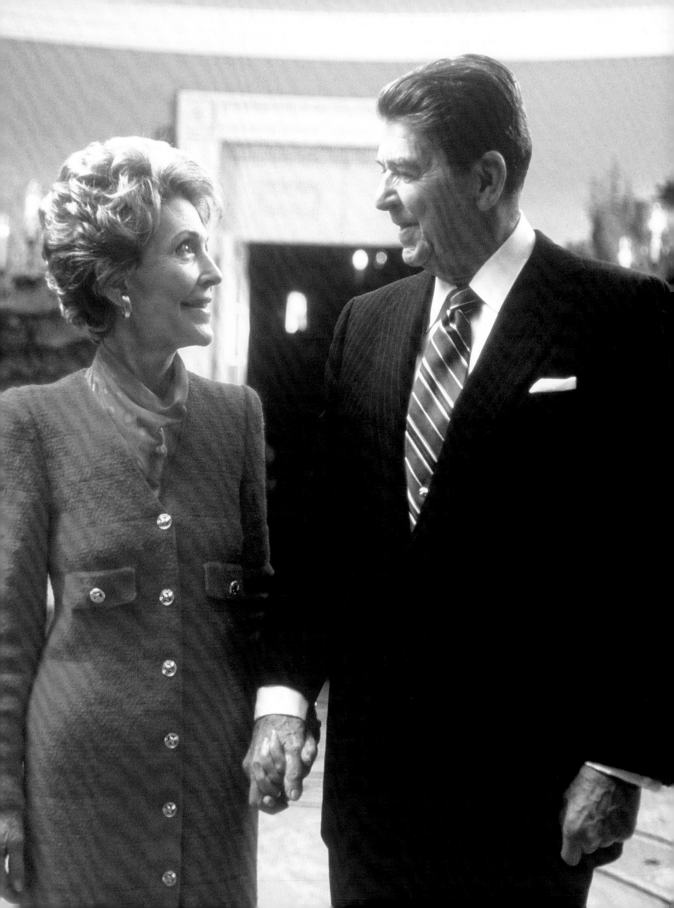

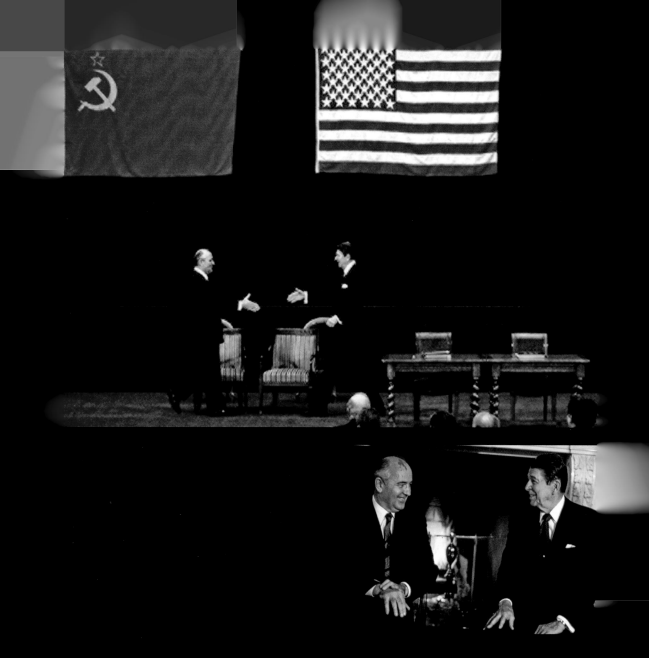

Reagan and Gorbachev

Reagan had caused great alarm when he started to talk about Star Wars missile defense shields, though the Soviets considered this to be the loony ramblings of a geriatric former movie star. But when the Gipper swept to re-election in 1984, the powers that be in the Kremlin realized the game was up. Whether Reagan's plans were practical or not, the Soviets were broke. They could no longer afford to keep the Cold War going. So they appointed Mikhail Gorbachev, the affable former agricultural minister, as premier because they sensed he might be the sort of man who could develop a personal relationship with Reagan. Their instincts were only too right. From their first meeting in Geneva, Switzerland (above), followed by a long walk during which Reagan enthralled Gorbachev with tales about his years in Hollywood, their friendship was sealed. It was the begin-

Every once in a while I was allowed to do an exclusive, where I would spend hours in private with the president. What I remember most about those times was how difficult it was to take pictures, because the president was constantly telling jokes.

Traveling with the Reagans was the best. If Ronald Reagan was going to China, for example, it would take forever just to get there. First we would fly to California and rest up for a few days, then on to Hawaii for another few days of rest and sun. Then to Guam, for another night's rest. Finally, after nearly a week, we would arrive in Beijing, tanned and rested. In contrast, with George H. W. Bush, we went to Japan and China and back to Andrews Air Force Base in three days.

And, of course, there was California. It has been estimated that Reagan spent more than a year of his eight-year term in the Golden State. For the press, these idyllic weeks were governed by the principle "If he doesn't bother us, we won't bother him!" Generally, two weeks would pass before we would see him, then he would come down from Rancho del Cielo for a day, do an event, then return to the mountaintop for another two weeks. My biggest mistake was that I didn't buy a house in Santa Barbara during the first year.

But if the vacations were fun, the real business of covering the president is what made it all worthwhile. There were trips to Europe, South America, and Asia. In most cases these trips resulted in major stories—so much so that *Time* would regularly send a contingent of four or five photographers on these trips, often with an advance contigent to set up the communications and couriers that would get the photographs back to the magazine. Once, on a trip to Bali, the air force flew a C-130 from Guam to pick up our film, and got it back to a staging area from which it could be sent back to the States.

I was too young for one of the most historic presidential moments, when John F. Kennedy said, "Ich bin ein Berliner!" at the Brandenburg Gate. But I was there, twenty-plus years later, when Ronald Wilson Reagan demanded, "Mr. Gorbachev, tear down this wall!"

And you know what? Gorbachev did.

1980s

Russian women give Nancy Reagan a kiss during the presidential visit to Moscow in 1987.

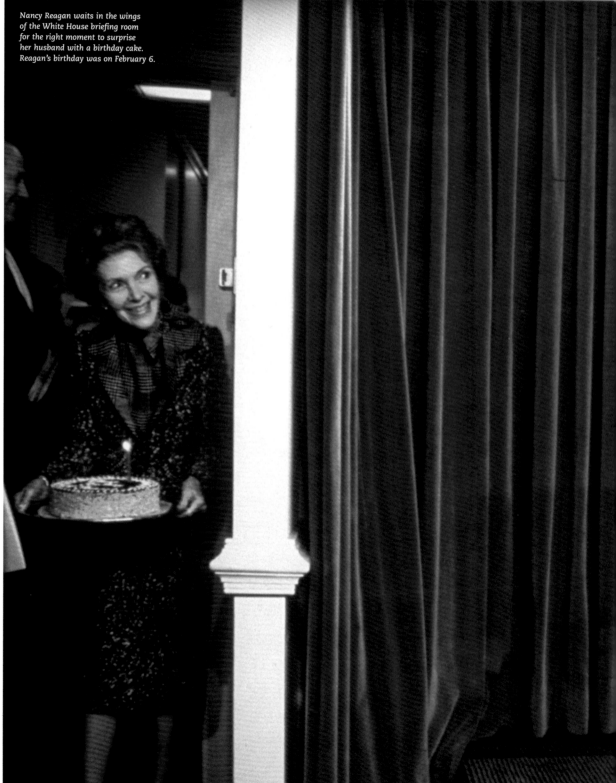

Nancy Reagan waits in the wings of the White House briefing room for the right moment to surprise her husband with a birthday cake. Reagan's birthday was on February 6.

1980s

1980s

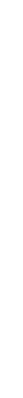

1980s

Opposite: President Reagan initials a wall at a railway station in Ohio during a 1984 whistle stop. Above: President Reagan laying a wreath at Kolmeshohe Cemetery in Bitburg, West Germany, in 1985. American World War II veterans and many other groups angrily denounced his visit to the German Army cemetery, and relations between the U.S. and West Germany became strained as the president received enormous pressure not to go. He stuck to his guns. Pages 238–239: President Reagan kicks off his 1984 campaign in New Hampshire.

REAGAN

1980s

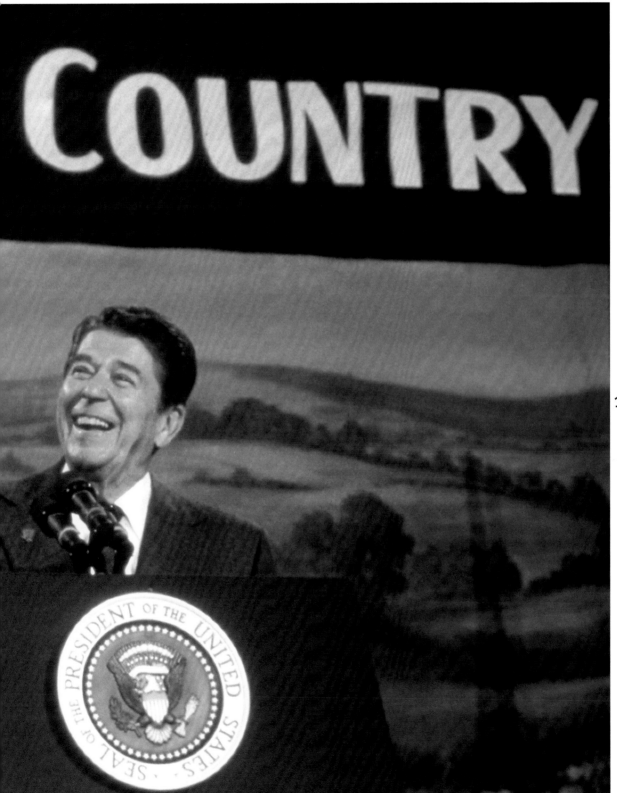

1980s

1980s

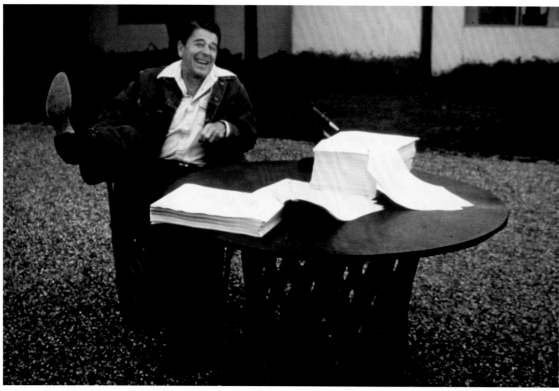

Above: President Reagan on vacation at Rancho Del Cielo, his home in California, in 1984. The president had just finished signing some tax legislation, and, unaware that the microphone was still live, he started to joke about his Star Wars weapons proposals, saying, "Mr. Gorbachev, the bombers are on the way!" The press had a field day with that one. Opposite: The Gipper on a whistle stop in Ohio during the 1984 campaign.

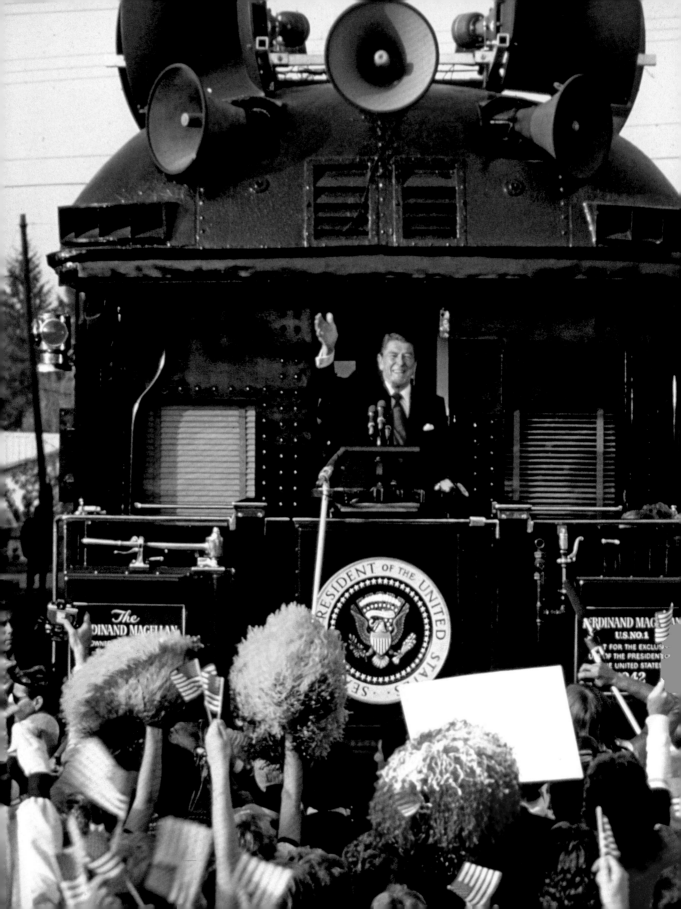

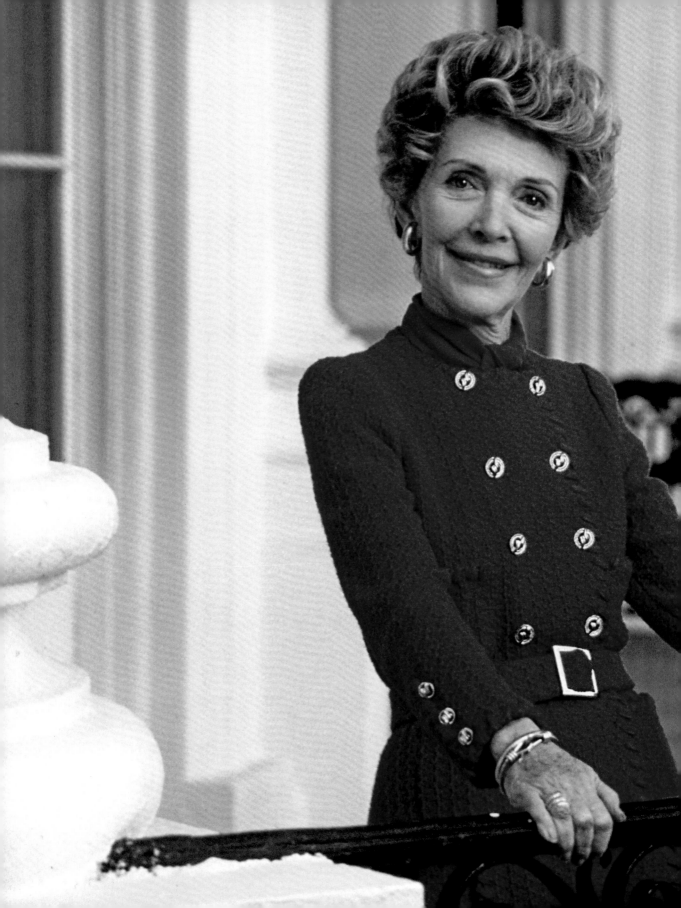

Nancy Reagan in her classic red suit at the White House.

Reagan Second-Term Cover

One of the first things a photographer learns in the news business is the value of just being there. In the weeks prior to the swearing-in of Ronald Reagan to his second term, long-range weather reports projected an exceptionally cold and snowy week of January 20. The buzz in the White House was that Nancy Reagan had no intention of allowing her husband to endure freezing temperatures while taking the oath of office on the capitol steps. One former president had died of pneumonia a week after his inauguration. Normally, an inaugural is covered by hundreds of photographers and reporters. However, if the ceremony were to be moved into the White House, the guest list would be pared down dramatically, with only a small press pool present. In such a case there would be only one newsmagazine photographer present, chosen by the rotating pool system, maintained among *Newsweek, Time,* and *U.S. News & World Report.* According to the rotation, *Newsweek* was scheduled to be the pool on Inauguration Day. Two weeks before the event, I slipped into the White House on a Sunday, a day the magazines did not normally cover the Oval Office, and having checked in with the press office, it was duly noted that I was present for pool duty on the day on which the rotation would have gone to one of the other magazines. By the next day, *Time* had been grandfathered into the rotation sequence—which wound up making me the pool photographer for the inaugural. Sometimes you have to be sneaky at being there.

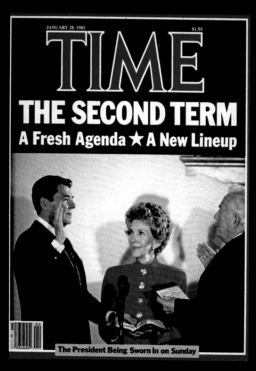

1980s

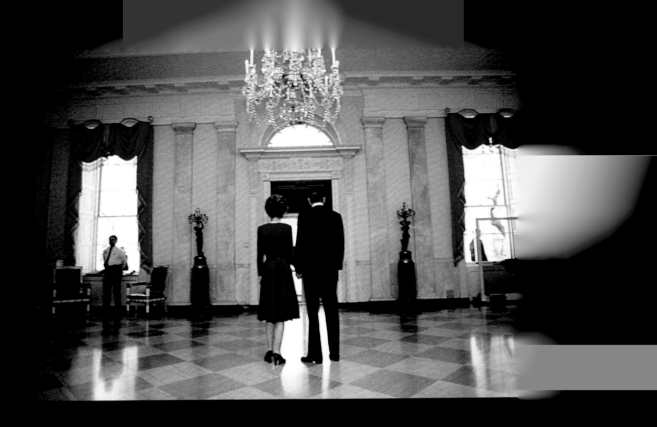

Ron and Nancy's Last Moments

In the fall of 1988, I started a campaign to convince the White House to allow me to chronicle the last few hours of Ronald Reagan's presidency in the White House. I took people to dinner, sent letters, Christmas cards, but to no avail. On Inauguration Day, I was scheduled to ride as a pool member to the capitol in the motorcade. The assembly time for the pool was to be at 10 a.m. I decided to take one last chance to get my exclusive. I showed up at the White House shortly after 7 a.m., to discover the pressroom deserted. I found one White House staffer cleaning up his office. It was our press handler and friend, Mark Weinberg. I went up to him and made one last plea: "Mark, at this point, what can it hurt?" To my astonishment, as he was throwing his personal belongings into a box, he said, "I don't care what you do!" Minutes later I found myself walking down the South Portico with the president of the United States. We rode together in the elevator to the State Floor, where the First Lady was waiting for the arrival of the Bush motorcade. There was a single uniformed Secret Service agent standing duty by the door. The next 15 minutes became one of the most frustrating times of my life because all the president wanted to do was tell jokes. Then the First Lady wanted to tell her jokes. And I was dying—I just wanted to get some pictures during those precious last moments! Finally, as the Bush motorcade drove up the driveway, the Reagans joined hands, turned their backs to me, and finally presented me with the moment I'd been waiting for. Today, if you visit the Ronald Reagan Library in Simi Valley, California, you will see a life-size version of this photograph positioned just outside of

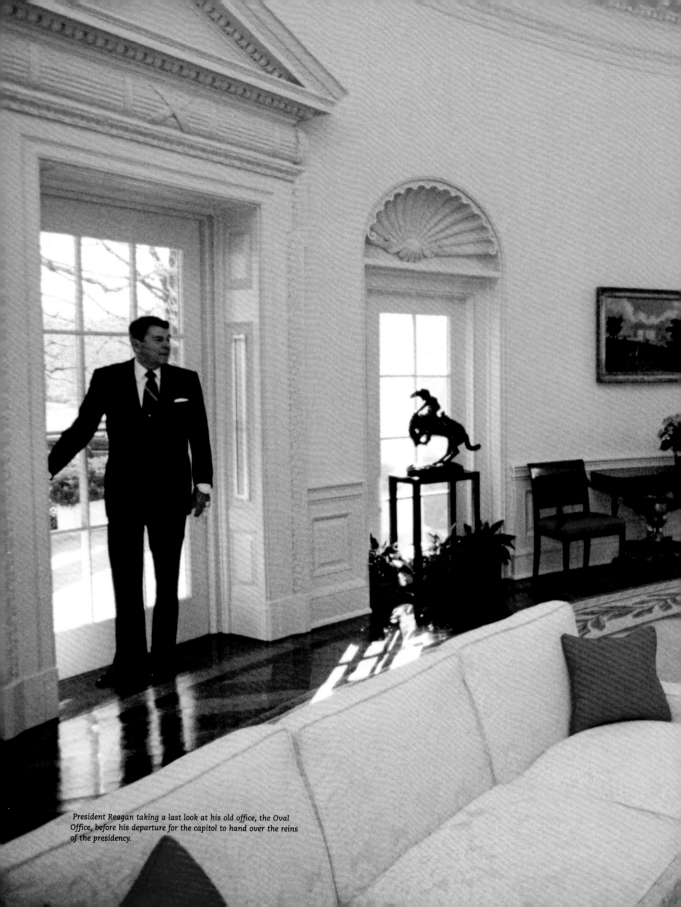

President Reagan taking a last look at his old office, the Oval Office, before his departure for the capitol to hand over the reins of the presidency.

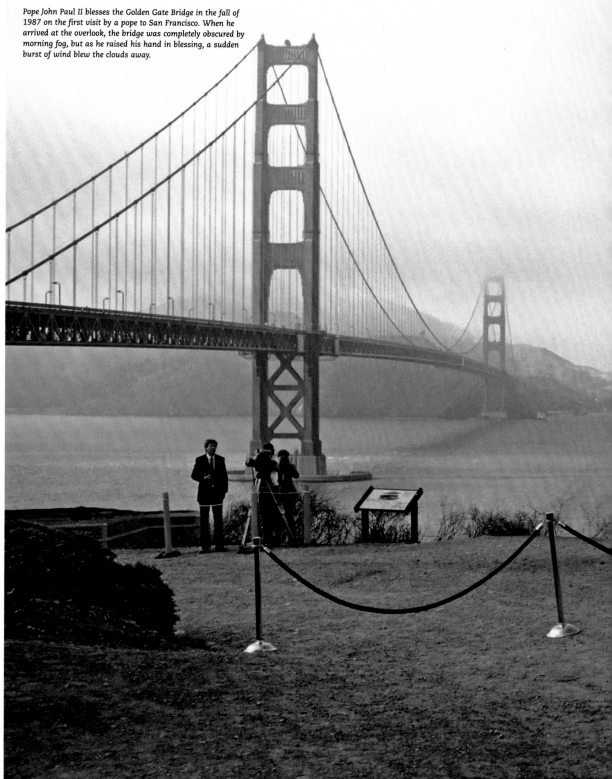

Pope John Paul II blesses the Golden Gate Bridge in the fall of 1987 on the first visit by a pope to San Francisco. When he arrived at the overlook, the bridge was completely obscured by morning fog, but as he raised his hand in blessing, a sudden burst of wind blew the clouds away.

1980s

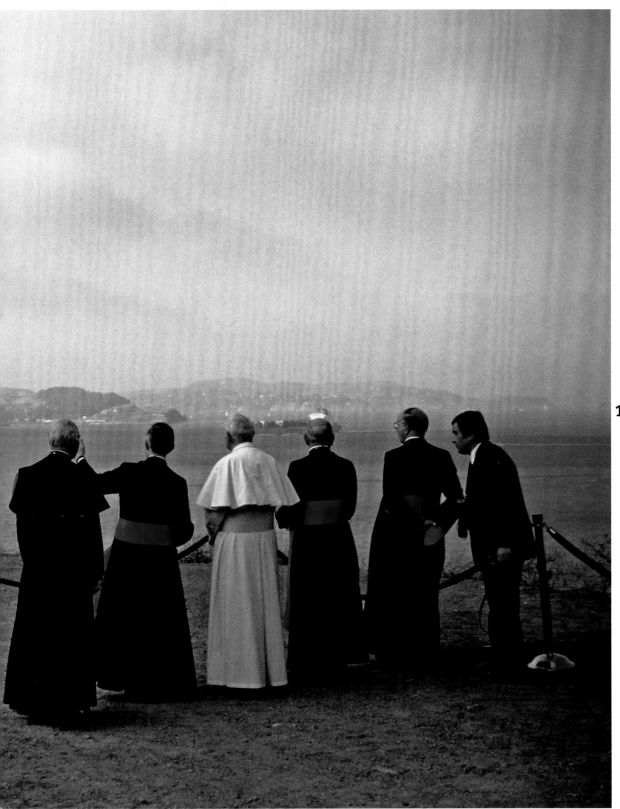

A moment in time can be eerily prophetic. On a cold December day in 1988, Soviet premier Mikhail Gorbachev attended a summit meeting on Governor's Island, New York, with president-elect George Bush and Ronald Reagan. In a month, Reagan would be headed home for California, his presidency over; Gorbachev would soon preside over the dismantling of the Soviet Union; and in slightly more than a decade, those twin towers Bush seems to be pointing at would be gone.

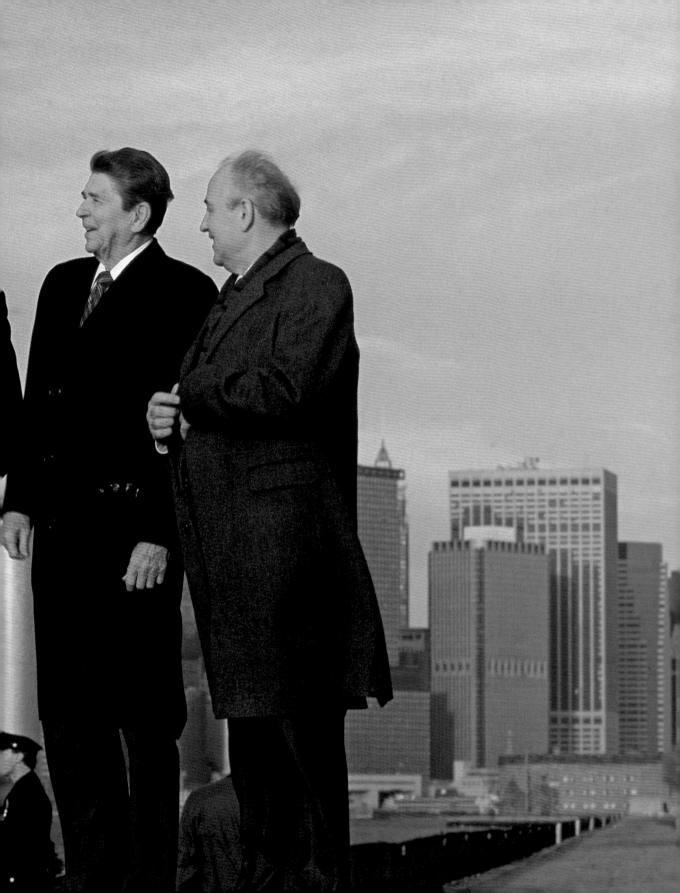

While covering President Clinton's visit to London, *Newsweek* photographer Wally McNamee and I found ourselves parked in a pool bus in front of the Churchill Hotel in Mayfair. The one thing that photographers probably do

most is wait. We sit in pool vans for hours, and to break the boredom we sometimes do mischievous things to each other. It often starts with the words, "Do you remember Grantville Whithers' last appearance?"

Sir Grantville Whithers is one of the most distinguished photographers in the world. A member and former president of the British Royal Photographic Society, he has been an intimate of kings, queens, prime ministers, and presidents. His access to the rich and powerful is unsurpassed.

Grantville Whithers also does not exist.

Nobody knows for sure when he first appeared on the scene of major events around the world, but we suspect he may have been a product of the imagination of photographer Robert Dougherty, until recently the Washington photo bureau chief for the Associated Press. Certainly created out of boredom, Lord Whithers was designed to test the mettle of young photographers on their first presidential trips to foreign lands. At least one of these young upstarts quit the business after an encounter with Whithers. Over time, Dougherty (or whoever the culprit was) found accomplices in spinning his web, including McNamee, and, I must admit, me.

In 1982, Nancy Reagan journeyed to England for the royal wedding of Lady Diana Spencer and Prince Charles. In her press corps were Dougherty, McNamee, and me. Also making his first overseas trip was a young UPI photographer, Chaz Cancellare.

Chaz was the nephew of famous UPI White House photographer Frank Cancellare and had only been covering the White House for a few months. On his first night in London, Chaz found himself tossing and turning in his bed. Shortly after dawn his phone at the Churchill Hotel rang. The groggy Chaz picked it up to hear the following lucid tones of a British gentleman: "Mr. Cancellare? Whithers here! Sir Grantville Whithers. I am a great admirer of your late uncle, Frank Cancellare. We were comrades in the press pool during the war, and his kindnesses to me I must say I have never forgotten. I wonder if it would be possible for the two of us to meet for a bit of tea this morning? I am very near your hotel, and if you could possibly be so kind as to meet me down in your coffee shop in the next half hour, I would be most grateful."

Chaz stumbled out of bed and threw on his clothes to make his way to the coffee shop. For the next hour he sat at a table waiting for his visitor. Finally, he went to the cash register to

inquire if anyone knew of Whithers, and the waitress handed him a note that read, "I'm fright-fully sorry, but I have been detained. I will try calling you in the next few hours." Chaz returned to his room, where he sat by the phone until finally it was time to join the pool for the first photos of the day.

By late that night, a jet-lagged Chaz fell into bed. No sooner had he dozed off than the phone rang again.

"Mr. Cancellare? Whithers here. I must offer you the most abject apologies, but Lady Diana required my presence almost all day, and I'm just now free. I know you must be exhausted, but if you will be so kind as to meet me in the bar, I would like to make you a proposition."

Chaz again got dressed and stumbled into the lobby bar. It was deserted. He sat down at the bar to wait. In a few minutes the bartender handed him the phone.

"Mr. Cancellare, Whithers here again. I'm just so dreadfully sorry for my rude behavior, but I was called at the last minute by the palace, and had to scurry off."

By this time, Chaz was steaming, and he was about to say so when Whithers continued, "Mr. Cancellare, as I told you this morning, I have always felt an obligation to your wonderful uncle, and perhaps, with your indulgence, I have a way to repay my obligation. I must request your utmost discretion on this matter for reasons that I will soon make clear."

Queen Elizabeth and the soon-to-be Princess Diana exchange kisses on the eve of Diana's marriage to the Prince of Wales in July 1981

By now, Chaz didn't know what to think. Whithers continued, "As you may know, as a past official of the Royal Photographic Society, I have been fortunate over the years to obtain the patronage of the palace. As a consequence, I have been privileged to be allowed to put a remotely operated camera in the royal coach as Lady Diana and Prince Charles ride to the palace from the wedding ceremony. My purpose, of course, is to be able to record the event not for commercial purposes, but as my wedding gift to the princess. However, there is no reason why I could not allow your organization to process the film and use the photographs, with the explicit understanding that you may never reveal how you obtained the photographs. You may claim all credit for them, provided that you return the original negatives to me later in the day. Of course, if anyone should discover that such a camera exists, the repercussions would be dreadful. So, Mr. Cancellare, does this offer sound interesting to you?"

Chaz's head was spinning. *Oh my God, the most important exclusive of all time! And it can be mine!*

As Chaz burbled how pleased he would be, Whithers concluded, "Magnificent, Mr. Cancellare. Your uncle would have been very proud."

At this point in our story, accomplices were enlisted. The first was Charlie McCarty, who was then in charge of UPI pictures in Europe.

After another sleepless night, Chaz called the London UPI bureau to tell them about the good fortune that had befallen him.

McCarty, who took the call, was suitably impressed, but he warned Cancellare, "Don't let this one fall through your fingers, kid!"

For the next few days, Cancellare was, to say the least, distracted.

Another accomplice who was drafted was Brenda Draper, the London picture editor for *Time*. Brenda became Grantville Whithers' loyal secretary, who was now calling Cancellare regularly with updates on his movements and on the reasons that Whithers kept missing his appointments—all involving the pressures of conferring with the royals at their country estates.

As the wedding day approached, Cancellare was becoming frantic. No matter how hard he tried, he kept missing Whithers. He would pace back and forth in his hotel room, not going out for meals, and he began to see his future slipping through his hands.

In desperation he called the UPI bureau, and this time reached Ted Majeski, the pictures' managing editor. Majeski had not been alerted to the scam and had no idea that Whithers was a fabrication. Chaz blurted out that no matter how hard he had tried, he had been unable to get back to Whithers to make the final arrangements.

Majeski suspected that another organization had somehow gotten wind of the big exclusive and made a better offer. At this point, afraid that UPI would be scooped, he called the palace press secretary to demand access to Whithers' photographs.

Now Scotland Yard was called onto the case. Who was Grantville Whithers, and how had he managed to infiltrate the royal coach? Calls went out from Scotland Yard to all news organizations trying to find out who this Grantville Whithers was dealing with.

I got a panicked call from Brenda Draper, whom had been called into the office of *Time* bureau chief Bonnie Angelo to find out what she knew about this plot. Her instructions were to get the exclusives for *Time* and, if that couldn't be done, to expose Whithers.

Now that the royals, Scotland Yard, and all the news organizations were frantically trying to find Whithers—and Chaz Cancellare was near nervous exhaustion—Whithers decided to disappear. And he hasn't been heard from since. Incidentally, Chaz Cancellare eventually went on to law school, and today he is an attorney, specializing in fraud cases.

After the Fall

In the decades following the fall of Saigon, I returned to Vietnam three times.

In 1985, I was allowed to visit the scenes of major battles during the war. This photograph was made in a tunnel in Cu Chi, which ran under the U.S. air base at Bien Hoa. The Vietcong had tunneled for miles under the base, and had built headquarters, rest areas, and even a hospital right under the Americans. Today the complex is a major tourist attraction. On my visit, I found this guide, who had fought the Americans from the sanctuary of the tunnels in the early 1970s. Frank Johnson, a photographer for the Washington Post, accompanied me. At that time there was no lighting in the tunnels, so I brought along a set of portable strobe lights, and set up one in the jungle over an air hole, and another at the entrance of the tunnel. I went in first, and since there was room for only one of us at a time, Frank watched from outside in utter frustration as my strobes popped, lighting the tunnel (he had not brought lights). When I emerged, I took pity on him, told him he could use my lights, and handed him the remote trigger device. The following January, Frank and I had competing portfolios in the White House News Photographers Photographer of the Year competition. I did not include this photograph because I thought it was hokey. Frank, on the other hand, had, and the judges decided that anyone nuts enough to drag strobes into the jungle deserved the award and gave it to him.

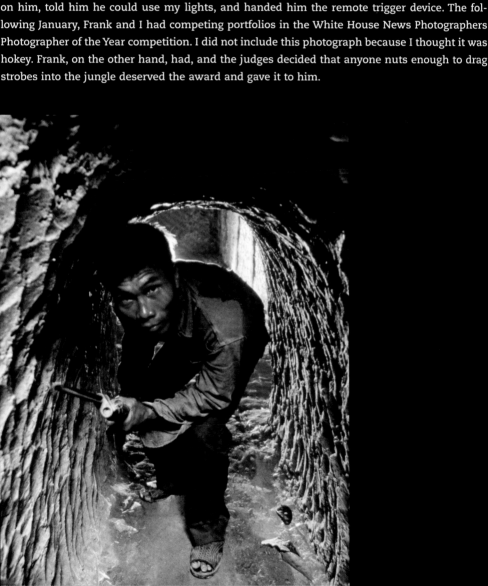

The Time *pictures staff in Beirut during the summer of 1982.*
From left to right: Robin Moyer, Bill Pierce, Catherine Leroy, me,
Olivier Rebot, and an unidentified photographer.

Beirut Bombing

One of the mottos of combat photographers is "Don't screw around!" A pro will always evaluate a dangerous situation before jumping into it. This doesn't mean that the unexpected won't happen, of course, but anything you can do to give yourself an edge on survival is worth it. After spending two months running *Time*'s photo coverage of the siege of Beirut during the summer of 1983, I was due to hand off the bureau to my replacement, Rudi Frey, who was arriving from Rome. I was to leave by fast car to Damascus late in the day, once Rudi was in place. That morning, I decided to take one last look at the Beirut seafront. I climbed to the fourth floor of a building under construction overlooking the Corniche. Legendary war photographers Don McCullin and Catherine Leroy accompanied me. As we were climbing the stairs to a room from which the wall had been blown away, Israeli jets, ships, and artillery opened fire on the city in a sustained assault. Shells were impacting scores of buildings along the Corniche. It seemed to me that the hits were getting closer, and at the same time I noticed McCullin appear below us in a red shirt on the deck of a swimming pool. I watched, horrified, as shells began to "walk" across the water toward McCullin. They were firing at McCullin! At right, you can see smoke rising from an amusement park Ferris wheel that was just below our building. In the next split second a shell hit the floor just above our heads, raining debris down on Catherine and me. We tumbled down the four flights of stairs and staggered out of the building, covered in dust. Catherine was beaming. She yelled at me, "Dirck, did you get it? What a great picture!" I answered her, "Well, yes, Catherine. And you know what? I had a POLARIZER on my lens!" Her Gallic reply is unprintable. The picture, the last I took of that war, made the cover of *Time* the following week, but I knew I had tempted fate with that one.

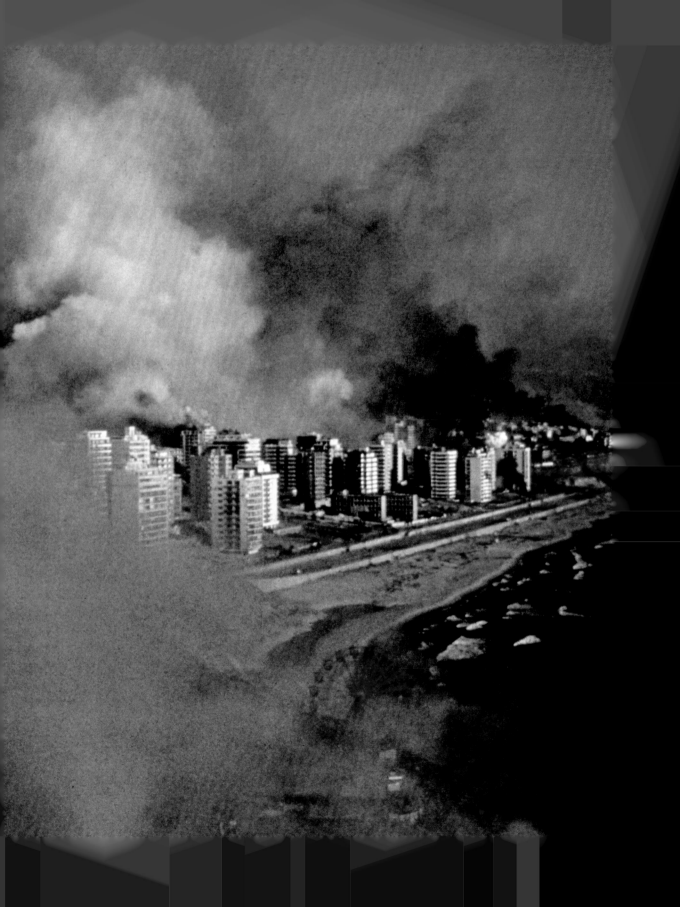

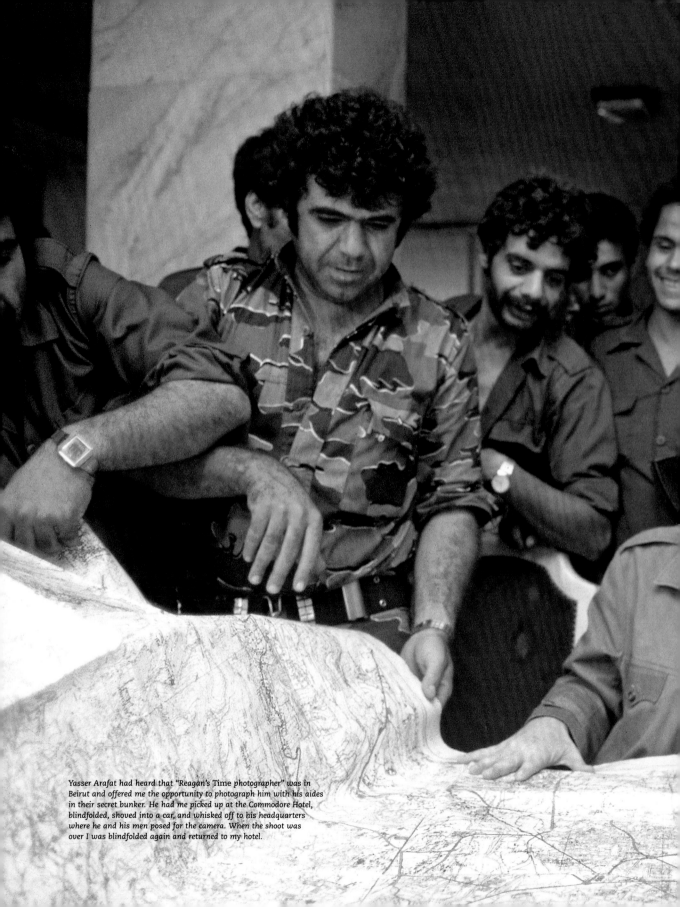

Yasser Arafat had heard that "Reagan's Time photographer" was in Beirut and offered me the opportunity to photograph him with his aides in their secret bunker. He had me picked up at the Commodore Hotel, blindfolded, shoved into a car, and whisked off to his headquarters where he and his men posed for the camera. When the shoot was over I was blindfolded again and returned to my hotel.

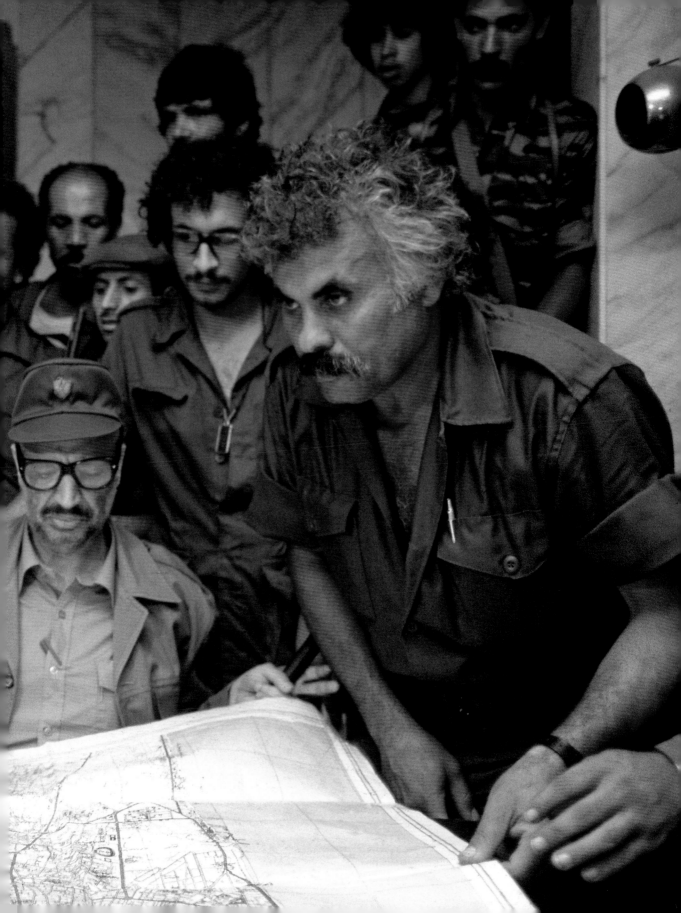

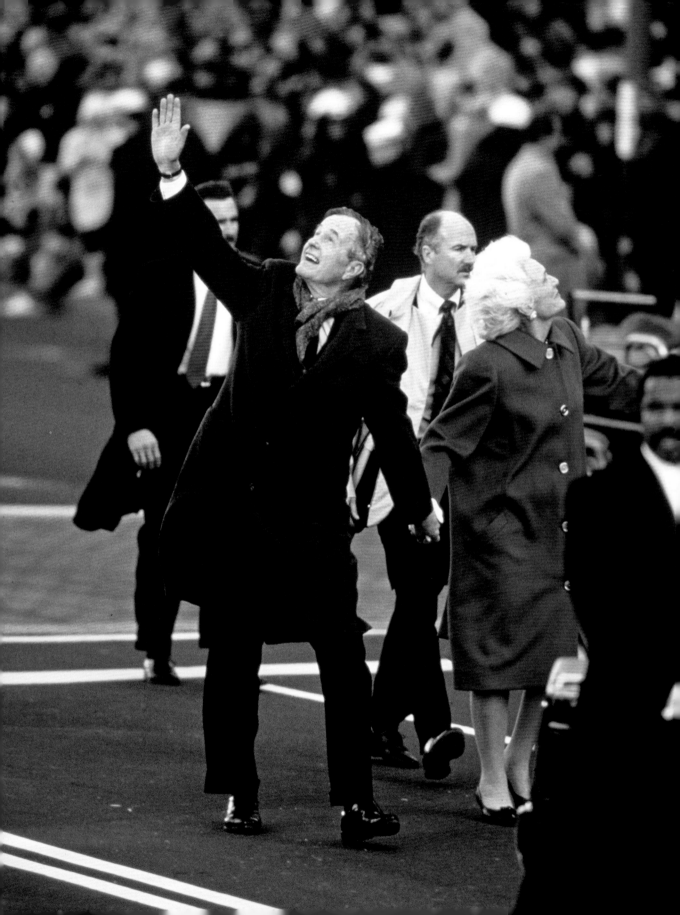

Photographers are not supposed to take sides. Our job is to objectively report through our images the character of the people we are covering. But with George Bush, or "Poppy" as he was affectionately called by his family, it was impossible to not like the man.

Part of it came from the simple fact that he liked us, the photographers who followed him wherever he went. He considered us to be impartial observers with no agenda (unlike many of the reporters), therefore he was always more relaxed around us.

1980s

He had a wonderful sense of humor and often poked fun at himself. And we soon realized, much to our delight, that he had a knack for offering us what could only be called goofy moments, which we found to be utterly endearing. The images of these moments never became cheap shots for us.

Over the years, Bush and I kept in touch. Once, when he was president, I couldn't resist sending him a postcard from Havana, Cuba, where I was covering Pope John Paul II's visit. I wrote, "Having a wonderful time—wish you were here" and got a kick out of imagining the consternation it would cause in the White House mail room.

He remembered details about my exploits, too. During a summit meeting in Brussels, as a group of photographers and I circled the table full of world leaders, he grabbed me as I passed behind him and told the president of France and chancellor of Germany: "You see this guy? He just talked Sylvester Stallone off a cliff!"

I learned early on that if I wanted to do a project on Bush, I would never under any circumstances use the argument that it was to record his legacy. He had absolutely no patience whatsoever for such grandiose sentiments. In his mind, he was simply doing his job.

So, at the end of the day I'm not exactly an impartial observer of the first Bush presidency. For the White House News Photographers' Association dinner in 2002, at which I was honored with a lifetime achievement award, Poppy sent a videotape to be played to the audience. In it he said he still couldn't figure out why I had creases in my blue jeans.

The president and Mrs. Bush wave to the crowd as they walk down Pennsylvania Avenue toward the White House after his inauguration in January 1989.

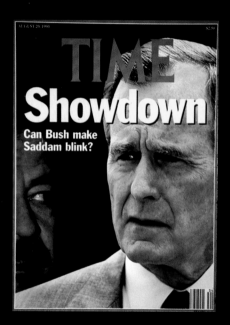

The War Decision

In August 1990, Saddam Hussein invaded Kuwait. I didn't recognize the George Bush who returned from Camp David that weekend. There was a look about him that was absolutely frightening. When a reporter asked him what he was going to do about Saddam, the president barked, "Just watch and wait!" Six months later, with coalition troops poised on the border of Kuwait, the president was prepared to deliver an ultimatum to Saddam to withdraw his forces or we would attack within 24 hours. I was just barely able to see the president at his desk in the Oval Office from my position in the Rose Garden. Suddenly, Secretary of State Jim Baker entered the office to tell the president that Russian President Mikhail Gorbachev was on the phone, begging for a delay in the announcement. I squeezed off a few frames through the windows with my handheld Canon 300mm 2.8 lens, as Bush rejected the Russian plea. This was the moment of decision that led to the first Gulf War, Operation Desert Storm.

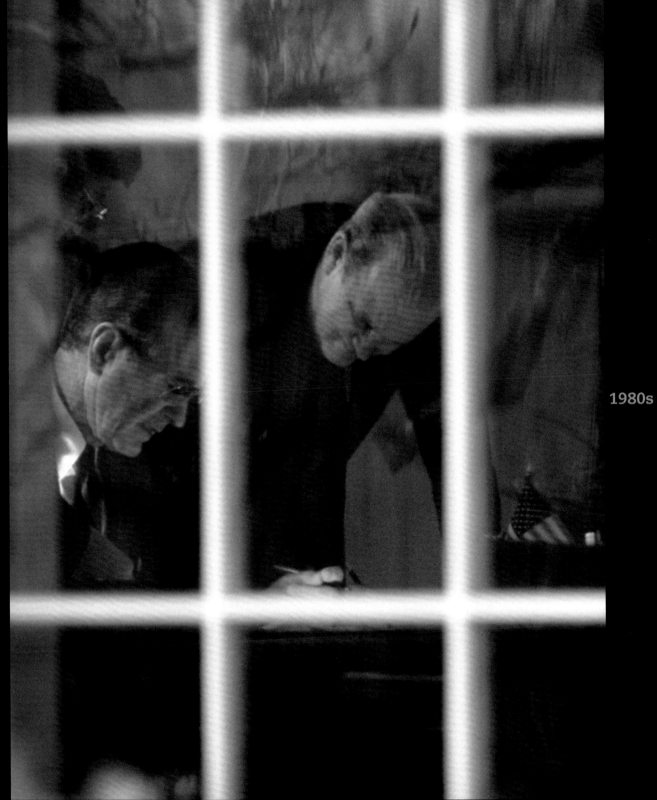

1980s

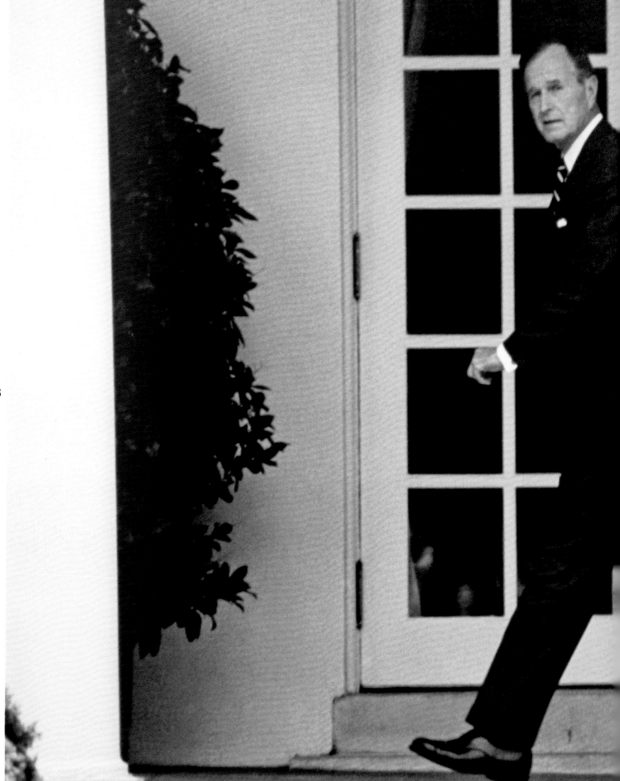

1980s

1980s

Pages 264–265: President Bush was the master of the goofy gesture. Here he's just playing to my camera. Above: At a fund raising event in Washington, Bush mimics playing a guitar. Opposite: President Bush considered himself to be the inventor of "power golf." His average time to complete an 18-hole course was just over two hours. He was not above moving his lay when no one was looking or pushing the ball into the hole. Pages 268–269: President Bush in Virginia in the last week of his 1992 campaign. Pages 270–271: Campaigning in Virginia on a hot September day in 1992, President Bush was having just too much fun. As the band played, he strode through the crowd and held up a Barbara Bush doll that a member of the audience had given to him.

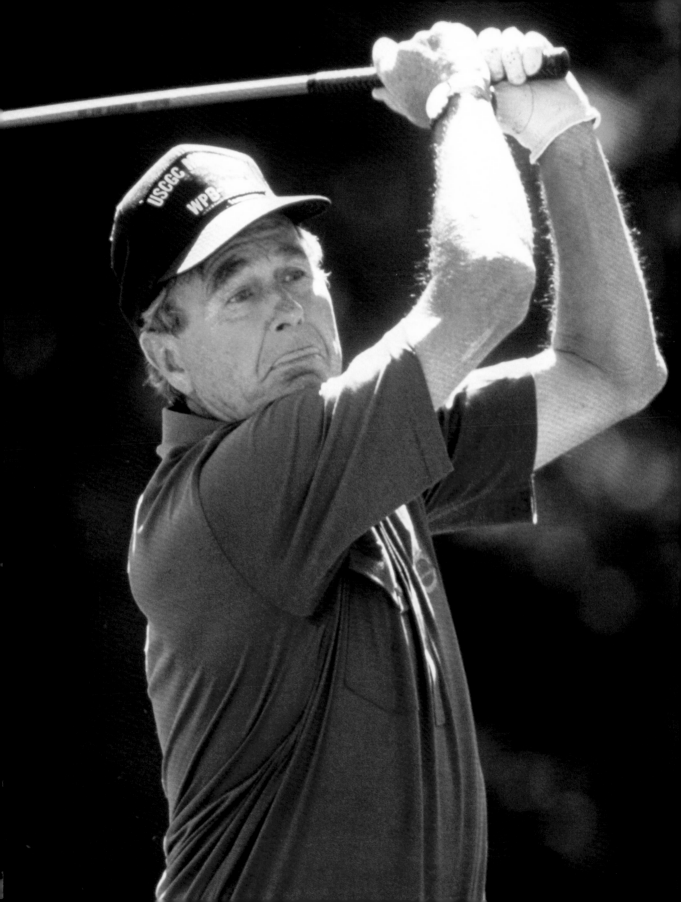

1980s

1980s

George Bush at the Cash Register

Sometimes pictures really do lie. This picture of George H. W. Bush at a cash register at a grocers' convention in New Orleans was at least partly responsible for his losing his re-election bid in 1992. Bush was being shown some new technology in scanner design when a reporter in the press pool cracked, "Look! He's never been in a supermarket!" That line made it into the pool report and was picked up by newspapers along with the photograph. It became symbolic of how out of touch with the American public the president had become. It wasn't fair, but then who said politics was fair?

Opposite: A few days before the 1988 election in Columbus, Ohio.

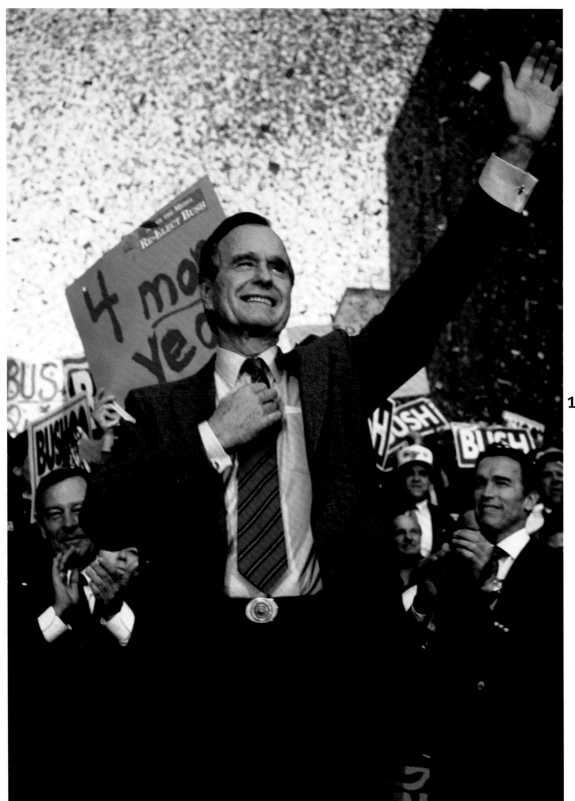

1980s

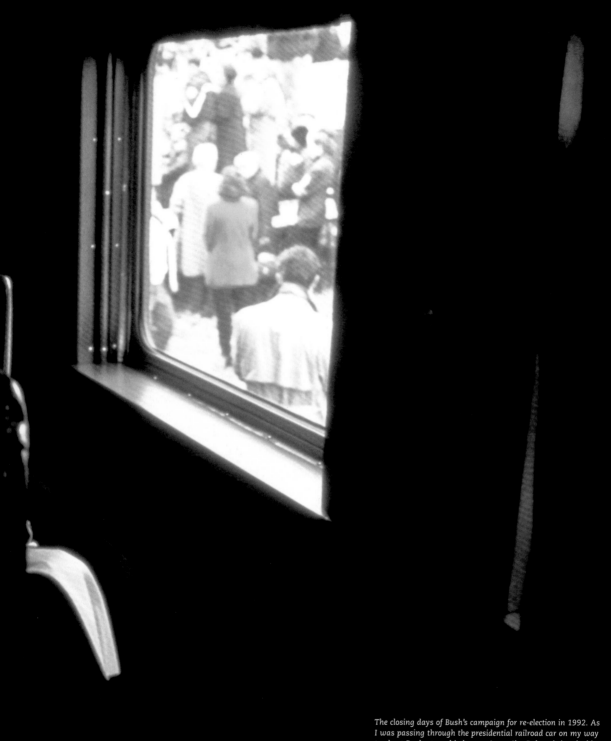

The closing days of Bush's campaign for re-election in 1992. As I was passing through the presidential railroad car on my way to shoot Bush at a whistle stop, I saw Jim Baker sitting, looking stunned and staring off into space. I realized then that something must have just happened, and I made up my mind that if he was still sitting there on my way back, I would take a picture. When I returned he was still there, silent and staring. In his hand was a note with the latest poll results showing Clinton breaking away to certain victory.

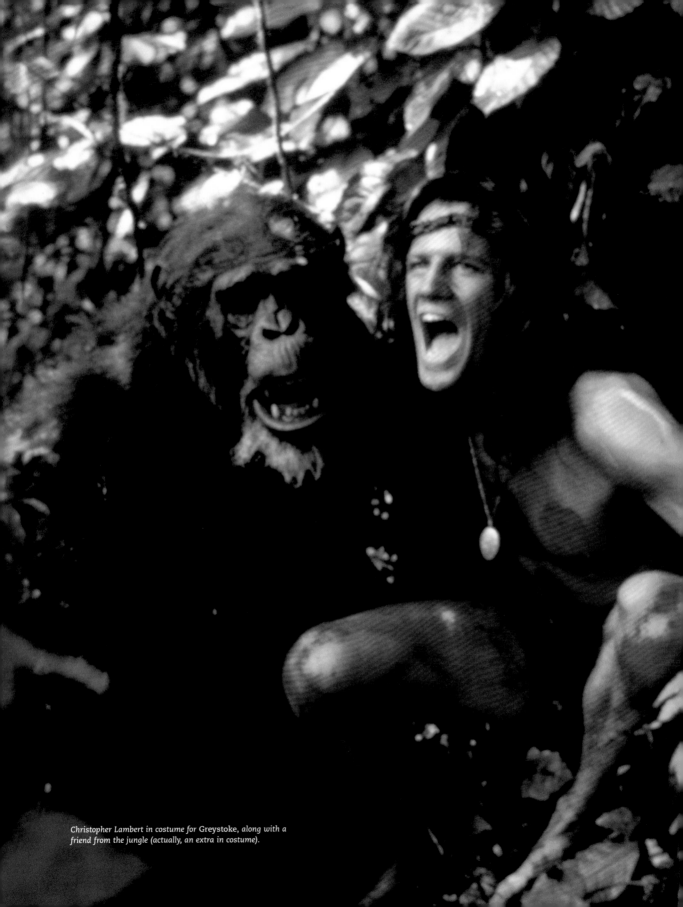

Christopher Lambert in costume for Greystoke, along with a friend from the jungle (actually, an extra in costume).

Someone once said that Washington is Hollywood without the talent. ▪ Actually, that's not a bad description. Both are company towns. Both hold an enormous influence on our daily lives.

Back in the late sixties, while I was with UPI in New York, I was invited by 20th Century Fox to become a "special" photographer during the filming of *Patton*, starring George C. Scott, which would be filmed in Spain. I spent a month behind the scenes on the sets and in the snows around Segovia while the filming progressed. It was my first encounter with the peculiarities of movie stars. On the first day of filming in a castle, which was decorated to look like Patton's European headquarters, we were to shoot a scene halfway through the movie in which the general is relieved of command after slapping a soldier, an incident that actually happened.

The call was for 8 a.m. on a Monday morning. Scott was already supposed to have been in makeup for several hours. By noon, there was still no sign of the actor. Five hours later, with still no sight of Scott, filming was suspended. The next day the same thing happened. By Wednesday, with Hollywood threatening to close down the film, producer Franklin Schaffner was frantic.

It turned out that Scott had a drinking problem. Sometimes, when faced with the start of a project, he would begin binge drinking. Members of the film crew had seen him staggering off to bed at six in the morning. Schaffner issued an edict: anybody caught drinking with Scott would be fired on the spot. By Thursday, the actor was on the set and did an amazing job with a critical scene.

The worlds of Washington and Tinseltown converged for me while I was covering the administration of Hollywood's own Ronald Reagan. His long, lazy summers spent at "the Western White House," his ranch in Paso Robles, California, left me with little to do, so I started driving down to Los Angeles to show my portfolio to the movie studios.

At Warner Brothers Studios I met Rob Friedman, who was then in charge of advertising and publicity. He looked at my book, full of all my *Time* covers, and said, "Don't you ever shoot for little magazines?" By the time I left his office I had an assignment to shoot their big location movie *Greystoke* in Africa.

That was the start of nearly two decades of working on major films. Over the years, that included such companies as TriStar, Paramount, and Universal.

My job was to do what the studios call "special photography." On the film there is always a unit photographer who works for the production. His or her job is to record every scene, showing up with the camera department and working until the film wraps. Most of these photographers are terrific. They have worked on films for years and know how to do it.

sometimes even after the film is completed, to shoot photographs that can be used for the posters—one sheets—or to get pictures that magazines can use. Among the best-known specials are Douglas Kirkland, Annie Leibowitz, and Greg Gorman.

One of the challenges in shooting films is that, because everything is done for the motion picture camera, takes are shot from the standpoint of action and reaction. In other words, one shot will have one actor challenging another actor; the next shot will have the reaction. Photojournalists try to get action and reaction in one shot. The best example is the environmental portrait, in which you have a subject in the foreground and the setting in the background. So what the special is asked to do is to combine elements into one graphic image. To do this, the photographer will often set up a studio somewhere on the set, where the artists can come in and pose for the still camera.

Working on movies requires a bit of savvy. As in covering the White House, one deals with very powerful people who are surrounded by a crew whose job it is to make the movie work. From the moment the photographer enters the set, everyone is aware of his or her presence. Film crews are families. They work together for months at a highly professional level. Any stranger who comes into their midst can be instantly disruptive.

I quickly learned that my job as a special was the least important one on the set. Everybody else had a job to do that was needed to produce the film. My role was insignificant. Yet I had to produce photographs. The most important person to a special is the assistant director; it is crucial that his or her support be enlisted. Also, because crews are families, everyone must be treated with respect. These people go around the world from project to project. If you have pissed off one crewmember somewhere, sometime, it can come back to haunt you. You are either good news or you are gone.

Janine Turner poses for a shoot I did on a day off from filming Cliffhanger *in Italy.*

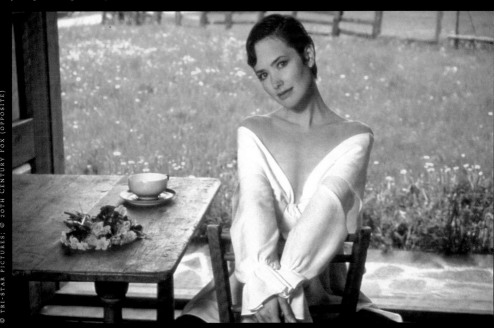

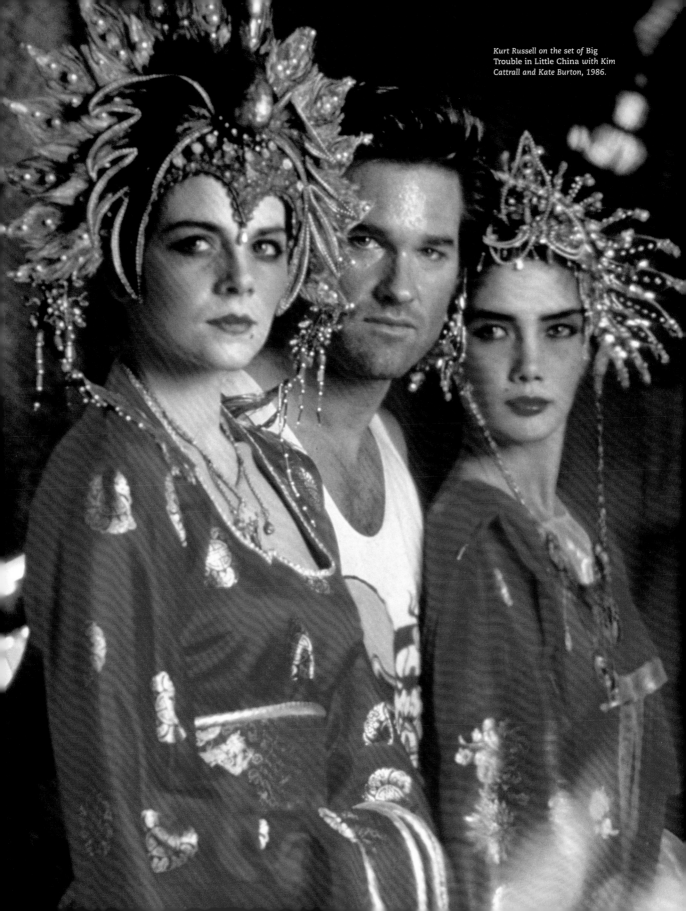

On sets, a photographer walks on eggshells. This is not the place to talk about the great stories you have covered in the "real world" or to make jokes. In fact, the less said the better. You must be aware of where the camera is at all times. It changes in the blink of an eye. It is also vital that you be tuned in to tensions on the set. Is the director in trouble? Is the star in a bad mood?

So back to *Greystoke*, a big-budget film about Tarzan that was being filmed in Cameroon. The first thing I had to do was to meet with its director, Hugh Hudson, who had just won an Academy Award for his film *Chariots of Fire*.

After meeting with him in London, it was agreed that I would show up for a charter flight from London to Cameroon several months later. In the meantime, I covered the siege of Beirut, which resulted in a *Time* cover.

Eventually arriving on the set of *Greystoke*, I was taken aside by Hudson and told, "I want you to imagine you are on a plane on the way back from Beirut, and it crashes in the jungle. You see something. It may be a man or an animal. You take a picture. But you don't know what it is. . . . That is how I want you to shoot this movie!"

He was serious. He was shooting the movie in chronological order (which nobody ever does). His reasoning was that no one would know what Tarzan looked like until he arrived in London a decade later. So for the next two weeks I took pictures of Christopher Lambert, who was playing Tarzan, through branches, trees, leaves—anything that would obscure who he was.

When the inmates are in charge of the asylum, it is best to be just another inmate.

Opposite: A so-called one sheet for Boyz N the Hood, *1991.*
Below: The women of Tai-Pan, *from left: Kathy Behan, Janine Turner, Kyra Sedgewick, and Joan Chen.*

While photographing on the set of the final Star Trek movie in 1991, I decided to do a portrait of the original cast. I picked the main parking lot at Paramount studios for a location—it can be flooded to create an ocean set with this "sky" background painted on the side of the main building. After wrapping their last scene, the cast, still in their costumes, ascended a stage I had built. At the same time, word about the shoot spread through the studio. The parking lot filled with hundreds of employees, and when I finally finished the shoot, the crowd broke into applause and tears. It was the end of an era.

Above: Director David Lynch in the Sonoran Desert shooting Dune, 1984. Opposite: Sting on the set of Dune. During this entire shoot in Mexico City I was suffering from shingles. The main job of the publicist was to bring me shots of tequila to kill the pain as I worked.

Above: Angelica Houston on the set of The Grifters, 1990.
Opposite: Talk about difficult! Can you imagine how hard it is
to get ten actors and a dog to hold still while the crew moves the
B-17 bomber out of the picture?

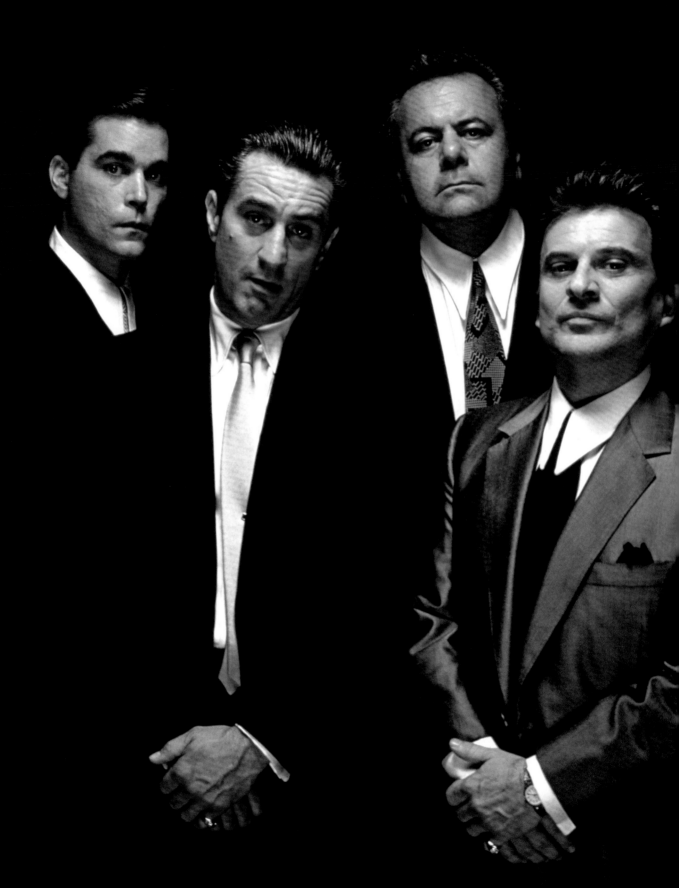

Goodfellas

Whenever I am assigned to photograph on a movie set, the first thing I set out to do is find a place nearby to set up my own little studio. My job is to interpret a film, not to document it. On my first visit to the set of *Goodfellas*, which that night was being shot in a huge Brooklyn restaurant and dance hall, I found a small storeroom filled with red tablecloths. I decided to tape one to a wall as a backdrop. In a way, that first act dictated the shoot. I pay particular attention on film sets to how the director of photography is lighting the film, and I make that mood the starting point for my own lighting. In this case, I placed one large light box, hanging from a boom seven feet over the floor, aimed straight down. During a meal break at midnight, the assistant director was able to get the cast—Robert DeNiro, Joe Pesci, Ray Liotta, and Paul Sorvino—into my little studio. After a long day of shooting they naturally fell into character and into this pose. Next I added a white card reflector pointed up at knee level, took the Polaroid, and showed it to them. They saw that I got "it" and relaxed into a wonderful session that resulted in the one-sheet for the movie and countless magazine covers.

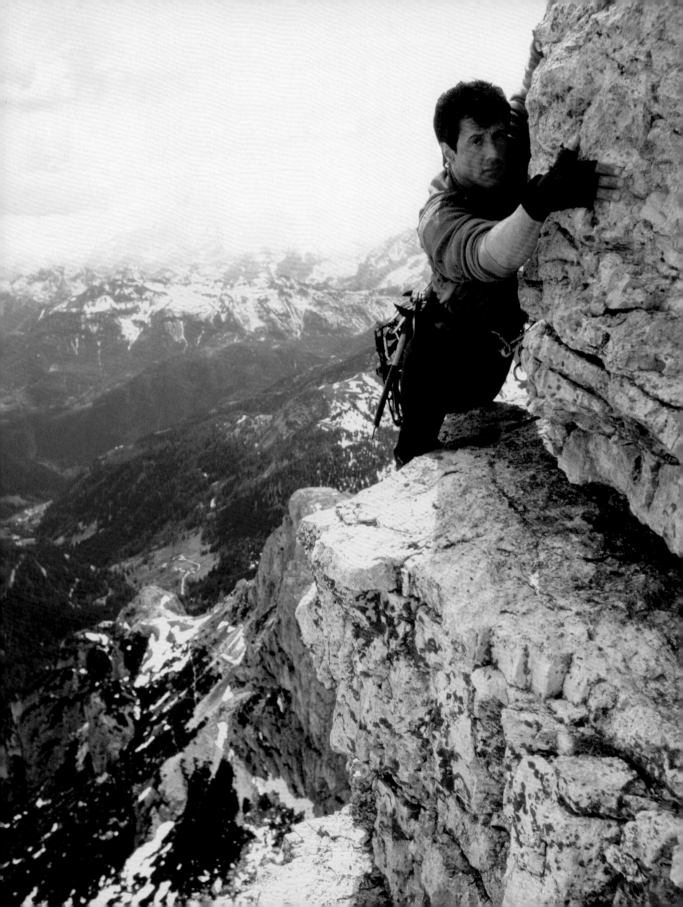

I received a call from Tony Seininger, one of Hollywood's favorite art directors. He wanted to hire me to work on a picture for TriStar. It was *Cliffhanger*, starring Sylvester Stallone. The main photography was to be

done on location in the Italian Alps. They would serve as stand-ins for the Rockies, where the story was supposed to take place. Filming was to be done in early March, when the mountains were still covered with heavy snow.

Tony sent me a pencil sketch of the scene that interested him for the poster. It showed a figure, intended to be Stallone, coming around the side of a cliff. He was holding a huge gun in his hand (never mind the fact that he never used one in the movie).

En route to Venice, I looked at the drawing and thought, *How hard can this be? It's just a guy coming around a rock!*

My first day on location I scouted the site—a plateau roughly a quarter of a mile long and several hundred yards wide. It was about 3,000 feet above the valley floor and could only be reached by a cable gondola. The temperature was in the teens, with light blowing snow. It quickly became apparent to me that there was no rock in sight—just lots of snow. During my week there, all filming was scheduled to take place on this plateau.

Opposite: Posing for my camera, Sylvester Stallone hangs off a cliff thousands of feet above the valley floor in the Italian Alps. Left: Art Director Tony Seiniger's sketch, the inspiration for the shoot.

Above: On location in the Italian Alps. Opposite: I am standing on the top of an outcropping of rock less than 3 feet in diameter (at far right, holding the camera), as Sly makes his way across the cliff face.

After I had explained to him what I needed to do, one of the mountain safety guides assisting the production company said, "No problem, just come over here." He led me to the edge of the plateau and told me to look down.

At this point, I have to tell you this: I am no mountain climber, nor do I have any urge to push the limits at great heights. I have never been able to figure out why skydivers feel the need to jump out of a perfectly good airplane.

Lying on my stomach, I gingerly inched my way to the edge and looked down. The guide said, "See that little outcropping a hundred feet below? Well, if you will climb down there, maybe we can talk Sly into climbing down there too."

I looked at the outcropping. It was a small area, roughly four feet wide and separated from the plateau by a distance of about six feet. Surely I would have to sprout wings to get to it.

"Not to worry," assured the guide. "We can put a harness on you, and help you down the side, and when you get even with the outcropping, you can just swing over." "*Swing over?*" I blurted in disbelief. Tarzan I'm not, and besides, those trees in the jungle were only a few feet tall—not 3,500 feet straight down!

The guide shook his head and left me alone to ponder the situation, which I did for the next hour. No matter how hard I looked around the top of that plateau, there was no goddamned rock!

Finally, I asked the guide if he could make absolutely sure I wouldn't fall. He replied with confidence, "No sweat." Well, we all know photographers will do *anything* to get the picture, so a few minutes later, there I was, crawling over the side. It was like going over the side of the Empire State Building.

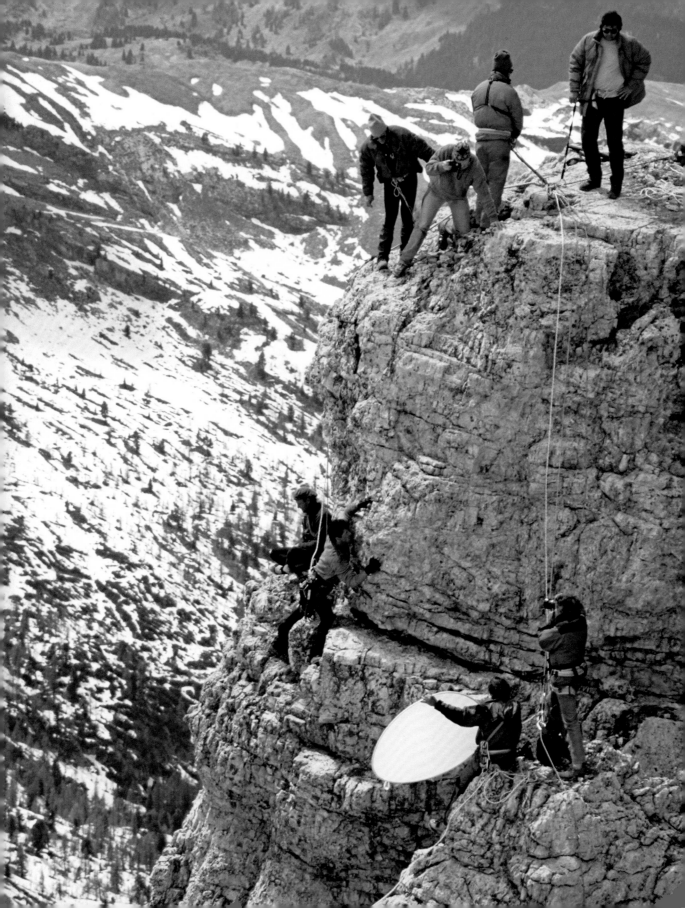

Yikes! This was my introduction to rock climbing—at 3,500 feet with no net. The top of the cliff, as is often the case, extended out over the side. So for the first ten feet, it was necessary to climb down the overhang, at roughly a thirty-degree angle to the cliff face. When I looked down, there was *nothing* under my feet. Any illusions I had that they would lower me down quickly vanished. This was fingernail dig-in time!

Very cautiously, with the help of the guide, I managed to make it down the hundred feet, until I was level with the top of the outcropping.

The moment of truth had arrived.

The guide yelled for me to do exactly what he did. Then, pushing himself away into space, he swung across the top of the outcropping. *He missed!* . . . *Here he comes, back!* . . . *Whop!* Right into the side of the cliff. I yelled to him, "I thought you said this was easy!" Muttering, he said something about not giving himself enough slack. On the next try, he was successful. He then called to me, "Come on over!" Clenching my teeth and cursing under my breath, I pushed away and *made it!*

For the next half hour, I just sat on top of that little piece of rock, afraid to even stand up. But the late afternoon shadows were beginning to fall, and I realized that I would have to get some shots soon. The guide swung back to the cliff face, and for the next few minutes pretended to be Stallone, inching around the side of the cliff. I shot tests with my Bronica, and sent them back up to the top of the plateau, where my assistant ran them over to Sly.

Another half hour went by. It was getting dark now, and snow was beginning to fall. The wind picked up and cut through my parka like tiny knives. About that time, I heard a bellow from a hundred feet overhead . . .

"YO!! YOU'RE OUT OF YOUR FUCKING MIND!!"

I looked up at Sly, only to see him turn and walk away.

Guess that means I'm not going to get my shot today, I mumbled to myself, as I managed to swing back and climb to the top of the plateau.

Arriving on the set the next morning, I saw Sly pacing back and forth at the edge of the plateau. Suddenly I realized—I've got him! So during the lunch break, I went to his tent and showed

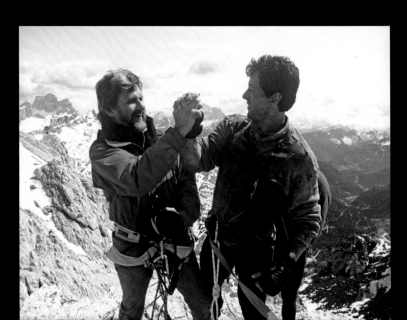

Sly and I, glad we made it through the shoot without falling off a cliff!

him the best Polaroid. It was a spectacular shot. The guide was big in the frame, with that 3,500-foot drop behind him.

Pushing my luck, I told Sly: "You know, what's so great about this shot is that not only is it going to be one of the best advertising shots ever made for a film, but it can only happen if you are willing to risk it. No double this time, it will be you hanging out there for real."

He bellowed, "GET THE FUCK OUT OF MY TENT!" But I just knew there was no way Sylvester Stallone was going to let some wiseass photographer show him up.

Sure enough, later that afternoon, I watched Sly stalk over to the safety people and ask the same question I had asked the day before: "Are you sure this is safe?"

After a less-than-certain-looking guide, seeing his future in show business vanish before him, nodded in the affirmative, Sly barked, "Well, let's get it over with!"

While I slipped back over the side, displaying my newly found, yet tentative, confidence, Sly buckled himself into his harness. Before the now-terrified director, Reny Harlin, could get to him, Sly too, was over the edge.

Harlin, along with Sly's personal trainer, started screaming, "Sly, are you *nuts?* This isn't even the movie; you're doing it for a still!"

With his guide by his side, Sly managed to make it most of the way down the cliff, but in his path, another outcropping meant that he would have to push out from the cliff face himself. I was ten feet away, atop my little rock, and I could hear that he was having problems. I yelled to him, "Hey, Sly! Would Neil Leifer do this for you?" I was referring to our mutual friend who had photographed Stallone on several films.

Sly stuck his head around the side of the cliff, to see me balancing on one foot, cameras around my neck, pretending to be some sort of daredevil. I must have been quite a sight. Well, he just broke up.

Pulling himself into position, snow swirling around him, and clad only in a shirt, Sly patiently posed for the next twenty minutes on the side of that cliff.

As the sun went down over the mountain, we clambered back to the top. A jubilant Sly Stallone and I high-fived each other—we got the picture!

Postscript

The next morning, Sly's trainer, Tony, came up to me on the set. He said, "I have to thank you." He explained that Sly had gone through a series of movies that had not performed well. It seemed that because of this, during the first weeks of filming *Cliffhanger*, Sly just hadn't had the macho bravado he normally demonstrated. "Last night, going over that cliff was all he could talk about," Tony said. "You know what, My Sly is back!"

I would like to say that there is a happy ending to this story, but it turns out that this photo session probably cost TriStar a lot of money. Sly had become so pumped over this short but daring adventure that he insisted on rewriting and refilming almost all the shots he had done before. This time, however, he would be on the cliff—not his double. The shots of Sly hanging on the side of the cliff at the opening of the movie are real.

Unfortunately, when TriStar tested *Cliffhanger*, prior to its release, their research data showed that people liked the movie, but that because of previous pictures he had made, they weren't sure they wanted to see Sylvester Stallone.

As a result, in the original ads, they dropped Sly's image from the above-the-line advertising, and used a silhouette of an anonymous figure leaping into space.

But I know, and Sly knows, and now you know, what we accomplished that day in the Italian Alps.

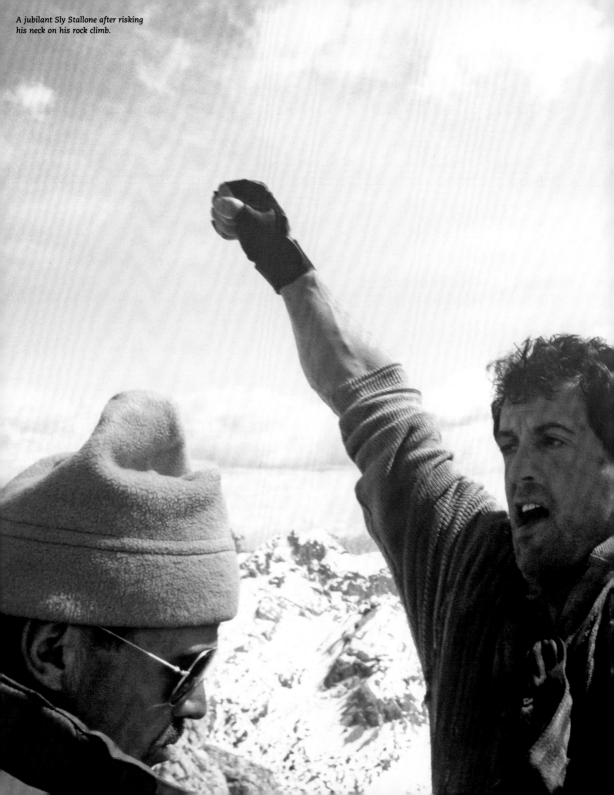

A jubilant Sly Stallone after risking his neck on his rock climb.

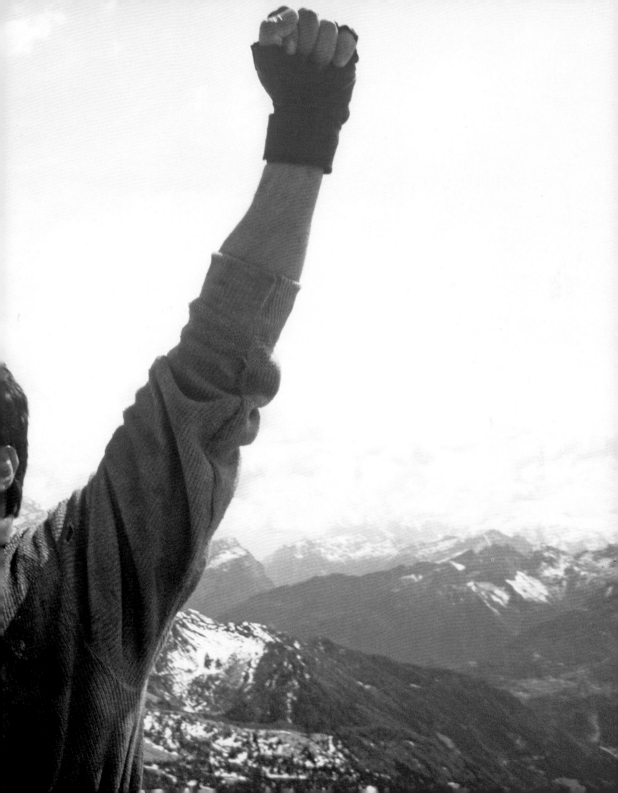

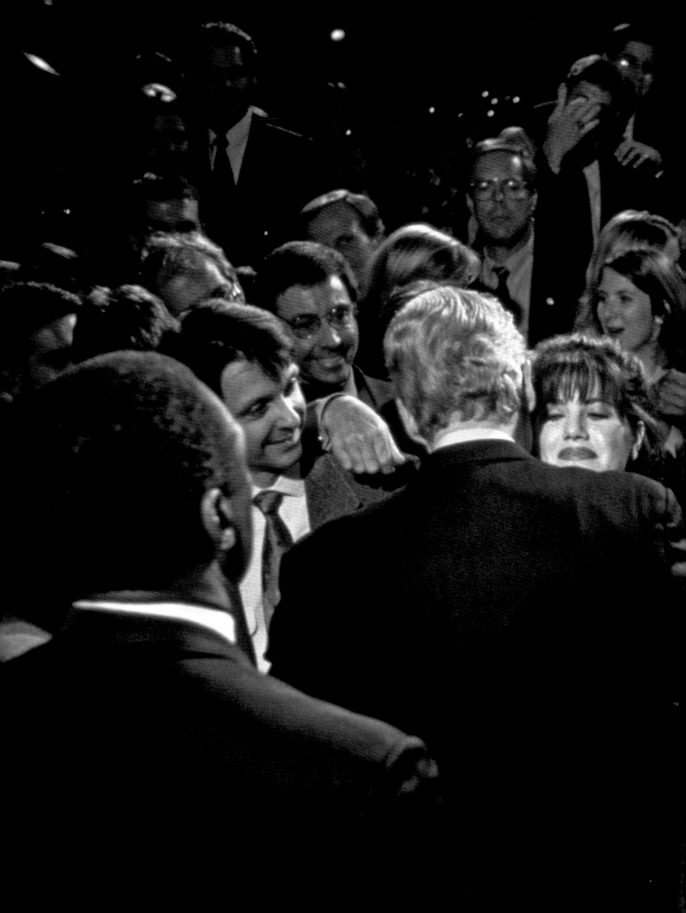

1990s

The Monica Lesson

I was once asked, on the National Press Photographers' discussion list, what it was like to discover a two-year-old picture that would turn out to be the "picture of the week." ▪ There have been lots of rumors running

around the photojournalistic community about the picture that was the cover of *Time*, showing Monica Lewinsky, with her bright red smiling lips and her eyes closed in anticipation, being embraced by President Clinton at a fund-raising event in October 1996.

Here, from the photographer's fingertips, is exactly what happened.

I have a theory that every time the shutter captures a frame, that image is recorded at a very low threshold on the photographer's brain. I have also heard this over and over from photographers around the world. It doesn't matter if the photographer saw the processed image or not. These split seconds, as the mirror returns, are recorded as photographic lint on the mind of the photographer.

When photographs of Monica Lewinsky wearing her beret on the lawn of the White House began to emerge, I knew I had seen that face, in some conjunction with the president. But I had no idea when or where.

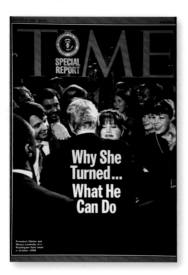

Opposite: The "platypus" is born. By the time the 1996 campaign was in swing, I had begun to shoot video as well as stills. Left: The fateful cover.

When I'm covering the White House, which I do every third month (nobody could do it more frequently), the pictures go first to the magazine because they have first-time rights on all the photos. Once they have gone through the take and pulled a few selects for the Time-Life picture collection, the take goes to my agent, Getty Images. They comb the take a second time and pull their selects. Eventually, the take comes back to me and resides in my lightroom until I sort through it again; then I send everything to the University of Texas, where my archive resides. I usually only get around to sending the pictures to Texas every eighteen months.

When the Lewinsky story broke, all those organizations started to go through their files, but found nothing.

Certain that I had shot Lewinsky somewhere, I finally hired a researcher to sift through the piles of slides in my lightroom. After four days and more than 5,000 slides, she found one image from a fund-raising event in 1996. I immediately looked through the other transparencies from that roll, but there was no other image of Monica. Considering it was the only frame, what was especially stunning about the shot was the quality. If I had been a movie director and hired extras and lit the hall, it wouldn't have been any better.

By that time, the original news break was over. I told *Time* we had found an image, and sent it to New York. We all agreed that this was an important image, but the story had moved away from us.

So we all sat on the picture for six months. When you think about it, that is incredible. Both *Time* and Getty kept a secret for six months!

1990s

A depressed President Clinton walks into the White House as Congress debates his impeachment in the summer of 1998.

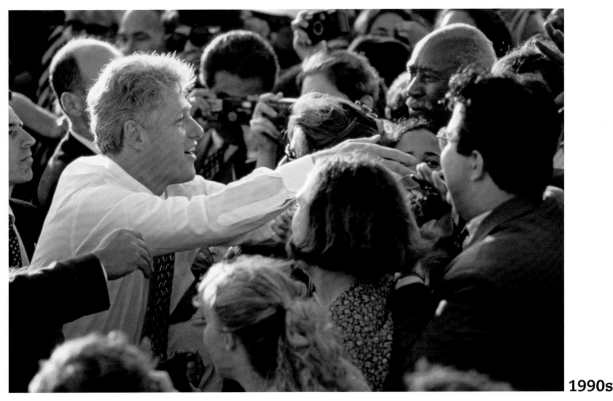

President Clinton doing what he loves best—shaking every hand in America.

When Monica went to the prosecutors and offered her testimony, the story went back to page one. At this point, *Time* and the agency went into action. The photo was run as a cover on *Time*, as well as in magazines and newspapers all over the world.

So, what is the lesson to be learned from this episode?

Ownership of your photographs is *extremely* important. (I am speaking especially to those photographers who record history, who have an obligation to make those photographs available to future generations.) The simple fact is that no organization has the memory of the image that the photographer who took it has. The people who want work-for-hire from photographers disassociate their greatest asset from the one thing they have to sell.

When I took the photo, there were three other photographers standing next to me, one each from AP, Reuters, and AFP. They were all professional photojournalists so I have to assume that if I got that photo, at least one of them would have gotten a good shot, too. So what happened to those photos?

The lights burned late for days at those wire services after *Time* hit the newsstands. But they couldn't find a similar image. Generally, right after photographing a presidential event, the wire photographers review their digital files. To save hard-drive space they often delete photographs that seem to have no value. Remember, nobody knew who the lady with the red lipstick was.

I made some money from this picture (not nearly as much as most people think), but if I did not own my photographs, if I did not have my own archive to go through, the picture would never have surfaced.

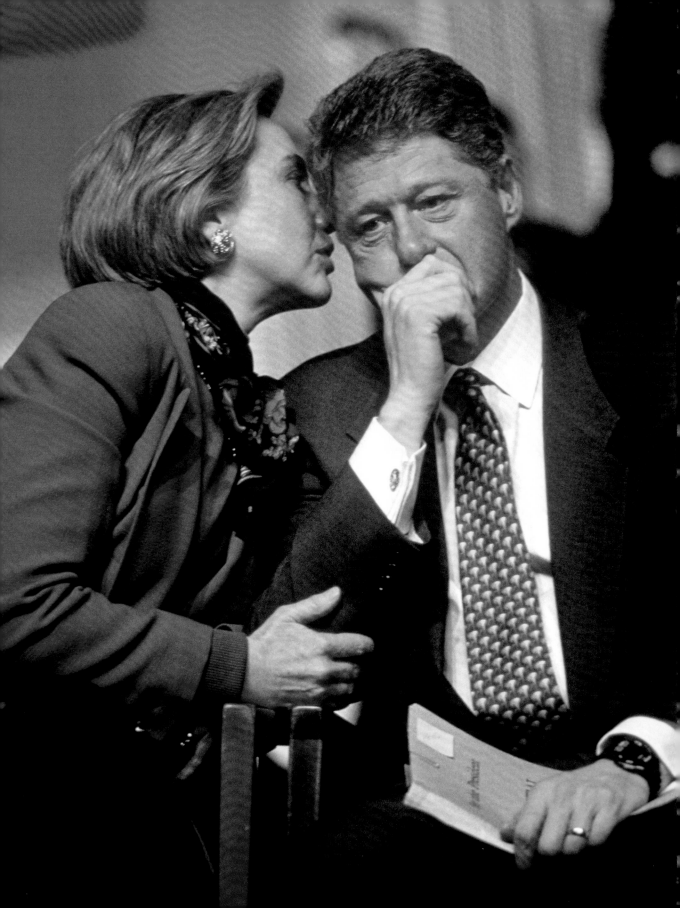

William Jefferson Clinton's time as president of the United States was running out, and his already furious travel pace had escalated to a maddening level. For those of us who covered these waning days of his administration, the

question was, "Are we going to survive to see the inauguration of a new president? Who will it be? Don't ask me . . . I'm just trying to keep up."

On Saturday, October 14, my alarm went off at 6 a.m. The next time I would lay my head down on a pillow would be at 4 a.m. on Tuesday the 17th, in Sharm al-Sheikh, Egypt, and that would only be for an hour. In one week we raced from fund-raisers in Denver and Seattle; to a hastily called Middle East peace conference; then back to the services held for those who died aboard the USS Cole, in Norfolk; then on to more campaigning and fund-raising in St. Louis, Boston, and Indianapolis.

As deadly rioting continued on Israel's West Bank, we all knew that the president was desperately trying to put together a meeting between Prime Minister Barak and PLO leader Yasser Arafat. A weekend trip to the Midwest and West Coast was canceled, then put back on the schedule as Clinton awaited word from the two leaders. It was 10 p.m. PST when my pager went off at a rally in Seattle. The message read: BAGGAGE CALL AT ANDREWS AIR FORCE BASE AT 5 A.M. Hey! We were on the other side of the country! So it was the red-eye back to Washington just in time to get on the plane to Egypt.

By Monday morning we were checking into a swank resort hotel in Sharm al-Sheikh. You note I say "checking in," because that was all we did. I picked up a key to a room that I would see, at 4 a.m., for a total of one hour on Tuesday morning.

Among the most frustrating events to cover as a photographer is a peace conference, especially one in the Middle East. They are a test of endurance, to say the least, with little to show for it. A White House pool photographer usually ends up sitting in some small room—in this case with only a few straight-backed chairs in a condo that was under construction—for a round-the-clock vigil. Even the food is no consolation. On this trip it amounted to little more than a cold pizza covered with questionable toppings. Fortunately, one of the wire photographers had brought along a DVD, which he could play on his laptop. So we watched Austin Powers—twice. By the early morning hours, most of us were sprawled across the stone floor. At 3:45 a.m., the president finally motorcaded back to the hotel. We were then given an hour and a half to take a nap and shower.

The First Lady gets the President's ear during their campaign for education reform, 1994.

By dawn, we were back in our holding room. At this point, the pool was beginning to get punchy. Someone came up with the clever idea to take a picture of the photo pool inside the empty swimming pool.

Then, as the sun began to climb, we took turns photographing each other sitting on the wall in front of our condo.

Finally, about noon, we got word that the conference was coming to an end. Well, more precisely, the Egyptian photographers got word. Due to translation difficulties, the Egyptian press office couldn't get our White House handlers to understand that there was about to be a press statement made by the leaders. Despite the Egyptian officials' assurances that we were now free to enter the conference site, our group stood riveted to our piece of concrete while the local photographers ran past us into the hall where the leaders were due to emerge. Eventually we got the idea and wended our way to the back of a huge room, dominated by a thirty-foot-long table, at which the three leaders sat, ten feet apart. Now, this type of seating plan hardly makes for an intimate photograph. But that is what we got before having to battle our way back out of the room, as police tried to keep us inside until the principals departed. Our petite White House press officer, Christine Anderson, threw herself into the doorway, acting like a 49ers' linebacker, and pulled us one by one out of the melee so we could catch the motorcade.

From there we headed back to the airport. Air Force One soared westward across the Atlantic, carrying us to Norfolk, Virginia, where the memorial services were being held the next morning. From there it was on to St. Louis to pick up the fund-raising appearances that had started the Saturday before. By nightfall, we were landing in Boston, only to jump onto a helicopter flying to Lowell, Massachusetts; then back to Boston for the second fund-raiser of the night; then onto Air Force One again, to fly to Indianapolis; getting to our hotel room at—when else?—4 a.m. Pool call was at 8 a.m. to motorcade to the state fairgrounds for yet another fund-raiser.

Later that afternoon, we staggered off the plane back at Andrews Air Force Base—total flying time for the week was fifty-two hours. Oh, and by the way, I think my film total for the week was twelve rolls, six of which were taken at the memorial services in Norfolk. Number of pictures used by *Time*—zero.

Two weeks later, we would once again be racing the sun westward, this time to Hawaii (for an hour), Brunei, which is about as far away from the States as you can get, and then on to Vietnam.

Did I tell you I think Bill Clinton was trying to kill me?

At this point I should make a few things clear regarding press trips with the president. Most people think the U.S. government pays for our air travel. Wrong. The cost of the charter that accompanies the president is equally shared by each member (or rather, the newspaper, magazine, or network sending them) traveling on the plane. That includes those members of the press traveling on Air Force One—in other words, when I travel on Air Force One, I'm paying my prorated cost of the press charter. The irony is, on Air Force One I don't get the first-class meals that I'm paying for. Another difference is that although the Air Force One seats are comfortable, business class, they don't match the fully reclining first-class seats, or for that matter, the three and four seats abreast that you can stretch out on in the press plane. Also, on an overseas trip, the press plane generally leaves at least twelve hours prior to Air Force One's departure, which allows its passengers to get a night's rest before the president arrives.

The magazine photographer's seat on Air Force One is rotated on a daily basis. For the trip to the Far East, it was my turn to be the "mag pooler." Actually, I would have been on the press plane except that, due to meetings with Arafat and Barak, President Clinton delayed his departure by a day.

Which is why I happened to arrive in Hawaii just in time to pass the rest of the press corps—headed for the airport all tanned and relaxed. They had attended a luau the night before, followed by a precious full night's sleep. We stopped too, of course, for about forty-five minutes, while Air Force One was refueled, then off we went on the fourteen-hour flight to Brunei, where the annual APEC (Asian Pacific Economic Cooperation) summit was being held. It's attended primarily by oil-producing nations. These summits were President Clinton's idea, but the most that can be said for them photo-op-wise is that we're treated to rather unusual shots of the leaders in wild and colorful theme shirts that the host country's PR people provide as souvenirs. Other than this, these gatherings are about as exciting as watching grass grow—or not watching grass grow, as most of the meetings are closed to the press. We did get to spend a lot of time standing in 100-degree heat and 100-percent humidity, waiting for the group photo—fourteen guys standing in a line with whacky shirts (they looked like some small nation's Olympic team).

1990s

The White House press pool—in the pool.

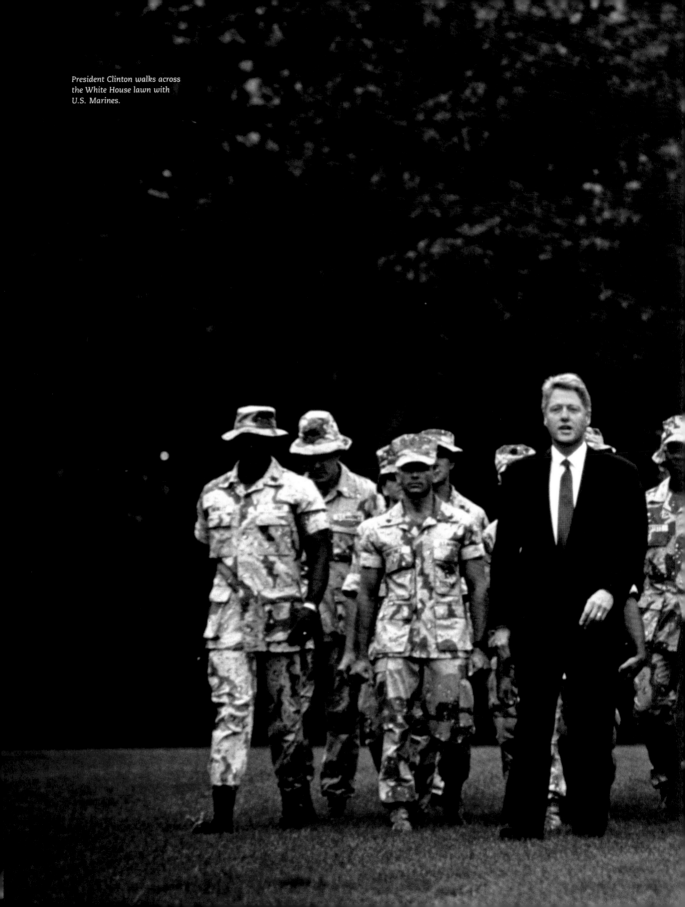

President Clinton walks across the White House lawn with U.S. Marines.

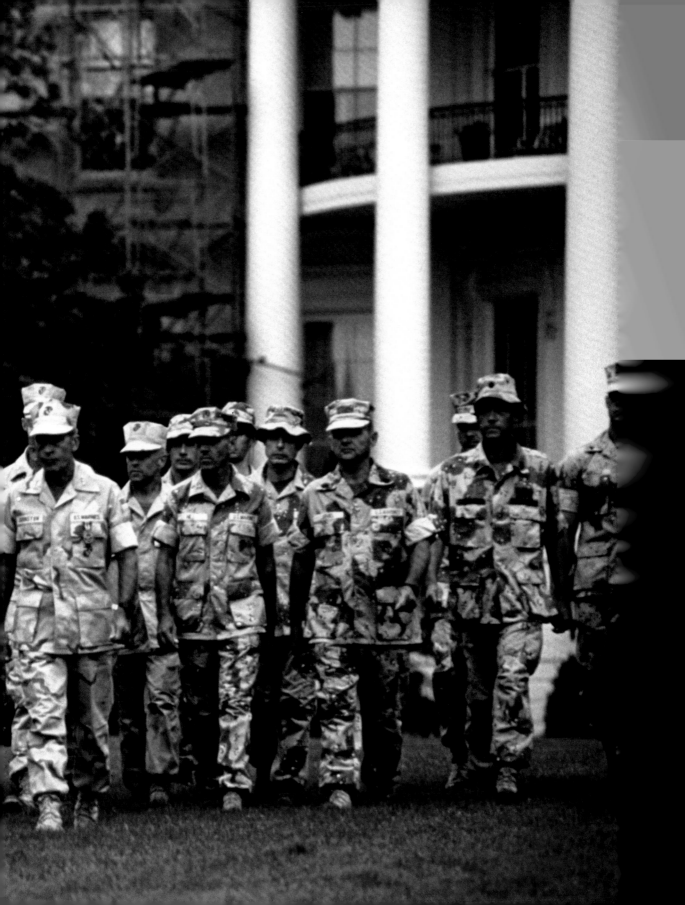

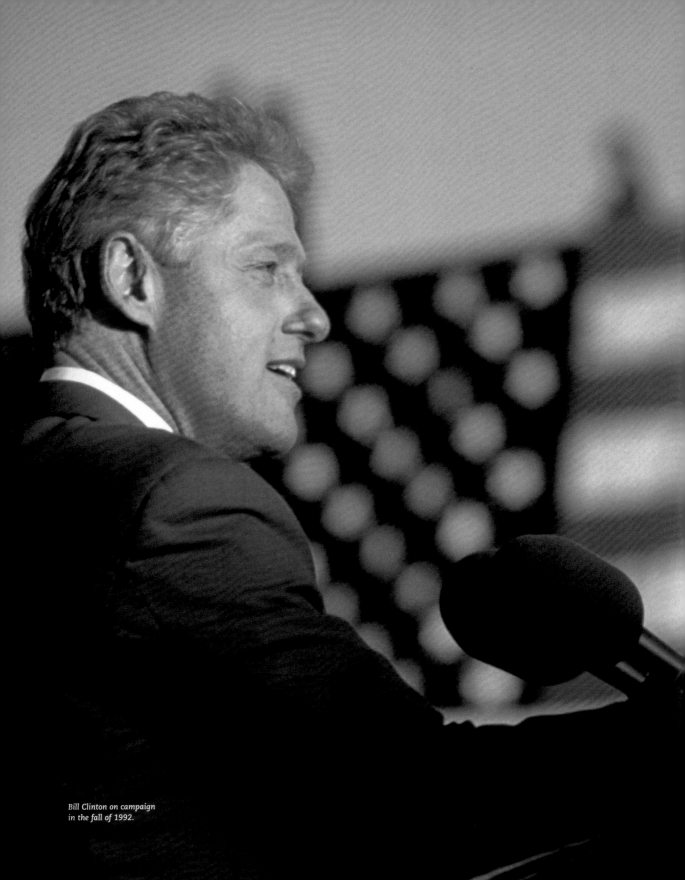

*Bill Clinton on campaign
in the fall of 1992.*

This is the story of the near-death experience of the tight pool when they were forced to take an 8.7-mile hike down a mountain with President Clinton and his family. ▪ Originally, the Clintons

were going to take a two-mile walk down a mountain road in Yellowstone, but after the family had been motorcaded to the 12,500-foot summit of Mount Webster and had a lunch of sandwiches and soda pop, our escort from the White House Press Office informed the tight pool (consisting of four wire photographers, one magazine photographer [me], a wire reporter, radio reporter, newspaper writer, and TV crew) that the president, Hillary, and Chelsea had elected to take a long, rough trail down the mountain. Because nobody had anticipated this, most people in the pool, me included, did not have hiking boots (I was wearing my running shoes), and of course we were each carrying about thirty pounds of gear. The worst thing was that we had no water for this trek, and temperatures were in the high eighties, and *very* dry.

Our escort kept telling everybody we had to go *now* in order to stay in front of the presidential party, as the ranger who was to accompany us looked on in horror. He tried to warn us by saying, "this is going to be a very arduous hike. It's nearly nine miles, and will take over four hours . . . don't take it lightly." But by that time the escort was sprinting up the trail, yelling, "Let's go *pool!*"

The first two miles was virtually nonstop down a thirty-degree slope that was nothing but loose rock and shale, which people were slipping and sliding down; then came the first of the uphills (after two miles of sliding down, my body appreciated the change), but within minutes people began to go down. The first was an AP photographer who had an asthma attack; then the White House doctor, who had been carrying her thirty-pound sack, fell out to stay with him.

All this time, the escort kept urging people to hurry, so the hike turned into a forced march. After the first hour, the lack of water took its toll. Everybody's lips turned white; I couldn't even open my mouth—no saliva!

The escort went back to help the AP photographer, leaving us to our own devices for a while, and we came to a beautiful meadow. It was picture-postcard perfect, so we decided we would set up for a photo.

We waited for twenty minutes for the Clintons to catch up, but at the last minute the escort came sprinting out of the forest and started yelling, "*No pictures . . . Move out!*"

At this point, TV cameraman Hank Brown lost it, and pointed out with some passion that we had been force-marched four miles for nothing, and that we should at least get something out of it. The escort then went ballistic and ordered Hank out of the pool. Hank couldn't believe it. "You want me to *leave the pool? Out here, in the middle of nowhere, with nothing but grizzly bears? You're crazy, man!!*"

1990s

311

So we picked up and moved out double-time through another mile or so of meadowland, which was a lot harder than it sounds because it was an extremely narrow, rutted trail, so you had to keep one foot directly in front of the other. With no ankle support, every inch became more and more painful. Our standing around for those twenty minutes waiting for a bloody photo op now began to cause our muscles to cramp, and with our white lips, we began to resemble the lost patrol.

At the five-mile point, the escort told us we would have to let the presidential party go by. By now, a TV soundman was suffering from heat exhaustion (this was the same guy who had started the hike by telling us proudly that every year he had gone to Outward Bound, so this would be a snap!).

The Clintons walked by, looking like they were on a stroll through Central Park. The president asked us, "How you-all doin'?" I told him we really needed water, that most of us were getting seriously dehydrated, and he threw me his water bottle, which we gathered around like wild beasts at a water hole and gulped down in no time.

Mrs. Clinton turned to Ralph Alsweig, the White House photographer—she was worried that the photographers didn't look good and wondered if we were going to be all right.

We all then fell in behind the presidential party, with presidential aide Andrew Friendly bringing up the rear with the stragglers, which by that time included another aide, Bruce Lindsay, whose knee had gone out.

The next three and a half miles were just a matter of survival, one aching foot in front of the other, lips and throats parched. All we could do was grit our teeth and keep going. The last half mile was Heartbreak Hill, which was another thirty-degree incline, and which sapped whatever reserves we had left.

1990s

We finally stumbled out of the forest and had our picture taken with the Clintons, which will be a real memento. We were joined at that point by the AP photographer who had been carried out on horseback. Alsweig felt so bad about his condition, he set up a special shot of the president and Hillary for him.

The good news is that following all this, on the way back to the helicopters, three elk suddenly appeared in a meadow, and the president, along with Hillary and Chelsea, paused to take a look, which resulted in a fine picture.

It's now the third morning after the death march, and I am finally beginning to walk normally. Vacations with the first family are just wonderful!

Right: Following what amounted to a three-hour forced march down the steep side of a mountain in Jackson Hole, Wyoming, the First Family pause to gaze at three wild elk that magically appeared at the right moment. It took all my remaining strength to hold my camera steady. Opposite: During the 1996 campaign, the First Family appeared almost normal.

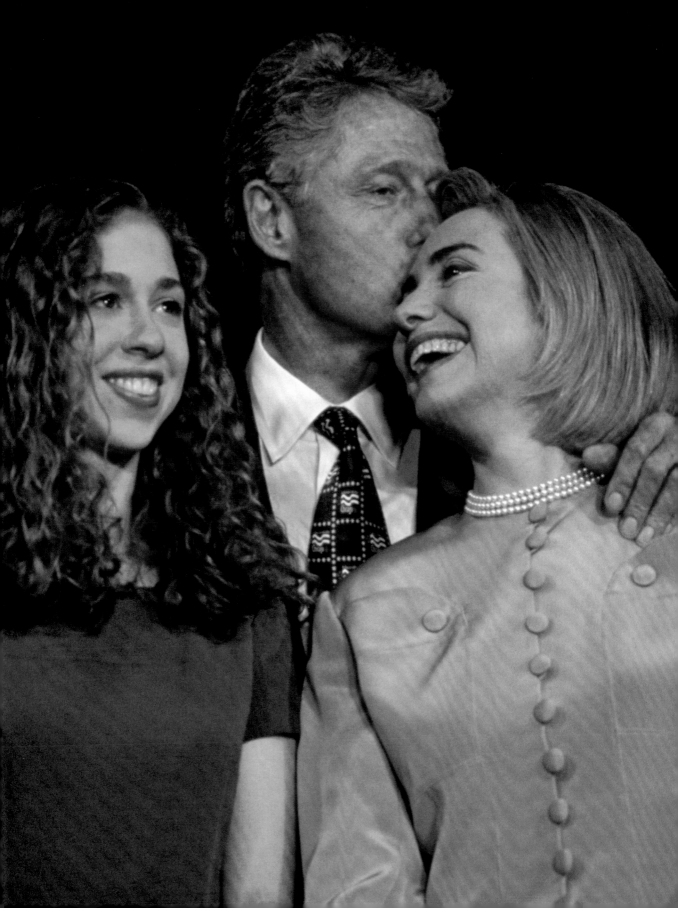

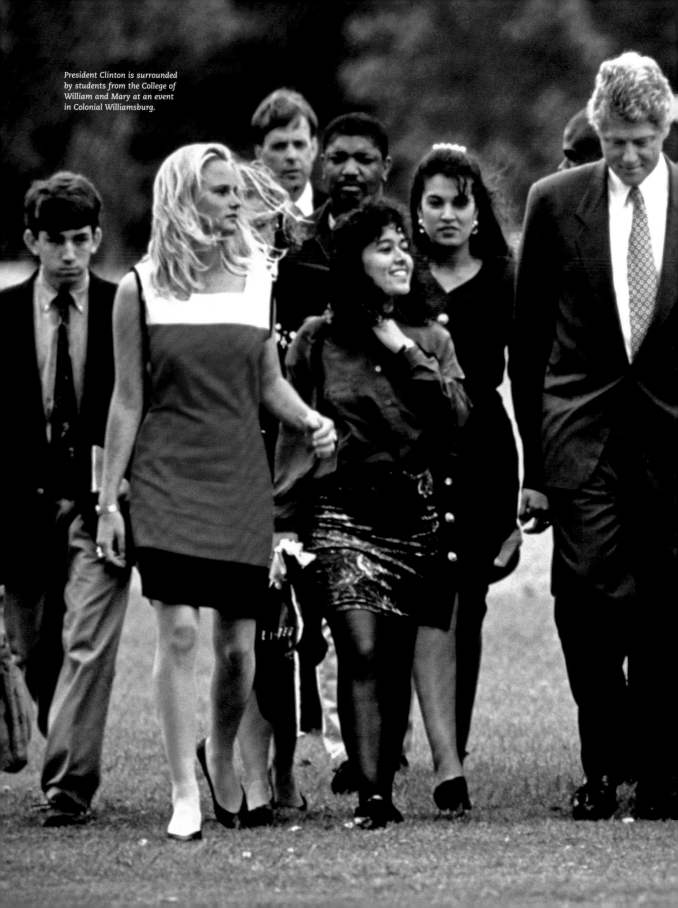

President Clinton is surrounded by students from the College of William and Mary at an event in Colonial Williamsburg.

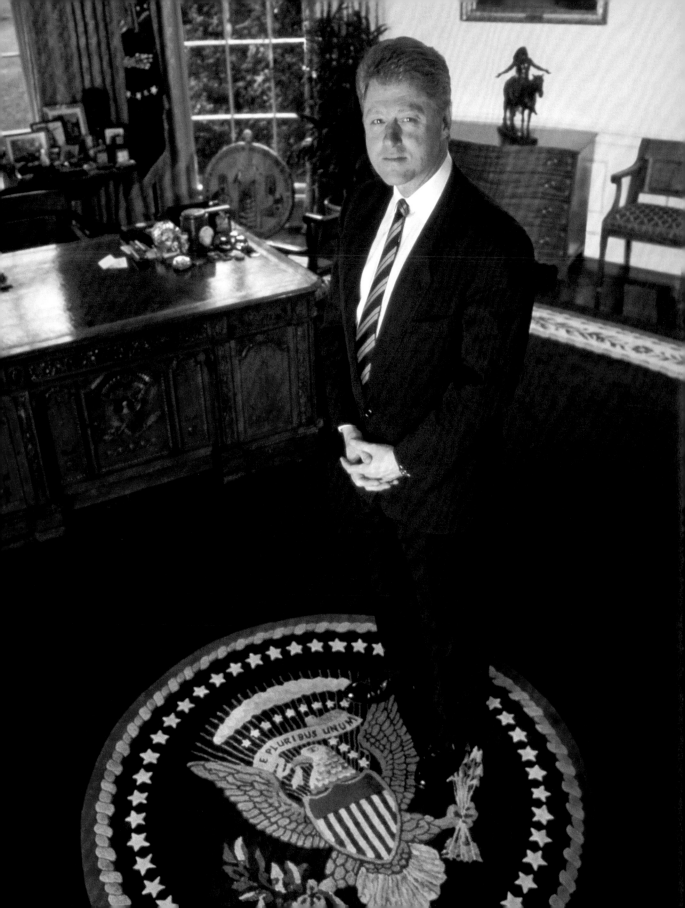

To Dirck Halstead
With Appreciation,

Bill Clinton

Opposite and above: President Clinton in the Oval
Office prior to the 1996 campaign. I'm perched atop
the ladder shooting the president for Time.

During a trip to Mexico, the president and Hillary don masks they found in a market. To me, this picture reveals an interesting metaphor for their relationship.

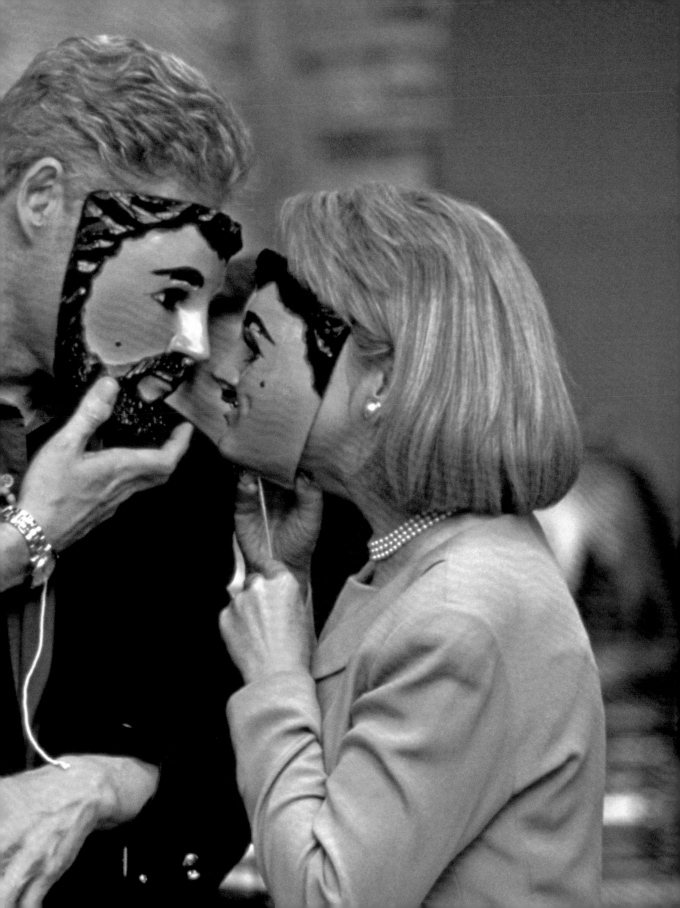

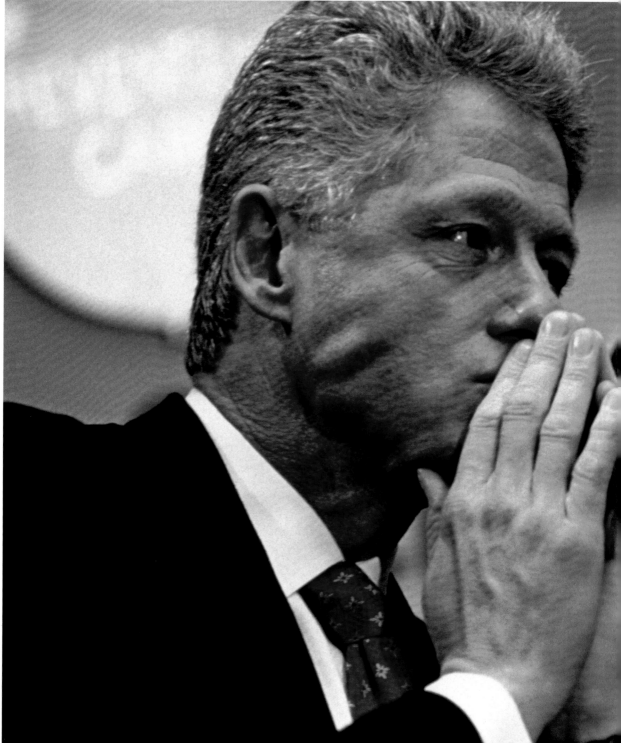

1990s

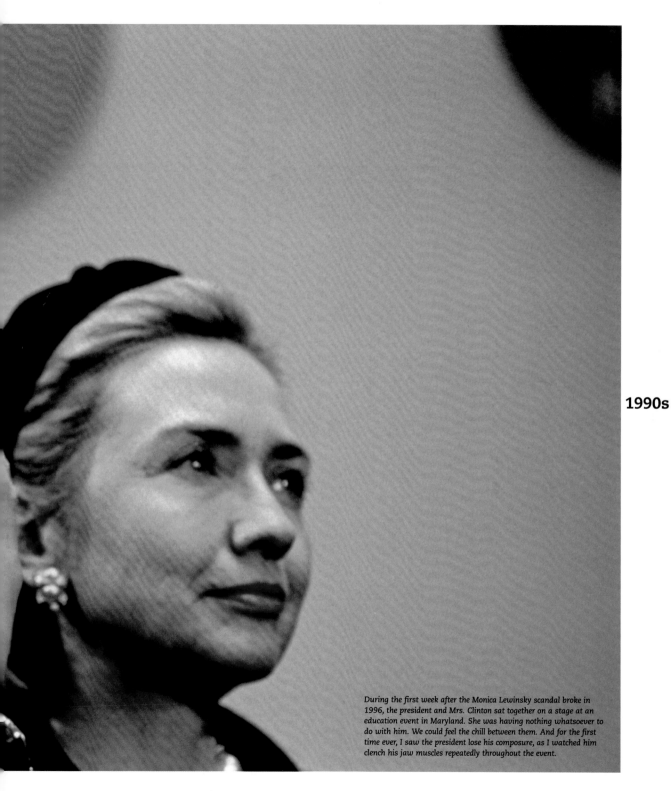

1990s

During the first week after the Monica Lewinsky scandal broke in 1996, the president and Mrs. Clinton sat together on a stage at an education event in Maryland. She was having nothing whatsoever to do with him. We could feel the chill between them. And for the first time ever, I saw the president lose his composure, as I watched him clench his jaw muscles repeatedly throughout the event.

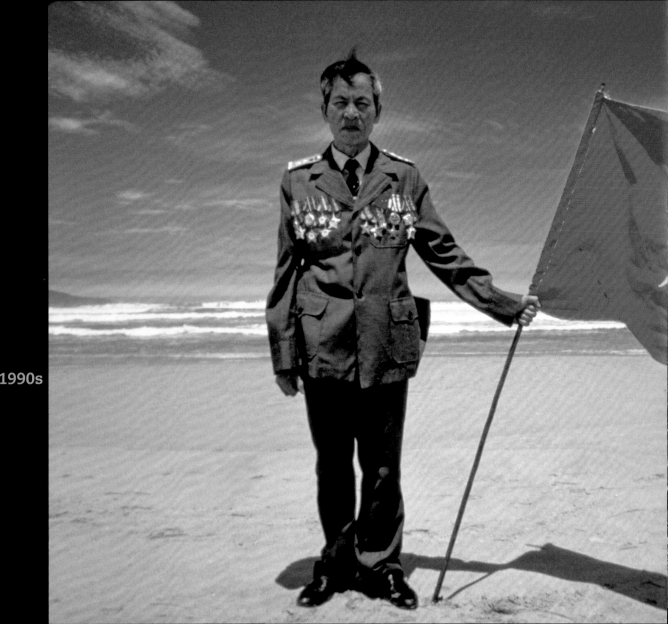

1990s

Colonel Do Sa

In 1994 I was invited by Rick Smolan to join ninety-nine other photojournalists from around the world to work on a book entitled *Passage to Vietnam*. We met in Hanoi, and after a few days there, we all dispersed to our assignments around the country. I was assigned to photograph Da Nang. The city had been a factory town for the American military during the war years, and its huge air base had launched the air war against the north. As a result, a sizeable percentage of its population had worked for the Americans but now was essentially jobless. I wanted to find some way of linking the present Da Nang to the war years. I began to ask my minders if they could find some soldier or officer that had fought the Americans. The next day they took me to a small apartment above a restaurant, where I met Colonel Nguyen Do Sa. He had been one of the north's most decorated officers, and had fought in over fifty battles against the Americans, including one here at China Beach in 1965. As we drove to the beach we saw hundreds of Vietnamese flags flying in a village. We borrowed one, and when the colonel walked out to the spot on which the first American troops had landed, an aide opened a velvet box

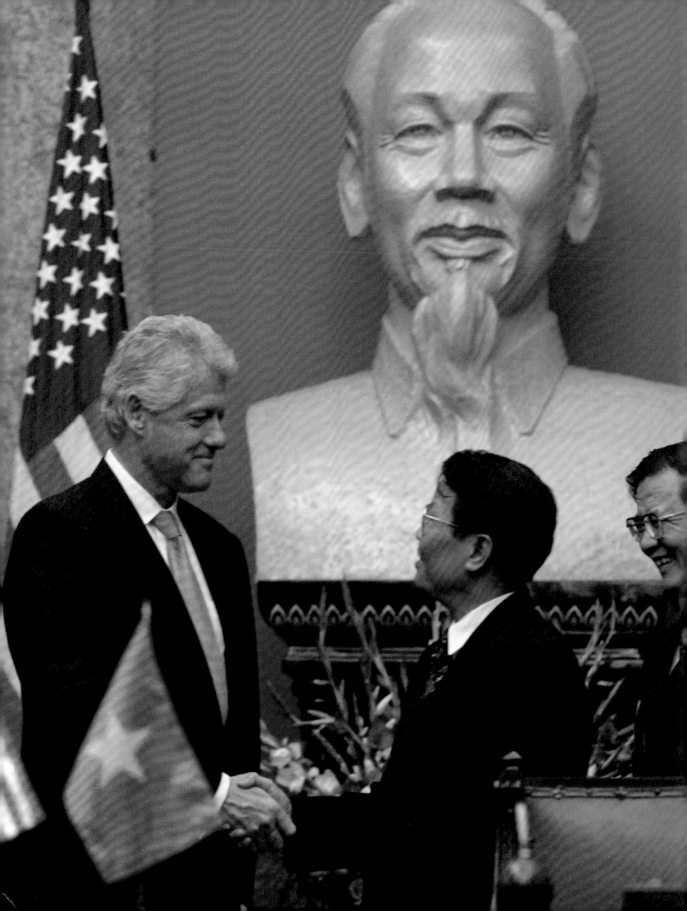

Since it was the last days of Clinton's administration, virtually no one was photographing him. Instead they were spending most of their time chasing down the presidents of the Philippines, Peru, and Japan, all of whom were uncertain as to whether their respective countries were

going to let them back in—they had either been voted out of office or were facing indictment. As it turned out, the fellow from Peru never did go home; he sought asylum in Japan.

But of course, the real point of Clinton's last trip overseas as president was so that he would be the first U.S. president to visit Vietnam since the end of the war. The officials and the people of Vietnam generally regarded the visit as though Clinton were some dotty uncle come to call, to whom they were obligated to be nice. That's how the government of Vietnam felt, and they tried to keep Clinton's schedule a secret from the public, but the arrival got out. When we drove into Hanoi, in the early morning hours, thousands upon thousands of ordinary citizens were crowded together on the sidewalks excitedly waving at the president's motorcade.

For those of us who had covered the war—David Hume Kennerly (*Newsweek*), Chick Harrity (*U.S. News & World Report*), Hank Brown (CBS), and me—it was very much a personal and emotional pilgrimage. That was certainly how our publications perceived it, especially in light of the fact that the U.S. elections had come to a screeching halt by decisions being made in Florida courtrooms. Nevertheless, we all gave it our best shot to get some pictures into our magazines. This was the first time I had been able to use a digital camera on a *Time* assignment (at the time they desperately hoped this technology would go away before some of their picture editors lost their jobs, because now the photographers could actually pick and send their photos to the editors). Both Chick and David were also touting the digitals, and we all discovered (a) it was really cool to see the little color pictures come up right away on the LCD, and (b) it was like being back in the wire services again, with all the control on our end.

2000s

Pages 324–325: President Clinton's trip to Vietnam is his last speech as a touring president in Saigon. It was also the end of my thirty years covering the White House. I couldn't get over the fact that I had managed to stick around long enough to see an American president give a speech in Vietnam. Opposite: I decided to shoot Clinton's trip to Vietnam entirely in digital. This was the first major international story that Time received in digital format. A new era had begun. Here, Clinton is shaking the hand of North Vietnamese President Tran Duc Luong.

2000s

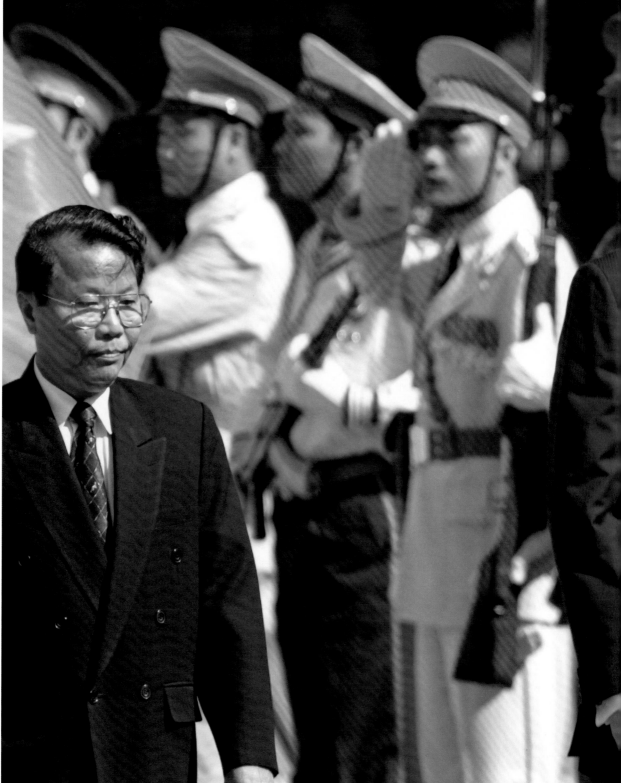

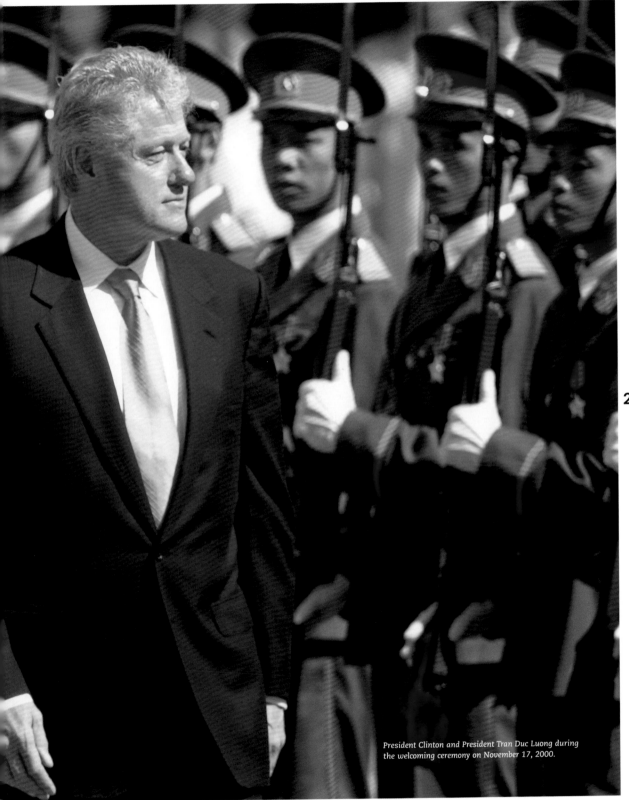

2000s

President Clinton and President Tran Duc Luong during the welcoming ceremony on November 17, 2000.

329

On the thirtieth anniversary of the fall of Saigon (aka "the liberation of South Vietnam"), residents are caught in a midnight traffic jam on Saigon's main boulevard in front of the colonial-era Hôtel Continental Palace. Today, seventy percent of the country's population is under thirty years of age.

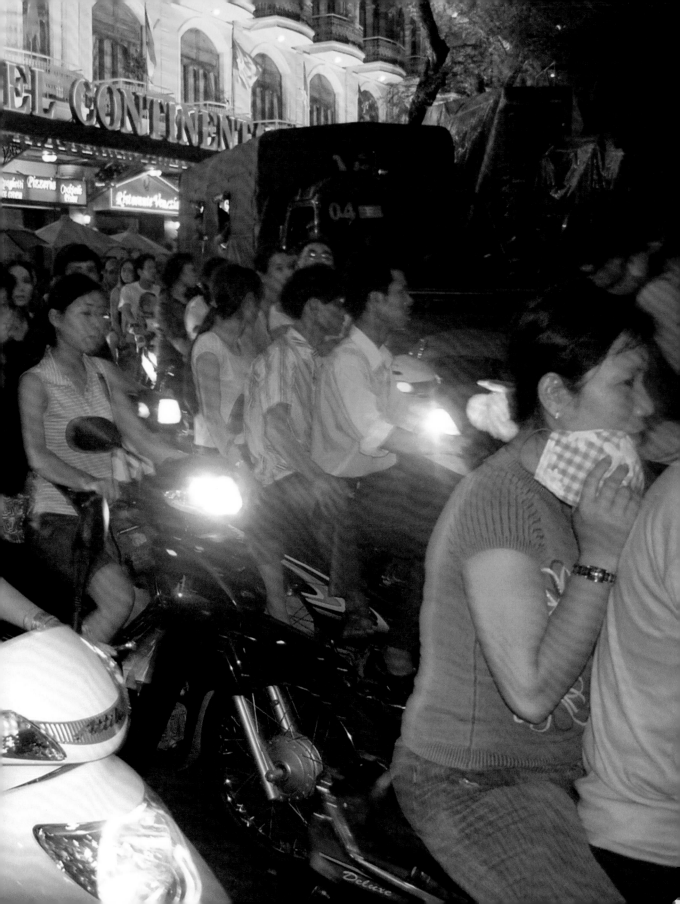

Over the years, I had gotten spoiled by *Time* couriers showing up in the middle of nowhere, taking my film, and getting it to New York in time for the edition. No muss, no fuss. Now, here I was again editing and transmitting pictures via computer from the other side of the world. When I was sending pictures from Vietnam thirty years before, it took me about nine minutes per image (assuming the frequencies were clear). Now, it was taking me about an hour per high-resolution picture. Lines in Brunei were simply impossible to transmit over. In Hanoi, from the hotel, every fifteen minutes or so, a tone would be placed on the phone line by the telecommunications ministry, and I would have to start all over again. I transmitted a total of ten pictures to New York, all of which looked great on their end, but it took me nearly fifteen hours to do it.

We had a lot of fun in Hanoi and Ho Chi Minh City, buying Vietnam War–era North Vietnamese Army caps and posing in the center of Hanoi. The Secret Service impressed their North Vietnamese

2000s

counterparts with the way they handled the press in a crowd. At one point, as I was being knocked off the sidewalk by an agent—who had a look in his eyes I've only seen once before in a Sam Remi movie—the Vietnamese cops standing nearby chuckled in admiration.

I must say, it was thrilling to see the crowds clap and push, surging forward to shake Clinton's hand. There was one moment that will remain with me always. It came near midnight at the Hanoi airport, at the conclusion of the president's visit. Clinton, the U.S. ambassador, and other officials formed a small reviewing line and stood as a United States military honor guard, in near silence, draped American flags over three coffins. Then, one by one, with only the sound of their shoes echoing in the night air, they carried the bodies of these recently found Americans killed in the war to a waiting C-141 transport for their final trip home. I felt some real closure on a lot of things at that moment.

On our final White House trip together—David Hume Kennerly, Chick Harrity, and I pose in front of the presidential palace in Hanoi. This was the first time any of us had been back to Vietnam since the war.

2000s

A few months after joining *Time* in New York in 1972, I found myself sitting in a hallway on the twenty-eighth floor of the Time-Life Building. Earlier that

day, all the employees of the legendary *Life* magazine had been called into the auditorium to hear the grim news that after thirty-six years of weekly publication, the proud flagship of the Time, Inc., empire was shutting down.

Carl Mydans, one of the charter photographers of the weekly, turned to his colleagues, who had all pulled bottles of wine from their lockers, and mused tearfully, "I never thought I would outlive my profession."

Even then, it was clear to me that things were dramatically changing. However, for the next fifteen years, I happily rode the wave of what was, looking back on it, a golden age of photojournalism. As a photographer for *Time* I was in constant motion, girdling the world, most of the time in a first-class compartment. The average length of time I would spend on an individual assignment was six weeks. There were major stories: "Defense," "The Navy," "The New Cities," "The New Beauties." In those days the managing editor of *Time* literally had no budget. Time's founder, Henry Luce, did not want his editors worried about the cost of coverage; it was up to the publisher to find the money.

But in the mid-eighties there was a profound change. It had less to do with the emergence of bean counters than with technology. Up until then, all Time, Inc., publications were printed on giant presses at R. R. Donnelley & Sons in Chicago. Because *Time*, for one, had a print run of over five million issues a week, it was necessary to print the magazine in sections, or forms. Black-and-white pages, which made up the "front of the book," containing the latest news, were printed at the last minute. However, four-color pages, which made up the middle of the magazine, were printed ahead of time, generally midweek. The color pages were crucial because that was where the advertising was. However, it was necessary to balance the advertising pages with the editorial content, so every week the magazine needed what they called "color acts"—which is where people like me came in.

However, in the late-eighties all that changed. ROP, or run-of-press, color was introduced. This meant that color could be published on any page. This is also when newspapers started to use color. And technology had gotten to the point that layouts could be transmitted electronically not only to Chicago, but to any printing plant in the world. Suddenly, thousands of plants, generally belonging to newspapers, could start turning out *Time*, *Newsweek*, *People*, *Sports Illustrated*, and so on. The great Donnelley printing plant is today a server farm.

The advent of color in newspapers started to change the face of photojournalism. Up until then, newspaper and wire-service photographers shot in black-and-white. Magazine photographers, of which there was a far smaller supply, shot in color. If you were working for *Time* it was because you knew how to shoot color, which was considered a special skill. However, once the wire photographers were forced to shoot color, things began to change. Suddenly there were thousands of photographers who could supply color images.

2000s

PHOTOGRAPH BY P. E. BENTLYE, 2001.

At first, the wires' capacity for using color was amateurish. It was necessary, for example, to shoot in color, which took longer to process, then to transmit three versions of the image, with the red, green, and blue components separated. The average transmission time of one image was seven minutes. Therefore, producing a color project would take up to an hour of valuable wire time. The end result was generally dismal, because the registration of the different layers was nearly impossible to justify. So for a few years, people like me were safe.

When Kodak and Nikon produced the first professional digital camera in the mid-eighties, they took one down to the Associated Press, which immediately ordered several hundred. The camera was essentially a Nikon F2 in which sensors had replaced the film chamber. It required an external battery pack to operate, and could only record a little over two megapixels, far lower than the resolution delivered by film at that time. It also cost a whopping $16,000.

However, by plugging the camera into a computer, which was also coming of age, it was possible to send full-color images to members and clients. The cameras were introduced at the political conventions and got their first real workouts at the World Series.

By the early nineties, the writing was on the wall. It was obvious to me that *Time* would soon be using digital photography, and I wanted to be part of the transition. However, for most of the nineties *Time* steadfastly stood by film—even though film was costly, had to be processed, and was often delivered by courier from all parts of the world, all of which was very expensive. *Time* picture editors insisted that they would never go to digital because they felt the image resolution wouldn't stand up in a double-truck spread. But as the image quality of these cameras went from two to four to six megapixels, more and more wire-service digital images were indeed becoming two-page layouts and covers. I kept begging *Time* to allow me to shoot the White House on digital, but was repeatedly turned down. It has always been my feeling that much of the reasoning behind this was the picture editors' fear that if photographers took pictures in digital and started sending them to *Time* by computer, the photographer would essentially become the editor of first resort. So who would need a picture editor?

Finally, on the last big trip I did for *Time*, my patience ran out. President Clinton was making a trip to Indonesia and then Vietnam. It was a historic trip—the first U.S. president to visit Hanoi and Saigon since the war. The timing was such that he would arrive in Hanoi on a Friday, which meant there was no way on earth that film could be couriered back to New York in time for the deadline. So I asked Canon to loan me a couple of D30 digital cameras, which were capable of delivering six megapixels, and I shot the trip in digital. That Friday night in Hanoi, I worked through the night transmitting to New York half a dozen images of the arrival and ceremonies on a very shaky 24-abs line that kept dropping off halfway through transmission. My colleague David Kennerly was doing the same for *Newsweek*. He scored big-time. That week he had a double-truck opener of the same picture I had sent to *Time*. However, my magazine remained indifferent to the digital transmission and didn't bother running it. But like it or not, that was the beginning of a new era for the newsmagazines.

Today, virtually every picture made of breaking news is shot in digital. Picture editors didn't lose their jobs. But it's more competitive for photographers since there are now far fewer assignments to be doled out, and color pictures can be transmitted from the wires and newspapers around the world, all delivered instantly.

Meanwhile, the marketing of photographs was also undergoing a huge change. The big agencies that represented photographers—Black Star, Magnum, Liaison, Sygma, and Contact Press Images—had essentially been mom-and-pop operations. They would deliver packages of pictures to editors at the magazines in person and do a pitch. One picture editor at *Time* remarked, "Every time I saw Eliane Laffont of Sygma walk through my door, I knew it was going to cost me $5,000."

These agencies split the money with photographers, generally on a fifty-fifty basis. They would then resell the same stories around the world.

In the mid-nineties, mega-agencies came into play. Bill Gates's Corbis, as well as Getty Images, started to buy up these smaller agencies. Photographs could be posted on their Web sites for purchase. Visits to the editors were no longer required. Photographs became commodities. At the same time, as publications started to become smaller parts of "vertical" corporations, they wanted *all* rights to the photographs they purchased. They wanted to use the pictures in ads, movies, games, and on the Web. Thus, what had previously been a deal between the photographer and the corporation for first-time rights now threatened to take away a photographer's right to continue to sell the same work elsewhere, thereby jeopardizing the photographer's financial security in later years.

About this time, I met a man named Michael Rosenblum, who had been a CBS producer. He had a vision about how to revolutionize television news. His idea was to train journalists in the use of the brand-new three-chip High 8 cameras that had just come onto the market. He, along with an entrepreneur, Paul Gruenberg, started a company called Video News International (VNI), and over the next eighteen months trained some 120 photographers, radio reporters, and print journalists in the language of TV news. Within a few months, VNI started placing shows on ABC's *Nightline*, produced entirely by the people they had trained. As time went on, VNI started doing some of the first reality TV shows, such as *Trauma: Life in the ER*. Within two years NYT-TV purchased the company.

After VNI was sold, I decided to start my own video journalism courses, called the Platypus Workshops, aimed at photojournalists. The name was based on the platypus, discovered in Australia in the late eighteenth century. This egg-laying amphibious animal turned out to be the oldest in the world. Its longevity was due to its ability to adapt to changing environments, which is exactly what photojournalists now have to do. So, in that vein, my focus was not so much on television as it was on the emerging Web. I understood that newspapers, which were in serious trouble due to dropping circulations and high costs, would eventually migrate to the World Wide Web. I also understood that with a growing acceptance of broadband, their sites would increasingly feature video, which would be a key component of their community-building efforts. Since 1999 we have turned out hundreds of "platypi," who have become vital parts of the new newspaper model.

2000s

About this time, Hewlett-Packard offered to sponsor a Web site for me, and I created a pioneering online magazine called the *Digital Journalist* in September 1997. Its mission was to become a twenty-first-century Web version of the old *Life* magazine. It would publish major photo essays by master and new photojournalists, cover trends in the industry, offer diverse columns and, most important, feature streaming-video stories and interviews. Today, photojournalists around the world not only read the *Digital Journalist* every month, but also contribute stories to it.

The Web is also redefining photo marketing. New companies such as Digital Railroad now offer photographers a chance to upload their portfolios and sell directly to clients.

In 2005 we saw the emergence of "citizen journalists." It started with photographs of the London subway bombings by amateurs who happened to have digital camera phones in their pockets. These grainy photos made their way onto front pages around the world. Now, there are agencies that specialize in aggregating and selling these images.

Clearly, at the end of the day, photojournalism is stronger than ever. What makes a photojournalist special is a lifetime of accumulated experience, the instinct as to what makes a story, and the ability to negotiate his or her way through it in order to produce those defining moments that come straight from the eye, heart, and soul. Today's photojournalists also need a healthy dose of adaptability when it comes to new technologies. As the old adage goes, "What doesn't kill us makes us stronger." I feel blessed to have been a photojournalist all my life. I don't plan to stop now.

Texas Hill Country

That last year of constant travel covering the Clinton administration really took its toll on me. By the inaugural of George W. Bush in 2000, I knew it was time to pack it in.

I continued to live in Georgetown, Washington, D.C., for a short time and published two award-winning issues of the *Digital Journalist*. But then I started to think about the next stage of my life.

My first major job as a photographer for UPI had landed me in Texas working at the Dallas *Times Herald* at the late 1950s. Texas was evolving from a sleepy second-tier state into the explosion of culture and investment characterized by John Bainbridge in his 1961 book, *The Super-Americans*. It was also at this time that George Stevens made his classic film *Giant*. This land of limitless opportunities and horizons was just the tonic a young photographer from Westchester County, New York, needed. Texas put its stamp on me.

In 1999, Dr. Don Carleton, director of the Center for American History at the University of Texas in Austin, approached me. At the urging of my colleague, David Hume Kennerly, Carleton had decided that the Center was going to become a major repository of photojournalism, and he invited me to contribute my archive of more than 45 years' worth of photography to the center. I agreed, and we continued our conversations over the next two years.

Then on Christmas Eve 2001, I was celebrating my 65th birthday at the home of my sister's fiancé in Hudson, New York. At some point in the evening I went looking for the bathroom, and as I was fumbling around for a light, I tumbled down 14 stairs into the basement. I broke my shoulder, five ribs, and tore my rotor joint. For the next week, I slipped in and out of consciousness at Columbia Memorial Hospital. In my drug-induced stupor, I envisioned a house in the hill country of Texas. I was sitting on a porch, rocking in my chair, with a dog by my feet. On the sixth day of my hospitalization, I sent an email to Don Carleton, telling him that I wanted to join my archives at the University of Texas.

I had finally gotten the message: it was time for a change.

I went down to Austin and made arrangements to teach photojournalism at the University of Texas and to become a fellow at its Center for American History. That week, a realtor showed me some houses. Strangely, the second house I saw was exactly the house I had dreamed about while in the hospital. Two months later, on July 4th, I moved in to my dream house in the Texas hill country.

But the rocker and the dog never materialized. Instead, as the editor and publisher of the *Digital Journalist*, my travel actually increased. Today, I attend most major photo industry conventions and speak to audiences around the world, as well as teach two workshops a year on video journalism.

I recently visited my old apartment at 320 West 52nd Street in New York. Even though I still love the excitement of the Big Apple, I'm glad I'm in a new phase in my life. But I'm happy to say my joy in taking pictures has never diminished. I love to get into my car and travel across the state to places like Big Bend National Park. The land and the people of Texas never fail to awe and inspire me. I've been a photojournalist all my life—I don't intend to stop now.

Big Bend National Park early on a spring day.

2000s

Above: Vicki Bass was a flight attendant when she met
her future husband, Sid Bass, one of the wealthiest men in
Texas. She now spends her time as a working cowgirl and
champion horsewoman on her ranch south of Fort Worth,
Texas. Opposite: Ms. Tracy in front of her café in Study Butte.

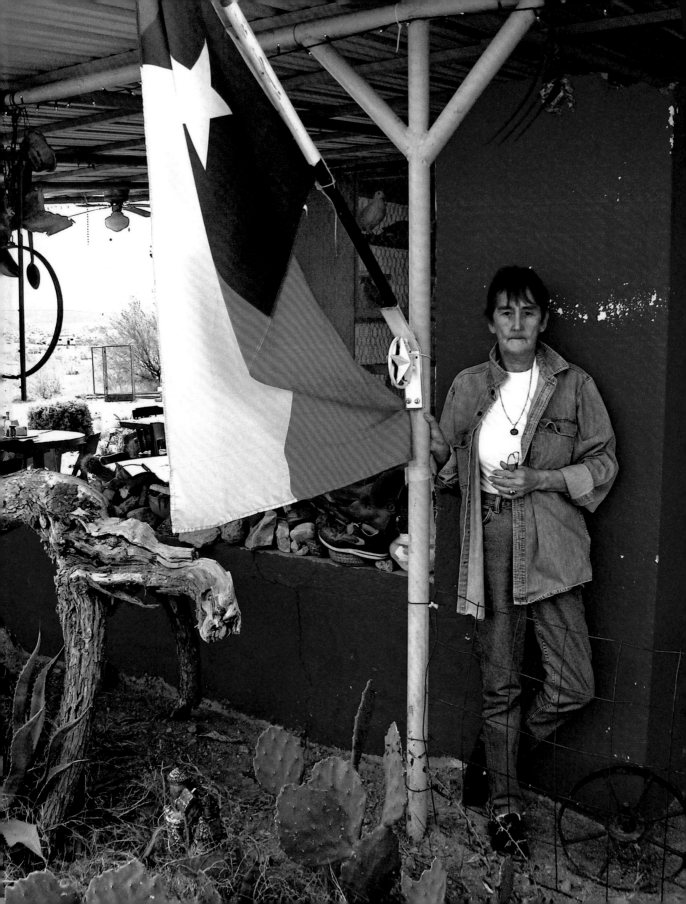

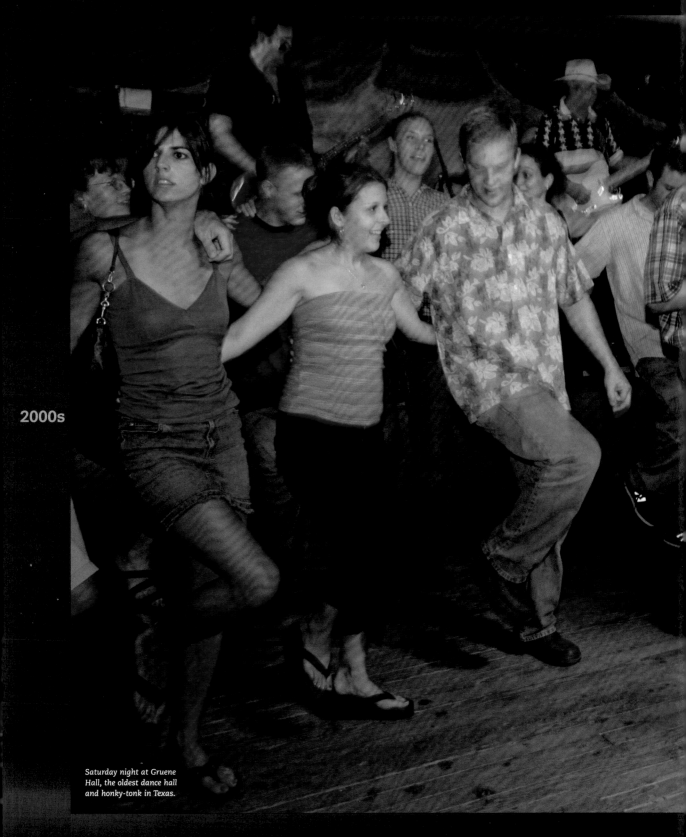

2000s

Saturday night at Gruene Hall, the oldest dance hall and honky-tonk in Texas.

As this book was nearing completion, I heard the news that Gordon Parks had died. I was in California teaching a Platypus Workshop, but I decided that I would take a detour through Fort Scott,

Kansas, on my drive back to Austin, Texas, to attend the funeral service. I'm glad I did.

I turned off Interstate 10 at Tucumcari, New Mexico, and headed east on Highway 54, cutting across eastern New Mexico, a sliver of Oklahoma, and then into Kansas. For the next eight hours I drove across the plains. It was a sparkling early spring day. The wheat fields and ranches stretched out to the horizon under a vivid blue sky. I passed through towns dominated by white grain elevators. I stopped for lunch in Liberal, Kansas, and had chicken fried steak in a family restaurant. As I drove, it occurred to me that it was this heartland from which Gordon had drawn his strength. He once said: " . . . I used to sit and dream of what I wanted to become. I always return here weary, but to draw strength from this huge silence that surrounds me . . ."

But for most of his life, he turned his back on his home in Fort Scott. He bitterly remembered the discrimination he had endured as a child in this small, segregated Kansas town "electrified with racial tension." But in the 1990s, the town reached out to its favorite son. Signs reading "Fort Scott, Childhood Home of Gordon Parks" were erected alongside the highway. That got his attention. In the last years of his life he returned the affection, embracing his Midwestern roots. In his honor, the Gordon Parks Elementary School was built in 1999 in midtown Kansas City, Missouri, to educate urban children. And with the proud urging of Fort Scott's townspeople, the first Gordon Parks Celebration of Culture and Diversity, a four-day event, brought him back to his hometown in October 2004.

As he was dying in New York, Gordon told his son David that he wished to be taken home to Fort Scott to be buried next to his family. I began to understand that it was this land of forever horizons that had inspired him as a young man and had given him hope to dream large.

This book begins with my first big break, photographing the funeral of Robert Capa. Now, fate has intervened and allowed me to end this book with images of the funeral of another of my heroes. Like Capa and Parks before me, I wanted to walk through the world and tell others of my passage. I am a citizen of America. I ache for the many problems we face. But when I think about the continuity of the dream that Gordon Parks lived out over his 93 years, I take heart, and think about my own dreams and thank God for my good fortune.

Gordon Parks is buried next to his mother, father, brother, and sister.

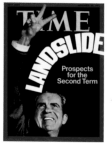

11|20|72

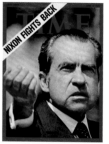

06|04|73

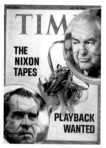

07|30|73

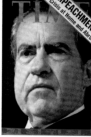

International edition|73

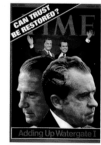

08|20|73

04|28|75

04|28|75

06|16|75

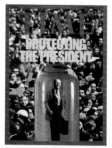

10|06|75

01|05|76

2000s

12|11|78

05|18|79

06|04|79

08|16|82

10|24|83

05|13|85

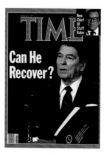

04|09|87

12|19|88

01|30|89

06|11|90

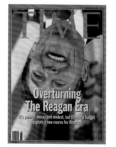

08|16|93

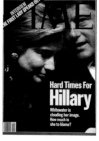

04|21|94

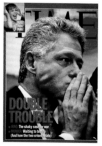

04|02|98

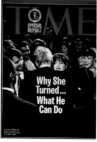

08|10|98

10|19|98

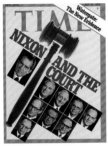

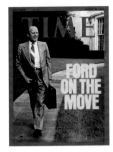

04|15|74 05|13|74 06|24|74 07|22|74 08|26|74

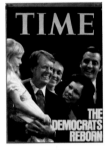

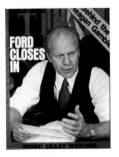

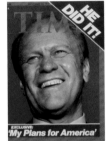

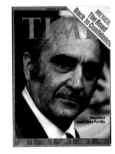

07|26|76 08|09|76 11|15|76 02|21|77 04|11|77

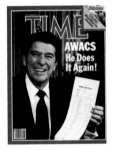

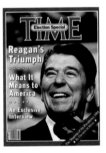

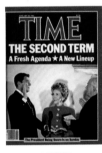

08|27|84 11|09|84 11|19|84 01|28|85 09|01|86

2000s

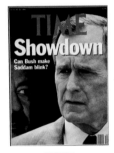

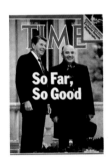

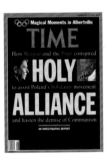

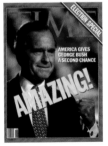

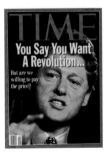

08|20|90 12|02|90 02|24|92 11|16|92 05|01|93

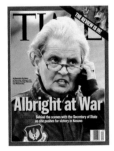

05|17|99 06|21|04

Dirck Halstead's 47 covers for Time.

ACKNOWLEDGMENTS

They say it takes a village to raise a child and, in a sense, the same is true of photojournalists. I wouldn't be where I am today had it not been for countless people along the way—far too many to acknowledge here. Still, a few do merit special mention.

First, and most importantly, I want to thank my parents, William and Leslie Halstead, who were responsible for nourishing a fledgling photojournalist. They had no idea what they had unleashed when they gave me a Kodak Duaflex camera and darkroom outfit for Christmas when I was 14 years old. For the next several years, the cost of the Christmas presents got ever more expensive, as I graduated to a Speed Graphic and thousands of dollars' worth of darkroom costs. My father was an engineer, responsible for, among other things, the development of FM stereo. My mother was an advertising executive. They have both passed on, but I am grateful to them every time I lift a camera.

There was a professional photographer in Bedford Hills, New York, Philip A. Litchfield, who took me under his wing when I was in high school and taught me the basics of the craft. He taught me well.

If I had to single out one person who was most responsible for my growth as a photographer, it would be Charles J. McCarty. He was the UPI Photo bureau chief in Dallas who hired me to join his staff at the Dallas *Times Herald*. Charlie was boot-camp tough. He would tolerate no excuses. Over time he went on to become the number two man at UPI in New York, then the vice president in charge of UPI's photo operations in Europe. I was just one of the many photographers who was forged by Charlie's "tough but fair" regimen.

Also at UPI in New York, assignment editor Larry DeSantis and managing editor Ted Majeski would constantly offer tough love and wonderful opportunities to help me grow in the profession.

I had the privilege of working under John Durniak, the director of photography at *Time* magazine when I joined the best bunch of photojournalists in the world in the early 1970s. Those photographers—Eddie Adams, David Hume Kennerly, Carl Mydans, Ralph Morse, John Zimmerman, David Burnett, Bill Pierce, Roddey Mims, P.F. Bentley, David Rubinger, Diana Walker, Cynthia Johnson, and Neil Leifer—provided spirited competition and loving support. But it was John whose imagination and enthusiasm for photojournalism fired us all.

In later years, Arnold Drapkin and Michele Stephenson kept John's tradition alive and well.

In the mid-1970s, Canon offered me use of some of their new equipment. Their incredible optics, especially their long lenses, gave me an edge at news events all over the world. The relationship with Canon, especially the support of David Metz in their professional markets division, has been unflagging. When I began to shoot video in the late 1990s, their head of video markets, Michael Zorich, offered support and equipment. Most importantly, they listened to my suggestions, and came up with radical new designs for camcorders. I am proud to be listed as a "Canon Explorer of Light" and look forward to continuing this relationship for years to come.

When I started to work on movies as a "special photographer," Rob Friedman, who was then in charge of advertising and publicity at Warner Bros., provided a warm welcome and sent me off to movie sets around the world. One of my first projects was *Dune*, where I met the De Laurentiis family. Dino De Laurentiis has produced more feature pictures than almost any other filmmaker, over 600 in his career. Not only did I work on dozens of films with him and his wife Martha and daughter Rafaella, but I was made to feel like one of the family as well. I still treasure this relationship.

Dr. Don Carleton, the director of the Center for American History at the University of Texas at Austin, invited me to donate my photographic archives to the Center, so that my photographs

will be available to students and researchers for many years to come. He also provided me with an office overlooking the campus, from which I was able to start work on this book. My friend and colleague at the center, Alison Beck, has generously given her advice and support along the way.

Photojournalists can be entertaining for a while, but we are generally lousy choices when it comes to marriage. We tend to have short attention spans and are extremely self-centered. Three of my wives have discovered this the hard way. Two of them, Betsy and Ginny, were far better than I deserved and have long since moved on. I wish them my love. For the past 26 years, my dear friend, Joan Gramatte, and I have somehow managed to maintain a special relationship that is as important as any marriage.

I could not have kept my business going, while jetting around the world, without the invaluable help of Marie Williams, who has been my right hand, taking care of the billing and banking, and paying all the American Express statements, sometimes with no money in the bank.

I owe a debt of gratitude to David Douglas Duncan who gave me the idea for the format of this book. It was his book *Photo Nomad* that convinced me that a photo book could be a reading book, not just another decorative item on someone's coffee table.

Finally, I want to thank the people who helped me to get this book published. My agent, Sarah Lazin, refused to give up as the book proposal made its way through publishers. Eric Himmel, the editor in chief of Abrams, took the leap of faith to commit to this project, and Andrea Danese guided me through the galleys. My copy editor, Cecilia White, did her best to keep me from making a complete fool of myself as I wrote. I was fortunate to be able to talk DJ Stout, the former art director of *Texas Monthly* and now the head of Pentagram in Texas, into designing the book. His associate, Erin Mayes, did the layouts. I am very proud of their efforts.

My thanks to them all—and to you, the reader, for sharing my moments in time.

DEDICATED IN LOVING MEMORY TO:

Charles J. McCarty and John Durniak—the best picture editors in the world—who led me; Alfred Eisenstaedt and Carl Mydans, who inspired and mentored me, who taught me what photojournalism is all about.

Editor: Andrea Danese
Designers: Erin Mayes and DJ Stout, Pentagram Design, Austin, TX
Production Manager: Anet Sirna-Bruder

Library of Congress Cataloging-in-Publication Data

Halstead, Dirck, 1936–
 Moments in time : stories and photos from one of America's top photojournalists / Dirck Halstead.
 p. cm.
 ISBN 13: 978-0-8109-5441-0
 ISBN 10: 0-8109-5441-9 (hardcover)
 1. Photojournalism. 2. Halstead, Dirck, 1936– I. Title.
 TR820.H256 2006
 070.4'9092—dc22

 2006016971

Printed and bound in China

10 9 8 7 6 5 4 3 2 1

HNA
harry n. abrams, inc.
a subsidiary of La Martinière Groupe

115 West 18th Street
New York, NY 10011
www.hnabooks.com